FILTERING HISTORIES

 AFRICAN PERSPECTIVES
Kelly Askew and Anne Pitcher
Series Editors

Filtering Histories

The Photographic Bureaucracy in Mozambique, 1960 to Recent Times

Drew A. Thompson

University of Michigan Press
Ann Arbor

For questions or permissions, please contact um.press.perms@umich.edu

Published in the United States of America by the
University of Michigan Press
Manufactured in the United States of America
Printed on acid-free paper

First published March 2021

A CIP catalog record for this book is available from the British Library.

Library of Congress Cataloging-in-Publication data has been applied for.

ISBN 978-0-472-07464-8 (hardcover : alk. paper)
ISBN 978-0-472-05464-0 (paper : alk. paper)
ISBN 978-0-472-12718-4 (e-book)

Publication of this volume has been partially funded by the African Studies Center, University of Michigan.

CONTENTS

Digital materials related to this title can be found on the Fulcrum platform
via the following citable URL: https://doi.org/10.3998/mpub.11476976

ABBREVIATIONS

AIM	Agência da Informação Moçambique
AHM	Arquivo Histórico de Moçambique
ANC	African National Congress
CDFF	Centro de Formação e Documentação Fotográfica
DIP	Departamento de Informação e Propaganda
DRE	Departamento de Relações Exteriores
Frelimo	Frente da Libertação de Moçambique
GIFOP	Gabinete de Informação e Formação da Opinião Publica
GNP	Gabinete dos Negociós Politicos
INC	Instituto Nacional de Cinema
PIDE	Polícia Internacional e de Defesa do Estado
Renamo	Resistância National de Moçambique
SCCIM	Serviços de Centralização e Coordenação de Informações de Moçambique

FIGURES

ACKNOWLEDGMENTS

This book is like a photograph, going through various processes of development, including cropping, printing, exhibiting, and archiving. I laid the foundation for the project while a graduate student in the Department of History at the University of Minnesota–Twin Cities under the advising of Allen Isaacman and Helena Pohlandt-McCormick. I had the good fortune to study with and learn from Naheed Gina Aaftaab, Jesse Bucher, Kelly Condit-Shreastha, Stuart Davis, Eléusio Felipe, Melissa Geppert, Elliot James, Neelima Jeychandran, Elizabeth Lundstrum, Terrence Mashingaidze, Clement Maskure, David Morton, Ireen Mudeka, Munya Bryn Munochiveyi, Jecca Namakkal, Govind Nayak, Andrew Paul, Amy Powell, Rajyashree Reddy, Laurie Richmond, Virgil Slade, Julie Weiskopf, and Elizabeth Zanoni. Ed Epping, Peggy Diggs, Guy Hedreen, Elizabeth McGowan, Molly Magavern, and Kenda Mutongi sparked and developed my initial interest in African history and art history as an undergraduate at Williams College, and offered immeasurable support during my graduate studies.

Graduate school marked my first foray into the fields of Mozambican historiography and Lusophone studies, and served as an introduction to a number of scholars whose guidance I have benefited from, including Yussuf Adam, Eric Allina, Fernando Arenas, Rui Assubuji, Hugh Cagle, Mariana Candido, Cláudia Castelo, Alda Costa, Colin Darch, Joel Tembe das Neves, Carlos Fernandez, Claudia Gastrow, Inês Gomes, Ros Gray, Pamila Gupta, Zachary Kagan Gutherie, Ariana Fogelman Huhn, Paolo Israel, Marissa Moorman, Benedito Muchava, Prexy Nesbitt, Michael Panzer, Christabelle Peters, Maria do Carmo Piçarra, Anne Pitcher, Carlos Quembo, Afonso Ramos, Catarina Simão, Felipa Lowndes Vicente, and Rosa Williams. I owe a special thanks to Jeanne Penvenne and Ariana Fogelman Huhn for sharing unexplored photographic archives, reading drafts of my work, and checking in over the years. Marissa Moorman's pioneering works on music and radio in Angolan and Portuguese history have been a powerful guide. This book wouldn't have reached publication without her unending mentorship and friendship.

I first learned about the field of visual history during a 2009 visit to the Center for Humanities Research (CHR) at the University of Western Cape in Cape Town, South Africa. Patricia Hayes, the founder of the Visual History Seminar (VHS), has graciously included me in CHR and VHS activities. Never has she missed an opportunity to learn about my work and to challenge me to move beyond the photograph in my writing and thinking. In fact, Patricia was the first person to push me to further develop this idea of photographs as "filters." My time at the CHR, and in Cape Town more generally, resulted in lasting friendships with Paolo Israel and Rui Assubuji, who always fed me and shared their experiences in Mozambique. I am grateful to Kathy Erasmus, Juan Ran Annachiara Forte, Premesh Lalu, Giacomo Loperfido, Ciraj Rassool, and Lameez Lalkhen for the countless free rides and hours of conversation that nourished me during intense moments of homesickness and difficult times with research and writing.

Fellowships and grants provided invaluable financial support: Project Funding and Dissemination Grants from the Experimental Humanities concentration at Bard College; the Bard College Research Fund; a grant from Bard College's Social Studies Division, IGK Work and Human Lifecycle in Global History at Humboldt University; Institut Français Afrique du Sud; the Mellon-Mays Graduate Initiatives Program; and the Woodrow Wilson Career Enhancement Fellowship. Farah Barakat, Armando Bengochea, Maria Cecire, Felicitas Hentschke, Ina Noble, Greta Tritch Roman, and Cally Waite administered these grants and ensured that I had the necessary support to successfully do my research and writing. Sue Elvin Cooper, the faculty grants officer at Bard College, helped me to prepare applications for many of these funding opportunities.

Photographs and oral histories are central elements of this work. From 2008 until 2016, Mozambican photographers and the viewers of their images welcomed me into their studios, darkrooms, and homes. During the summer of 2008, Ricardo Rangel and I had a standing meeting on Saturday mornings. His wonderful partner Beatrice Rangel would fill gaps in Ricardo's memory, and always invited me to stay for *almoço do Sabado* (Saturday lunch). Even after Rangel's death in summer 2009, Beatrice and the Rangel family continued the tradition, and, if I was in Maputo, they made sure I was included. During my extended visits to Mozambique from 2008 to 2016, the commercial studio owner José Machado spoke to me between taking client portraits and facilitated interviews with photographers based in Maputo and Beira. Maria de Lurdes Torcato, Luís Bernardo Honwana, and Polly Gaster were

important interlocutors, who challenged me to hone my understanding of the role of the press, photographers, and filmmaking in the postindependence history of Mozambique and helped facilitate introductions to individuals I cite in the chapters that follow. The archival staffs of the Arquivo Histórico de Moçambique, Arquivo Histórico Diplomático, Arquivo Histórico Militar, Centro de Documentação e Formação Fotografica, Biblioteca Nacional de Moçambique, Biblioteca Nacional de Portugal, the Basler Afrika Bibliographien, the Instituto per la Storia della Resistenza e della Società Contemporanea, and the Schomburg Center for Research in Black Culture provided incredible support for identifying, digitizing, and securing publication rights for the images featured. Colin Darch's Mozambique History Net and JSTOR ALUKA: Struggles for Freedom—Southern Africa were resources for images when I was unable to return to Mozambique. Finally, I wish to thank Shea Wert and Betsy Cawley of Stevenson Library at Bard College and Amy Herman of the Bard College Visual Resource Center. During the final stages of the peer-review process, some of the photographs submitted were deemed unusable because of image quality. Shea Wert worked their magic under a tight deadline and secured high-resolution reproductions.

At various stages in the research and writing process, I presented portions of the book project at symposia and invited lectures hosted at Bayreuth Academy of Advanced African Studies, Boston College, Boston University, Columbia University, Freie Universitsät Berlin, Iwalewahaus, the New School, Universitsät Basel, Universitsät Bielefeld, Universitsät Der Künste Berlin, University of Western Cape, Wesleyan University, and the Wits Institute for Social and Economic Research. The annual meetings of Arts Council of the African Studies Association and of the African Studies Association have presented opportunities to learn about the research of other scholars and to hone the historiographical arguments of this text. The conveners and discussants of these events, and their participants, have offered innumerable comments that have strengthened my arguments and provided greater context for my analysis. Thank you to Rukimini Barua, Heike Behrend, Melanie Boehi, Keith Breckinridge, Mariana Candido, Naveen Chander, Fred Cooper, José C. Curto, Maria José de Abreu, Andreas Eckert, Daniel Eisenberg, Julia Engelschalt, Maya Figge, Katharina Fink, Joshua Grace, Pamela Gupta, Patricia Hayes, Sean Jacobs, Chitra Joshi, Jonathan Klaaren, Priya Lal, Premesh Lalu, Silvia Lara, Brian Larkin, Christopher Lee, Elisio Macamo, Darren Newbury, Sarah Nuttall, Juan Manuel Palacio, Suren Pillay, Lucilene Reginaldo, Seth Rockman, Ellen Rothenberg, Aditya Sarkar, Nadine Siegert,

members of the Toronto Photography Group, Jennifer Tucker, Ben Twagira, Laura Ann Twagira, Ulf Vierke, Richard Vokes, Tobias Wendl, and Leslie Wilson. Special thanks to Melanie Boehi, Mónica de Miranda, Brendan Embser, Ângela Ferreira, Katharina Fink, Sean Jacobs, Yvette Mutemba, and Oluremi Onabanjo—all have presented me with opportunities to expand my research and writing in the fields of African and African diasporic modern and contemporary art. Christopher Pinney offered generous and substantive feedback on drafts of chapters at the beginning of the book project. The photographic histories, visual analyses, and curatorial projects of Tina Campt, Elizabeth Edwards, Nicole Fleetwood, Leigh Raiford, Shawn Michelle Smith, and Krista Thompson have served as inspiration and guides along the way.

Bard College has been my professional home since fall of 2013. Working alongside a dynamic group of colleagues and students has pushed the interdisciplinary boundaries of this work and enabled me to proudly embrace my intellectual identity as a visual historian. My undergraduate and senior-project students at Bard College and the Bard Prison Initiative have indulged my interest in history and photography, introduced me to new photographers and photographic movements and practices, and brought to class their own rich experiences with the medium of photography. My colleagues in Historical and Africana Studies, Susan Aberth, Richard Aldous, Myra Armstead, Mario Bick, Diana Brown, Omar Cheta, Christian Crouch, Robert Culp, Tabetha Ewing, Cecile Kunitz, Gregory Moynahan, Miles Rodriguez, Alice Stroup, Yuka Suzuki, and Wendy Urban-Mead have encouraged me to integrate my research into my teaching and vice versa. Omar Cheta, Wendy Urban-Mead, and Yuka Suzuki took time away from their own manuscripts to read draft chapters, while Robert Culp, Christian Crouch, Tabetha Ewing, Patricia López-Gay, Miles Rodriguez, and Sophia Stamatopoulou-Robbins offered priceless advice during the peer-review process. Thomas Keenan, Kerry Bystrom, Maria Cecire, Susan Merriam, and Danielle Riou have all nurtured my interest in visual and media studies and collaborated on a series of workshops that brought together faculty from across the Bard College International Network. Omar Cheta, Dina Ramadan, Miles Rodriguez, Nate Shockey, Patricia López-Gay, and Sophia Stamatopoulou-Robbins have been my comrades in arms. We joined Bard in fall 2013 and embarked on writing our respective book manuscripts at the same time. You all have offered wisdom and laughs, and your guidance and friendship have made me a better researcher, writer, and teacher.

I first met Anne Pitcher in March 2017 to discuss the book manuscript

and the possibility of publishing with the University of Michigan Press. From the outset, Anne pushed me to be bold and imaginative. Her words of wisdom and guidance helped me produce my best work. Anne, and her coeditor of the African Perspectives Series, Kelly Askew, along with Ellen Baurele, the executive editor of the press, seamlessly ushered the manuscript through the peer-review process with boundless support and encouragement. From the start, Anne and Ellen pushed for a large number of images to be published—a rarity in publishing. The peer reviewers challenged me to clarify the book's framing concepts, to address the secondary literature, and to create a space for the display of photographs alongside historically contextualized visual analysis. Anna Pohlod oversaw the book's submission while Mary Hashman handled production. Daniel Otis thoughtfully copyedited the text. Gratitude is also owed to Roberta Engleman who created the book's index, and Judy Loeven who reviewed the final proof pages.

From the time I started dissertation research in 2008 until 2020, I have watched my extended family grow and change in wonderful ways. Nicholas Lewis, you are always a phone call away for counsel and encouragement. Alexander Franklin has always offered me a space to realize that there was a world outside of academia. Sandy Choi, Patricia López-Gay, Nico Lemery Nantel, Luca Nantel-López, and Miles Rodriguez provide wonderful excuses and opportunities for procrastination. Sarah Bove, Ricardo da Costa, Laura Grüenewald, Cristina Franco Lopez, Simão Oliveira, Joana Pedro, Benjamin Potter, and Barbara Ribeiro were there from the start. Leica Rosenthal read final chapter drafts and provided edits that prompted me to expand my thinking about photography and the postcolonial moment. Shannon Allen, David Dupre, Harlow Allen-Dupre, Joy Allen, and Edward Allen have welcomed me into their lives for Thanksgivings, Christmases, and birthdays. I am forever grateful for the counsel, love, laughs, and baked goods. Deborah Blades and Colin Blades-Thomas have been some of my biggest cheerleaders.

I dedicate this book to the three women who raised me. As I wrote this book and anxiously awaited the peer-review reports, I lost my aunt and godmother Janice Young to cancer. During her chemotherapy treatments, Janice always reminded me that I could write a book, and that I would finish it. Janice never lost her self-confidence. Her strength and full-hearted desire to beat cancer provided me inspiration. I only wish she were here to see the finished product. My grandmother, Dora Thompson (aka Madre), took me to school as a young boy and has watched as I become the first person in my family to receive a PhD. Over the course of this journey, my Madre has offered much-

needed advice and counsel. She always knew when to ask about the book's progress and when not to ask but to instead give encouragement. My mother, Mitzi Thompson, raised me as a single parent and worked tirelessly to put me through the best schools. She never missed an opportunity to visit me abroad when I conducted research for this book. Our mother-son travels provided me with the biggest honor—the opportunity to share my life's work with one of the people I most admire.

I close by thanking Camille Hearst, who saw this project through its final stages and who encouraged me to not lose myself in the piles of paper and the pressures of writing. Your kindness, measured nature, generosity, friendship, and most of all love make me a better person and help me to have perspective and compassion. Camille, the future looks so bright and clear with you in the picture.

Introduction

Filters, Filtering, and Mozambique's Photographic Bureaucracy

Photography has an uneasy yet essential relation to the history of Mozambique as a colony and an independent nation. What follows is a messy and uncontained history of representation and visualization that unfolded against the backdrop of anticolonial struggle and postcolonial state development in Mozambique. At the center of the study is how photography inhabits and influences the operation of bureaucratic structures in Mozambique and how state and nonstate actors put photography to extraordinary and varying use. For the better part of the twentieth century, Mozambique was a site of war and anticolonial struggle. After its independence from Portugal in 1975, it confronted another war, this time with its territorial neighbors, Rhodesia (present-day Zimbabwe) and South Africa, over white apartheid rule. Populations living in Mozambique and in exile experienced these conflicts, along with the nation's independence and postindependence struggles, through taking and viewing photographs.

The October 3, 1964, edition of the Mozambican newspaper *A Tribuna* featured a photograph (figure 1) of two boys seated in front of a camera. One of the boys is dressed in an oversized suit jacket and shorts; the other wears a short-sleeved shirt and shorts. Next to the seated figures, another person stands barefoot with an umbrella between his legs. The standing boy uses his hands and chin to hold in place a piece of cloth, the backdrop for the makeshift studio setting. The pictured photographer uses one hand to direct the poses of his clients and the other to focus the camera. Off to the photographer's side, another man, possibly waiting for his own photograph, looks at the photographer responsible for the image that resulted in figure 1. The published picture

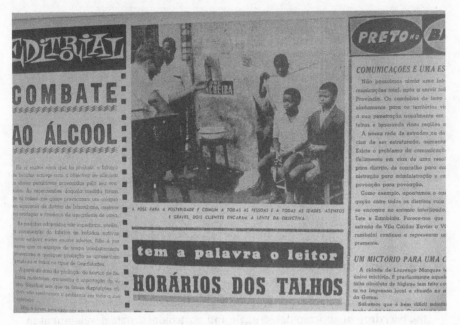

Figure 1. "A pose para a posteridade é comum a todas as pessoas e a todas as idades. Atentos e graves, dois clients encaram a lente da objectiva." ("The pose for posterity is common to all people and to all ages. Attentive and serious, two clients face the lens of the camera.") *A Tribuna*, 3 Outubro 1964, Arquivo Histórico de Moçambique.

included the following caption: "The pose for posterity is common to all people and to all ages. Attentive and serious, two clients face the lens of the camera."[1] Facing the camera, looking at photographers as they take pictures, and retrieving headshots are characteristic features of daily life in Mozambique that date back to the colonial period and have continued in recent times.

Photo captions such as the one in figure 1 appeared in the progressive colonial-era Mozambican newspaper *A Tribuna*. Editors used photographs paired with text to report on undocumented aspects of daily life. From 1961 to 1964, *A Tribuna* was one of the only independently owned newspapers in Mozambique,[2] and photographers were as important as writers to *A Tribuna*'s editorial team. The acclaimed Mozambican writer Luís Bernardo Honwana, who worked at *A Tribuna* as a print journalist, identified the Mozambican photographer Ricardo Rangel as the photographer who produced prints published by *A Tribuna*, such as figure 1.[3] In contrast to photographers working for newspapers operated by the colonial state, Rangel used his camera to pic-

ture black individuals subjected to Portuguese rule as the sitters, makers, and consumers of their own photographic images. By publishing Rangel's images, *A Tribuna*'s editors challenged the publishing and social norms that determined how Mozambique's white populations viewed the colony's native black populations, and in the process nurtured readers' anticolonial and proindependence sentiments.

On September 25, 1964, eight days before the publication of the image in figure 1, the liberation movement Frente da Libertação de Moçambique (Frelimo) launched a war for Mozambique's independence from Portugal.[4] Frelimo's political and diplomatic leadership was familiar with the work of photojournalists like Rangel. José Oscar Monteiro, who headed the liberation front's diplomatic office, first in Algeria and later in Rome, had paired Rangel's photographs and those that appeared in colonial state-run newspapers with images of the war front produced by Frelimo's own photographers.[5] According to Monteiro, Frelimo deployed Rangel's photographs as a type of filter for foreign audiences.[6] In the context of the armed struggle, Rangel's photographers served two purposes: first, to illustrate the injustice of Portuguese colonialism, and second to demonstrate the "progress" of the liberation war effort under Frelimo.[7] The movement's use of Rangel's pictures differed from that of *A Tribuna*, and ultimately represented a contrasting view on photography's role in the fight for Mozambique's independence. In response to both *A Tribuna*'s and Frelimo's respective uses of photography in the 1960s and early 1970s, Portugal's authoritarian state and its colonial counterpart in Mozambique increased its oversight over the circulation of photographs.

During its independence war (1962–1974), Frelimo's diplomatic and military representatives lacked the capacity to provide headshots to populations living in Mozambique and Tanzania, so Frelimo's leadership arranged for selected soldiers to train as photographers. The photographs created a collective portrait of an independent Mozambique. During the war, Frelimo officials and photographers rejected the notion of individuality that they believed came with headshots and labeling photographs in terms of their authors and depicted locations. In 1975, the official year of Mozambique's independence from Portugal, Frelimo's leadership assumed control with photographs of the war that it had amassed. However, military, diplomatic, and humanitarian offices lacked individual headshots of the populations that had come under the control of the newly empowered Frelimo administration. Many Mozambicans who lived through the war had never viewed an image of members of the liberation movement, let alone pictures of themselves. Faced with having

to introduce themselves to the population and the outside world, Frelimo's leadership across different government ministries took an interest in how to organize the photographs of liberation into an archive, how populations appeared in front of the camera, how photographs appeared in newspapers, and what sort of photographs photographers produced. This aesthetic realm gave the ruling party an opportunity to address the representational politics associated with its rise to power, the day-to-day work of governing that followed, and the transformation from a liberation movement into a ruling political party.

In the years after 1975, there were extended periods of destabilization and war in Mozambique. Photographers worked on behalf of state-run media. Like their predecessors, photographers produced images (similar to figure 1) that depicted someone with a camera, a photographer taking a picture, or people looking at photographs. The visual trope of picturing photographers at work dated to the colonial era and re-entered public view through the state-run press. In reality, though, the "pose of posterity" documented and captioned in figure 1 was elusive for many Mozambicans after 1975.[8] Studio and street photographers filled the voids left by the incapacity of the state apparatus under the ruling Frelimo party to produce and issue photo identification. Supply shortages coupled with increased public demand prevented populations from obtaining headshots. Outside of the picture frame, Mozambicans demanded explanations of why photographers failed to print their images and of how their images appeared on movie screens.[9] What was once a constant feature of colonial daily life—the headshot—disappeared in 1975. Images like figure 1, which had been symbols of independence under colonial rule, came to represent the varied documentary and surveillance regimes to which the state subjected Mozambicans after independence, to assert control over the bureaucracy that Frelimo had inherited from Portugal.

The book's title, *Filtering Histories: The Photographic Bureaucracy in Mozambique, 1960 to Recent Times*, encompasses its framing and major arguments. The following questions constitute the book's core arguments. How and why did photographs become a political force in late colonial and independent Mozambique? What does the history of photographic use by Portugal's authoritarian state, its colonial counterpart, and Frelimo as both a liberation movement and a political party reveal about how the medium of photography represents and obscures political power? What remains today of the photographs and photography-related institutions that existed at Mozambique's independence? Thinking about the centrality of photography and

histories of photography to nation-building processes also requires that we consider what historical actors living during both colonial and independent periods *do to* and *with* photographs. What kinds of photographic repurposing and (re-)casting of history occurred in periods of colonial rule and independence in Mozambique?

Filters and filtering are apt metaphors for thinking about history. The photographic practices institutionalized by the colonial and independent state structures in Mozambique create a visual narrative frame for understanding Mozambique's past and projecting its future. One part of the photographic process in Mozambique involved photographers using filters, including lighting, camera lenses, flashes, contact sheets, and chemical solutions, to alter what appeared in the camera lens, negative, and print. Another aspect of photography involved journalists, newspaper editors, and government officials in Mozambique debating how the publication of photographs would influence public opinion and what was the best way for photographs to enter into public circulation. We should also recognize that photographs were especially important in colonial and postcolonial state processes of surveillance and identification. On the one hand, framing photographs as filters is one way to determine what images did and did not circulate. On the other hand, the process of filtering that state and nonstate actors actively undertook is a method for tracing photography's role in the administrative governance and the making of Mozambique as a colony and an independent nation. Each governing regime in Mozambique had its own filters and its own methods for using filters. Ultimately, bureaucracies enacted filters. Such histories of photographic use and representation reflect a state activity that influenced the lives of people living in Mozambique during the colonial period, during the fight for independence, and after independence.

In the years after independence, Frelimo government officials faced limitations in operating the bureaucracy that the Portuguese authoritarian and colonial state left behind. To compensate for the challenges they faced, Frelimo's leadership used photography as a discourse, a medium, and a visual tool of governance. Despite the arguments that images made, the practice of photography endorsed by the independent state did not necessarily mark a rupture from a colonial aesthetic and colonial surveillance practices; rather, they represented a form of bureaucratic continuity. One could even go so far as to say that the independent state appeared more targeted and deliberate in its use of photography than its colonial predecessors.

On one level, this book presents a history of photography in Mozam-

bique. On another, it is about the importance of photography and its history to the state-formation processes associated with colonialism and independence. Throughout the text, I chart changes in photography's form and function over periods of colonial war, liberation struggle, independence, and civil conflict. I also consider how photographers pictured the day-to-day activities, policies, and discourses of the colonial and postcolonial state. Photographs come to inhabit bureaucratic structures at different points in time, and have implications for the very ways that state structures, such as those developed in Mozambique from 1960 until recent times, displayed and asserted their power.

MOZAMBIQUE'S PHOTOGRAPHIC ECONOMIES: A BRIEF HISTORY

Despite advances in conceptual thinking about photography's relationship to history, the field of photographic studies has sidelined the history of photography in Mozambique.[10] Studies of the region of West Africa and the nation of South Africa dominate the historical literature on photography, photographic portraiture, and photojournalism.[11] Current writings on African photography frame debates over portraiture as exclusive to studios and individual sitters.[12] At first glance, figure 1 suggests that the history of photography in Mozambique was no different from that of other parts of Africa and other global contexts where photography flourished. As an image, figure 1 represents the photographic economy that characterized Mozambique in 1964, displaying black populations as the sitters, consumers, and even makers of their own photographic images. The taking of figure 1 by Ricardo Rangel and its publication in a newspaper also represents a photographic economy that contrasts with that of others on the African continent. In Mozambique, there was not the particular divide between press and commercial photography that characterized the operation of photographic economies in the rest of Africa and other parts of the globe.

The history of photography in Mozambique does not have a specific origin or start date.[13] Mozambique is geographically and culturally situated at the intersection of the Portuguese-speaking world, the Indian Ocean, and Anglophone southern and eastern Africa. There are ways to read the history of photography in Mozambique in relation to diverse traditions of photographic practice and photo viewing that unfolded between and within these geographical contexts. Such a line of interpretation differentiates the history

of Mozambique from other global histories of image-making and helps in interpreting the role of photography in Mozambique's colonial and independence histories.

From the days of the daguerreotype in the late nineteenth century and the stereoscope of the early twentieth century, photography proliferated in a decentralized fashion mainly in Portugal's African colonies of Mozambique and Angola.[14] Photographers roamed Mozambique and Angola independently or with colonial expeditions, producing photographs that informed the Portuguese view of Africa. According to the Angolan writer José Agualusa, "[T]he start [of photography in Angola] was auspicious. The series of four albums with exceptional images collected at the end of the 19th century, between Cabinda and Moçamedes, by [José Augusto da] Cunha Moraes helped (a lot) to invent Angola."[15] José dos Santos Rufino, one of the more recognized photographers of the early twentieth century in Mozambique, similar in professional stature, practice, and formal style to Moraes, produced photography albums on the themes of urban architecture, rural landscapes, agriculture, and industry, to name a few topics.[16] Photographs of colonial Mozambique and Angola also circulated on cartes de visite, or postcards, that colonial residents sent to people living in Portugal.[17] Agualusa argues that the histories of photography in Mozambique and Angola initially mirrored each other, yet by the end of the nineteenth century, their respective photographic histories began to follow different trajectories.[18] Agualusa was of the opinion that Cunha Moraes "did not have followers [in Angola] at the same level" as photographers who practiced in Mozambique.[19] Mozambique's photographic economy was far more active and dynamic than that of Angola because of a range of historical actors, working both independently and in the service of the Portuguese colonial state apparatus. Practitioners in colonial Mozambique used photography to tremendous effect, part of which involved picturing key historical events of the nineteenth and twentieth centuries.

Mozambique contrasted with some areas of East and West Africa and with the nation of South Africa, in that the commercial photography studio was the central backdrop to photography's practice, development, and proliferation. The rapid rise of studio-centered practices in Mozambique coincided with the rise of Portugal's Prime Minister António Salazar in 1926 and his formalization of an authoritarian corporatist new state, or "Estado Novo."[20] A wave of disenchantment over the policies of a Republican administration, especially with regard to the colonial administration, brought Salazar to power.[21] Salazar sought to reduce the drain of the colonies on the metropole's

finances by strengthening trade between Portugal and the colonies. To attract investment and present business opportunities, the Estado Novo encouraged people living in the metropole, especially those who were poor, to relocate to the colonies for work.[22] Furthermore, Salazar embarked on Estado Novo at a time when Europe more broadly was rethinking and revamping its colonial endeavors in Africa and other parts of the world. In fact, to win the support of Portugal's citizens and to ward off criticism, Salazar embraced and promoted Gilberto Freyre's racial ideology of Lusotropicalism.[23] The theory proposed that Portugal was in the best position to colonize Africa because its citizens were direct descendants of Africans and the nation was close geographically to the continent compared to other European nations. The theory was never meant to be realized, but only served to justify the colonial project that Salazar embarked on under the Estado Novo.

Immigrants from Portugal and elsewhere used their skills and interests in photography to open commercial photography studios in Mozambique. The influx of immigrants and the opening of photography studios presented new opportunities for nonwhite populations native to Mozambique to pursue careers in photography and to access the photographic economy as workers, patrons, and enthusiasts. The Mozambican historian António Sopa has noted that the number of commercial photography studios in the colonial capital of Lourenço Marques ranged from two to four between 1889 and 1932, and in northern Mozambique there was one enterprise and sometimes two.[24] Then from 1933, the year Salazar declared the Estado Novo, to 1975, the year of Mozambique's independence from Portugal, the number of commercial photography studios in the Lourenço Marques grew from four to thirty-three. In the countryside, over the same period, the number of studios expanded from three to ten.[25] The statistics compiled by Sopa did not account for those who practiced photography outside of the studio setting.

At the outset, studios offered a range of services to local populations and state institutions. One of the first and longest-running studios in Mozambique was A. W. Bayly.[26] The owner came from South Africa and opened a space that included a photo studio, a darkroom for film processing, a bookstore that sold photographs produced by the studio, and an exhibition space.[27] The studios that followed A. W. Bayly generally focused on photographing, film processing, and selling state-of-the art photography equipment. Many studios in Mozambique formed exclusive distribution agreements with global photography manufacturers, including Kodak (A. W. Bayly), Fuji (Foto Portuguesa), and Ferrania (FOCUS), to sell their respective color and black-and-

white automatic and manual film products.[28] The sale and use of marketed camera products linked colonial Mozambique's photographic economy to regional distribution hubs in South Africa and Rhodesia (present-day Zimbabwe), territories under white minority rule.[29]

The patrons of photography studios between 1933 and 1975 were wide-ranging, and sometimes even included agents of the colonial state. Colonial Mozambique had a vibrant amateur photography scene that involved enthusiasts taking pictures and exhibiting them at local social clubs. Portuguese soldiers used purchased cameras for both recreational and reconnaissance operations. White settlers from Portugal were not the only ones with photographic aspirations and pursuits. Importantly, and sometimes this is not acknowledged, many black residents of colonial Mozambique wanted photographs of themselves to send to loved ones or documentation of family celebrations, including weddings and baptism.[30] There was also the case of José António Manhiça, who was Mozambican by birth but worked in the immediate years before Mozambique's independence in the mines in South Africa.[31] Manhiça used his wages to purchase camera and films. On Saturdays, just outside of the mine gates, he operated an informal studio (similar to the one in figure 1) and made money photographing his fellow miners.

Although photographs could be taken and purchased, the person behind the camera did not necessarily know how to develop and print photographic film.[32] Under the practicing conditions that emerged in the 1940s and continued until 1974, clients no longer needed studios to take their photographs; the printing and processing of films was of greater priority. Some commercial photography enterprises that opened between 1933 and 1975 were not studios per se but instead functioned mainly as film laboratories.[33] One of the more immediate results of unprecedented consumer demand was the elevation of the importance of the darkroom within the photographic economy. Photography sections at state-run colonial-era newspapers employed a limited staff, and the colonial state did not employ dedicated photographers. To fulfill demands in Portugal and across the colony for photographic documentation, the colonial state hired photographers affiliated with specific commercial studios to document state ceremonies and visits from high-level officials.[34] The work of processing photographic films fell onto the blacks and other nonwhites who studios and film laboratories increasingly hired to operate darkrooms. Some of the film technicians included Ricardo Rangel, Kok Nam, Francisco Cuco, and Sebastião Langa, to name a few; many others remain nameless because of poor historical documentation.[35] These technicians

became some of Mozambique's most famous photojournalists and operators of commercial studios in the postindependence period.

In the colonial period, the importance of the darkroom and the work of film technicians helped to expand the photographic economy that serviced the colonial state and produced a new platform for viewing and critiquing the colonial system.[36] The Mozambique-born photographer Carlos Alberto Vieira was the head of the photography section at the major colonial newspaper *Notícias*. Viera relied on the services of Rangel to develop films not slated for news publication but instead for commercial sales. Rangel's work in the darkroom, where he frequently met with colonial-state journalists such as Vieira, resulted in an opportunity to join the press. From inside the newsroom, Rangel's skills and photographs had another effect. Many of Rangel's photographs faced censorship and resulted in the temporary closing of newspapers where he worked. Nam, a photographer of Chinese descent born in Mozambique, followed a similar trajectory as Rangel from the darkroom to newsroom. In contrast to both Rangel and Nam, after working for two prominent photography studios, Langa joined a research institute, where he operated the darkroom and photographed office activities. In his spare time, he photographed family celebrations for the community where he lived.[37]

The interdependent nature of the relationship between press and commercial photography ended just before Mozambique's independence from Portugal in 1975. Mozambique's standing as a colony of Portugal became uncertain with the military coup in Portugal on April 25, 1974. Unsure of what independence would bring, many studio owners who were not born in Mozambique decided, like many other settlers, to close their respective businesses and leave Mozambique.[38] In advance of their departure, some studio owners handed control of their businesses to the black employees who staffed and cleaned the darkrooms.[39] The sudden closures of studios created supply shortages. Long-standing distribution agreements with major photography manufacturers also ceased. To lessen the economic impact and to assert control over the chaotic situation, Frelimo's senior leadership nationalized private industries, which included photography studios, and prohibited studio owners from departing with the photographic materials that they had used for business purposes. Such action propelled the photographic economy into a tailspin. Increased state action was needed to procure supplies and have photos taken. After independence, the field of photography was disjointed and there were few practitioners, paving the way for the state to introduce varied, haphazard means of surveillance. Photographers, such as Mahiça,

who had operated outside of the formal photographic economies that linked South Africa and Mozambique, used their skills to meet the state's need for headshots.[40]

Many people who lived in colonial and independent Mozambique never saw photographs printed in newspapers and faced difficulties obtaining photographs of themselves. Nonetheless, especially after independence, people who lived in Mozambique ascribed a representational authority to photography over other visual media. As a PhD student, I interviewed in June 2008 the famed Mozambican painter Valente Ngwenya Malangatana;[41] I wanted to understand the role of painting in the fight against Portuguese colonial rule. Malangatana responded to my initial introduction and query with a question: why I was talking to him? After discussing the limited availability of paintbrushes and canvases before independence, he advised me to speak with the photographer Ricardo Rangel. Malangatana's statement and its historical reference implied that, in terms of priority and production, photography superseded other forms of visual arts. To expand on Malangatana's point, in the broader context of the history of photography and independence in Mozambique, there is an indication that populations understood certain historical developments in relation to their abilities to obtain their headshots for recreational or institutional purposes. Another indication of the representational significance ascribed to photography is that Frelimo's leadership decided after independence in 1975 to photograph Mozambique's new president, Samora Machel, rather than have an international artist like Malangatana paint an official portrait. As in many other African countries, the ruling party preferred the indexicality of the photographic medium to painting's "likeness" as it sought to replicate, mass reproduce, and circulate the image of its leader.[42] Popular and state perceptions of photography's indexicality changed within the larger context of Mozambique's history and the photographic practices that characterized different historical periods.

At one level, figure 1 depicts the types of social, political, and economic relationships established through making and viewing photographs in colonial Mozambique. At another level, figure 1 alludes to the fugitive nature of the photographic moment. The notion that something always escapes from the frame is amplified by the particular absence of the headshot that supposedly resulted from the photographic practices documented in the figure. Those who used photography had the sense that photographs possessed elusive meanings or significance, and produced other accompanying images as well as words to affix specific meanings to photographs.[43] As a result, various

types of photographs circulated in Mozambique during and after Portugal's colonial project under the Estado Novo. These varied forms of images, and the image-making practices that produced them, would influence how populations in Mozambique viewed themselves and Mozambique's history.

Published and archived photographs in Mozambique show photographers taking pictures and clients waiting for photographers to take and develop their headshots. As a result, the professional practice never escaped documentation. Art historians, scholars of visual studies, and photography theorists have sidelined the ways that photographers, like those in Mozambique, documented their own practices. There is also the question of how press photographers situated their practice in relation to more commercial ones.[44] North American and European interpretations of photography haven't considered the interdependent nature of photography's practices such as those that took place in Mozambique. The interrelationship between commercial and press photography in Mozambique created certain precedents with regard to self-representation, and also influenced the photographs of Mozambique that international audiences viewed.[45] Officials who staffed state structures in colonial and independent Mozambique took an interest in the very issues that current scholarly literature on photography both considers and overlooks.[46] In their day-to-day activities, state officials debated the use of photography and experimented with the publication of images—hence the need for the concept of a "photographic bureaucracy."

THE PHOTOGRAPHIC BUREAUCRACY

I analyze the history and photography in Mozambique from two directions. On the one hand, there is the history of photography in Mozambique. On the other hand, there is the history of Mozambique through photography—that is, how different historical actors used the medium and practice of photography to represent and interpret the events associated with Mozambique's colonization and independence. In fact, such photographic activities had a broad range of territorial and political implications for Mozambique's standing as a colony of Portugal and as an independent nation.

The literature on state formation after colonial rule in Africa discounts photography as a form of representation and political practice.[47] In response, photography theorists Allan Sekula and John Tagg have attempted to advance conceptual understandings of photographs as documents and photographers

and photographs as agents of the state.[48] However, the analytical gains of Sekula and Tagg impose their own normativity on the writing of histories of photography. The universalistic expectations introduced by these two theorists have minimal transferability to non-Western contexts such as Mozambique.[49] As was the case elsewhere in Africa and other parts of the world, state officials in Mozambique used photography as an instrument of surveillance and identification. State use of photography was variable. Neither was it always positive—state actors committed abuses through photography. How the history of Mozambique appeared through photographs and how photographers documented state activities acquired added importance in a place like Mozambique, where at the time of independence from colonial rule, populations neither spoke the official language of Portuguese nor were formally educated.[50] Thus, the Mozambican state's interest in photography was as a governance strategy, not merely a modernist developmental project.[51] Photographs, films, and posters became essential features of state control and regime building.

World War II called into question European colonization of Africa from an economic, political, and humanitarian standpoint. The war had weakened the industrial economies of many Allied nations, and only intensified public skepticism in Britain and France about the nations' respective colonial projects in Africa.[52] Moreover, as Fred Cooper has highlighted, the defeat of Adolf Hitler and Benito Mussolini and their fascist projects undercut the racist "civilizing" logic that had emboldened European colonialism in Africa.[53] By the late 1940s, Great Britain and France faced growing demands for independence from across their colonies. Yet instead of relinquishing control over its colonies as other European nations had, Portugal defended its interests, going as far as to engage independence movements in Guinea-Bissau, Angola, and Mozambique in direct military combat from 1960 to 1975. Portugal's dictatorship could not risk giving up control over the colonies in Africa without risking its own political survival.[54] Such action only delayed the inevitable. In the events of the 1974 military coup and decolonization that followed, the colonial wars in Africa cost the Portuguese authoritarian state its power and legitimacy.

In the wake of World War II, nation-states and liberation movements incorporated photography into their strategic operations. European nations confronted the need to refashion the image of their colonial projects in Africa for their respective constituencies and the international community. Furthermore, liberation wars and decolonization efforts in Africa, Asia, and Latin

America ushered in new global political orders. Groups opposed to colonial rule found ways to harness photography to win popular support and document their activities. Perhaps unsurprisingly, considering its limited industrial capacity and impoverished populations, Portugal had trouble producing and circulating sufficient information about the colonial wars in Africa. Somewhat ironically, the colonial state established by Portugal in Mozambique acknowledged and even embraced the ways that nonstate actors had managed to deploy photography.

By the early 1960s, independence efforts extended from Angola into Mozambique. Portuguese officials in Portugal and Mozambique specifically developed bureaucratic structures and administrative procedures related to how military, press, and diplomatic units used photography. The Portuguese government under Salazar relied on a colonial state structure to implement policy and protect national interests in Mozambique and the other Portuguese colonies. Oddly enough, Portuguese representatives in Portugal and colonial officials in Mozambique used photography to different ends. In Portugal, the government prioritized the hiring of typists, librarians, and archivists instead of photographers. In contrast, the surveying of photographs, whether those published in newspapers or those that Portuguese soldiers looked at while off duty, was of particular interest to the colonial state's representatives in Mozambique.[55] A great deal of correspondence between Portuguese officials in Portugal and Mozambique occurred through the communicative discourse of *fotografia*. *Fotografia* generated its own administrative offices and regulations. Officials discussed at length their rationale for making photographs, the desired content of collected pictures, and ways to use sound to compensate for the military's limited use of photography. In archives and correspondence, however, there are few or no actual photographic prints. In fact, the amassing of typed text in response to the relative absence of photographs signified the widely held belief that photographs could not be put to use without interpretation. Colonial Portuguese officials' views on photographs counter the purpose of bureaucracy, however, and state officials in Portugal and Mozambique alike struggled to use photography.[56]

At the same time, anticolonial efforts spread from Angola (1960) to Guinea-Bissau (1963) to Mozambique (1964).[57] In September 1964, two years after its founding, the liberation movement Frelimo launched a war against Portugal's military for control over Mozambique. Frelimo resulted from the merging of three distinct political groups based in eastern and southern Africa. Based in Tanzania, the group urgently needed to establish diplomatic

relationships with other nations, and to cultivate a unified and internationally recognizable image of its war effort. Part of the liberation movement's military and political strategy involved establishing areas inside Mozambique freed from Portuguese control, *zonas libertadas* or "liberated zones." Frelimo's use of photography grew out of the need to identify its members, many of whom faced complex bureaucratic regimes of documentation and surveillance as they traveled within and outside of Tanzania. In 1969, the year of the assassination of its president, Eduardo Mondlane, Frelimo's Departamento de Informação e Propaganda (DIP) trained a group of soldiers as photographers, which included Simão Matias, José Soares, Daniel Maquinasse, Carlos Djambo, and Artur Torohate. Rather than providing headshots to members, DIP dispatched the photographers to the liberated zones. There, Frelimo's photographers documented interactions between Frelimo leadership, soldiers, and civilian populations. Also, DIP in coordination with the Departamento de Relações Exteriores invited foreign journalists, photographers, and filmmakers from abroad to travel alongside Frelimo soldiers and photographers to produce images of the war effort. DIP circulated collected photographs produced by its own photographers, while visitors created feature films and photobooks for international distribution. The photographers, who worked under DIP's direction, produced a visual record of the war. In the process, the photographers of the liberation struggle and the users of their images developed certain philosophies regarding photographic use and archiving that would ultimately influence how Frelimo, as a ruling party, used photography as a tool of identification and as a form of representation after independence.

On April 25, 1974, a military coup in Portugal ended the forty-two-year reign of the authoritarian regime. Four months after the coup, Portugal's military entered a cease-fire agreement with Frelimo, and a month later took steps to transfer its control of Mozambique. In response, and in preparation for independence, the liberation movement's Comité Central (Central Committee) announced the formation of a transition government, which included members previously involved in the liberation war and the organization's use of photography. Members of the transition government as well as the journalists charged with reporting on developments deemed image making to be a critical tool in the orchestration and representation of the handover from Portugal.

From 1974 to 1990, Mozambique was the site of extraordinary activities geared toward image production and the training of image makers. The

country had even gained the attention of international filmmakers associated with Third Wave cinema.[58] The ruling government invited famous filmmakers along with solidarity activists who had assisted in the liberation struggle.[59] In conjunction with state engagement with filmmakers, the Instituto Nacional de Cinema (INC) opened in 1976 with the mandate to train a new generation of Mozambican camerapersons and filmmakers and produced feature-length and short films about the independent nation. Almost six years later, in 1983, the photography school Centro de Documentação e Formação Fotografica (CDFF) started its operations, and journalists at the news-wire service Agência da Informação de Moçambique (AIM) launched a photography section. During the early 1980s, journalists and filmmakers explored the possibility of a national television station. Such projects, easily dismissed as the "excess" of modernism and the "grandeur" of underdevelopment, represented the ruling party Frelimo's geopolitical priorities as a result of changes in the Cold War and southern Africa's confrontation with apartheid.[60]

The ruling party's inability to issue headshots and maintain archives of identity documents dates to the period of the liberation war. Since 1975, this inability has tested the mechanisms by which the photograph became a force in the public domain and influenced how Frelimo officials converted the party's image into one of power.[61] The state under Frelimo failed to create population registries and gather census data. Instead, state officials accepted documentation issued by the colonial state, before introducing from 1976 until 1982 a series of new documents to enhance state officials' abilities to identify populations.[62] Having originated in Frelimo's anticolonial war, the introduced photo-identification policy required populations to retrieve their own headshots. In 1975, a negligible number of people had photographs of themselves, and those who did could not use them for state documents—a practice the colonial state had previously allowed. The state transferred the responsibility to produce headshots for documentation to commercial and street photographers, who responded by halting the production of full-body portraits, which had been a popular feature of the colonial era's visual economy. On the one hand, the headshot attached to forms of documentation acquired increased importance, as it often allowed Frelimo state officials, especially at the local level, to further question a document's authenticity and subject document holders to additional verification processes. On the other hand, societal pressures to obtain headshots and photo identification became especially acute as people left rural areas for cities due to drought, poverty, and increasingly after 1981, the war that gripped the countryside. The government's inability to provide headshots

combined with the challenges faced by studio-and street-based photographers to meet popular demand generated a situation where Frelimo officials found themselves replicating colonial-era forms of surveillance.

The photographic bureaucracy is a framework through which to consider how colonial and postcolonial states organize bureaucratic institutions and how a national liberation movement like Frelimo transformed itself into a political party and has managed to govern for more than forty years. I seek to analyze the paradoxes of decolonization—how states disband and/or mobilize the governing structures and surveillance practices of their colonial predecessors.[63] The story presented here is one of innovation and not appropriation.

Portugal and the colonial state that it funded in Mozambique did not create the photographic bureaucracy. Independence brought the ecologies of photographic production adopted by the liberation movement into contact with those of the colonial state. The ruling party Frelimo established its control over Mozambique using the framework introduced by Portugal and its colonial administration.[64] Members of Mozambique's transition government, formally introduced in September 1974, laid the early foundations of the photographic bureaucracy when they not only oversaw the state's acquisition of the photographic studios abandoned by settlers, but grappled with how to picture the rise of Frelimo to power from the rural liberated zones of northern Mozambique. In the years after the transition, members of the Frelimo government would prioritize and regulate the planning of photographic and cinematic content.

As was true with Mozambique, politics did not produce photography. The materiality of photographs, their "life," had effects that neither the colonial nor postcolonial states in Mozambique could ever have anticipated. Colonial and postcolonial states, like the ones that developed and operated in Mozambique from 1960 through 1993, have tried to harness photography for both ideological and administrative purposes. Those charged with representing state interests and with policy enforcement struggled to put photography to rational use. From a logistical and technical standpoint, there was no way to control what photographers pictured and how audiences responded to photographs. Photographs inhabited bureaucracies in different ways, ranging from headshots to halftones published in newspapers. Photography as a mode of representation and form of political practice always elicited reactive or activist impulses from the Mozambican state apparatus, both during and after colonial rule. Such responses reflected the

contradictions of the colonial and decolonial project. In effect, then, photography produced politics, and not vice versa.[65]

FILTERING AS HISTORICAL METHOD AND PHOTOGRAPHS AS HISTORICAL SOURCES

The resurfacing and repurposing of photographs characterizes the history of photography in Mozambique. As we saw, figure 1 is an example of one type of photograph that newspaper editors in colonial and independent Mozambique published regularly. Figure 1 passed the censorship protocols enforced by the colonial state, but many other images did not. Photographers and the colonial-era newspapers they worked for kept the negatives, contact sheets, and prints of images that were either censored by the colonial state or that photographers neglected to submit for publication. After 1974, the editors of Mozambican news publications returned to these previously censored or undisclosed images from the colonial era, and published reprints of censored images as part of the coverage of the end of Portuguese rule and the ushering in of independence. While certain images were taken up by various sectors of the photographic bureaucracy, others were entirely dismissed either because they did not suit a particular agenda or due to their aesthetic qualities.

In their individual practices, photographers like Rangel assigned particular importance to the reprinting of images. As figure 2 depicts, on multiple occasions after independence, Rangel reprinted the image shown earlier (figure 1). The technical processes associated with reprinting, which he mastered as a darkroom assistant in the 1940s, included frequent reuse of negatives. Reprints such as figure 2 showed details that smaller published versions removed from the public's view. Also, Rangel sometimes dated and captioned the reprinted photographs. For example, figure 2 includes the handwritten year "1958" and the translated caption, "Traveling photographer at the Vasco da Gama Market." The year on the reprint differs from the date of the photograph's publication in the press. Photographers amassed images, and newspapers offered one of many platforms for photographers to circulate them and for publics to see them. Regardless of their actual date of production, newspapers relied on photographs as an instrument to inform and influence public opinion.

There are many filters at play here in the making and viewing of figures 1 and 2. Newspaper editors debated the publication and censoring of images.

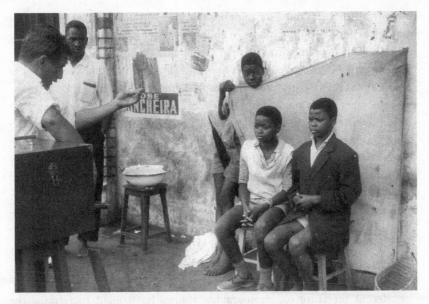

Figure 2. Ricardo Rangel, 1958, "O foto ambulante no Mercado Vasco da Gama" ("Traveling photographer at the Vasco da Gama Market"). Caixa: Rangel: Tempo Colonial, Centro de Documentação e Formação Fotográfica, Maputo, Mozambique.

Developing and printing photographs involved photographers and/or darkroom assistants using technical knowledge to produce negatives, contact sheets, and exhibitions—materials that all enable various means of reproducing images. There are different audiences for photographs, and people viewed photographs such as figure 1 through various media and in different forms. As the example of figure 1 and figure 2 illustrates, no two photographs are the same. A multitude of photographs are in circulation at any given time, and as a result they act as filters on one another. Government officials, newspaper editors, journalists, and photographers used photographs as filters to influence how populations viewed historical events in Mozambique. Thus, photographs have varying abilities to reveal and obscure historical information. Thinking about photographs as filters, and about filtering as an actual historical process, allows consideration of the photographs that publics don't see, and of how audiences in Mozambique used photography to either participate in or learn about particular historical events—issues of critical importance to the state's operation and public standing.

The significance of the word "filter" does not come from its widespread

rhetorical use. Filtering is a material practice and a technical process that unfolds without photographers or the users of photographic images having to refer to it by name. The photographers studied and cited in the following chapters never explicitly used the word "filter" (in Portuguese, *filtrar*) to speak about their respective photographic practices and professional trajectories. Nonetheless, filters and the process of filtering were fundamental to how they used the equipment associated with film processing and the circulation of printed photographs. I explain the unspoken process of filtering and the varied forms of filtering that accompany the use of photography by framing filtering as a type of historical method. Filtering becomes a way to analyze photography's role in state formation processes in colonial and independent Mozambique. In the remainder of this section of the chapter, I elaborate on the specific concepts of filters and filtering by explaining the research methodologies applied in my study of Mozambique's history and the history of photography in Mozambique. Also, I address the specific types of photographs under analysis in the forthcoming chapters.

Recent literature on photographic studies has sought to reframe the interpretative significance accorded to photographs, and to understand the contrasting ways in which populations use and reference photography in their daily lives.[66] To move beyond the assumption that photography always results in photographs, cultural theorist Ariella Azoulay proposes the concept of a "photographic event."[67] The very possibility that a photograph exists of an event is just as important as if there was a physical printed image. She writes, "Everyone knows that the arrival of the camera on the scene creates a hubbub—it might serve as a magnet for one event or distance and disrupt another. The photographed person will not necessarily view the photographs taken at the photographic event of which they were part, but this does not obliterate the fact that it took place."[68] Furthermore, offering the example of an interrogation officer who tells a prisoner about a photograph, Azoulay contends that not everyone is permitted to use photographs in the same ways.[69] The guard never has to show the picture to exert power over the prisoner. Speaking of the existence of a photograph is enough to manifest its power. "[P]hotography," she adds, "has become a potential event even when there is no camera visible."[70]

Figure 1 references the centrality of the "photographic event" to the daily experiences of those living in Mozambique under colonial Portuguese rule. The halftone references the photographic awareness of civil constituencies and the ways they are permitted to use photography. To Azoulay's point, not

everyone viewed an image of themselves. Colonial-era newspaper readers of *A Tribuna* viewed the image. However, those positioned in front of the camera viewed their image in the form of the headshot. Then too, the people pictured in the presence of the camera may have viewed neither the headshots of themselves nor the actual newspaper print. Instead, they may have memories of being in the presence of a photographer. In support of Azoulay's idea regarding the photographic event, the boy holding the umbrella between his legs and the cloth as a backdrop only becomes visible because of Rangel's published print, and not through the image of the headshot produced by the photographer that Rangel pictured.

After independence, photographs such as figure 1 continued to appear in the press, but they had a different importance. For example, after 1975, people faced unprecedented pressures from the Frelimo state to obtain headshots for government identification or risk deportation. Amid film shortages and restrictive government protocols on photographing, photographers photographed and printed scenes like the one documented in figure 1 to meet their professional obligations. Viewing photographs of other photographers at work in the Mozambican press during the nation's war with the South Africa–backed opposition movement Resistância Nacional de Moçambique (Renamo) only reinforced public difficulties with obtaining headshots and state-issued identification. Letters to the editors published in the weekly magazine *Tempo* from the late 1970s until the early 1990s document one of two situations. First, people positioned themselves in front of cameras without any guarantee that they would receive their headshots. Second, even if they obtained their headshots, government offices failed to deliver the proper photo identification in a timely fashion. Under these photographic conditions, the "potential," or possibility, for photographs becomes more important than the actual retrieval of a printed image. Furthermore, the photograph printed is misleading and misrepresentative of the documented situation—another understudied component to the photographic event.

The press in Mozambique was a critical component in the making, printing, and archiving of photographs. From a technical standpoint, figure 1 is not a photograph per se; it is a halftone. Halftones are images that resulted from the reproduction of a photograph selected for publication in a newspaper. Differentiating between a photographic print and a halftone is important when considering the varied contexts in which audiences in Mozambique viewed or did not view photographs and the different types of material formats that circulated photographs. Press accounts are an important source of photographs.

The ways that editorial boards use photographs introduces a space to study the historical significance of making and viewing photographs in Mozambique. Furthermore, the distinction between photographic prints and halftones helps us think about the photographic images that resulted from the activities of newspaper editorial boards in Mozambique. A brief historical outline of the use of photography by Mozambican newsrooms will help readers understand how photographs circulated within the context of the press and how I use newspapers as historical sources for the study of photography.

Even though they were prohibitively expensive, newspapers were a popular venue for both literate and illiterate people in colonial and independent Mozambique to look at photographs. Before the 1940s, for reasons related to technology and trained personnel, populations living in Mozambique viewed photographs in almanacs and illustrated magazines.[71] In the wake of World War II, regional and national newspapers started to open photography departments that competed in importance with print journalism. Photographers worked with print journalists to plan and execute newspaper content, which involved taking specific photos for long-form articles and photo-boxes and working with editors to caption selected photographs. Furthermore, photographers sometimes delved into print journalism, writing reviews for photography exhibitions and other photo-related activities, such as demonstrations of photography equipment sponsored by international photography manufacturers. The photography sections of newspapers contributed to the professional rise of nonwhite photographers and changed how populations in Mozambique viewed images.[72] According to the Mozambican writer and novelist Mia Couto, the newspaper *A Tribuna* from 1961 to 1964 had developed strong and aggressive anticolonial language, and had given a platform to personalities who were more "Mozambican" than "Portuguese," a signal of hope for Mozambique's independence from Portugal.[73] The editorial transformation ushered forward by *A Tribuna*'s editors involved pairing photographs with articles and reserving the top half of the first inside page to print stand-alone photographs with captions. Perhaps as a result of its revolutionary tactics and impact, the colonial state purchased *A Tribuna* in 1965, leading to journalists leaving.[74] Afterwards, the editorial board ended the publication of photos such as figure 1.

Five years later, some of the journalists from *A Tribuna*'s early days joined together to form a new printing company called Tempográfica, which published the weekly magazine *Tempo*.[75] *Tempo* was similar in format and function to other illustrative magazines printed on the continent in the 1960s

and 1970s, including *Drum* (South Africa) and *Bingo* (Senegal).[76] *Tempo* published color prints on its cover. From 1970 to 1975, editors paired photographs with articles and used the magazine's back pages to print full-page photographs taken by Ricardo Rangel and Kok Nam, who served as the magazine's main staff photographers. Editors acknowledged the works of photographers with bylines, a standard not practiced by colonial-era newspapers. The use of bylines and *Tempo*'s weekly publication allowed photographers to produce photographs for specific articles, and to publish photographs taken independent of new assignments. At independence in 1975, staffing shortages and government reorganization resulted in the closing of colonial-era publications such as *A Tribuna*. Frelimo state officials under the direction of the Ministério da Informação replaced publications and introduced new image-making centers, such as the INC, CDFF, and the news agency AIM. These new platforms for image making and circulation would rely on the expertise of colonial-era photographers to train a new generation of photographers.

Colonial- and independence-era newspapers are available for consultation in Mozambique at the Arquivo Histórico de Moçambique (AHM) and the Biblioteca Nacional de Moçambique, and they offer one historical record of the photographs and photo-related materials, such as advertisements and exhibition reviews, that readership viewed at specific points in time. The photographs featured in newspapers are sometimes the only images that remain of a particular historical event in Mozambique. After 1975, when operators of the photographic bureaucracy struggled to issue photo identification and register populations, the press produced photographs that showed officials responsible for forced population relocations writing down information. Such photographic records document bureaucratic procedures officials adopted in lieu of writing and in consequence of other bureaucratic failures. In turn, I reproduce throughout the book the halftones published in newspapers and magazines from 1960 through 1994. Reproduction of halftones illustrates the images as readers viewed them and displays the historical evidence that informs my visual and historical analysis of photography's significance. Even in spite of the photographs that they include, newspapers are imperfect historical sources.[77]

The colonial and postindependent state in Mozambique recognized the importance of the interaction that the press facilitated between the state and civilian populations. Under the Portuguese colonial administration, the Commisão do Censura required editors to submit their proof pages for review before publication. After the end of Portuguese rule, another form

of censorship surfaced. Due to a combination of factors, including techno-
logical limitations and fear of upsetting government officials, photographers
started to photograph what they perceived state officials as wanting them to
show.[78] Newspapers and the photographs they include are the result of highly
mediated processes that occur over the span of time occupied by the pho-
tographer and the photographed sitters and by the photographer and news-
paper editors.[79] The possibility of self-censorship raises the need to consider
the other types of images circulating at a particular point in time inside and
outside of the press. The press generated photographs that editors and state
officials never intended readers to see. Also, to avoid backlash from editors
and state officials, photographers did not take certain kinds of photographs.
Photographers' practice of self-censorship reinforces our need to question
the photographs that did appear in newspapers and the absence of certain
types of photographs, and also to think about the implications of people posi-
tioning themselves in front of cameras even when they know they will never
view their photographs.[80]

There is a particular recursive quality to the image that resulted in figure
1. The image refers to the technology that the pictured photographer used to
photograph the boy, and to the historical context in which people encoun-
tered cameras. While Azoulay encourages us to think of a photograph as a
potential event, historian James Hevia considers the photograph as part of a
"network of actants."[81] Inspired by the theorist Bruno Latour, Hevia presents
the concept of "photography complex":

> [W]e might therefore see the photography complex as a network of actants
> made up of human and nonhuman parts, such as the camera (including its
> container, lenses, treated plates, moving parts, and the many variations of its
> form), optics theory, negatives, and chemicals for the development of "posi-
> tive" prints (the albumen process, the moist collodion process, gelatin emul-
> sions, dry plates). There is also the staggering array of reproductive technol-
> ogies through which images move and circulate, especially those for printing
> photographs in books and newspapers (e.g., photolithography, photography-
> on-the-[wood]-block, line engraving, photogravure, and process halftone
> engraving). Then there is the photographer, that which is photographed, the
> transportation and communication networks along which all of these parts
> travel, and the production and distribution networks that link faraway places
> to end-users.[82]

Hevia goes on to argue that the photograph is "neither [a] reflection nor [a] representation of the real," but instead "a kind of metonymic sign of the photography complex in operation."[83] I would add that, as was the case in Mozambique, the photographic complex never escaped documentation in some form or manner. Mozambicans who came in contact with photographs sensed that their significance was elusive, and to ascribe meaning produced a whole range of other types of images in addition to both spoken and written words. Thus, photographs exist in different material, discursive, and visual formats that emerge in layers across time, space, and media.

In addition to colonial-and postindependent-era newspapers, the AHM houses the photographic prints gathered and produced during the liberation struggle by Frelimo's Departamento de Informação e Propaganda (DIP). Jorge Rebelo headed DIP during the Frelimo liberation war (1964–1974), overseeing the activities of the office's photography section, and he afterward served as Mozambique's minister of information. In an interview, Rebelo suggested that there was no time for photography during Frelimo's armed struggle.[84] As the book will show, Frelimo trained its soldiers as photographers in order to document the war. Nonetheless, DIP officials and affiliated photographers showed little interest in developing an archive of images organized according to subject matter and dates. For the liberation movement, authorship was ideologically unimportant. Photographs were the direct result of a collective effort, not the product of one photographer. In 1974, Frelimo organized the transfer of DIP and other administrative offices from its former headquarters in Dar es Salaam, Tanzania, to Lourenço Marques (now Maputo), Mozambique.[85] During the transition, boxes of photographs and printed negatives fell overboard.[86] What was left of the visual archive of liberation went to the Gabinete da Presidência, and then, at an undisclosed date, to the AHM. Somewhere between printing in Tanzania and my first consultation of the archive in the summer of 2008, the backs of the photographs acquired cardboard backings along with substantial handwritten text, including dates, names of the photographed, names of photographers, and unfinished texts. For reasons of necessity and political expediency, Frelimo leadership and party officials became increasingly involved after independence in organizing the liberation struggle's photographic archive. The absence of negatives presumably complicated the use and reproduction of the images. In fact, prints of the liberation-struggle photographs surfaced in personal and institutional collections in Mozambique, such as that of the CDFF, pointing to their influ-

ence on the postindependence training of photographers and bureaucratic uses of photography adopted by state structures.

In his seminal essay, "Art in the Age of Mechanical Reproduction," the cultural theorist Walter Benjamin writes about photographic reproductions of works of art (i.e., the iterability of [already] human-made objects), and he locates the idea of reproducibility as a central element in the history of photography.[87] Benjamin argues that photographs reinvent the aura of painting. An original is reinvented by reproduction, and the reproducibility of photography is a determining factor in originality. Thus, reproducibility, an element of filtering, refers to two things: the production of the image in the first place and the possibility of a different author producing reproductions—that is, further iterations—of the image. There are various forms of reproduction, which Benjamin distinguished as manual, process, photographic, and technical.

With regard to filtering as a topic of analysis and historical method, photographic and technical reproductions are of particular interest. Photographic reproduction refers to the actual taking of photographs through processes of "enlargement or slow motion," and involves the "captur[ing of] images that escape natural vision."[88] Technical reproduction entails printing and/or reprinting photographs, which in Benjamin's words "put the copy of the original into situations which would be out of reach of the original itself."[89] The postcolonial archive, in a place like Mozambique, depends on the reproducibility of the photograph, and takes selective advantage of the photograph's reproducibility. Even then, reproducibility is neither infinite nor undifferentiated, but rather filtered through and marked by other constraints, including archival failure.[90] Figure 2 is a case in point. The image offers a visual context for reflecting on the modifications that photographers embarked on after taking a particular picture. Also, the photograph (figure 2) opens a space to reflect on the varied forms of reproducibility possible, depending on whether the image existed as a print or a negative.

The CDFF played a major role in reprinting photographs like those of the liberation struggle, and presents one historical context to reconstruct and explore the reproducibility of photographs as Benjamin proposed. The site of the CDFF previously served as the headquarters of a major photographic laboratory in Mozambique, FOCUS. Rangel and Nam got their professional start in photography at FOCUS, where they worked as darkroom assistants. Colonial-era print journalists relied on FOCUS to print photographs for the press.[91] Under the directorship of Rangel from 1982 to his death in 2009, the CDFF operated as a training facility, initially for government employees

to learn photography. The training of photographers resulted in the CDFF amassing an archive of negatives and prints by its students. Also, Rangel in his capacity as director, along with CDFF instructors, used the facility to continue their individual photographic practices in various ways. In fact, the CDFF houses Rangel's private photographic collection, which includes: photographs he personally collected, an incomplete set of negatives from his professional practice as a photojournalist, and photographs other photographers took of him while on assignment.[92] The CDFF received photographs from state agencies, in addition to orders from government institutions to reprint photographs and to produce photographic materials. I use, and in some instances republish here, materials from the CDFF archives for the following three purposes. First, I compare the negatives, contact sheets, and exhibition prints of various photographers with the photographs published in colonial- and independence-era publications, to identify the authors of published photographs and to determine the photographs left unpublished. Second, exhibition prints and film negatives present a context to consider how editors and photographers cropped and altered photographs. Third, the CDFF archive acts as an image resource to track the pictures from the colonial era that the Mozambican press published after independence.

Part of my method in re-creating, tracing, and evaluating the processes behind photographic filtering involves oral interviews. Between 2008 and 2016, I conducted interviews with photographers, whose images I analyze throughout the book, and with the print and radio journalists and editors they worked alongside. I also interviewed members of Frelimo's Comité Central, DIP, and DRE. Those individuals affiliated with Frelimo whom I interviewed included soldiers who trained as photographers and high-ranking officials who managed the photographic bureaucracy after independence. Many of these officials spearheaded Frelimo's use of photography for diplomatic and political purposes and are responsible for making the history under analysis in the coming chapters. In fact, they continue to work as gatekeepers for Mozambique's past, determining how the past is understood and discussed in Mozambique.

Part of the research process, which I conducted in Portuguese and occasionally English, entailed studio apprenticeships and enrolling in a training course in 2010 at the CDFF, where cited photographers had either worked or processed their films. Photographers invited me into their darkrooms, studios, and homes in order to show me their archival collections of images and negatives. Also, they demonstrated the techniques they had adopted

and developed for taking and processing their films. I learned how to take pictures, develop film, and print negatives in the very spaces where many of Mozambique's photographers studied and worked. Photographers commented on experiences using certain photographic equipment and highlighted the aesthetic and technical approaches they developed. Print journalists and editors addressed the editorial policies and protocols involved in the publication of photographs. Throughout the book, I reference interviews with photographers, print journalists, and newspaper editors to re-create the debates over photographic representation and Mozambique's history that consumed state-run media and government institutions.

Oral interviews, like photographs, are anything but self-evident and transparent.[93] In 2010, I interviewed Fernando Lima, who in the 1980s worked for the news agency AIM, and after 1993, the end of the civil war, joined an editorial collective to open the independent newspaper *Savana*.[94] Lima explained that a space had emerged for him and other journalists to speak in ways not previously permitted due to the circumstances of war that gripped Mozambique.[95] He stated,

Of course, the context [has] changed. If I would [have answered your questions about my relationships to Frelimo] 30 years ago, I would [have been] more careful in telling you that because eventually I would be taken by someone as counter-revolutionary. I would [have] chosen more carefully my words in explaining that to you. Taking this perspective of 35 years of independence, I looked at myself at what I can and cannot do.[96]

Specific interviews with photographers and the users of their images are illuminating at many levels. First, their content helps to reconstruct the history of photography in Mozambique and how it intersected with the state-formation processes that characterized colonization and independence. Second, interviews with photographers and the users of their images introduced and addressed photographs that are unavailable in the archival collections that I consulted and that the Mozambican press did not publish. The interviews I conducted between 2008 and 2016 function much like a "phantom archive," to use the words of anthropologist Christopher Pinney, providing insight into how photographs influenced national memory and substituted for or replaced national consciousness.[97]

The photographs of Mozambique that government officials in Portugal viewed during the war (1960 to 1974) did not speak for themselves. To put

photographs to rational use required writing. Interestingly, after independence, the Frelimo government regularly convened journalists, photographers, and government officials to determine the function of print journalism and photography. Convenings of the government and press units involved drafting communiqués by government officials, publicly circulating government officials' remarks, and producing individual written reports on the standing of different news organizations and an evaluation of their activities. Writings on photography are yet another filtering of the photograph, and of Mozambique's history.

I use written correspondences available in Portugal's military, diplomatic, and security archives, the Arquivo Histórico Militar, the Arquivo Histórico Diplomático, and the Arquivo Nacionais Torre do Tombo, to establish the communications surrounding the representation of Portugal's colonial war. Also, I explore what Portuguese officials thought they could do with the photographic image over the course of the colonial war. Documents produced by members of the Frelimo government from 1975 until 1994 provide insight into how officials regulated the production of photographs and chart the anticipated role of photographs in the state project.[98] Officials in both the colonial Portuguese and Frelimo governments used writing to control what appeared in the public display of photographs and to ascribe meaning to them. The different forms of writing that the Portuguese government and liberation front Frelimo produced help to illuminate the shifting role of photography within the context of the documentary regimes that the authoritarian state and liberation struggle imagined. Also, the varied forms of writing and correspondence help to identify the diverse photographic images that circulated.

BOOK STRUCTURE

Photography's practice and use follows nonlinear chronologies. It is more like a layering—a photograph like figure 1, taken in 1957, is only published and captioned seven years later, in 1964, and filtered through the words and different environments affected by conflict. Or, photographs censored in the colonial period by the Portuguese state were published after independence in Mozambique, suddenly filtered by victory and the state's nation-building ambitions. What was once a tool of resistance sometimes transformed into an object through which state structures mask their own failures and even abuses. Also, people's abilities to obtain headshots in an independent Mozam-

bique determined how the state's news agencies were able to photograph populations during the civil war. The book's chapters, like their respective subject matter, function as filters. Each chapter focuses on certain historical events that unfolded simultaneously yet within different material and discursive realms, in order to place them into conversation with each other.

The book covers the years 1960 to 1994, a period when Mozambique underwent the bitter, bloody end of colonialism, the transition to independence, and a protracted war following independence that only ended in 1992. From 1960 to 1974, Mozambique was the site of war between Portugal and the liberation movement Frelimo. Portuguese officials and historians refer to the war in its colonies as the "colonial war," whereas Frelimo refers to it as the "armed struggle." Chapter 1 looks at the war from the perspective of Portugal's government and the colonial institutions it developed in Mozambique, whereas chapter 2 explores the war from the perspective of the liberation movement Frelimo.

The chronologies of chapters 1 and 2 are slightly different. Chapter 1 begins in 1960, chapter 2 in 1962. Chapter 1 starts in the year 1960 for several reasons. First, I seek to contextualize the war in Mozambique within the broader anticolonial struggles that surfaced across the Portuguese-speaking empire. Second, in the early 1960s, Portugal's government stopped referring to places in Africa as colonies and elected to characterize them as territories, or extensions of Portugal. In addition, the photographic economies in Mozambique changed greatly, part of which involved black populations native to Mozambique using photography with greater frequency and effect. In contrast, chapter 2 starts in 1962, the year of Frelimo's founding, and covers until 1974, when Portugal declared a cease-fire and initiated a transition of power in September 1974. As the Mozambican author Mia Couto explained, and as I will address in chapter 3, the end of the authoritarian state in Portugal after the April 25, 1974, coup was not Mozambique's independence. Only on June 25, 1975, a year after the military coup in Portugal and after a transitional government, would Mozambique be independent.[99]

Soon after independence, Mozambique was once again the site of war. An independent Mozambique threatened the legitimacy of white minority-rule governments in neighboring Rhodesia (present-day Zimbabwe) and South Africa. Furthermore, Frelimo's decision to use Mozambique as a safe haven for liberation groups in Rhodesia and South Africa heightened the threat and frequency of military attack. Southern African historiography treats the postindependence war as one extended conflict from 1975 and 1994.[100] The book's last three chapters take various approaches to the chronology of 1975

to 1994 with an eye toward the complexity of historical moment, the different historical views of the war, and lastly, the diverse photographic practices at play. Chapter 3 looks at the years from 1974, the start of the transition of power between Portugal and Frelimo, through 1980, when Zimbabwe became independent. Chapter 4 outlines a history of identity documents in Mozambique from 1975 through 1994, and considers how the historical use of identification documents influenced how the independent state and its populations displayed themselves to one another. Chapter 5 treats Mozambique's war with South Africa and the civil war that followed after 1980 as separate from Zimbabwe's independence, and focuses on the years 1981 and 1994.

Different forms of filtering unfold around and through the practice of photography and in relation to many state and nonstate actors. At the center of each chapter are visual epistemologies that characterize the forms of filtering under study. The forms of filters and filtering help illuminate the debates around photography and photographic representation that state and nonstate actors participated in at specific moments in time. The visual epistemologies under study include photography as infrastructure (chapter 1), paper diplomacy (chapter 2), the photographer as bureaucrat (chapter 3), the presence and absence of identity documents (chapter 4), and dead photographs (chapter 5).

Portuguese journalists and government officials struggled to obtain photographs of anticolonial unrest in Angola and Goa, a colony of Portugal in 1961. However, Ricardo Rangel, the Mozambican photographer, documented the announcement of Goa's independence in Mozambique and the protests that ensued. Perhaps aware of the predispositions of photographers in Mozambique, Portugal's authoritarian state took steps before and during the colonial war in Mozambique and its other colonies to strengthen its control over the appropriation, censorship, and classification of photographs. Chapter 1, "Portugal's Photographic Play," explores the bureaucratic infrastructures and hierarchies of credibility that the Portuguese authoritarian state and colonial state in Mozambique established to control photography's use from 1960 to 1974. The reforms and processes adopted by the local administration and military in Mozambique quickly entangled the colonial state activities with local photographic practices. What resulted was a state apparatus distrustful of photographs and reliant on words and sounds to control their functions. During a transition of power, the colonial state bequeathed to its successor, the liberation movement Frelimo, the very structures of information gathering and processing that it had developed over the course of its control of Mozambique.

Chapter 2, "Paper Diplomacy," studies the development of Frelimo's photography department within the broader context of its war for Mozam-

bique's independence. Frelimo's photographic capacities grew out of complex diplomatic efforts involved in identification, registration, and the printing of paper. Unlike its supposedly well-resourced enemy Portugal, Frelimo's DIP managed in 1969 to organize a photography training course for selected soldiers. Before then, Frelimo's diplomatic, military, and administrative representatives had used photography studios in Dar es Salaam to take pictures of its leadership and to develop found footage of its war activities. Driving the need for photographs was the documentation that Frelimo's soldiers and leadership required to travel in and out of Tanzania, where the group maintained its headquarters in exile. Furthermore, Frelimo's Comité Central faced the need to justify its war in ways not required of its archenemy Portugal. The chapter provides a history of Frelimo's photography section and the role of paper in organizational efforts to conduct international diplomacy.

Riots, protests, and settler departures accompanied the announcement of Mozambique's independence from Portugal and the handover of power to the liberation group Frelimo. To bring order to such disruption, Frelimo's representatives turned to the photographic archive and practicing philosophies developed during the liberation struggle. From 1975 to 1980, Frelimo officials ranging from the Ministério da Informação to the Gabinete da Presidência relied on photography as a tool of intervention to strengthen its control over an understaffed bureaucracy that Portugal left behind. Part of the reconfiguration of the state apparatus involved reorienting photographers and bureaucrats alike to the narrative of liberation and training them to use the photographic archive that Frelimo's DIP had amassed during the liberation war. Chapter 3, "The Photographer as Bureaucrat, the Bureaucrat as Photographer," analyzes how Frelimo officials in various ministries organized photographs of the liberation struggle into a visual archive. Here too, I consider the repurposing of photographic images that resulted from exchanges between state officials and photographers employed at state-run media.

In the span of sixteen years, which also corresponded with periods of destabilization and civil war (1981 to 1994), Frelimo's Ministério do Interior in coordination with other government departments at the national, provincial, and local level introduced eight forms of identification documents. The introduced forms required people to obtain a headshot of themselves. However, many people had never seen an image of themselves in the form of a headshot. Furthermore, certain technological constraints impeded photographic production and document issuing. What resulted were people standing in

lines for documents such as the worker's card or rationing card. Chapter 4, "IDing the Past," maps the historical use of photographic documentation by the state and civilian populations. The very absence of documentation gave the Frelimo government new opportunities to identify populations and to justify people's removal from overcrowded urban areas. The independent state's use of regulatory strategies, and the abuses of power that resulted, mirrored those devised under the colonial state and the liberation movement.

Shortly after Zimbabwe's independence in 1980, journalists in Mozambique with state support opened a photography wire service at the news outlet Agência da Informação de Moçambique (AIM). If we think of what appears in the photographic frame of AIM photographs as sometimes contingent on how populations accessed and thought about photography through the availability of identity documents (the subject of chapter 4), then chapter 5, "Naming Mozambique's Dead Photographs," explores through AIM photographs a more nuanced history of civil conflict in Mozambique and the politicization that ensued around the war. Chapter 5 considers how Frelimo deployed photographs by AIM as tools of counterinsurgency and the effects of such action on the naming of the war. Photographs are especially important to bureaucracies in times of such crisis. However, the photographs AIM produced were of value neither to Frelimo, because it found them too violent, or to international news agencies, because they viewed the photographs as state propaganda.

In 2009, the Frelimo government instituted biometric identity cards and passports. As recently as the summer of 2016, tensions increased between Frelimo and its long-standing opposition Resistância Nacional de Moçambique (Renamo) and prompted a revisiting of the 1992 Peace Accords. In response to and amid state struggles to adopt the biometric system, a Frelimo parliamentarian proposed a return to older forms of paper identification introduced during the liberation struggle. The epilogue places the 2009 introduction of the biometric system and the 2016 call to return to older paper forms of documentation within the broader histories of photography's bureaucratic and documentary functions outlined in the preceding chapters. I reflect on the older systems of identification and registration that preceded the biometric system and consider whether such innovation continues or disrupts past photographic traditions. The ruling party Frelimo relies on complex photographic regimes and histories of photography to remain in power. Longer histories of photographic representation and display continue to influence the sociopolitical and economic conflicts that gripped Mozambique after 1994.

Portugal's Photographic Play

In a letter drafted on the letterhead of the Gabinete dos Negócios Políticos (GNP) dated August 23, 1960, a state official named Alexandre Ribeiro da Cunha expressed concern about the "numerous occasions" on which there was a "lack of photographic and other materials" on the Portuguese presence in Africa.[1] The historical moment was one when "propaganda play[ed] an important role and spread across the world, good or bad ideas, truths and falsehoods according to the origin of propaganda."[2] The Portuguese government's propaganda efforts, Cunha noted, paled in comparison to those of organizations of lesser standing such as the American Committee on Africa.[3] Supposedly, the lack of "photographic and other materials" stemmed from the failure of the GNP's staff to put photographs to use in the ways that freelance journalists did. The limited, and often faulty, use of photography led Cunha to question why the Portuguese government produced postcards with photographs of "The Marginal Avenue in Luanda[, Angola]" at a time "when it [was] necessary to explain what Luanda [was] and [Portugal's] determination to stay in Africa because [Portugal was] an African country."[4] For Cunha, "photographs, facts, and statistical elements about non-discrimination, teaching, and the work of Europeans" had "uncontestable" and "remunerative" value when it came to reforming the Portuguese nation's image in the world and defending its presence in Africa.[5] Nonetheless, Cunha's statements suggest an acute awareness in 1960 of the Portuguese state's inability to produce and circulate photographs with any effect.

Cunha's assessment of the Portuguese government in 1960 was neither unwarranted nor entirely inaccurate. The largest allocation of land for colonization in Africa to Great Britain and France had ended the nineteenth-century vision of Portuguese leaders, which entailed uniting the land between Angola and Mozambique.[6] In 1926, Prime Minister António Salazar and his authori-

tarian government assumed control of Portugal, one of Europe's poorest coun-
tries, with under-resourced industries and an undereducated population. To
assert control, and in search of economic prosperity, the authoritarian state
tapped into the long-standing colonial aspirations of Portugal's citizenry.[7] Part
of Salazar's reforms involved revamping preexisting colonial state structures
in Africa and Asia, staffed by Portuguese civilians, who would implement laws
issued by Lisbon and handle the day-to-day tasks of governing.

By the end of World War II, the European colonizers with the most land
in Africa, Great Britain and France, proceeded to end their colonial occupa-
tion. Portugal's worldwide colonial empire was vast for the time period and
in comparison to its actual land size. Despite signs of decolonization, and
with its colonial empire in hand, Portugal joined the United Nations in 1955.[8]
By 1960, as Cunha himself noted, it was no longer enough for the Portuguese
government to say that its colonies in Africa were an extension of Portugal.
Not only had nations in West and East Africa declared their independence
from Europe, but unrest had rapidly surfaced inside of the Portuguese colo-
nial African empire. By 1960, the allegedly homogenous Portuguese state in
which the metropole was indivisible from its colonies quickly was breaking
down into dissonant parts.[9]

Anticolonial conflicts developed across the Portuguese Empire in 1961,
and by 1964 escalated to full-scale war. An understudied aspect of the mul-
tifront war effort was the ongoing attempt by Portuguese officials and their
colonial counterparts from 1961 to 1974 to gather and use photographs. For
example, in February 1961, anticolonial forces in Angola attacked Portuguese
civilians, and in response, the Portuguese government commissioned pho-
tographers to document the dead and mangled bodies, circulating the photos
as a pamphlet.[10] Six months later, in December 1961, Indian troops declared
the independence of Goa, a Portuguese colony in southern India. A newspa-
per published in Lisbon criticized the lack of photographs of the actual attack
by Indian troops.[11] Unlike in other colonies, part of the popular response
in Mozambique to news of Goa's independence involved taking and looking
at photographs. According to available photographs, news of Goa's declared
independence reached Mozambique in 1961 or early 1962, and Portuguese
settlers took to the streets in protest.[12] In the years after the initial widespread
unrest, there is some historical evidence that suggests that staff at the GNP
and other Portuguese government ministries faced continuing difficulties in
replicating the propaganda it had developed in response to events in Angola.
Also, reporting on Portugal's war in Mozambique suggests that soldiers used

photographs of the Portuguese military response to war in Angola to incite war in Mozambique.[13]

Several observations can be made from the brief history of photographic use outlined above. First, news of anticolonial protests traveled across the Portuguese Empire via varying aesthetic dimensions and with variable effects. Second, any attempt by government officials in Portugal to gather photographs of activities in its colonies only exposed the unpreparedness of state structures and how officials reacted to photography. Third, a certain capacity to produce and circulate images existed in Mozambique by 1961 that eluded government officials in Portugal and their colonial counterparts. At the center of the chapter are queries over how images traveled across the Portuguese Empire, specifically between Portugal, which struggled to instrumentalize photography, and Mozambique, where photographers and photographs appeared to be ubiquitous.

As part of its response to anticolonial opposition, Portuguese officials in Lisbon at the GNP and the Polícia Internacional de Estado (PIDE), to name a few agencies, had to reconcile the authoritarian state's need for photography as a tool of propaganda with the colonial state's and Portugal's abilities to actually produce and circulate images. Portuguese officials charged with managing the nation's diplomatic affairs were suspicious of picturing the state and policies related to colonial rule. Over the duration of the war, instead of hiring photographers, Portugal's authoritarian state employed typists, secretaries, and translators, who issued policy directives regarding how to obtain and use photographs.[14] For example, officials at the GNP valued writing about photography, *fotografia*, between 1960 and 1974, and used correspondence regarding *fotografia* to frame the interaction between Portugal and the colonial state in Mozambique. As a result, Portuguese officials at the GNP and other government agencies involved in security, diplomacy, and the military generated their own sets of classifications, evaluative documents, meeting minutes, and distribution protocols. Oddly, though, printed photographs were missing from specific communications. On different occasions during the war, officials represented photographs through words and used illustrations to compensate for the unavailability of photographs or their own hesitations about putting a particular image into circulation. Based on the varied responses to adopted modes of image production and circulation, Portuguese authoritarian state structures lacked photographs and continued to question photography's evidentiary capacities.

Portugal and its colonial state in Mozambique were not a monolith.

Another picture of Portugal's war for its colonies developed in Mozambique from the perspective of those parties living in the colonial state. While officials in Lisbon typed and read about difficulties associated with circulated information gathered from photographs, newspaper readers in Mozambique viewed photographs not available to audiences in Portugal. To stage and document itself, the colonial state in Mozambique accessed a different set of audiovisual equipment, which included cameras, recorders, microphones, and additional image-making practices. Colonial state officials reacted to photographs through censorship, and also surveyed the media that soldiers encountered when off duty.[15] Discord and fissures surfaced within state structures regarding how to defend Portugal's interests militarily and politically. The fact that certain photographs were available in the colonies and not the metropole of Lisbon suggests that Portuguese officials were unable to exercise the same level of surveillance in the colonies. The colonial state in Mozambique appeared to be willing to overlook acts that normally would have been censored in Portugal.

This chapter uses the concept of "photography as infrastructure" to explore how Portugal used photography in an effort to continue its empire— the forms of filtering officials from Portugal and its colonial state in Mozambique participated in during the colonial war, and the types of images that practices of filtering did and did not produce. Traditionally, the literatures on photography and infrastructure have not engaged one another.[16] Furthermore, until recently, histories of Portuguese colonial war have marginalized the importance of photography as a practice and a source of images.[17] Histories of photography, especially as they relate to Africa, have yet to consider a history of photographic practices that take place between a colonial power such as Portugal and a colonial state such as Mozambique.[18] For both Portugal and Mozambique, photography operated much like bridges and roads. In some instances, the inability of both the authoritarian and colonial states to build bridges and roads and to complete other large-scale developmental projects compelled government representatives to become more involved in the seeming minutiae of controlling the information gathered from looking at and circulating photographs. Here, theorist Marie-José Mondzain is particularly helpful in thinking about how photography operates as a type of infrastructure through which other traditional forms of infrastructure acquire visibility or invisibility.[19] Mondzain connects photography's development to a history of credulity. She argues that photography's power derives not from its ability to depict. Rather, photography's power emanates from the ways that

historical actors are willing to use and defend the representational medium even if the contents of photographs are not true.[20] Photography operates from the negative, a space of absence and unimportance. In so doing, *fotografia* as discourse makes something present that is not actually visible within the photographic frame. The surfacing and disappearance of certain photographs in parts of the Portuguese Empire result from a type of photographic production that occurred exclusively between Portugal and its colonial state in Mozambique with varying aesthetic qualities.[21]

The chapter's first section looks at the varied photographic responses of the Portuguese authoritarian state and nonstate actors in colonial Mozambique to the unrest that unfolded in 1961 across the Portuguese Empire. I am especially interested in unpacking how populations viewed their place in the Portuguese Empire in relation to the types of images that did and did not circulate during and after 1961. The filter of "photography as infrastructure" is particularly useful for thinking about the images that circulated and the practices of photography that the Portuguese authoritarian state and the colonial state in Mozambique accessed. Certain images available in Mozambique were not viewed in Portugal, and vice versa, as the chapter's second section illustrates. Further to the point, the second section argues that the colonial state appeared to be more willing to show its representatives looking at photographs and to overlook activities that the authoritarian state in Portugal would have censored. Third, I explore how the bureaucratic and discursive infrastructure of *fotografia* served as a point of interaction between Portugal's authoritarian state and the colonial state in Mozambique. Tensions emerged despite Portugal's policy of indivisibility between the metropole and its colonies. Toward the early 1970s, the Portuguese authoritarian state's and colonial Mozambican state's efforts to halt support for the liberation movement Frelimo involved radios, megaphones, loudspeakers, and airplanes heard overhead as they distributed propaganda. The chapter's final section presents instances where sound took precedence over the visual as a result of attempts by Portuguese military and diplomats to compensate for the difficulties that they and their colonial counterparts faced when using the discourse of *fotografia*.

PHOTOGRAPHIC UNREST

By 1960, before the colonial wars' official start, members of Portugal's governing class expressed concerns over the Portuguese state's capacities to pro-

duce propaganda in defense of its political and economic interests in Africa. Months after one official complained, Portuguese civilians living in Angola faced anticolonial unrest followed by an outright war. Shortly thereafter, India's national army detained Portuguese settlers and government personnel before declaring Goa's independence from Portugal. Diplomatic officials in Lisbon struggled to gather photographs of the emerging political and military conflicts in the colonies, contributing to a type of photographic unrest. Over the course of its colonial wars, particularly in Mozambique, the authoritarian state based in Lisbon struggled to use photography in ways that the colonial state and nonstate actors in Mozambique could use it. Unbeknown to political officials in Portugal, another vision of the Portuguese Empire developed inside Mozambique, where acts of reading frequently accompanied the taking and viewing of photographs.

Portugal's military engagement in Angola preceded the other wars that would unfold across the empire and ignited a need for photographs that Portugal's authoritarian state always struggled to meet. Diplomatic, military, and political officials across the authoritarian state undertook unprecedented actions to obtain photographs of attacks and military action in Angola. On March 15, 1961, the Union of People of Angola led by Holden Roberto attacked Portuguese settlers in Northern Angola. This was not the first encounter among anticolonial forces and Portuguese civilians and stationed military forces. In the months before, in January and February 1961, anticolonial forces had launched protests against Portuguese occupation, which resulted in the Portuguese military and police using extreme force against local populations. In the wake of the March 15, 1961, attack on Portuguese settlers, civilian photographers and print journalists traveled embedded in Portuguese military units in Angola. The unnamed photographers returned with pictures of dead and decapitated bodies that the Portuguese delegation to the United Nations would show publicly.[22]

Almost nine months after the start of war in Angola, another political crisis developed, in Goa. In December 1961, Indian forces declared Goa's independence.[23] Once again, diplomatic officials in Lisbon scrambled in search of photographs of what they referred to as an "invasion."[24] However, officials' pursuit of photographs and attempts to frame the narrative increasingly revealed an all-out struggle for the survival of the Portuguese Empire. Officials in the GNP and other departments of the Ministério do Ultramar used the absence of pictures to question the legitimacy of the Indian Union's claims over Goa and to argue that there was little Indo-Portuguese support

for Indian troop actions.[25] The Portuguese press had obtained and printed a long article by a French journalist reporting for *Le Figaro*. The journalist, Max Olivier-Lacamp, wrote:

> The strange thing: there exists no official photographic document of the military campaign. And that as happened with the civilian journalists, the photographers and filmmakers of the Indian army, [who] were numerous, did not view the invasion. The rare [media professional eyewitnesses who observed] the entry of the Indian troops in Panqim were unable to prevent the confiscation or the destruction of a part of their films by the police or by the civil administration.[26]

Behind the scenes, diplomatic officials in Lisbon authorized the censoring in Portugal of another French publication, *Le Match*, which included "inconvenient photographs related to Goa," and made arrangements to broadcast Portuguese propaganda on shortwave radio from Miramar to Goa.[27] Regarding the censorship of images of Goa, a representative from GNP wrote the following to the Presidential Council on January 5, 1962:

> It is considered undesirable [to publish] photographs of the camps of prisoners, since their effect on Portuguese public opinion would be inconvenient: either the [prospect] was good . . . because it served the intentions of the Indian Union[, or the prospect] was bad, . . . and it was creating unrest among the [Portuguese] families that ha[d] relatives [in Goa].[28]

The comment on the prisoner camps referenced attempts by the Portuguese authoritarian state to detain Indian nationals living in the empire.[29] This widespread detainment of Indian nationals compelled the Indian Union to release the detained Portuguese settlers. Removing certain photographs from public view and claiming that some photographs of the "invasion" were unavailable was part of a larger public relations effort to de-escalate tensions. In part, the Portuguese diplomatic and political apparatus, from the GNP to PIDE, wanted to resist Portugal's involvement in another war. In addition to meeting with newspaper directors and contemplating holding national and international press conferences, GNP officials discussed at length the Indian Union's detention of journalists.[30] The deliberation centered on claims that the Union of International Journalists had requested the release of journalists and that the Indian Union continued to hold the journalists "because

the Portuguese government [had] not solicited anything [regarding their release]."[31] Portuguese diplomats believed the actions of the Indian Union were an attempt to force Portugal to declare war rather than recognize the situation as a human rights issue.[32] The positions of Portuguese diplomats did little to change the fact that certain images of unrest surfaced in the colonies that the metropole could neither access nor control.

Portugal's authoritarian state interpreted events in Goa as an invasion, while those living in Mozambique sometimes interpreted them as a declaration of independence. The Portuguese press claimed that no photographs existed of the invasion of Goa. However, in Mozambique, people gathered outside of a café and competed for a glimpse of a newspaper bulletin with the announcement of Goa's independence.[33] The Mozambican photographer Ricardo Rangel, who at the time worked at the colonial-era publication *A Tribuna*, stood at the window of a café behind another patron to document the scene (figure 3). The picture showed the reading of texts by the very people responsible for administering colonial policies alongside the people subjected to colonial state policies. The photograph situated the taking and viewing of images in relation to the reading of news. According to the photograph, processes of colonization and decolonization unfolded in tandem. Another type of photography developed independently of the Portuguese authoritarian and colonial states. Rangel and the populations he photographed had developed their own photographic responses to colonial affairs and developments unfolding around the Portuguese Empire.

In the days after press coverage on Goa, residents of Mozambique used text and illustrations, and not actual photographs, to display positions that were neither visible to the camera nor legible in photographic prints without captions. Rangel's contact sheets disclose that populations living in Mozambique used nighttime demonstrations to express their opinions on Goa's independence.[34] People, cars, and buildings cluttered the initial proofs. People walked alongside moving cars draped with banners and Portuguese flags; one banner showed an illustration of a trickster with the text, "The two faces of Nehru," and others conveyed messages such as "We do not cede Goa."[35] In the same picture, people held a sign that read, "We do not want Indians in Portuguese lands. To look at them is to see Nehru."[36] Other angles displayed people on the sidewalks displaying messages such as "It is a lie. Goa is not surrendered." Protestors implored the Portuguese government to assassinate Nehru, India's leader. The Portuguese word for "look" elicited hatred toward Indians in the name of defending the nation of Portugal.

Figure 3. Ricardo Rangel, 1964, "O início do desomonamento do Império Português: Placard em Lourenço Marques anuncia do a anexação de Goa pela India—1964" ("The initiation of the collapse of the Portuguese Empire: A placard in Lourenço Marques announcing the annexation of Goa to India—1964"). Caixa: Rangel: Tempo Colonial, Centro de Documentação e Formação Fotográfica, Maputo, Mozambique.

Newspaper readers in Mozambique did not view Rangel's image. The same held true for Portuguese populations and their viewing of photographs that Portuguese government officials obtained after the 1961 attack in Angola. Rangel's photographs of the announcement in Mozambique of Goa's independence and of the protests that followed had greater value unpublished. Portugal's diplomats, on the other hand, perceived a need to not only gather photographs of the 1961 attack but to put the collected images into global circulation through texts such as the 1963 seven-page booklet *Genocídio contra Portugal*.[37] Texts and translations were printed after the first attack in Angola and as the liberation movement Frelimo prepared to launch war against Portugal. I conclude the section by unpacking the fractures and dissonances that developed around the varied processes of filtering in light of political unrest that Rangel and diplomats in Portugal undertook through photography.

Photographs produced over the period of imperial unrest and only available in Mozambique suggest that photographers' professional responsibilities literally thrust them in front of the Portuguese colonial state, but they had

their own conflicts. One photographer who regularly photographed the colonial state in Mozambique was Carlos Alberto Vieira, who was in charge of the newsroom where Rangel had worked during the 1950s. Joaquim Vieira, the son of Carlos Alberto, framed his father's professional duties in the following terms:

> My father was the chief of the photographic section and the decision of sending the photographers to that type of official coverage was in his hands and [those of] the owner of the newspaper. Despite him never [being] a member of the only Portuguese party, the National Union, he [was] never [ignored] when [editors decided] to put him in front of [colonial] official[s] [or] works.[38]

With emphasis on the autonomy of his father, the younger Vieira described his father's work in terms of picturing the colonial state apparatus. In his view, the decision to photograph rested with newspaper editors, not the colonial state. Prior to 1961, Rangel had found himself in disagreement with editors such as Vieira over the publication of his photographs.[39] Also, editors like Vieira were not immune to their own struggles picturing the colonial state.[40] To photograph scenes like the announcement of Goa's independence, Rangel faced the prospect of photographing the colonial state and subjecting his photographs to critiques by Vieira and the colonial state's media apparatus.

Rangel guarded figure 3 as a negative. At an unspecified date, he reprinted the negative. One of the reprints included the handwritten caption, "The initiation of the collapse of the colonial Portuguese Empire: A placard in Lourenço Marques announcing the annexation of Goa to India—1964."[41] The date 1964 contrasts to the year when Goa's independence occurred, 1961, suggesting that Rangel developed the actual print years later or misremembered the year of Goa's "independence" when he reprinted and captioned the image. Ironically or not, 1964 was the year the liberation movement Frelimo launched its own independence war against Portugal. Rangel's use of the word "annexation" in the caption suggests that he sympathized with the Indian Union. In 2000, he reflected on the sentiment that fueled his documentation of the announcement in Mozambique and the ramifications that followed. He stated:

> When I left prison [after being arrested by PIDE], I hated the Portuguese. I wanted to kill the Portuguese. I was asking where I would be able to kill the Portuguese. And years later, when the war in India for the liberation of Goa

broke out, I wanted to enroll in the Indian army that was fighting in Goa in order to kill the Portuguese. I did not have in that time what [Eduardo] Mondlane and Samora [Machel, the leaders of Frelimo's liberation struggle] taught, in other words, the enemy's true definition. The enemy was not the Portuguese [people] but the colonial system.[42]

From Rangel's purview, the photograph of the announcement of Goa's annexation offered new possibilities to imagine and picture independence from colonial rule. He went as far as characterizing the aim of figure 3 in the following terms: "to open eyes to the relation of all [injustices] to the political."[43] The proliferation of photographs, some published and others in negative form, established new spaces from which nonstate actors viewed and responded to the actions of the Portuguese authoritarian and colonial states.

Booklets such as *Genocídio Contra Portugal* enhanced the public circulation of photographs and raised awareness about the attacks.[44] However, throughout the pamphlet, text and a protective seal controlled the public viewing of photographs. The Portuguese authoritarian state had its own apprehensions about publishing photographs and the context most appropriate for showing them to audiences. For example, at the outset, the featured text identifies the intended audience as adults, further noting that the book's content was not "suitable for the squeamish or sensitive."[45] Words used in everyday language, according to the text, lacked the ability to "accurately" characterize the horror.[46] The protective seal was the final barrier between the reader and viewing the photographs. The text on the seal presented readers with the choice of believing the text or seeking additional proof through viewing the photographs. The seal read:

WARNING: DO NOT BREAK THIS SEAL BEFORE READING THE FOLLOWING NOTE: This sealed section of our pamphlet contains photographs of horribly mutilated bodies. They are dreadful illustrations of the worst kind of atrocities and therefore should not fall into the hands of minors. Nor are they even suitable for the average adult to see. They are presented, very reluctantly, only as irrefutable proof of assertions which are so awful that they might otherwise be disbelieved. We earnestly hope that most readers will accept as true the written evidence submitted in the first part of this pamphlet and may therefore consider that they will be spared much pain if they choose to refrain from breaking the seal.[47]

The protective seal allowed editors to refer to the photographs without having to display them. The existence of the photographs of mutilated Portuguese women, men, and children suggested the attack had happened. The text asked readers to believe what they read instead of looking at the photographs. Interestingly, the Portuguese and English versions of the booklet presented the photographs differently. The English version included the photographs grouped at the end of the text. In contrast, the Portuguese version featured the photographs interspersed through the text. The photographs were displayed differently to English- and Portuguese-speaking audiences, and readers' decisions to look at the photographs in the first place were also expressed in different ways. The booklet reflects the diverse ways in which photographs circulated across the Portuguese Empire.

For any combination of reasons, including their gruesome content, public response, and the potential for inciting further anticolonial unrest, staff at the GNP and other Portuguese government agencies failed to produce a text similar to *Genocídio Contra Portugal* in relation to conflicts the regime confronted in Goa, Mozambique, and Guinea-Bissau that followed after events in Angola. Nevertheless, soldiers such as the Portuguese commander Jorge Jardim brought images of Angola with them to Mozambique.[48] As part of counterinsurgency tactics, commanders and soldiers alike shared photographs of Angola to raise troop morale and incite war in Mozambique.[49] Publications like *Genocídio Contra Portugal* temporarily filled the voids introduced by geographical distances and the varied abilities of Portugal's authoritarian state to gather information on colonial state affairs. Nonetheless, via the technologies and infrastructures of photographs, "antennas, radios, journals, [and] word of mouth," a sentiment surfaced in Portugal in 1960 and remained unchanged that the colonies were of greater importance than populations in the metropole.[50] Many citizens living in Portugal believed that the authoritarian state had neglected them in favor of defending its colonial project in Mozambique and the other African colonies. By 1962, people living in the metropole wanted to sell off the colonies.[51]

THE VIEW FROM PORTUGAL

Over the course of the 1960s and 1970s, as part of his newspaper assignments, Rangel frequently stood before Portuguese soldiers as they marched

Figure 4. Ricardo Rangel, undated, untitled. Caixa: Rangel: Tempo Colonial, Centro de Documentação e Formação Fotográfica, Maputo, Mozambique.

in front of civilian populations in Mozambique's colonial capital (figure 4). Troop parades and induction ceremonies increased in frequency as the conflict unfolded in 1964 between the Portuguese military and the liberation front Frelimo. Parades, and photographs of them, were familiar to newspaper readers in colonial Mozambique. As an object intended for public viewing, the image in figure 4 removed from public view the actual war unfolding outside of the colonial capital. The soldiers that Rangel photographed were photographers themselves.

Portuguese soldiers stationed in Mozambique frequented the very commercial studios where Rangel and other nonwhite photographers and film technicians started their professional careers. Soldiers purchased cameras, films, and prints, which they carried to military bases across Mozambique to produce their own pictures.[52] The photographs that soldiers took of themselves and of native populations sometimes traveled between the colony and metropole, and through their content and varied use brought into view the war in Mozambique as it unfolded. Diplomats, administrators, and military

officials associated with the Portuguese authoritarian state and the colonial state in Mozambique found different uses for the photographs taken by soldiers. In fact, representatives of the colonial state were more interested than their metropolitan counterparts in the anticolonial aesthetic that increasingly surfaced from the use of local photography by nonstate and state actors.

Even before the start of war in Mozambique, military officials based in the colony and Lisbon found use for photographs. Military officials in Lisbon collected photographs and organized them into albums with text. One such album is available at the Arquivo Histórico Militar in Lisbon, and features photographs of soldiers holding cameras, attending to the injured, and reading books with images.[53] The photographs included minimal contextualizing information. In many instances, the name of the photographer was unavailable.

Some photographs were useless regardless of their authentication, but others were self-evident and usefully powerful. One of the only names of a photographer to appear was that of the South African S. J. McIntosh. However, there was no specific record documenting the circumstances under which McIntosh or other unnamed photographers traveled to the pictured battlefields. The album included the date range of 1961 to 1975 and made no mention of the specific locations where they were photographed in Mozambique.[54] The album showed, then, that there were photographs of the war, even if they only circulated internally. Additionally, the photographic album displayed an attempt by its unspecified maker(s) and viewers, presumably state bureaucrats and military personnel, to transform photographs into sources of information.

Various forms of image making and image viewing occurred while Portuguese soldiers defended Portuguese interests in Mozambique from 1961 to 1974. In one photographic example (figure 5), a soldier bent down to assist a fallen comrade. The attending soldier looked directly at the photographer, acknowledging the camera's and the photographer's presence on the front lines. That soldier opened his mouth while the other soldiers present turned their backs to the camera. In another photograph (figure 6), a soldier rested on an inflatable mattress holding a cigarette in one hand and a book in the other. The soldier read a translated version of Russian author Mikhail Sholokhov's book, *Morreram pela patria* (*They Fought for Their Country*), about World War II in the USSR. The cover image showed men firing guns from behind a makeshift barricade. The soldier's sunglasses masked whether he was reading or glancing at the photographer. The photographer and camera

Figure 5. Unknown photographer, 1961–1975, untitled. PT-AHM-110-BY-PQ-21–6, Fototeca, Arquivo Histórico Militar, Lisbon, Portugal.

were present on the battlefield. But there is no way to know how soldiers felt about having their pictures taken and what they were trying to express. In effect, figures 5 and 6 and the other accompanying photographs in the album denote the representational limits of photographing the war. Ultimately, figures 5 and 6 fashion the photographer's and camera's presence as limiting rather than illuminating.

As the previous section argues, acts of viewing photographs, sometimes in tandem with acts of reading, factored into how civilian populations tracked news across the Portuguese Empire. Similarly, books, photographs, plays, and movies were formative to soldiers' war experiences. Based on the album's existence and preservation, military officials in Portugal generated an unspecified value from looking at the photographs of soldiers on the front in Mozambique. Somewhat in contrast to the mechanisms of surveillance adopted by the Portuguese state, starting in 1960 the colonial state's civilian and military governing apparatus assessed and documented the images soldiers consumed.[55] The Portuguese military's counterinformation section

Figure 6. S. J. McIntosh, 1961–1975, untitled, Mueda Air Base, Mozambique. Code: PT-AHM-110-J6-PQ-5–13, Fototeca. S. J. McIntosh, Arquivo Histórico Militar, Lisbon, Portugal.

inquired about the books, pamphlets, engravings, and photographs that soldiers purchased, found, and even were offered.[56] Soldiers also answered questions about films viewed, meetings observed, and radio programs and music heard.[57] Where the military tracked soldiers' consumption of audio-visual images, the colonial state's media operation published photographs of soldiers watching films, such as *Patton* and *Green Berets*.[58] These films, along with books such as *Morreram pela patria*, situated Portugal's colonial wars within the defense of democracy and Western values that had justified World War II and, to a certain extent, the Vietnam War. At the level of viewing and reading, these images attempted to win soldiers' loyalties by displaying the heroics of war.

The information-gathering mechanisms of Portugal's military in Mozam-bique overlapped with soldiers' patronage of commercial photography stu-dios (figure 7). Studios such as Focus (Lourenço Marques), Estudio Alfa (Nampula), and Foto Rodrigues (Nampula) advertised their film-processing and printing services to soldiers in the weekly illustrated insert published in *Notícias* called Coluna em Marcha (The column on the march). Studios promised to develop soldiers' films in color within twenty-four hours, to pro-

Figure 7. Page excerpt of Coluna em Marcha (The column in motion). *Notícias*, 11 Agosto 1973, Biblioteca Nacional de Moçambique, Maputo, Mozambique and the Center for Research Libraries.

duce each photograph as "an unforgettable memory," and "to send [to any province] colored and cropped prints along with rolls of film."⁵⁹ The advertisements suggest that soldiers used purchased cameras and film to photograph each other rather than going to the studio for a portrait; they dressed in fatigues or civilian clothing, with their hands crossed or placed on their hips or behind their backs. Soldiers submitted to the colonial state-run newspaper *Notícias* the images that they printed at studios along with short texts, requesting "second mothers," "moral support," and answers to questions such as what women wanted in a husband.⁶⁰

Coluna em Marcha represented a different editorial approach to the representation of the colonial war in Mozambique. Civilian audiences in Europe and North America frequently viewed colonial and war contexts in Africa, Latin America, and Asia through illustrated newspapers. Coluna em Marcha first appeared in 1972, around the same time that Portugal launched Operation Gordian Knot, one last military attempt to defeat Frelimo. Before the early 1970s, the Portuguese authoritarian state and the colonial state in Mozambique had resisted showing the scenes of war to audiences across the Portuguese Empire.⁶¹ The newspaper *Notícias* published the Coluna em Marcha insert in its middle pages, and many of the editions in which it appeared featured photographs like figure 4 that Rangel and Vieira took of the colonial state.

Photographs and illustrated graphics comprised the bulk of the insert. Soldiers took many of the published photographs, and editors often used captions in addition to stand-alone articles to highlight the importance of photographs to soldiers, sometimes even featuring soldiers' writing about their own photographic collections. Coluna em Marcha featured photographs depicting a woman and young child photographing a troop ceremony.⁶² Civilian populations identified with the troop inductions and other military celebrations to the point that they photographed them for recreational purposes (figure 8). The editors of Coluna em Marcha pointed out the symbolism of civilians photographing troop ceremonies, specifically in terms of the high quality of their photographs that warranted publication on the front pages of daily newspapers.⁶³ Soldiers also used Coluna em Marcha to express their love of photographs. For soldiers, personal family photographs exemplified the time that elapsed during the war and substituted the sense of loss they felt until they returned from the war. For example, a soldier concluded a piece titled "Fotografia (para a Eva)" ("Photography [for Eva]"), stating, "And now nothing more is possible for us than to look at that photograph, to remem-

COORDENADA E DIRIGIDA POR *GUILHERME DE MELO*

12-5-1973 • ANO V — 248 • SAI AOS SÁBADOS

EM DIA DE JURAMENTO
OS CHEQUINHAS SÃO HERÓIS!

ESTA PÁGINA, ESTE NÚMERO...

Sempre que nos é possível, procuramos oferecer vos, amigos, um suplemento diferente. Com um esfarrapado mais movido, mais variado. Com um conteúdo igualmente mais movimentado, um tudo nada a fugir à habitual clausura dos meus queridos, meu amor, sabes que se gosto de ti, não sabes?... Se eu estou nos apaixonei; se eu que os encontram aqui, em LM, em férias em tratamento, nos procuramos para convosco conversarmos, meta notas de interesse para o suplemento surgirá, como neste número. E se tu que estás lá fora clicas nos vivíamos fotos, apontamentos, crónicas tratamento relacionadas com o ora dos à dia, também poderíamos variar cada vez mais o conteúdo da «Coluna». É pede auxílio, amigos?...

Entretanto, quaisquer contacto da vossa parte, poderão ser feitos pelo telefone 34122, de preferência entre as 13 e 14 e cerca das 23 horas. Sempre.

UM PÁRA DESCEU DO ALTO...

José da Encarnação Barros é um moço pára-quedista que visita Lourenço Marques pela primeira vez. Veio de férias. Ele-lo com o orientador deste suplemento semanal e Adjunto da Direcção de «Notícias», vendo o emblema da Comp. Cac. Pára-quedista 37, a que pertence, e que, entusiasmado, vos encontrar no quadro de recordações neste jornal, aqui deixado pelos que o antecederam na sua missão militar quando, no 16 de junho de há dois anos aqui vieram desfilar (entrevista na página 4).

Nesse, dia do sul. Manhã de céu roberto, azul a luminoso. Dia de Juramento de Bandeira para mais umas tantas centenas de recrutas que o partir desse instante completaram a sua formação para Sargentos Milicianos. Fim do CSM, como é na literatura.

Presentes as autoridades civis e militares da praxe, presentes, ainda, os pais, a ...

TROPA & POESIA

Rui Pedro di Sari é um soldado que veio para Lourenço Marques evacuado, recolhendo ao Hospital Militar. Como militar nós veio visitar — como poeta conhecido conversámos. Porque para além da saudade que hoje é, Rui Pedro foi, donde sempre, um jovem dono de letra e que dando os títulos dos versos e lá, na Metrópole, publicou trabalhos nos diversos jornais e revistas. A conversa que com ele tivemos e a poesia que nos deixou, encontram-se na sua secção militar na página 3 desta mesma edição.

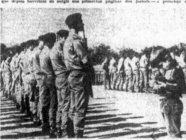

mães, irmãos, avós, noivas, amigos e amigas, namoradas de todos esses rapazes que, do peito orgulhosamente inflado e olhar alevantadamente posto no seu fim de horizonte, acabaram de prestar a seu Juramento sagrado. Pela Pátria. Por todos nós.

E entre a labor das chapas habituais, fixando as memórias, o nome solene que depois haveriam de surgir nas primeiras páginas dos jornais — a presença do...

inacreditável mais nave da máquina em punho, de mira amiga e da mais-que-tudo, de dedinho trémulo batendo a chapa para o filha do seu querida na tropa.

O lado humano de todas as coisas. Até mesmo das mais solenes — como o é, sem dúvida, um Juramento de Bandeira. O dia em que, aos olhos dos que lhe são queridos, cada cabeça é um Herói!

HINO
À BELEZA

Seu nome é Carla Barros. É a nova Rainha da Beleza Feminina em Portugal 73. Ela desfilando na passarela do Casino Estoril, após a sua coroação — verdadeiro hino à Beleza e à Vida, que oferecemos aos leitores deste suplemento semanal. É que a partir deste momento alegremos, alegramos, nós dueblamos, nesta cabeceira de torinda em toda escassez se camarata, se a onda fer que a ofuscara em Marchas chegue. E, com ela, a *sorriso* gentil de Carla.

ESTE SUPLEMENTO É DEDICADO PELO "NOTÍCIAS" ÀS FORÇAS ARMADAS DE MOÇAMBIQUE

Figure 8. Page excerpt of Coluna em Marcha (The column in motion). *Notícias*, 12 Maio 1973, 1, Biblioteca Nacional de Moçambique, Maputo, Mozambique and the Center for Research Libraries.

ber those good moments and to make [plans] for the future, because within months the person in that photo [actually] will be in our arms. That's what photographs are like."[64] Photographs were place holders, or substitutes, until soldiers reunited with their loved ones presumably at the end of the war.

Commercial photography flourished in Mozambique independent of the Portuguese authoritarian state and the colonial state apparatuses. As a result, soldiers' recreational use of photography sometimes contributed to the Portuguese military's reconnaissance efforts. The advertisements and photographs published in Coluna em Marcha indicated that soldiers photographed each other. Interrogation reports authored by soldiers also noted that they photographed local nonwhite populations that had frequented military bases or had abandoned Frelimo. These reports often stated, "The person was photographed; the photograph will be sent later when possible."[65] One possible reason the photograph was "sent later" was because soldiers took the photographs on the same films they used to photograph themselves and because the military base lacked a laboratory to develop and print films. The military used gathered photographs of local populations in its reconnaissance and counterinsurgency efforts to diminish popular support for its enemy.

Under advisement from the GNP, the Portuguese military in Mozambique circulated different paper propaganda. Some of these pamphlets featured photographs of black populations that had abandoned Portugal's enemy Frelimo (figure 9). These full-body portraits were stylistically and visually similar to the photographs that soldiers took of themselves and circulated through newspapers. Tellingly, the photographs of local nonwhite populations printed on pamphlets included shadows, which often indicated the presence of the Portuguese soldier who took the picture. The mode for representing populations native to Mozambique was interconnected to soldiers' attempts to picture themselves. These image-making practices filtered out across the colony, and the Portuguese Empire more broadly speaking, through a variety of mediums, including the portrait, the propaganda pamphlet, and the typed text on interrogation reports.

By the early 1970s, in an effort to produce an image of war, the colonial state found use for photographs by and of soldiers. Figures 7 and 8 represented the new image of war, and resulted from a willingness to illustrate the war front to native and settler populations. Also, colonial administrators increasingly appeared in published newspaper prints alongside photographers, such as the press photographer Ricardo Rangel (figure 10). In the case of figure 10, state actors looked at the very photographs that colonial-state censorship

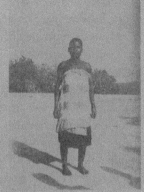

MINYANO BUANAPUNDE CHEIA

kihotyawa muini
kihahiya a bandidu
kihaperezentari
u Boma Putukezi

KIHAKHELELIYA RATA

Ninokhala uwani
Kihana cholya
kihana ikuo
kihana inupa
kihana amushi

KINOKHALA RATA

MINYANO BITI CHEIA KIHOTYAWA VAMOSHA NA AWANNYAKA MACHAPA VANO KIHOKHALA RATA. NIRI U NHANCUNDA. KHAWO ANITHUKILE.

KONOWALEPELA AKHUNANAKA OTHENI AMINI CHINOHIMYA I BOMA PUTUKEZI MUHI-YEKE MUINI MWAHIYEKE A BANDIDU.

MUHOKOLYEKE, MUWACHEKE UWANI. UNO NO KHALA RATA. AHAWO MAKE ISABAU CHOLIYA NI IKUO.

MUHOKOLIEKE, AKHUNANAKA MUHOKLIYEKE, MUWEKE UWANI. A BANDIDU ANOWO-THA. KANNOTHUKIYA, KANNEVIYA, KANNOTARAWIYA.

MUHOKOLIYEKE, MI BITI CHEIA KIHOHIYA MUINI KINOKHALA UWANI NUKITELA NRIMA. UMALEKE UHUVA. AMALEKE MATEKENYA.

MWITUPHINI ATHU ANOHUVA CHINENE. A BANDIDU ANONIMANA MWANA ONLAKA. A BANDIDU UNIYERA CHOLYA CHIHU.

UNO U NANCUNDA ATHU OTHENI ANOLIMA KAVO ANEYA CHOLIYA. UNO NNOWAPYA RATA. NNOKHALANA INUPA, NNOKHALANA IMATA, NUKHALANA AMUSH. MUHOKOLIYEKE, MUHOKOLELEKE UWANIHU, MUHOKOLELE U NANCUNDA.

KINOVELELIHA ISALAMU CHINCHI WA AKHUNANAKA

MI BITI CHEIA

Figure 9. Gabinete da Informação e Formação da Opinião Publica (GIFOP), "Minyano Buanpunde Cheia," 1967. SR 29: Moçambique (GIFOP), Gabinete dos Negócios Políticos, Arquivo Histórico Diplomático, Lisbon, Portugal.

office had deemed unsuitable for public viewing in the 1950s and early 1960s. In spite of the censorship protocols, the colonial state deemed it acceptable to show its representatives standing next to Rangel, who himself had faced state censorship. Figure 10 and its publication in the mainstream press marked an increasing willingness and engagement on the part of the colonial state to allow nonstate actors to use photography independently of the state apparatus. Certain anticolonial sentiments in Mozambique precipitated new modes of photographing and economies of photographic production. Members of the colonial state tried to pursue the colonial state's interest by accessing the visual economies that generated photographs like those depicted in figure 10, the actual press image and the photographs that Rangel points to in the image. The Portuguese authoritarian state appeared unwilling to follow the colonial state's approach to and use of photography as depicted in figure 10.

In Portugal, the photographic record regarding the metropole's use of photography in colonial affairs is limited. In Mozambique, there is a largely photographic, and not textual, imprint of colonial state use of photography. Diplomatic and military officials in Portugal compiled photographic albums of the war front. They also used typed text to register photographic and other image-making activities.

The strategies for image making adopted by Portuguese government representatives were perhaps one reason why government officials in Portugal regularly lamented the state's incapacity to produce photographs. Over the duration of the war, the activities of officials in Lisbon suggest that there was minimal use of photography and a certain recognition that printing more photographs actually produced little political or economic benefit to their day-to-day administrative responsibilities and the advancement of Portuguese interests. As in the example of attempts by Portuguese officials to obtain images of Goa after Indian forces declared independence, the metropole found ways to profit from the absence of certain photographs. As the war continued into the late 1960s and early 1970s, colonial state actors in Mozambique accessed with greater frequency the same photographic economies that had not only made it possible for Ricardo Rangel to practice photography but had nurtured the anticolonial positions of populations living in Mozambique.

Different modes of photographic production and viewing separated and distinguished the metropole from the colonial state and vice versa. Photographs had assumed a range of material and discursive formulations that, according to historian Georges Didi-Huberman, defined their existence and allowed them to outlive their subjects, producers, intended and unintended

Figure 10. "No auditório e galeria de arte: O governador do distrito inaugurou a exposição de Ricardo Rangel." ("In the auditorium and gallery of art: The district governor inaugurated the exhibition of Ricardo Rangel"). *Notícias da Beira*, 19 Dezembro 1969, Arquivo Histórico de Moçambique, Maputo, Mozambique.

audiences, and those who wrote about them.[66] Within the nexus of Portugal and Mozambique, Portuguese soldiers, colonial officials, photographers, and their sitters questioned photography and grappled with their respective use of the photographic medium. State and nonstate actors in Mozambique believed that the colonial state went to great lengths to censor photographs. Differing familiarities with photography complicated the ways Portugal's authoritarian state interacted on a daily basis with the colonial state in Mozambique. These differences of photographic use were one of many outcomes that resulted from Portugal's and the colonial state's ongoing struggles to integrate the production and circulation of photography into their bureaucratic operations amid political turmoil. What was good for audiences to see through photographs in Portugal was not necessarily what the colonial state wanted populations in Mozambique to see, and vice versa.

PHOTOGRAPHY'S *FOTOGRAFIA*

Fotografia translates from Portuguese into English as "photography," a reference to the technical and professional practice of taking photographs. It also denotes the physical object, the "photograph." To many civilian populations living in Portugal and in colonial Mozambique during the war, *fotografia* referred to a physical photographic print. In contrast, governing structures in Portugal and Mozambique dismissed *fotografia* as stand-alone documents and forms of evidence; that is, for Portuguese and colonial state administrators, *fotografia* assumed a discursive and material importance within the collection, classification, and distribution of information. State institutions prioritized making it possible to produce photographs over ensuring that they were actually in constant production.[67] The intent behind the concept and written text associated with *fotografia* was never to document a specific event or to ensure that populations in Mozambique and Portugal viewed photographs. Use of the discourse of *fotografia* served to remove certain photographs from public viewing, and in the process, created a heightened sense of the unavailability of photographs for officials based in Portugal.

Diplomatic, military, and political officials in Portugal developed their awareness of state capacities to use photography in relation to its communications with the colonial state in Mozambique. Many authoritarian state personnel thought that photographs needed to be interpreted through writing.[68] Part of the responsibilities of the political class in Lisbon was to draft, agree

on, and distribute protocols and procedures for colonial state representatives in Mozambique to follow. Colonial state officials in the Gabinete do Governo-Geral de Moçambique, the Gabinete da Informação e Formação da Opinião Pública (GIFOP), and the Serviços de Centralização e Coordenação de Informações de Moçambique (SCCIM) received instructions from Lisbon on how to treat and circulate photographs and other forms of information. According to these instructions, they grouped photographs with "reports, documents, facts, materials, diagrams, letters, reports or observations of any kind," and categorized all these objects as "news."[69] News was not evidence, but was instead defined as "[throwing] light on the actual or probable enemy in order to know, clarify, or delimit any danger and situations of dangerous threats, produced accidentally or incidentally."[70] Only after extensive study and verification did "news" become "information."[71] Directives such as "Technical Definitions and Concepts of Information" characterized "information" as:

> [K]nowledge regarding enemy threats endangering the interests of the state obtained through research, study, and interpretation of news, specifically that which refers to political-military and socio-economic organization and geographic, climatic, or ecological characteristics of the region [that] has an effect or is able to have one.[72]

But photographic prints were not considered information. To transmit the information obtained through news, officials used written correspondence, telegrams, radio messages, and in-person contact. The evaluation of "evidence" mirrored the reasons why so many states relied on photography in the first place: the belief that whatever the camera pictured must be true. In this context, the absence of photographic objects in correspondences and archives in Lisbon is astonishing.

The power of the Portuguese authoritarian state and the colonial state in Mozambique faltered because of insufficient knowledge. *Fotografia* was a textual tool deployed by the Portuguese authoritarian state to expose the burdens and perceived risks of trying to produce photographic prints. In 1967, as part of a psychological action campaign, GIFOP relayed instructions on how to distribute and use "black-and-white photographs" and a "poster" on themes of "Portugal [and] Unity" and "Progress."[73] With these instructions came requests for images. The Gabinete Provincial de Acção Psicológica struggled in 1971 to meet such demands. In one response, an official explained that the colonial state lacked the necessary funding "to obtain black-and-white or

color slide photographs" representative of all the provinces.[74] Larger debates unfolded within the context of the Ministério do Ultramar regarding the slowness and care under which administrative officials in Portugal in particular were prepared to meet institutional demands.[75] One official recommended that the government invite newspaper journalists to the war front in Mozambique to address the difficulties faced in locating photographs for press publication.[76]

Two agendas guided Portugal's and the colonial state's information-gathering activities: a need to (1) search out subversive activity, and (2) understand what worked to create a climate for such activity. In 1961, the secret police identified that "subversive elements" had used special chemicals to secretly communicate.[77] When the paper was heated, the messages were revealed.[78] Officials identified news sources, using a point-and-letter scale to rate their confidence in the identification of the origin and their assessment of the truth of the source. As part of the evaluation process, officials considered "the necessity of the knowledge" and compared the "opportunity" in relation to the "appropriateness" of circulating the gathered information.[79] Once again, face-to-face communication was prioritized when sharing materials classified as "information."[80] However, officials charged with evaluating materials generated additional typed documents when trying to transform "news," sometimes gathered through objects such as photographs, into "information" and when documenting the information's transmission and reception. In October 1964, Portugal's authoritarian state imposed security protocols on the handling of these writings. Such actions shifted the scale and nature of governance between the metropole and the colonial state. In some instances, colonial state officials at SCCIM replicated the methods for handling and archiving information first implemented in Angola.[81] The colonial state also received queries from US-based distributors of surveillance equipment, such as wiretaps, to compensate for *fotografia*'s perceived failings, including time lags and the subjectivity of enforcing press censorships.[82]

Certain idealizations of Portugal's colonial project in Africa, like the indivisibility of the metropole from the colonies or the metropole's policy of nonracialism, were not susceptible to becoming a part of the photographic record despite attempts to ascribe meaning to actual photographic prints and to produce new images. Different notions of censorship surfaced among state and nonstate actors in Portugal and Mozambique during the colonial war.[83] Officials struggled to translate into writing the difficulties they faced when implementing *fotografia*'s directives. Photographers were of no use to gov-

ernment and colonial state agencies. Typists, archivists, and librarians were a higher priority to government agencies in Portugal, tasked with evaluating, producing, and storing illustrated drawings and other graphics in the absence of photographs.[84] Administrative activities centered on these materials, and limited *fotografia* as a means of visualization and representation.

The opening in Portugal and Mozambique of GIFOP corresponded to Portugal's efforts to decentralize the government and to give the colonial state in Mozambique more autonomy. GIFOP represented the Portuguese authoritarian state's entry in the early 1960s into the "information and public sector," aiming to foster links between Portugal and its overseas territories through "condensed world" news.[85] Librarians, typists, and archivists classified documents for distribution and registered received communications, while radio, print, and television journalists ensured coverage of Portugal.[86] GIFOP issued instructions and reports to both Angola and Mozambique, and generated pamphlets, leaflets, and posters.

The Commisão do Censura complemented and supplemented some of the functions GIFOP served at the level of the colonial state. For example, the agency monitored the text and photographs that appeared in the Mozambican press. Views varied across the Portuguese Empire regarding the pervasiveness of censorship. According to José Oscar Monteiro, who participated in the pronationalist activities of the Lisbon-based Casa dos Estudantes do Império before leaving his law studies in the early 1960s to join the liberation movement Frelimo, "[The] Portuguese censorship board did not censor pictures. They censored the documents, the text and the articles. I remember that we [Casa dos Estudantes do Império] did not have to submit the pictures with the articles, which allowed [the newspaper] to put pictures to convey the message."[87] In contrast, photographers such as Ricardo Rangel and the print journalists he worked with believed that the Commisão do Censura took particular interest in photographs. By the latter stages of the war, officials of Gabinete do Governo-Geral de Moçambique and GNP shared in these ambivalences and debated the rigidness of censorship policies, proposing the colonial state's collaboration with the press.[88]

Both GIFOP and the Commisão do Censura reacted to images at varying stages of their production and circulation. Colonial state censors struggled to implement the written guidelines for information gathering and distribution issued by SCCIM. Newspapers editors and journalists submitted incomplete headlines and images not intended for publication in order to complicate the job of state censors.[89] The Commisão do Censura in Mozambique functioned

like a type of filter as it evaluated the potential effects of publishing text and photographs. Sometimes the bureau made decisions without ever seeing the actual materials intended for publication. The same office was responsible for determining what images and text circulated in the world, and relayed the colonial state's messaging agenda. To such ends, where photographs were available, they stamped them. The stamp *autorizado*, or "authorized," approved publication, whereas *cortado* or "cut," barred publication. There were no written explanations for the decisions made. These processes and the treatment of images and writing generated another set of texts and images.

Members of the Commisão do Censura in Mozambique corresponded directly with the Gabinete do Governo-Geral de Moçambique, which oversaw the bureaucratic affairs of the colonial state. In correspondences dated from 1959 to 1961, officials of the Commisão do Censura complained about the professional and personal hardships associated with their work.[90] For example, one representative at the Commisão do Censura recounted how newspaper editors submitted late and incomplete front pages. Those charged with censoring the Mozambican press had their sleep interrupted by late-night phone calls.[91] Their complaints were justified—they reflected attempts by newspapers editors to reject censorship and what they saw as the colonial state's intrusive and unnecessary activities.[92] Complaints by staff at the Commisão do Censura resulted not only from issues with staffing and finances, but also, as one official suggests, with the colonial state's inability to fully control the press apparatus.[93]

These processes of censorship generated a range of material responses from editors, and ultimately created new filters through which photographs circulated internally within the press. Editors kept photographs designated as *cortado*, or "cut," as prints and negatives rather than destroying them.[94] Also, they defied the practices imposed by the Commisão do Censura. Sometimes editors replaced "cut" photographs with unapproved photographs or no photographs at all.[95]

Not all colonial policies lent themselves to photographic documentation. Nonetheless, the images regularly censored by the Commisão do Censura were of value to other colonial state agencies, such as GIFOP. In the case of GIFOP, censored images served colonial state efforts to discipline troops, to illustrate the war's "just and imperative cause," and to "disclose the rights and duties [threatened] in the face of the subversive war."[96]

Not all images with informational value were reusable (figure 11). Back in Portugal, over the course of the late 1960s and early 1970s, GIFOP studied

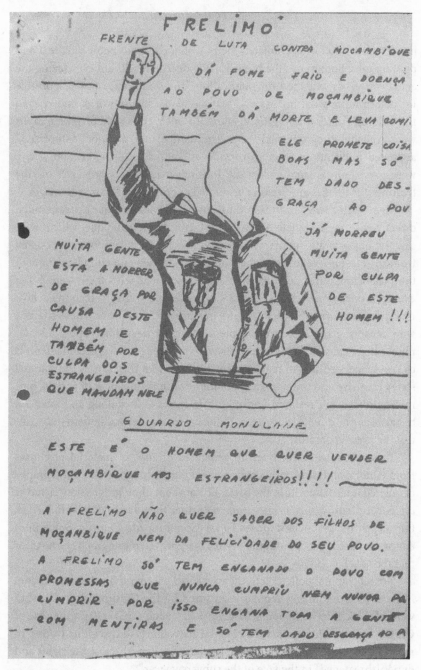

Figure 11. Unknown author, 1966, untitled. SR:029/Moçambique/Z.43, Moçambique (GIFOP), Meeting Actions, Arquivo Histórico Diplomático, Lisbon, Portugal.

and developed its propaganda strategies in relation to documents that Portuguese troops collected. One pamphlet from 1966 featured a generic drawing of a revolutionary figure without a face. The figure had a raised fist, a symbol associated with militancy. There is no indication why the figure was faceless, but Portuguese text identified the figure as Eduardo Mondlane, Frelimo's first president. GIFOP concluded that Frelimo had used the pamphlet to deter its members from joining the Portuguese side and to warn members against Portuguese propaganda. The image presented Mondlane as responsible for "all bad things that happened to Mozambicans," and the pamphlet introduced themes such as hunger and false promises that Portugal could use to exploit tensions internal to the liberation movement Frelimo.[97] GIFOP dated the pamphlet to 1967, a year before colonial officials analyzed and circulated internally the document. According to GIFOP the image and text were unusable: "whatever activity of 'direct counter-propaganda' exercised in that time did not satisfy the important criteria of 'opportunity' [needed to justify a specific military action]."[98]

GIFOP officials referenced in their correspondence the complementary presence of photographs, not the lack of images, but the material absence of photographs in printed propaganda is astounding. GIFOP often produced propaganda that displayed illustrations (figure 12) instead of photographs. Since the eighteenth century, Portugal had trained its soldiers as cartographers and illustrators,[99] and illustrations allowed Portugal to compensate for circumstances where certain scenes were unphotographable or where officials confronted the constraints of reproductive technologies and printing methods. Illustrations showed Frelimo soldiers destroying villages and whipping native populations (figure 12). Drawings of those living under Portugal's control showed families eating together and receiving health services.[100] Critic and art historian John Berger explained that the lines that constituted drawings are important, not because "they record what you have seen," but because of "what [they] will lead you to see."[101] GIFOP used these drawings, like figure 12, to address the political and military work that *fotografia* failed to perform. For example, GIFOP identified populations to target and differentiated suitable materials for each group.[102] These groups, in order of importance, included (1) traditional authorities and spontaneous leaders (trainers of opinion), (2) religious authorities, (3) native populations, and (4) European populations.[103] Radio was a priority for European populations, whereas GIFOP emphasized direct contact with religious leaders and information centers, music, and dance outlets for local black populations. Interrogation reports of

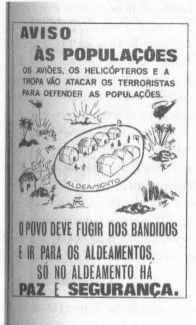

Figure 12. A Ação Psicológica (APSIC), "Relátorio de acção psicológica" ("Report of psychological action"). 1971, PT/AHM/FO/O63/A/15/954/1, Arquivo Histórico Militar, Lisbon, Portugal.

populations who abandoned Frelimo further emphasized the importance of seeing visual images and how populations considered photography and illustrations to be propaganda.[104] On coming face-to-face with Portugal's military, one person said he did not flee Frelimo because he had viewed propaganda distributed by the Portuguese military. However, the propaganda failed to arrest the "fear of death" that filled him and others when they encountered Portuguese soldiers.[105] Drawings compensated for *fotografia*'s inability to generate photographs, at the same time evoking a type of violence through their vulgar content and popular use.

The institutional and discursive structures inscribed on and through *fotografia* produced instances where there were no photographic prints. On July 10, 1973, the priest Adrian Hastings published an article in the London *Times* with the headline "Portuguese Massacre Reported by Priest," claiming Portugal's army destroyed a whole village in Mozambique over its support of Frelimo.[106] Portugal disputed the claim on the basis that Wiriyamu, the site of the supposed attack, was not an actual place on a map. The colonial press reported on protests that developed in response to the priest's accusations, and the Portuguese authoritarian state attempted to invite foreign and national journalists to the supposed attack site. In fact, two years before the incident, Portugal's military planned to send a film and sound crew to Tete, the location of Wiriyamu, which could have provided images for such political disputes.[107] There were no photographs of victims, dead or living, only those produced after the event that depicted witnesses, protest rallies, and Portugal's attempts to defend itself through meetings and press conferences. Views were polarized in Mozambique, where people took to the streets with signs calling for foreign officials "to piss off" and questioning attacks on Portugal. Regarding the events in Wiriyamu, *fotografia* skewed and distorted.[108] Populations in Mozambique and Portugal read and heard "information" produced by the filter of *fotografia*. Sometimes they even viewed actual photographs of what was incommunicable between government and administrative officials in Portugal and Mozambique.

SONIC VISUALIZATIONS

Populations living in Mozambique regularly encountered photographs through sound after 1970. Native populations recounted to Portuguese soldiers the war propaganda they had viewed, while the military used sounds to

broadcast images of empire and war.[109] The assemblage of sound and image helped Portugal's military lessen the distance between itself and Mozambique. The use of sound for communication and surveillance also placed different levels of the metropole and colonial state into contact with each other.

Early on in 1960 and over the course of the colonial war, the photographic and cinematic endeavors of colonial states in Angola and Mozambique conflicted with Portugal. Colonial state officials navigated technical difficulties, and found themselves subject, not to the laws they created, but to the laws enforced by the Portuguese authoritarian state. For example, aerial photography and filming were impossible without authorization from Portugal's civil aviation department and the Ministério do Ultramar.[110] Once the request was granted under a 1958 military law, additional oversight was needed from the Força Aérea Portuguesa and Ministério do Ultramar.[111] The officer who authorized the request framed gathered visual materials as of a technical nature rather than a political one, reasoning that aerial photography and filming required "a specialization that transcended the scope [i.e., mandate] of [his] office."[112] These complications between Portugal and Mozambique over the production and circulation of images continued in 1966, as officials faced difficulties with importing films to Mozambique and Angola, where there were twenty-one and twenty-seven cinemas, respectively.[113] To address conflicts, colonial state officials found themselves relying on Portuguese laws, not regulations developed by the colonial Mozambican state. In the case of the importation of films, an official referenced a 1961 law aimed at economically integrating Portugal with its colonies to eliminate legal and administrative disparities that prevented the films being distributed from Portugal to Angola and Mozambique. A tax on commercial cinemas was also introduced.[114] Under these circumstances and tensions, colonial state officials in Mozambique expanded their use of audio equipment and the production of sounds.

The Ministério do Ultramar never provided specific photographic equipment or training to members of the state apparatus in Portugal or in Mozambique. However, the colonial state's regional offices in Mozambique, sometimes with directives from Portugal, explored new audiovisual approaches to intervene in the war. These strategies included building radio towers, using megaphones, and applying bureaucratic techniques for monitoring what people said, heard, and saw. Voice messages, and the sounds produced through their distribution, brought dispersed populations into contact with the war front. Sounds gave illustrative pamphlets new meanings and resulted in new ways for officials to clarify administrative and military agendas. Also, the use

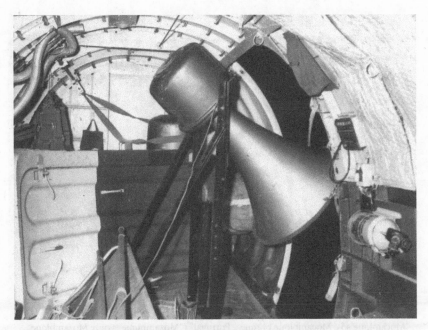

Figure 13. Unknown photographer, 1970, "Moçambique: O equipamento do som montado ao Dakota por a difusão da mensagem ao população e os guerrilheiros" ("Mozambique: Sound equipment mounted to the Dakota for the diffusion of the message to the population and the guerrillas"). Fototeca: Moçambique: Fotografias de diversos assuntos em Moçambique, PT/AHM/FE/110/B7/MD/14/4, Arquivo Histórico Militar, Lisbon, Portugal.

of sounds and the accompanying infrastructure allowed for the archiving and use of photographic discourses in the war's latter stages. For example, by the early 1970s, administrative records appeared in the form of charts that illustrated how Portugal followed the distribution of pamphlets with voice messages amplified by megaphones.[115] Military and administrative officials' own struggles to make use of photography only escalated long-standing worries over losing the colonial wars in Africa.[116] Nonetheless, some of the only photographs that officials either attached to internal correspondence or featured in photographic albums were of colonial state attempts to monitor or use sound.[117]

Classifying sound as a matter of military security removed photographs of sound production and distribution from the public sphere (figure 13). One such photograph displayed a megaphone inside the cabin of an airplane in the position designated for the cabin door. The photograph included the caption,

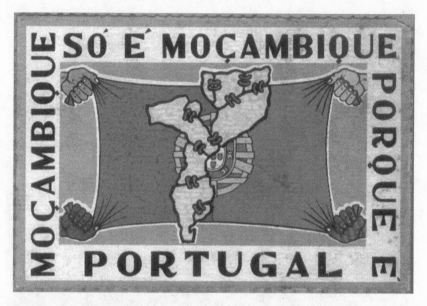

Figure 14. Gabinete da Informação e Formação da Opinião Publica (GIFOP), 1963, "Moçamique só é Moçambique porque é Portugal" ("Mozambique is only Mozambique because it is Portugal"). Relátorio Da Missão-A Moçambique, Centro de Documentação e Informação, Instituto Português de Apoio ao Desenvolvimento, Lisbon, Portugal.

"Mozambique: Sound equipment mounted to the Dakota for the diffusion of the message to the population and the guerillas." GIFOP officials characterized the depicted megaphone as unhindered "weapons of opportunity," since it permitted the replaying of conversations and use of rumors. Megaphones presented colonial officials with new operational terms that differed from the written directives Portugal sent to colonial officials in an effort to evaluate and produce propaganda. They also removed the element of literacy. As voice was critical to messaging, operators received instructions to pay attention to how much time passed between inviting people to surrender and their responses after the invitation. Officials used megaphones and loudspeakers in conjunction with pamphlets "to complete and support each other."[118]

A sense of urgency developed in Portugal and Mozambique by the late 1960s, and resulted in the extension of the ground war to the air. Fears surfaced that Frelimo's army would exploit any errors in propaganda and counterpropaganda. In 1967, the Presidente da Commisão de Censura in Mozambique received an internal communication advising the use of the word

"metropole" to refer to Angola and Mozambique rather than using the word to refer only to Portugal.[119] Furthermore, GIFOP authorized the printing of posters, photographs, and stamps of the president of Portugal intended for display on personal cars, storefronts, and mail sent between Mozambique and Portugal.[120] One printed stamp (figure 14) featured the flag of Portugal. Positioned over the coat of arms was an outline of Mozambique in green and red—the color of Portugal's flag—holding together the provinces that constituted Mozambique. Multicolored hands, a reference to Portugal's policy of multiracialism and the indivisibility of Portugal and Mozambique, pulled at the flag's corners. Surrounding the flag was text: "Mozambique is only Mozambique because it is Portugal." Portuguese military airplanes distributed in Mozambican war zones a poster version of the stamp in 1971 aş part of its psychological action campaign. Portugal had proclaimed that Mozambique was Portugal, but with this messaging, Portugal and the colonial state intended to reach various groups differentiated by race, skin color, and nationality, in particular settler populations from Goa and China, along with native populations classified as "assimilado."[121] The circulation of the poster as airborne leaflets to these audiences emphasized that a war would break out among different ethnicities for control over Mozambique, which would benefit those who "waited for an opportunity to dominate the territory and benefit its habitants."[122] GIFOP believed the message was of interest to settler populations who had a "personal interest from an economic and political perspective."[123] Whereas settlers received the poster and "face-to-face contact," GIFOP proposed pairing the poster with examples from Biafra, Congo, and the Republic of Guinea—sites of civil wars—along with daily news and radio broadcasts for the benefit of native and assimilated populations.[124]

During the period when the Portuguese military distributed pamphlets from airplanes, broadcasts from megaphones and radios reinforced the message of circulated propaganda. Interestingly, populations who had abandoned Frelimo normally recalled the sounds of Portuguese military aircraft when recounting their wartime experiences to Portuguese soldiers. Sounds were better heard at night than during the day. Those who abandoned Frelimo responded to the broadcasted sounds with the same attention they gave to music.[125] Confusion persisted, despite the accompanying sound. Interrogated populations recounted instances where they failed to understand the propaganda and how "guerillas," the term Portugal used to refer to Frelimo soldiers, collected distributed pamphlets, destroyed them, and informed populations that the pamphlets were poison.[126] Nonetheless, the Portuguese soldiers who

conducted these interrogations concluded that their propaganda worked on the basis of these accounts of sounds. According to one such report, the "presence of [Portugal's] troops incited a desire for [native] populations to present themselves, fleeing the suffering [in which] they lived."[127] This tracking of the reception of sound through oral conversations and typed interrogations reports highlighted the visual, oral, and aural aspects of the photographic complex and the filters it relied on. On the one hand, the circulation of pamphlets and information from megaphones created a supposed "truth."[128] On the other hand, according to Portugal's military, Frelimo's "guerillas" said "that no one believ[ed] what they hear[d] since it [was] all lies."[129]

THE END OF THE BEGINNING

At some point in 1974 or 1975, men dressed in military fatigues and others in civilian clothing stood in line behind luggage trolleys at the airport (figure 15). The appearance of the soldiers and civilians reflected the intermingling of the official and unofficial elements that defined the interactions between the metropole and the colonial state in Mozambique. Some of the people looked at each other as if they were talking. Others looked to the side. Beyond the line, a person walked by. In the background, a person kneeled near an entranceway, and a person walked through a door in an unknown direction. The contrasting movements suggest the indeterminacy that characterized the scene and, more broadly, the historical moment. Ricardo Rangel, the photographer who pictured the announcement of Goa's independence (figure 3), photographed the scene, which he titled, "The returning Portuguese soldiers" and featured in the series "The fleeing settlers," a reference to the populations that left Mozambique at independence.

The sitters in Rangel's photograph experienced different opportunities to view themselves in front of the camera and through photographs. The sitters for figure 15 neither recognized nor contested Rangel's taking of their picture. They did not view the print, because Rangel never formally published the image for public consumption. Instead, civilian and military populations encountered photographers and cameras on the front lines and in cities. They lost and left behind the pictures they viewed in newspapers and other public forums. Populations articulated political views in front of the camera, thereby situating themselves within or outside of the confines of the colonial state and Portuguese Empire. In their various forms, photographs attuned their viewers

Figure 15. Ricardo Rangel, 23 Junho 1975, "Retornando soldados Portuguese" ("The return-
ing Portuguese soldiers"). Caixa: Fuga dos Colonos ("The fleeing of the settlers"), Centro de
Documentação e Formação Fotográfica, Maputo, Mozambique.

differently to the histories of colonialism, decolonization, and independence
that played out through photographic production and spectatorship. Quite
possibly, the viewers of these pictures celebrated the fact that certain pho-
tographed sitters survived the war. Some comrades had died in front of the
camera, or because of what collected photographs depicted (figures 5 and 6).

The departing civilian and military elements that Rangel photographed
were responsible for producing and using written and illustrated materials
through the apparatus of *fotografia*. Before their departure, the procedures
associated with *fotografia* authorized colonial state officials to destroy gov-
erning and administrative documents. Administrative and security officials
in Portugal had developed instructions for the destruction of *fotografia* doc-
uments, particularly those generated in moments of strife and instability.[130]
In a 1969 memorandum, the director of the SCCIM explained the following:

> Emergency Destruction—All organizations must foresee in times of peace,
> states of emergency or of war, etc., a plan of destruction of all the very secret

documents in your possession. This plan must be studied by [those] respon-
sible for the security service, which should provide for the intended purpose
the most adequate and accessible means. The destruction should be done
as quickly as possible, and communicated . . . with justification of action
taken.[131]

Individuals received authorization to destroy, by fire and under guard,
administrative documents and all materials used in their reproduction. The
existence of such instructions reinforced the popular belief that the colonial
state either stole or destroyed documents during their departure.[132] Rangel's
photograph of the departing settlers was a result of the policies and filters
enacted through *fotografia*. The photograph documents and accounts for the
ongoing implosion of the colonial state. To a certain extent, the instructions
for documents produced a situation where Rangel's photographs of Portu-
guese soldiers leaving Mozambique can be interpreted as both revealing and
hiding the politics surrounding the end of the colonial war and the processes
of decolonization that followed. Furthermore, the photographic print (figure
15) substitutes the destroyed written documents as a historical record and
bureaucratic tool.

The administrative offices, their organizational structures, and their spe-
cific governing functions became part of the state that the liberation move-
ment Frelimo would assume control over in Mozambique on June 25, 1975.
Frelimo faced an entanglement between the colonial past and an independent
future. The next chapter explores how Frelimo used photographs to produce
an image of a Mozambique freed from Portugal's control. Frelimo ascended
to power at independence with a vision that was not entirely compatible with
the bureaucratic structures that had facilitated Portugal's photographic play
for Mozambique.

Paper Diplomacy

In 1962, the liberation movement Frente da Libertação de Moçambique (Frelimo) formed under the presidential leadership of Eduardo Mondlane and announced its intention to end Portuguese control over Mozambique. Frelimo's leadership, composed of a Comité Central (Central Committee), accepted the invitation of Julius Nyerere, then the president of Tanganyika (present-day Tanzania), to open administrative offices in Dar es Salaam, along with military and refugee camps in the country's southern parts. Two years later, on September 25, 1964, a Frelimo soldier by the name of Alberto Chipande fired gunshots at Portuguese soldiers, marking the start of the independence effort's military phase.[1]

Before 1964, some Frelimo soldiers had received military training in Algeria, whose independence war and ultimate independence from France had inspired Frelimo's own military struggle against Portugal. As the previous chapter illustrated, the start of Frelimo's military engagement with Portugal followed a series of military confrontations between Portugal and anticolonial forces across the Portuguese Empire, against the larger background of European decolonization of Africa and new wars of occupation such as the Vietnam War. In lieu of a full-fledged bureaucracy, Frelimo's administrative, diplomatic, and military arms used photography to cultivate an international profile and to manage the presentation of its war effort to both its membership and the external world. The varying demands of different audiences sometimes created conflicts in how information was presented and received.

Frelimo's initial foray into photography predated the liberation movement's war with Portugal. Before 1964, representatives from the Departamento de Relações Exteriores (DRE) and the Departamento de Informação e Propaganda (DIP) fielded requests from designated combat areas in Mozambique for membership cards and photographs of leadership. From the outset,

the political movement lacked photographers and a darkroom to develop and print films. In the early days of the struggle, Jorge Rebelo carried a small Olympus camera that took seven photographs per roll of film.[2] Correspondences internal to Frelimo's DRE office and dated to 1963 reveal that various Frelimo administrative departments had requested "snaps" of Frelimo's members and leaders from a commercial photography studio.[3] But workers' limited technical abilities, along with understaffing, constrained DIP and DRE activities.[4] Then, in 1966, DIP staff established a photography section.[5] Three years later, unlike any other southern African liberation movement, Frelimo's DIP mobilized enough resources to train selected soldiers as photographers. From 1969 until 1974, Frelimo soldiers-turned-photographers traveled in northern Mozambique and through the military and refugee camps of southern Tanzania, where they photographed local populations, weapons training, and the efforts of the Frelimo Comité Central to connect with local populations.

Foreign and local military, political, and humanitarian support was critical to the success of the liberation effort. Thus, discussions about taking and using photographs spanned many Frelimo departments involved in external affairs, administration, culture and education, and defense. The photographs produced by Frelimo photographers from 1969 onward were part of a larger, ever-changing audiovisual assemblage that unfolded around the gradual emergence and continual use of photography within Frelimo's organizational structure. Making and circulating photographs produced one of the many visions of war through which the liberation movement responded to Portugal's own photographic play (the subject of chapter 1).

Quickly after its formation, Frelimo entered an extended period of war. President Mondlane and members of DRE and DIP confronted the benefits and disadvantages of using photography. Consistently evident to Frelimo's leadership, and to a certain extent to its membership, was how nation-states and liberation movements were conducting wars through the visual realm.[6] In 1962 and over the duration of the independence struggle, the organization held no formal territorial claim to Mozambique. Lacking national symbols and identity documents, Frelimo's leadership and membership faced rigorous bureaucratic formalities and diplomatic protocols while traveling between Mozambique and Tanzania and from Tanzania to other parts of the world.[7] Frelimo's standing as a liberation movement, and not a sovereign government, excluded the organization from access to military, humanitarian, and economic channels and support traditionally afforded to nation-states

such as Frelimo's enemy and NATO member, Portugal. A major issue for Frelimo was purchasing weapons.[8] As historian Michael Panzer argues in a study of Frelimo's years of exile in Tanzania, Frelimo functioned much like a "proto-state."[9] Frelimo's ambitions to operate at the level of an independent nation-state conflicted with the geopolitical realities of its actual standing as a liberation movement hosted in exile by Tanzania, another socialist-leaning nation-state.[10]

Part of the perception of illegitimacy of Frelimo stemmed from the absence of images depicting a Mozambique independent of Portuguese control.[11] Even before 1969, when they produced small quantities of photographs, Frelimo political leaders faced the challenge of distinguishing its movement from those of other southern African liberation groups, and presenting the war in ways that international audiences could use to differentiate it from other wars in Asia and Latin America.[12] Ultimately, though, attempts by DIP and DRE to navigate the international media landscape and represent Frelimo's war against Portugal helped to expand the liberation front's access to supplies needed for using photography. Frelimo's use of photography stemmed from the fragile and fraught geopolitical alliances necessary to carry out such an expansive multifront nation-building exercise from exile.[13] Thus, I want to propose the concept of "paper diplomacy" as one filter through which to study how Frelimo expanded its use of photography to stage the war for liberation. One way the liberation front organized itself administratively and sought global recognition of its activities was through this filter of paper diplomacy.

To explain the context: Frelimo's war over Mozambique appealed to the geopolitical interests of socialist- and communist-leaning nations in Eastern Europe and Asia, most notably Russia and China, and Frelimo's leadership identified with Marxist principles, but they saw little diplomatic upside to being "totally dependent on those organizations" and "a puppet of the Cold War."[14] Furthermore, many Frelimo leaders and members found that Frelimo's complicated diplomatic relationships with China and Russia involved efforts to influence their political activities.[15] Thus, they had to seek aid from other sources. Janet Mondlane, the director of the Mozambique Institute and wife of Frelimo's first president, successfully negotiated financial and humanitarian aid from church organizations, solidarity groups, and private foundations based in the United States and Europe.[16] For purposes of communication and archiving, Frelimo's diplomatic and administrative representatives requested paper and folders from potential donors and Cold War allies.[17]

Aid groups supportive of Mozambique's independence often responded to requests from the Mozambican Institute and Frelimo's other administrative arms with paper, cameras, film, typewriters, manual printers, and watches.[18] Solidarity groups in the United States and across Europe recognized that they might be criticized for supporting political organizations like Frelimo, and therefore supplied such materials to avoid the potential backlash that would have resulted from more direct military or financial support. Foreign aid directed at Frelimo precipitated DIP, DRE, and the Mozambican Institute, to name a few Frelimo offices, to search for additional paper to make use of the goods received from abroad.[19] DIP's and DRE's ability to use photography depended on their expanded intake and need for paper, which conceivably would allow images to be printed from negatives and circulated through printed news bulletins.

Filtering for Portugal's authoritarian state and its colonial counterpart involved creating different hierarchies of credibility to address photography's perceived ambiguities. As discussed in chapter 1, from 1960 to 1974, Portuguese officials in Lisbon and Lourenço Marques used written correspondences for two main purposes, first to reproduce and respond to the illustrated images circulated by Frelimo's army, and second to articulate strategies for responding diplomatically and militarily to the anticolonial war that engulfed Mozambique. The leaders of Frelimo's DIP and DRE offices shared the concerns of its Portuguese enemy when it came to how its leaders' and members' images appeared in public. But unlike their Portuguese counterparts, DIP and DRE dispensed with using writing as a filter for their use of photography. For the various Frelimo offices involved with the movement's use of photography, filtering was about more than producing and amassing images. According to Margaret Dickinson, who made the 1971 film *Behind the Lines* about Mozambique's liberation war,

> All the aid from the West was humanitarian. And so, it was extremely important to prove that they [Frelimo and its donors] really were doing humanitarian work. Of course, the opposition would say, "Oh of course you are giving it for schools but they [Frelimo] don't have schools in liberated areas. [Instead, Frelimo] is recycling [the aid] into weapons."[20]

DIP's and DRE's use of paper and photography allowed Frelimo's photographers to show foreign visitors taking pictures, Frelimo leadership sorting through photographs, and military trainings. But DIP and DRE staff rec-

ognized the limited value of internally produced photographs to the war's advancement and ultimate success. In fact, through extensive diplomatic maneuvering, DIP and DRE had arranged to train Frelimo soldiers as photographers to accompany visits by foreign journalists and filmmakers to areas inside of Mozambique under Frelimo's control. After the 1969 training, Frelimo photographers were in a position to accompany outside visitors on their journeys to the liberated areas. The photographs collected by Frelimo photographers after 1969 were as much about documenting the war from the liberation front's perspective as they were about showing foreign visitors the liberated areas. Photographs produced internally by DIP served as another type of filter that influenced how the violence associated with the war appeared to the outside world and in the archive of images amassed by Frelimo photographers. After the war for liberation, photographs gathered as a result of DIP activities would offer the liberation movement options for how it represented its war effort in retrospect (the subject of chapter 3).

Histories of photographic production and the experiences of photographers are absent from the current historiography of the liberation struggle in Mozambique, and southern Africa more broadly.[21] Furthermore, historical studies and commentaries on photography too often marginalize the importance of photography for African liberation movements, electing instead to focus either on African states' postindependent use or the documentary traditions that developed in South Africa in response to apartheid.[22] Also, the literature on photography in Africa evaluates the use of the camera in war contexts through the interpretative frame of the gun.[23] Paper diplomacy and the use of photography by diplomatic and military actors representing Frelimo provide a template that defies notions of "global" photography that continue to characterize the current literature.[24] Photography and the reproductive capacities associated with paper allowed Frelimo to produce and respond to the politics it faced when fighting for Mozambique's independence from exile.

To address voids in the current literature on photography in Africa and lines of thinking about photography in a context of war and violence, this chapter looks at Frelimo's use of the photographs and written documents to orchestrate an image of a Mozambique freed from Portugal's control. Matters of identification were at the forefront of Frelimo's need for and use of photography. The first section of the chapter addresses how from 1962 to the early 1970s Frelimo consistently used images and language to establish the identity of the organization and its members. I situate DIP's expanded use of photog-

raphy, which includes training photographers, in relation to the acquisition and operation of a printing press in 1969. In the second section, I am particularly interested in the geopolitical and diplomatic conditions associated with the acquisition, use, and circulation of paper from 1962 to 1969. Also, I outline the material and technological challenges that DIP and DRE faced when producing images for external and internal use. The experiences of Frelimo photographers suggest an uneasy relationship between the cameras and guns that photographers and other Frelimo soldiers carried. The chapter's third part considers how photographers pictured the war and responded to the challenges presented in the second section from 1969 until early 1974, when the military coup in Portugal occurred. Finally, I address how Frelimo through DIP and DRE managed its access to the field of action it generated through paper diplomacy as it aimed to generate a specific historical narrative in the service of the liberation movement's diplomatic and political aims.[25]

IDENTIFYING AND ENTERING THE FRAME

The challenge of identifying members was especially acute for a liberation movement like Frelimo. Frelimo's administrative departments oversaw people's movements between Mozambique, where it established areas freed from Portuguese control, and its headquarters in Tanzania. DRE corresponded with Tanzania's Immigration Office and the African Liberation Committee to obtain identity certificates, visas, and reentry permits for its traveling membership and foreign visitors. Certain bureaucratic norms determined how Frelimo identified its members, and the circumstances in which people were permitted to appear before the camera. The documentation DRE issued to members over the course of its war with Portugal differed from how the organization's leaders presented themselves before populations living in the liberated zones.

At the outset, in 1962, Frelimo had trouble presenting a unified front. The liberation movement formed and initiated its political operation in 1962 against the backdrop of independence efforts across the Global South and Europe's post–World War II economic and political reorganization. In the early 1960s, throughout eastern and southern Africa, three exiled political groups existed, each with its own international partnerships, seeking Mozambique's independence. Frelimo resulted from the merging of the Mozambique National African Union (MANU), the National Democratic Union of Mozambique

(UDENAMO), and the National African Union of Independent Mozambique (UNAMI). Regardless of its ideological leanings and political agendas, Frelimo required diplomatic and humanitarian support.[26] Part of the strategy to address the challenge of merging the different groups involved continually alerting organizations, such as the Czechoslovak Co-op News and the Korea Committee for Afro-Asian Solidarity, that the groups MANU, UDENAMO, and UNAMI no longer existed after 1962, and that all future correspondence from different organizations should be addressed to "Frelimo."[27] DRE correspondence stated that after an analysis of "the grave condition confronting our Motherland 'Mozambique' [. . .] leaders of UDENAMO and MANU had voluntarily joined together in order to form Frelimo. . . . Frelimo is, at present, the only Mozambican Political Party. All correspondence that [was] formerly address[ed to these other parties] must be addressed to Frelimo."[28]

As a liberation front, Frelimo aspired to project an image of unity to potential allies. From 1963 to 1964, Frelimo's diplomatic office received outside counsel to insert itself into the regional politics of East Africa.[29] In 1964, a Kenyan political activist by the pen name R da Gama Pinto updated Marcelino dos Santos, Frelimo's secretary general, that in 1963 MANU had unsuccessfully sought the recognition of the British government and had reregistered as a political organization in Kenya despite pledging its support to Frelimo.[30] Pinto took it on himself to write directly to the Kenyan leader Tom Mboya, whom he believed was central to unifying the factions that constituted Frelimo and to establishing Frelimo's credibility in East Africa. In a letter to Mboya dated March 5, 1964, Pinto stated that MANU was "working in cross purpose with FRELIMO" and that "elements in the U.R.A. [the United Arab Republic]" were weakening Frelimo.[31] Pinto added in "that you [Mboya] will agree that it is not in the interest of Mozambique to have more than one party to achieve the initial goal of liberation, particularly as it gives opportunities for exploitation, receiving of aid, etc."[32] As part of his efforts to update DRE on his lobbying activities, Pinto provided dos Santos with a copy of UDENAMO's constitution and manifesto and encouraged the future Frelimo vice president to request the film *Goa—Yesterday and Today* to assist Pinto in "bringing this film out to show Goa [and] Portuguese colonialism so that . . . local friends can be sympathetic to [the] liberation cause."[33]

DIP and DRE faced bureaucratic hurdles when they addressed the task of staffing the liberation front and projecting a unified image. A large portion of Frelimo's leadership would come from outside of Mozambique and Tanzania. Long before Frelimo attempted to identify its membership base, Freli-

mo's first president, Eduardo Mondlane, had recalled Mozambican students such as Sérgio Vieira and Joaquim Chissano to return from their studies in Europe to assist Frelimo with liberation efforts.[34] In 1963, Vieira lived in Rabat (Morocco), and Chissano in Paris.[35] Their return to the emerging theater of war required more than purchasing a plane ticket. Ideologically and politically "Mozambican," many of the students that Frelimo recalled from abroad were Portuguese citizens, according to the passports they carried.[36]

There was no easy way for students and activists who lived abroad and were sympathetic to Frelimo to return to Tanzania. From the perspective of Valeriano Ferrão, who returned to Tanzania from his studies in Switzerland to assist with Frelimo's secondary schools in Bagamoyo (Tanzania), it was bad diplomacy to travel on a passport issued by Portugal.[37] Recounting his own journey to Tanzania via Algeria, he stated, "I couldn't go with a passport [from Portugal]. [It would have been] politically bad for Frelimo itself. Meaning that if I came there [on a passport issued by Portugal], [it would have represented that] finally Portuguese citizens [had joined Frelimo]."[38] In the case of Chissano, Mondlane advised traveling to Dar es Salaam and then on to Algeria, where he would open Frelimo's permanent delegation.[39] Other future leaders sometimes returned from Europe to Tanzania through Egypt, where DIP and DRE had a political office. To evade the limitations imposed by their Portuguese passports, those returning to Tanzania acquired Algerian passports under different aliases.[40] Travel documents issued by the Algerian government were not renewable and took substantial time to receive. Responses to delays by document holders suggest a certain desire by Frelimo diplomats for a passport issued by Algeria and other West African nations, but not by Frelimo's host nation of Tanzania.[41]

Thus, as a political organization and liberation front, Frelimo lacked the documentation that foreign governments recognized, and had to rely on the travel documentation of its allies. Over the entire duration of the liberation struggle and within the geopolitical sphere of exile, Frelimo's DIP and DRE offices grappled on multiple fronts with the fact that its leaders and members were not officially identifiable. During 1963 and 1964, to give a particular example, Frelimo officials managed to obtain headshots to identify and seek recognition for its members and leaders both externally and internally; the Tanzanian government required Mozambican refugees to have photo identification.[42] In addition, those selected by Frelimo's Comité Central to study abroad for military and educational training needed individual headshots.[43] Foreign governments required headshots to issue travel permits and

visas for international travel. Potential and then current Frelimo members as well as populations seeking Frelimo's assistance lacked their own cameras to photograph themselves and lacked photographs of use to Frelimo and the bureaucratic processes of obtaining photo documentation. Thus, on numerous occasions in the latter months of 1963 and in 1964, Chissano, in his capacity as secretary of education and assistant to then-president Eduardo Mondlane, wrote on behalf of "refugees and Frelimo members" to the Studio Hiro in Dar es Salaam and requested the photography studio take "snaps" of the listed persons.[44] As he requested photographs, he also responded to individual's inquiries about joining Frelimo. Chissano discussed the goals of Frelimo and noted that entry did not ensure a scholarship to study abroad, as was the common belief.[45] DRE's attempt to establish norms for membership and international recognition through travel documents unfolded alongside institutional efforts to provide members and leaders with their own individual headshots. The process of retrieving and using headshots on behalf of those photographed forced Frelimo's DIP and DRE offices to confront the liberation movement's own ability to produce printed photographs for internal and external consumption. There were also implications for Frelimo's various administrative arms not having information about its members that foreign governments required to issue travel visas. Many Frelimo members who needed to travel lacked birth certificates and other documentation required for passports issued by Tanzania and other governments allied with Frelimo.[46]

Inside bases in southern Tanzania and northern Mozambique and in the absence of actual photographic headshots, Frelimo's military instituted its own strategies for identification and documentation from 1963 until the war's end. The forms of recognition they adopted were not dependent on actual photographic prints or documents with photographs and functioned like the visas and travel documents issued by foreign governments to Frelimo's diplomats and students. Often, Frelimo headquarters failed to fulfill requests from military camps for membership cards, travel passes, and cameras.[47] In 1964, Frelimo's Zambia representative was notified by DRE that security concerns prevented the distribution of party membership cards.[48] In addition to party membership cards, *guias-de-marchas* were widely used to facilitate and track the movement of Frelimo soldiers, but not civilians. They did not require headshots. Military officials typed the *guias-de-marcha*; the text verified the document holders as party members and requested that people provide hospitality or forgive the taxes associated with border crossing. Party membership cards and *guias-de-marchas* were inconsistently issued and served as

substitutes for the widespread lack of photo identification. Despite the irregular use of documentation, an official in 1964 remarked that people "crowd[ed] around Frelimo's unity" and there were "classes," including "supporters (non-militants), militants, and [those] responsible."[49]

Frelimo's leadership identified themselves by other means than using the identification that DIP and DRE issued sparingly to Frelimo members, traveling delegations, and civilian populations. In November 1963, department heads received a memorandum ordering them to craft an autobiography and to submit a photograph. Forms such as the *guias-de-marcha* specified the document holder's name, party membership number, the duration of the intended journey, and financial situation. In contrast, the memorandum on autobiographies requested the authors' birthplaces, the locations of their academic studies, and the activities they had performed on Frelimo's behalf. In actuality, collected autobiographies included the names of the authors' parents, military experiences, ages and professions of siblings, and the locations of a person's studies. Unlike the *guias-de-marcha*, the autobiographies included a *meio-corpo* (i.e., half body) photograph of the authors, which required officials to visit photography studios.

At an unspecified time, as evidenced by the existence and availability of two photographs, Frelimo developed the capacity to photograph its leaders and members together (figures 16 and 17). For Frelimo's leadership and members, the taking and viewing of photographs went hand in hand. Frelimo's leaders and its membership could familiarize themselves with each other through photographs. In figure 16, spread across the pictured table were documents and photographs. Seated at the table were three men. Two of them looked at the photographs they held. The third man, closest to the camera and photographer, looked at the other men. Figure 17 showed the same men pictured in figure 16, based on their dress and appearance. The only difference was that two of the three men in figure 17 were seated before an unidentified group of individuals who had their backs to the camera and photographer. Behind the seated figures facing the camera and photographer hung Frelimo's flag adorned with photographs. One photograph on the flag showed one of the seated figures who faced the camera in figures 16 and 17. The display of photographs, as shown in figure 17, made it possible for members (many of whom had their backs to the camera) to identify the pictured individuals in figures 16 and 17, from left to right, as Alberto Chipande, the head of defense, Samora Machel, the president of Frelimo, and Joaquim Chissano, another high-ranking Frelimo leader. The picturing of Machel as depicted in figure 17

Figure 16. Frente da Libertação de Moçambique, undated, untitled. Caixa: Luta Armada, Centro de Documentação e Formação Fotográfica, Maputo, Mozambique.

dates the photograph to after the 1969 killing of Eduardo Mondlane, Frelimo's first president.

Frelimo expanded its use of photography from 1962 to 1969, but the organization did not photograph every one of its members and ensure they had proper photo identification. Instead, Frelimo's DIP had identified value in using the available photographic materials to depict its own capacity to look at images—in effect, to identify its members, to present its leaders to members in person through images, and to show its members looking at their leaders in person and through photographs. According to DIP's head, Jorge Rebelo, Frelimo distributed photographs so that people living in Mozambique "recognized the leader" in times of struggle and connected Frelimo's message with a leader.[50] There were bureaucratic and logistical challenges, however, regarding when, where, and how Frelimo leadership and its members appeared together in the photographic frame and in the documents often required for travel. At certain times, DIP needed to represent Frelimo's

Figure 17. Frente da Libertação de Moçambique, undated, untitled. Caixa: Luta Armada, Centro de Documentação e Formação Fotográfica, Maputo, Mozambique.

military capabilities and Frelimo members no longer as refugees, but as military soldiers, inhabitants of Mozambique, or both. The liberation movement's ability to identify itself as an organization with a membership developed by addressing bureaucratic formalities, which required photos and attempts by different organizational offices to access materials that facilitated photography. Donated watches, typewriters, radios, and manual printers expanded DIP's internal ability to produce photographs, books, and pamphlets, and they changed photography's reproducibility and circulation.

PHOTOGRAPHY'S PRINTING (IR-)REPRODUCIBILITY

During its fight for Mozambique's independence, DIP head Jorge Rebelo claimed that the liberation movement never prioritized its internal practice

and use of photography.[51] The training of photographers was not part of the educational opportunities presented to Frelimo by international solidarity groups such as the Solidarity Committee for Democratic Germany and the Free German Trade Union. According to Rebelo, Frelimo's priorities were "food, medicines, books for schools in the liberated zones, cameras were not [a priority]."[52] When Frelimo tried to procure weapons from its allies, it instead acquired cameras and film because of international donors' fears of facing criticism and igniting Cold War rivalries. Rebelo himself noted, "From time to time, we would get support in the form of cameras and films. Although very little."[53] He then added, "We [were] aware of the importance of photography because we did not manage to produce as many [photographs] as we wanted."[54] Rebelo framed Frelimo's desire for and use of photography as ambiguously defined. In so doing he highlighted a particular tension between the realities of war versus the importance of picturing a narrative of liberation. Frelimo's various administrative departments learned to address certain political objectives and material needs by asking donors for cameras, chemical paper, and copying machines and by internally questioning the organization's ability to use the photographic medium.[55]

DIP's expanded use of photography in 1969 corresponded to the acquisition of printers and the development of an internal printing press (figure 18). Donated printers were the subject of photographs (figure 18). A man dressed in civilian clothing stood in the photograph's mid-ground. Instead of looking at the camera, he looked down at the printer. The gun across the man's chest was a reminder of how printing intersected with the realities of war. Another version of figure 18 appeared five months after independence as a halftone published in the weekly magazine *Tempo*.[56] The following caption accompanied the photograph's republication:

> Information and propaganda had a fundamental role during "Gordian Knot."
> It was through *Heroics* and *25 de Setembro*, two information bulletins that circulated in the liberated zones, that all populations learned of the advance of the enemy and of the success of the armed struggle. In the photo, the [printing] of *Heroics* in the liberated zone.[57]

Figure 18 printed as a halftone, along with the paired caption, established the view, albeit in retrospect, that the printing and circulation of images characterized Frelimo's use of photography, which showed that photographs were taken and information bulletins printed. Printers were objects

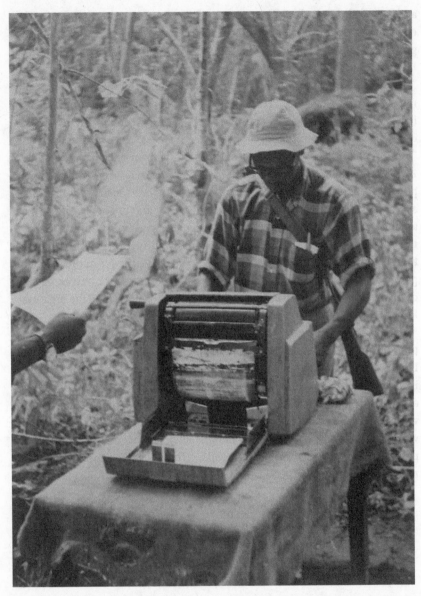

Figure 18. Frente da Libertação de Moçambique, undated, untitled. Caixa: Luta Armada Centro de Documentação e Formação Fotográfica, Maputo, Mozambique.

worth photographing. The printer pictured in figure 18 could not reproduce photographs, however.

International support presented its own predicaments, sometimes requiring DIP and DRE offices to explain internal organizational conflicts to its allies before it received aid such as printers.[58] The Mozambique Institute's focus was issues of education, and it facilitated the acquisition of printers. Nine months after a mail bomb killed Frelimo's first president, Eduardo Mondlane, Frelimo received a letter from Finnish high school students who had raised funds dedicated to the purchase of an offset printer.[59] The letter noted how reporting in Finland on the fund-raising efforts, along with coverage in *Le Monde*, *East African Standard*, and *Agence France-Presse*, raised questions over Mondlane's death and how it would affect the Mozambique Institute's activities.[60] The student group advised Frelimo's Comité Central to halt its acquisition of printers until it could answer the group's queries.[61] Only after receiving a response would the Finnish student group release the collected funds. Paul Silveira was one of the people Frelimo's DIP charged with operating the printing press. In an interview, Silveira alluded to DIP efforts to resolve the situation.[62] After donating the money, according to Silveira, the Finnish group stipulated that DIP use the press to produce schoolbooks and "maybe a part for the health services, [but] no propaganda."[63]

Before they had a fully operational printing press in the early 1970s, DIP officials used an assortment of typed text and illustrative drawings in the absence of photographs. DIP lacked the laboratories necessary to develop photographic and cinematic films.[64] As a result, many images previously collected by DIP remained undeveloped.[65] Until then, DRE, and not DIP, had used the limited photographs available for bureaucratic purposes of identification. The opening of the printing press brought dispersed forms of visual and textual representation into new relationships with each other, and made it possible for DIP to produce its own propaganda to dispute Portugal's accusations of abuse and characterization of Frelimo as a terrorist organization.[66] Silveira noted that Frelimo did use the press to print propaganda. When printing press staff was informed that a visitor wanted to see the machines, they would hide the propaganda.[67] Frelimo printed schoolbooks "all over again,"[68] not because Frelimo's history was always changing, but in the words of Silveira, because "the Portuguese politicized even mathematics."[69] For example, Silveira recalled a mathematics book for first graders having "a nice beautiful cover with Portugal, Angola, Mozambique and all of the colonies," and a first page that showed "Portugal [as] the biggest country in Europe"—images

(see figure 14 in chapter 1) that promoted Mozambique as an extension of Portugal and part of Portugal's attempt to resist the pressures of decolonization. Silveira's recollection of the mathematics text illustrated his familiarity with such imagery.[70] However, he neglected to say what image Frelimo used to replace it; instead, he said, "So we had to basically change everything."[71] "Changing everything" referred to the type of revision and mass reproduction that donated printers allowed. Photographs were "indispensable" to "the illustration of lessons."[72] For example, during the editing process, Frelimo officials such as Fernando Ganhão commented on photographs corresponding to "reality," on the irrelevance of certain images, on photographs replacing other photographs, and on better captioning.[73] Then there was the example of the illustrated Frelimo letterhead. From Silveira's perspective, Portugal's soldiers "were almost illiterate" and "Frelimo had a lot of intellectuals at the time."[74] Circulating a communiqué on Frelimo letterhead, according to Silveira, served to question the assertions of Portugal's military that Frelimo was composed of terrorist bush fighters and that "most of the Mozambican people [were] with the Portuguese government."[75]

There was the actual printer, and then there was the photograph of the printer (figure 18). The printer and the photograph of the printer have their own respective reproduction capabilities and values. Figure 18 juxtaposes the printer with other donations, such as watches, that Frelimo received. Watches and radios accompanied the delivery of cameras, films, and printers. Frelimo's defense official received requests for radios.[76] One correspondent explained how the camp felt "outside of the current of information," and "needed to be informed of our situation, of the enemy, and of the current international situation in order to keep up with the actual phases."[77] Silveira and other persons who participated in Frelimo's independence efforts recognized attempts by the Portuguese military to control the airwaves in response to the authoritarian and colonial state's own difficulties with photography. Furthermore, Silveira commented that he and other Frelimo members were "dumbfounded" when they saw Portuguese propaganda, which included sketches of soldiers beating other soldiers, a soldier running away, and proclamations that Frelimo killed disobedient soldiers (figure 19).[78] When it came to the watches, there was no explanation for either why they were received or photographed. But requests identified their recipients as the drivers of Frelimo's defense representatives, the camp's secretary, and "those responsible for guiding the working hours of people."[79] Silveira framed the reproducibility of text and image within the space of other auditory and visual technologies in the following terms: "You couldn't

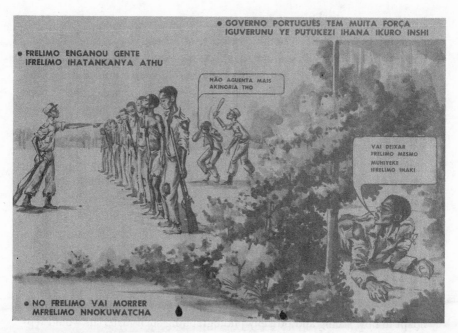

Figure 19. Gabinete de Informação e da Opinião Pública, untitled, Colecção de Panfletos. SR:029/Moçambique/Z.43, Moçambique (GIFOP), Arquivo Histórico Diplomático, Lisbon, Portugal.

say, well I heard it [on the radio or through megaphones]. You couldn't exaggerate [when the Portuguese killed soldiers] and say 100. You couldn't because the Portuguese, they tried to control the radio. The printed word [and image] was stronger."[80] The printer and photograph of the printer afforded Frelimo opportunities to counteract Portuguese propaganda directed at the broader public. Frelimo soldiers and emissaries could carry "visual images and text" when they met with fighters and peasants, and this activity allowed them "to explain" and "to show" the war at hand.[81]

Another history of Frelimo's use of photography concerns the development of the printing press and its ability to print photographs. The soldier-turned-photographer Daniel Maquinasse dated the development of Frelimo's photography laboratory to the same year as the opening of the printing press, 1969.[82] He credited an unnamed Swedish man with training preselected soldiers in "practical classes," which consisted of taking pictures during the day and working in the laboratory at night.[83] The photographs Frelimo generated alongside and in relation to the use of the printing press (figures 16–18)

countered the illustrations that Portugal circulated (figure 19). Photographs depicted Frelimo leaders standing before soldiers and interacting with populations from whom they sought support. Instead of beating them, as Portugal's pamphlet showed (figure 19), Frelimo soldiers lectured and received food from local populations (figures 20 and 21). Frelimo photographers were responsible for developing their own and their peers' film.[84] Reproduction of photographs was not restricted to one photographer. In fact, the film laboratory allowed DIP and other Frelimo departments to develop and print not only newly gathered films but also undeveloped films from before 1969. The increased capacity of Frelimo's DIP came at the cost of having to carefully manage received materials, sometimes at the request of donors. The liberation movement's efforts to obtain printers, guns, and materials necessary for the use of printers and guns influenced the degree to which DIP was able to practice photography and reproduce photographs.

Frelimo's Comité Central stood to gain militarily, politically, and diplomatically from the day-to-day business of liberation. However, Frelimo's members had to recognize the restrictions imposed on donated materials and adapt to how seeing and possibly photographing such materials would represent its power. For example, in an internal memorandum from the Departamento do Defesa to the military camp in Bagamoyo, Tanzania, an official announced the visit of President Mondlane "accompanied by an individual not of Frelimo."[85] The request asked for the cleanup of the camp and that military activities not be displayed, since "the person accompanying [Mondlane did not] know that this [was] a military camp" but instead had an interest in refugees. Any notion of an aesthetic of liberation functioned more like what theorist Susan Buck-Morss called an "anaesthetic," "whereby [the] aesthetic changes from a cognitive mode of being 'in touch' with reality to a way of blocking out reality, destroy[ing] the human organism's power to respond politically even when self-preservation is at stake."[86] Photographs of armed populations had to be staged because certain conditions of documentation and reproducibility could never be guaranteed, and they were not always to Frelimo's benefit. For example, there were real dangers to people transporting war materials during daytime, and so they often traveled at night, carrying materials on their heads out of the view of the photographer and Portugal's army.[87] Then, in daylight, they used canoes to retrieve materials and to blend the arming of populations into the fabric of daily life, all movements Portugal viewed as normal.[88] Thus, although photographing the arming of local populations may have won Frelimo popular support in the liberated zones,

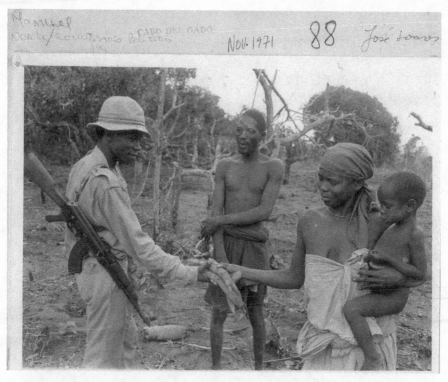

Figure 20. Frente da Libertação de Moçambique (José Soares), Novembro 1971, untitled. Cabo Delgado, Coleção: Luta Armada, Arquivo Histórico de Moçambique, Maputo, Mozambique.

it risked jeopardizing its relationship with allies who differed on Frelimo's military strategy.[89] On the one hand, photographing watches on wrists and guns on chests disrupted notions of the expediency and hierarchy associated with the photographic apparatus. By blurring the personal and the everyday with the political war at hand, such photographic strategies provided Frelimo with images that it hid certain internal divisions and displayed a unified war effort. On the other hand, in the context of the liberation war, photography and its reproducibility were not concerned with labeling and classification; recognition of the liberated zones, and not who made a particular photograph, was more important, so that the public would see that the struggle had local relevance.[90] Rebelo regarded authorship as of no significance to populations living in the liberated zones, stating, "Most of the people could hardly read. When there were photos, they recognized this is my school, this is my military base."[91] For photographers like Carlos Djambo, the laboratory and

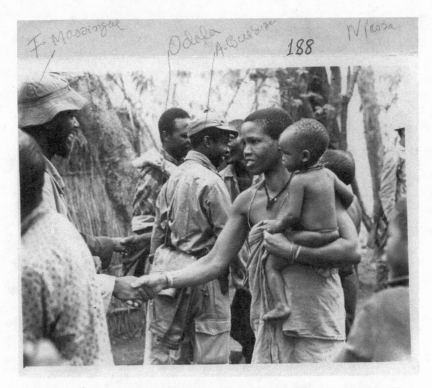

Figure 21. Frente da Libertação de Moçambique, undated, untitled. Niassa, Coleção: Luta Armada, Arquivo Histórico de Moçambique, Maputo, Mozambique.

the work associated with developing and printing reaffirmed his commitment to the liberation movement.[92] On the importance of the laboratory, Djambo noted, "What is important? We want[ed] to do this work. The importance appears in the work [not the photographer doing the work]. The work does not give importance to the person who makes it."[93]

THE CAMERA, GUN, AND TECHNOLOGICAL LIMITATIONS

Initially, Frelimo's Comité Central prioritized fighting over photography. Soldiers left their cameras behind and learned to fire guns.[94] The acquisition of guns through diplomatic back channels paved the way for soldiers to have photographic materials and train as photographers. Sometime in 1969, Rebelo, in his role as head of DIP, selected a group of soldiers, including

Daniel Maquinasse, Simão Matias, José Soares, and Artur Torohate, to train as full-time photographers. Afterward, in the early 1970s, DIP trained other photographers, two of whom were Carlos Djambo and Camilo de Sousa; the others remain unnamed. After the first formal training, and once inside of Mozambique, photographers confronted photography's other war: photographing in the presence of the gun. Photographers struggled to reconcile their compulsions to photograph with the need to fight the enemy, Portugal. Frelimo's war waged via photography generated its own photographic filters, which affected how DIP was able to represent its war internally and externally.

Many of the soldiers selected to train as photographers had prior experiences with photography, which in some cases had compelled them to join Frelimo's fight. Both Maquinasse and Matias owned small automatic cameras and used them to photograph their friends and families.[95] In the case of Maquinasse, after joining the Portuguese military to do compulsory service, he discarded his Kodak Instamatic for a "better camera," a Halina.[96] Torohate's experience with photography was somewhat different. After Torohate registered for a driver's license, the Portuguese military sent him deployment orders.[97] Collectively, through these photographic experiences and encounters with photographs, Frelimo soldiers-turned-photographers developed what Torohate characterized as "a consciousness of independence [as] possible for us," which led all of them either to flee Portugal's military or to leave their homes to join Frelimo.[98]

Frelimo military officers were both suspicious and curious about the cameras, images, and experiences with photography that Frelimo recruits brought to the struggle. Pedro Odallah, a military officer in Frelimo during the war, was on hand when Maquinasse deserted the Portuguese army with his camera.[99] According to Odallah, the Departamento do Defesa guarded Maquinasse's camera and photographs out of security concerns.[100] Even so, there were officials working across the organization who accepted and valued photography. Years after the end of the war, Matias recalled purchasing a camera when he began his studies at the Mozambique Institute.[101] There, in his words, he had "unquestionable authority" to photograph classes and visiting delegations.[102]

On the war front, guns and cameras functioned in opposition to one another. The tension between the camera and the gun would determine what scenes Frelimo photographers selected to picture or left undocumented. One of the first Frelimo soldiers to photograph, José Soares, equated the power

and function of the camera to that of the gun.[103] When I asked what he could do with the camera that was impossible with a gun, Soares responded,

> I, with a camera, am able to do the same thing as with a gun. Thus, the camera has the objective of destroying the enemy. This is not true? We took images of soldiers, fugitives, captured soldiers. We had to do [this] with the camera. We destroyed the plan of the enemy. . . . For these reasons, I tried a lot to go to the line of the enemy, the line of combat.[104]

However, the experiences of Soares's peers suggest that guns in the presence of cameras presented Frelimo photographers with a choice: whether to continue photographing or to drop the camera for the gun. In one instance, Matias accompanied an American film crew that came under attack by a Portuguese-launched air raid.[105] Matias continued to photograph instead of picking up his gun.[106] From the perspective of independence, Matias recounted the moment with great pride, explaining how he felt empowered, or in his words, "on equal footing with my comrades," as his camera fired alongside the guns. In that instance, "the profession [of the photographer] imposed on them [was] superior to the fear."[107] The decision of Matias and the film crew to continue photographing generated the first images of Portugal attacking Frelimo and of an air raid—subject matter that traditionally had eluded Frelimo photographers. There were also instances of war left undocumented. Maquinasse damaged his camera and lost his films when trying to help a soldier who could not swim. Besides the difficulties associated with filming at night or in the dry season, photographers, although they may have been armed with battle plans and weapons, often had neither a battle nor a victory to take pictures of.[108]

The gun surfaced in Frelimo photographs partially because the military base Nachingwea was the site where Frelimo photographers processed and printed their films. Frelimo photographers were treated as soldiers—their being photographers was considered incidental. Training as a photographer occurred within the context of military combat exercises. Also, DIP's own expanded photographic capabilities, which included "the first beautiful machines [i.e., cameras]" and "the development of [a] laboratory," occurred alongside a military buildup.[109] Maquinasse and his peers observed women transporting weapons on their heads with their children on their backs.[110]

Soares deemed the rhetoric of the gun suitable for defining the camera's function, but his understudy, Djambo, understood the technique for using the camera as differing from that of the gun.[111] Djambo learned under Soares's

direction to take photographs of what he called "a practical war," by which he meant the arming, feeding, and defending of local populations and establishing areas free of colonial rule. Djambo would later travel to Dar es Salaam, where he studied film processing under Maquinasse.[112] I asked Djambo whether he thought his technique for taking pictures differed in the heavily policed military training camp of Nachingwea and in the liberated zones inside of Mozambique, which the Portuguese military frequently attacked. Djambo responded by asking, "Do you know what technique is?" He continued, "[Technique] is what you encounter. It [technique] depends on what you encounter. You can't say that you took the same pictures in Tete that you took in Cabo Delgado."[113] At one level, the reproducibility of an image denoted the ability to produce many copies of a photograph presumably with the aim of increasing the visibility of a particular historical occurrence. At another level, through the repeated picturing of the gun and the increased number of images that could be circulated, Djambo and other Frelimo photographers generated new filters through which DIP could designate photographs produced internally from those by visiting delegations—another dimension to the reproducibility of photography.

Photography orchestrated the arming of local populations, adding to its political and diplomatic value, in contrast to the effects of Portuguese military propaganda and counterinsurgency tactics (documented in chapter 1), which urged people to disarm. Because of the obstacles that combat presented to taking photographs, soldiers frequently displayed their guns in front of cameras during military trainings and drills. In conjunction with such staging, photographers like Djambo discovered that wide-angle lenses were of particular use when photographing meetings and military parades in different provinces, because they allowed him to pack more people and weapons into the frame and to show them as groups rather than individuals (figures 21 and 22).[114]

Including guns in photos imposed certain limitations on photographer's lines of sight (figures 22 and 23), and ultimately determined what aspects of the war appeared in the picture frame. Like photographers, soldiers used binoculars and built-in viewfinders on guns to identify their targets on the ground and in the air (figures 22 and 23). In addition to surface-to-air weapons, they carried smaller, hand-held AK-47s, which were generally used for ground combat (figures 18 and 22). Camouflage hid soldiers and their weapons from the view of Portuguese planes and helicopters (figure 22). One issue with photographing alongside the gun was that the cameras used by Frelimo

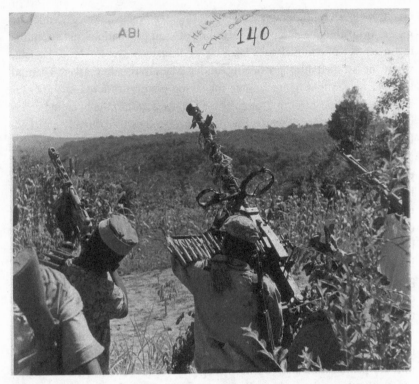

Figure 22. Frente da Liberatação de Moçambique, undated, "Metalhadora anti-aérea" ("Anti-air machine gun"). Coleção: Luta Armada, Arquivo Histórico de Moçambique, Maputo, Mozambique.

soldiers had only one lens; they couldn't zoom, which is an essential technique used to document military combat.

Looking through the camera lens, which resembled the viewfinder attached to a gun, photographers saw various terrains.[115] Trees and other vegetation introduced shadows into the frame.[116] The inability to zoom offered no room for operational error. Photographers only took multiple shots if they suspected they had made an error when photographing.[117] Even if they succeeded in picturing military operations, there was no way to ensure the film would be processed. Photographers' hands were the last safeguard to ensure the successful printing of recorded images, and they were often unreliable.[118] As Djambo explained, there was "no darkroom for tactic[al] purposes," only a laboratory for printing photographs without adjusting or manipulating them.[119] He acknowledged the lack of technical and compositional choice. He personally preferred Kodak films,[120] but choice "depended on the mate-

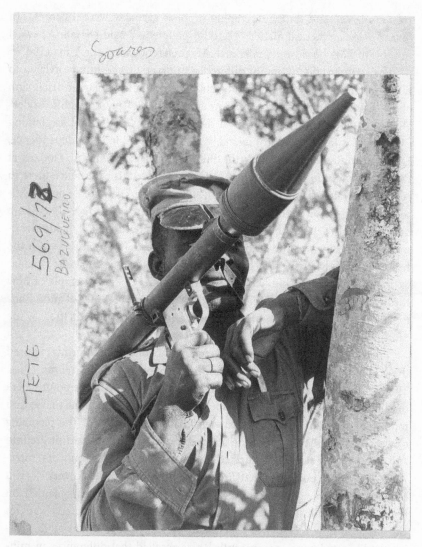

Figure 23. Frente da Libertação de Moçambique (José Soares), undated, "Bazuqueiro" ("Bazooka"). Tete, Coleção: Luta Armada, Arquivo Histórico de Moçambique, Maputo, Mozambique.

rials available," and the photographic supplies available were different, not "exact."[121] As a practical matter, "I had no preference," said Djambo. "I [was] not able to work because of preference. My preference was to have material."[122]

For Djambo, the notion of difference in practicing technique related to taking photographs of military subjects closed off a much larger discussion about his aesthetic practice. In contrast, the idea of photographic "styles" elicited laughter from Djambo.[123] "I did various styles," he said, explaining photography in relation to cinema.[124] After Mozambique's independence, Djambo studied cinema under the French filmmaker Jean-Luc Godard at the Instituto Nacional de Cinema (INC).[125] He used his experience there to reflect on photographing the liberation struggle. For Djambo, he never photographed "general panorama."[126] Instead, close-ups of the face (like figure 23) presented "details" that "spoke more."[127] He continued, "I made documentaries in cinema. The body was not of interest. The interest was in the head, the eyes, the view."[128] To bring the facial countenance into view, Djambo exchanged his wide-angle lens for a normal one—another example of how the line of sight changed around photographing in the presence of guns. Photographs of guns, such as figures 18, 20, 22, and 23, acted as filters to show the more stylized aspects of the war.

Frelimo-trained photographers were unaware of how their prints exposed the conflicting military and political strategies proposed by Frelimo allies. The camera's lens extended the photographers' view only to the point where they showed the guns and not the specific targets (figure 22). The makes and models of the guns photographed were easily identifiable.[129] The picturing of weapons and their positioning alluded to the Soviet's support of Frelimo and the proposed strategy of surface-to-air warfare. There are only oral interviews, no visual evidence, that Frelimo's military used helicopters.[130] And based on available photographs, the camera remained firmly planted on the ground, an allusion to the ground war that China advocated.[131] Soares was privy to how ideological differences prevented delegations from visiting the liberated zones concurrently.[132] He recalled that differences in military and political strategy, along with their competing interests in the Cold War, prevented Frelimo from hosting the Chinese and Soviets at the same time. Such details eluded Djambo, who saw it as his responsibility to take and print photographs, leaving the job of how to use the photographs to his "chief," Rebelo.[133] Rebelo's task, in the words of Djambo, was to "make a strategy in order to make news and [get photographs into the press], to circulate images."[134] So even among photographers, the task of taking pictures amid war generated different views.

SURFACE DIPLOMACY

The Vietnam War coincided with Portugal and Frelimo's war over Mozambique. The conflict in Vietnam presented nations such as Portugal and anticolonial movements like Frelimo with new freedom to represent their respective war efforts.[135] According to photo theorist Susan Sontag, photographers working during World War II and the Vietnam War traveled relatively freely, often to the war's front lines, unbound by the restrictions of nationality.[136] Changes in the public's tolerance for violence and states' abilities to manipulate news coverage increased the picturing and publishing of photographs of dead and injured bodies, regardless of the photographed sitter's consent.[137] For example, to shift attention away from its ongoing wars in Africa, the Portuguese authoritarian state permitted newspapers in Portugal to publish photographs of the US war in Vietnam. The media policy enforced in Portugal regarding the display of war did not prevent Portuguese soldiers stationed in Mozambique from using their personal cameras to photograph combat and scenes of daily life.

Frelimo photographers did not travel between Tanzania and Mozambique "unbounded by the restrictions of nationality" like the photographers Sontag referred to. Furthermore, Frelimo found little use in replicating how the Portuguese government presented the Vietnam War to audiences in Portugal. From Frelimo's perspective, television was central to the real-time diffusion of images of the Vietnam war.[138] But the way that images on television looped and flickered across screens, or "just stay[ed] with you," was of little benefit to Frelimo.[139] When speaking about photography's function in relation to text and television, José Oscar Monteiro, Frelimo's diplomatic representative in Algeria and Italy, stated, "There [was] a major change [with] the invention of television. But there is always and was always a lot of space where television did not reach. [Photographs] allowed for a more reflexive approach on events."[140] There were no television sets in Frelimo's liberated areas. Frelimo used the war in Vietnam to rhetorically align itself with global resistance efforts in opposition to Western imperialism, part of which involved celebrating the founding and independence of its allies China, USSR, Cuba, Vietnam, and North Korea by posting photographs of each nation's "leaders and heroes" along with "flags and other symbols" obtained from diplomatic representatives in Tanzania.[141] To understand Monteiro's notion of reflexivity when it came to photography is to understand how Frelimo administratively addressed the limitations of circulating its image of war within the broader global context of the Vietnam War and other anticolonial struggles. Diplo-

macy occurred at the level of the photographic surface, especially in terms of labeling image content and controlling audience reception.

Frelimo's DIP received endless requests for photographs from solidarity activists, scholars, and international donors, along with appeals from photographers, filmmakers, and journalists to visit the liberated areas.[142] DIP and DRE officials understood the need "to take as many pictures as possible of every situation possible and not to forget where [the picture] was taken."[143] There was a point in time, toward the start of the war and despite lingering suspicions about photography, when Frelimo prioritized seeing photographs as more important than identifying and labeling them. The idea of labeling location came into play "at a certain moment" when Frelimo realized that "too broad information was not good."[144] Efforts to meet requests alerted Frelimo to the "public's" desire for specificity. There was a gap between the public's way of seeing and Frelimo's own vision as depicted by photographs internally produced. As a result, according to Monteiro, "the only places where [Frelimo] really showed [its] pictures were in [its] own publications."[145] There was the need "to document" what Frelimo was doing and building, what Monteiro described as using "photography as a motivation element."[146]

The notion of "specificity" and "motivation" came in the form of another type of filter, photographs by foreign visitors produced alongside those of Frelimo's photographers. Visits to the liberated areas inside Mozambique presented diplomatic hurdles, political liabilities, and security risks. On May 20, 1970, the Japanese photographer and member of Japan's Anti-Apartheid Committee, Tadahiro Ogawa, wrote to Frelimo's Executive Committee asking permission to visit.[147] In a correspondence dated a year earlier, a representative from the DRE had notified Ogawa that Tanzania, not Frelimo, authorized visits to the liberated zones.[148] Even after he had met high-ranking Frelimo officials in 1967 and 1968 and donated radios, used clothing, and photographs to Frelimo, Tanzania denied him the entry visa needed to visit the liberated zones. While DRE made recommendations to Tanzanian authorities, officials publicly noted Frelimo's resistance to intervening in such processes based on matters of bureaucratic procedures and not wanting to lose favor with the host nation.[149] Behind closed doors, though, DRE expressed dismay over such regulations. For example, in a letter, then–Frelimo vice president Uria Simango wrote about "how there were no shortage of companies that wanted to make films for Frelimo" but that the Tanzanian government reserved its judgment for "reasons of security and others that [Frelimo] didn't know."[150] Tanzania's monitoring of liberated-zone visits coincided with unrest inside

the liberation front. Possibly in response to the Tanzanian government's denial of entry visas, Mondlane considered "de-emphasiz[ing]" Frelimo's international operations and transferring its headquarters to Mozambique.[151] Mondlane offered the following rationale: "This [transfer to Mozambique] will help to eliminate the kind of contradictions which we often get involved in with those countries which support us but which often do not understand sufficiently our internal problems."[152] Mondlane's plans never materialized. Nonetheless, DRE did manage to secure entry into Mozambique via Tanzania for guests from Russia, Bulgaria, the German Democratic Republic, Algeria, and Somalia.

Monteiro explained Frelimo's willingness to invite foreign visitors to the war front:

> To be there and take a picture, we much preferred that because it was very good for them [visitors] to see. And we always, had very good reports because people could see for themselves. So, that's why when we used to interview them to have their positions. Because, this would motivate.[153]

Ogawa finally visited Mozambique and the liberated area of Cabo Delgado in 1973 for a week. Frelimo's news bulletin *Mozambique Revolution* featured an article by Ogawa penned after he returned to Dar es Salaam (figure 24).[154] Noting similarities between Frelimo and its "comrades," the PAIGC in Guinea-Bissau, Ogawa described what he photographed. "Inside your country," he wrote, "I saw many fighting, working, and studying people on many [farms] or in bases, schools, and in hospitals."[155] Frelimo photographers pictured Ogawa and other visitors resting, walking, and using their cameras.

There was a reflexive quality to the photographs that Frelimo photographers gathered when accompanying foreign visitors to the liberated zones. Frelimo faced the need to "convey [its] message to the outside world about the struggle, about the existence of Mozambique, about the existence of colonialism, and then about how we were moving [forward] in the struggle."[156] A photograph (figure 25) possibly produced by Frelimo depicted Rebelo as seated at a table with members of local populations, some seated and many standing. Seated across from Rebelo were the Chinese visitors who Frelimo hosted. One of the visitors focused his camera on Rebelo and the people surrounding him. The photograph reflects the multiple cameras present during visits to the liberated zones and the simultaneous taking of pictures from different angles. Within the frame of having his photographed taken by the

We must learn from the spirit of your struggle

First of all I must thank FRELIMO people to have permitted, made arrangements and thus helped my travelling in your country of Mozambique, as a photographer and as a member of the Japan Anti-Apartheid Committee. Inside your country, I saw many fighting, working, and studying people in many shambas or in bases, schools and in hospitals. Your activities are almost the same as those in your comrades' country, Guiné Bissau, where I similarly visited in 1971.

I must say I am deeply impressed with the progress of your struggle, and I did see with my own eyes how Portuguese have been exploiting your villages. And the cruel forced labour, which resemble gum-juice squeezed out from cuts of gum trees, makes us realize the figure of imperialism and colonialism.

In Japan, we have a proverb, «One made a Buddhist image, but he forgot the spirit of Buddha». This means that a finely carved sculpture of Buddha can hardly appeal to the people if the carver himself has forgotten the most important

Tadahiro Ogawa, a Japanese photographer and anti-apartheid activist, visited liberated areas of Cabo Delgado Province from April 22 to May 5. He wrote for "Mozambique Revolution":

thing, in this case the spirit of Buddha, which is the very motive and element of the whole work.

Here in Mozambique, the «Buddhist image» is seemingly rather small. But great and strong is your spirit. Your schools are built under the trees and have hardly any big classrooms. Desks and chairs are made by the branches of trees. But your schools have much greater spirit and more essential spirit than ours. Your hospitals also teach us the way hospitals should be based on humanism.

It is easy for you to understand this, if you have a look at the problems of pollution in the so-called advanced countries. For instance, we

Japanese established big industries and our economy seems to be considerably powerful, but we have lost some very important things such as clean air, healthy environment to live in, and so forth. So I think there are many things which careful observers must learn from the «spirit» of your nation-building. (And, if I may add, socialists in this regard make no exception; they will also learn a lot). We must study the great spirit of your struggle which shows us the essence of matters.

Lastly may I again extend my thanks to the Party and all the people of Mozambique. I think it is my duty to go back and tell the Japanese people exactly what I saw in this part of the world, especially how everyone was committed to the construction of a new order by revolutionally changing their own ways of life.

8

Figure 24. Tadahiro Ogawa, "Visitors in Free Mozambique: We Must Learn from the Spirit of the Struggle." *Mozambique Revolution*, April–June 1973, 8, Mozambique—Politics and Government—To 1975—Periodicals, Schomburg Center for Research in Black Culture, New York, New York.

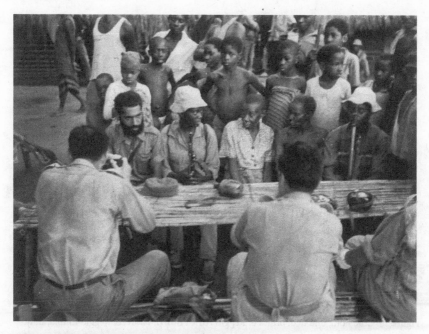

Figure 25. Unknown photographer, undated, untitled. Coleção: Luta Armada, Arquivo Histórico de Moçambique, Maputo, Mozambique.

visitor, Rebelo appeared uncomfortable and turned his head slightly away. For Frelimo, figures 24 and 25 acceptably displayed foreign visitors inside Mozambique. From a political and diplomatic standpoint, these images represented how Frelimo opened its liberated zones to visitors in ways that generated photographs "that [did not] look like propaganda."[157]

Contrary to the opinions of Frelimo's propaganda and diplomatic officers, foreign audiences did view Frelimo-produced photographs.[158] In fact, photographs such as figure 18 served as the basis for additional foreign aid. Bruna Soncini, the wife of Giuseppi Soncini, the director of the hospital in the Italian town of Reggio Emilia and the town's deputy mayor of international affairs, recalled seeing a photograph of a man using a printer, similar to figure 18.[159] Reflecting Reggio Emilia's communist ideals and anticolonial positions, the town's mayor, Renzo Bonazzi, had opened lines of communication with Frelimo's vice president, Marcelino dos Santos, in 1965, and he pledged "direct and concrete help" to the people of Mozambique. Part of the exchange with Frelimo involved the hospital in Reggio Emilia making prosthetic limbs for Frelimo soldiers.[160]

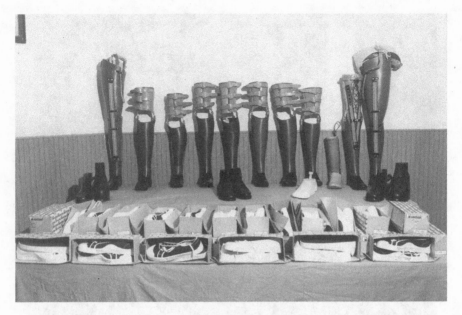

Figure 26. Cine Foto, undated, untitled. Reggio Africa Box 11, Istoreco, Reggio Emilia, Italy.

Photography proved unsuitable when doctors visited the liberated zones to measure body parts, and was only of use when the hospital in Reggio Emilia prepared to ship Frelimo the materials. Doctors from Reggio Emilia traveled to Mozambique and Tanzania in the early 1970s. Medical personnel collected measurements and then produced illustrative diagrams of the needed prosthetics.[161] On the advice of Frelimo's DIP, the hospital in Reggio Emilia contracted a local photography studio to document the contents of the shipping crates and the shipping crates themselves once they were prepared for shipment (figure 26). The hospital sent the crates to Frelimo via Tanzania's Office of the Prime Minister. Shortly after sending the prosthetics and other medical supplies, the hospital provided the Prime Minister's Office and Frelimo with copies of the photographs and shipping information. Not pictured by officials from either Reggio Emilia or Frelimo were the recipients of the limbs. The paper diplomacy provided license and context for representing Frelimo's activities without relaying images of the injured or dead, all the while furthering the ultimate aim of independence. Also, there was a need for photographs (figure 26) to show people what was being sent to Frelimo; such photos were useful only in the context of diplomatic affairs.

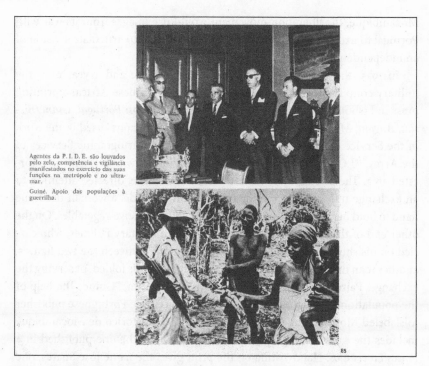

Figure 27. "Guiné: Apoio das populações á guerrilha" ("Guiné. The help from the populations to the guerrilla fighter"). In *4 Países Libertados: Portugal, Guiné/Bissau, Angola, Moçambique*, edited by Paulo Madeira Rodrigues (Lisboa: Círculo de Leitores, 1975): 85.

MISLABELING LOCATIONS: CONCLUSIONS

By 1974, the final year of Frelimo's independence struggle, different forms of filtering were under way in terms of the circulating of Frelimo photographs and how recipients processed Frelimo's image. The forms of filtering adopted by DIP and DRE reflected the long-standing problems these offices faced when trying to establish international recognition of the liberation movement and to depict the progression of Frelimo's war. Certain processes and theories of identification and documentation that had unfolded around and through DIP's use of photography became increasingly apparent with decolonization and independence. Such modes of recognizing and identifying Frelimo photographs are especially important to delineate the visual and auditory formats that liberation-struggle photographs acquired over time, and how the photographs became a part of national consciousness. After assuming control over

Mozambique, the liberation movement would use images from its war with Portugal to exercise its power over Mozambique and to articulate a vision of an independent nation.

In 1975, the year of Mozambique's independence and a year after the military coup that initiated decolonization in Portuguese Africa, a printing press in Lisbon published the book *4 Países Libertados: Portugal, Guiné/Bissau, Angola, Moçambique.* The book featured photographs "used in the work of the Service of Photography and Cinema of the Cartographic Services of the Army."[162] One of the published prints (figure 27) was an image in a forested area. The photographer, and the resulting image, directed attention to an exchange unfolding in the foreground. On one side, a woman used one hand to hold her child and another to either give or receive vegetables. On the other end of the exchange was a man dressed in military fatigues, who carried on his shoulders a gun pointed at the ground. Between the two figures, another man dressed in a loincloth stood with his hands folded, observing the exchange. Paired with the photograph was the caption, "Guine. The help of the population to the guerilla fighter."[163] Somehow, the Portuguese publisher mislabeled Mozambique for Guiné. The Arquivo Histórico de Moçambique includes the same photographic print (figure 20) as the one published in *4 Países Libertados.* Handwriting on the print gives the name José Soares, one of Frelimo's photographers, and the date November 1971. The handwritten text also describes the scene as "Political commission in the North," which according to the included stamp was the province of Cabo Delgado.[164]

Photography by Frelimo and of its activities circulated widely. Over the course of the war (1964–1974), DIP and DRE offices worked to prevent misuse and mislabeling of images, such as took place with figure 27. As Monteiro put it, images of Frelimo's were often mislabeled long before the publication of *4 Países Libertados.*[165] To avoid mislabeling and misappropriation, DIP officials and Frelimo diplomats were willing to get into conflicts with diplomatic allies, solidarity activists, and newspaper editors. For example, Monteiro debated an Algerian editor who claimed that Mozambique and Angola were the same.[166] On hearing Monteiro's complaints about mistaking Angola for Mozambique, the Algerian editor responded, "I understand your point, but we are all Africans, Angola, Mozambique, [and] South Africa."[167] In another instance, the Conference of Nationalist Organizations of Portuguese Colonies (CONCP) had Frelimo diplomats and political representatives on record objecting to the production of a film about a soldier affiliated with Angola's liberation struggle under the Movimento Popular de Libertação de Angola (MPLA).[168] Frelimo

officials believed that the development of the war in the interior merited priority over a profile of a soldier. Despite the objection of the Frelimo delegation, CONCP supported the film's production as long as the MPLA agreed.[169] In another instance, the lack of clarity regarding a television documentary promised by the Soviets, among other issues, delayed a Frelimo trip to the Soviet Union. The Frelimo photographer, Artur Torohate, reflected on how Frelimo's limited internal capacity to develop films restricted his training in cinema and ultimately led him to practice photography and video.[170] Part of the issue for Frelimo and its allies was Mozambique's place in the broader war for independence that gripped Africa. There were contrasting views on the part of Frelimo's Comité Central and the movement's allies. Nevertheless, Frelimo's DIP and DRE had used the acquisition of paper and struggles over how to caption images printed on paper to address the technical and technological limitations that resulted from the donations of printers, cameras, and films. In so doing, Frelimo's DIP and DRE expanded the organizational capacity to process undeveloped cinematic and photographic films collected in Mozambique, and to reproduce collected images in different material forms and formats.[171]

The production of photographs was influenced by processes of photographing, writing, and speaking. These formulations of photographs determined the conditions under which populations participated in the war and how they told stories about it long after Frelimo came to power in 1975. For Pedro Odallah, a former liberation fighter involved in high-level defense operations, looking at photographs from the liberation struggle by Frelimo-trained photographers evoked memories of photographs that were no longer physically accessible.[172] Odallah recalled that one of his favorite photographs, taken in Niassa Oriental, showed himself with Armando Guebuza, who at the time was a political commissioner and would go on to become Mozambique's third president.[173] At the Arquivo Histórico de Moçambique there is a photograph (figure 21) that illustrates three soldiers off to one side, barely inside the pictured frame, some of whom held their hands out. Standing across from them are women, who carried babies on their hips and shook the hands of the soldiers. The print (figure 21) included the handwritten names Guebuza and Odallah along with a stamp that designated the location as Niassa; textual information suggested that figure 21 may have been the one Odallah referenced in our interview.

DIP officials believed that populations living in the liberated zones interpreted photographs on the basis of the appearance of pictured persons, and not according to specific names or locations.[174] "What location is it?

The people [were] able to recognize the people that they knew, the people [then] recognize[d] the locations," said Odallah.[175] Odallah went on to recall a photograph taken during a journey with an American film crew who had accompanied the leader Guebuza. The detail most vivid to Odallah was of him receiving manioc. The manioc is not visible in the print available at the Arquivo Histórico de Moçambique (figure 21). The absence of the manioc raises the possibility that there was another picture, or that the Frelimo photographer had never photographed the scene recalled by Odallah. Odallah would go on to explain that on the visit to the liberation zone in question, an American film crew had accompanied Guebuza and that they attacked.[176] This information places Frelimo photographer, Simão Matias, who had accompanied the film crew and Guebuza, as the author of the photograph he remembered. On the same visit, the delegation led by Odallah and Guebuza had witnessed a Portuguese air raid, which the American film crew and Matias tried to document on camera. Odallah's own recollection of Frelimo photographs highlights different modes of recognition, framing their importance not only in terms of what printed photographs depicted, but of how their depictions allowed certain details of the war to be masked. Photographs existed in various material and auditory forms. In fact, the presence of cameras in the liberated zones and the various spoken and visual images that they produced allowed DIP and other Frelimo agencies to censor images of direct combat and to present the war as a respectable enterprise. Figures 20, 21, and 27 were all part of paper diplomacy and the filtering processes that Frelimo's DIP and DRE undertook through photography.

June 25, 1975, marked Mozambique's official independence from Portugal. Much of the world, along with populations living in Mozambique, had never viewed an image of the liberation war or of Frelimo's leadership. Photographs of the liberation war would acquire another function. DIP's practice and use of photography—"the paper diplomacy"—had produced its own visual history of liberation and independence. An additional issue was how Frelimo would look back on the liberation struggle once it was the ruling party of an independent nation. In the years after 1975, Frelimo's leadership and soldiers would become not just the subjects of photographs—they would assume power over what images populations viewed of Mozambique.[177] As a ruling party, and as it sought to assert control, Frelimo increasingly relied on the photographs of the liberation war to picture and define its power.

The Photographer as Bureaucrat, the Bureaucrat as Photographer

Starting on April 25, 1974, Mozambique's fate as a colony of Portugal entered a period of uncertainty. A military coup toppled Portugal's authoritarian regime, throwing Portugal's colonial wars in Africa into further chaos and increasing the prospect of independence. Portuguese soldiers based in Mozambique abandoned the military. Portuguese and Mozambican civilian and political groups alike took to the streets to oppose the prospect that Mozambique's independence might bring the liberation movement Frelimo to power. Additionally, fearful of the uncertainty, civilians living in urban and rural parts of the colony planned to depart. Twelve years after the start of its war with Portugal and three weeks after declaring a cease-fire with the Portuguese military, on September 25, 1974, Frelimo's Comité Central appointed a transition government to oversee the Portuguese government's handover of control in Mozambique. Nine months later, on June 25, 1975, Mozambique celebrated independence from Portugal.

The state apparatus that the Portugal authoritarian state and the colonial state had designed was highly compromised in terms of its governing capacities and the technical and material resources at its disposal. In the years after independence, Mozambique faced profound changes and challenges. First, Frelimo grappled with transforming itself from a liberation front into the ruling political party. Second, Frelimo's political leadership pledged its support to independence efforts in neighboring Rhodesia (present-day Zimbabwe), placing Mozambique at the center of the war against white minority rule in southern Africa.

As the liberation movement Frelimo attempted to establish control over Mozambique, its leadership and the staff of different government ministries

found an unexpected ally in the practice of photography and the circulation of photographs. Figure 28 is a case in point. A soldier holds an AK-47—the signature weapon of the liberation struggle—across his chest. The soldier stands outside a school named after the Portuguese Episcopalian minister and missionary D. António Barroso. To the soldier's side, young smiling children walk outside the school gate in the opposite direction of the soldier. In the background, close to the open door, a woman assists the children. The presence of the soldier reflected the state's nationalization of private schools, law firms, doctors' offices, funeral homes, and residential buildings within weeks of Frelimo's declaration of independence. There is no indication of why nationalization required the presence of the armed military guard; one possible explanation is that the gun might reference the political instability and threat of war that preceded and continued after independence.[1] Nationalization was the first step that the ruling party took toward its adoption of a Marxist-Leninist platform, and it coincided with a systematic reorganization of the state's governing and bureaucratic institutions.

As evidenced by figure 28, the Frelimo government after just one year in power expanded its capacity to practice photography through its nationalization policy. Greater control and use of photography helped the state manage its image. Starting in late 1974, Frelimo's Ministério da Indústria e Comércio acquired the photography studios and photographic equipment that laws required departing settlers to leave behind.[2] State takeover of abandoned photography studios further implicated the taking, archiving, and circulation of images (here presented with regard to figure 28) in reforming the state apparatus, and generating what I call "the photographic bureaucracy." The content and the spatial relationships (i.e., soldier/photographer, soldier/children, photographer/children) depicted in figure 28 among the photographed subjects mirrors the activities that transpired during Mozambique's transition from colonial rule and continued after its official independence in 1975.

The taking and printing of photographs such as figure 28, among many other images, were part of a broader attempt by various agents of the Frelimo government to use photography as a filter to organize the state bureaucracy. The various leaders of Frelimo's Comité Central, along with those who headed government ministries, specifically the Ministério da Informação, sought to create filters that controlled how the state's leadership and activities appeared in photographs. I located figure 28 at the national photography school and photographic archive, Centro de Documentação e Formação Fotográfica (CDFF), in a box titled "Nacionalizações" ("Nationalizations"). The location

Figure 28. Photographer unknown, 1976, "Nacionalizações 24 Julho 1976" ("Nationalization 24 July 1976"). Caixa: Nacionalizações, Centro de Documentação e Formação Fotográfica, Maputo, Mozambique.

and format of figure 28 suggest that the state interpreted the photograph's value in terms of having state-affiliated photographers and other government administrators see the image in the context of a state institution such as the CDFF. The photograph's back featured a stamp from the Direcção Nacional de Propaganda e Publicidade (DNPP), an indication of state attempts to control the contents of photographs and the role of photographs in defining the institutional tasks of state agencies. The stamp appeared in the very place the colonial state's Commisão do Censura had stamped to authorize or prohibit the publication of photographs.[3] Coincidentally, in 1976, the year the photo in figure 28 was produced, a working group at the DNPP launched a review of what photographs and advertisements newspaper editors published.[4] Photographs like figure 28 were part of the Ministério da Informação's attempts to plan, frame, and control newspaper content. State expectations of what photographs should show differed from those of the photographers and users of images. Photographers often failed to follow the directives issued by state agencies such as the DNPP and the Ministério da Informação.

Photographers faced problems when taking photographs like figure 28. An undated internal government report concluded that nationalization had posed difficulties to the "registering of history" that was "inherent to the profession [of photography]."[5] Photographers accused Frelimo soldiers of harassment.[6] There was no public and state acknowledgment of the need for photography and of the work associated with making photographs. From the perspective of the civil servants charged with overseeing the photographic bureaucracy, photographs registered social and political events and functioned as documents of "informative, didactic, and historical importance."[7] However, not all photographs actually served the state's political agenda. Processes of filtering were inherent in making photographs, and state officials used them to control the content of images. Attempts to regulate newspaper content and what photographers pictured resulted in ideological struggles between the state and photographers. Such activities profoundly impacted what photographers pictured and what photographs audiences viewed in the press.

From 1974 to 1980, the actions of officials charged with operating the photographic bureaucracy exposed the paradoxes of decolonization. Part of the process involved the production of textual and visual information through which photographs circulated in both the public sphere and government institutions. Writing and photographing became one type of filter through which civil servants working in various ministries, including the Gabinete da Presidência and the Ministério da Informação, exerted control over the bureaucratic apparatus that Portugal's authoritarian state and colonial state had left behind. Part of the takeover process involved journalists, photographers, and filmmakers determining the publication value of photographs from the liberation war, a large portion of which remained uncaptioned by 1974 and 1975. I consider filtering here in terms of how Frelimo officials, newspaper editors, and press photographers alike used archived photographs from the colonial era and liberation struggle to refilter (i.e., frame) the history not only of the independence struggle but of the transition period. Additionally, I map the photographic practices and pictures that resulted from the Frelimo state's intervention in photography starting in 1974.

The chapter's first two sections explore how photography and events during the transition period influenced understandings of photography among nonstate and state actors living under the colonial state and Frelimo. Portugal's authoritarian and colonial states reacted to photographs, and Frelimo's leadership and the government departments in their control were calculated and activist in their varied uses of photography. The third section tracks

changes in aesthetic forms and practices. I consider how Frelimo officials represented the government and operationalized the theories of photography that the party had developed in the context of the liberation struggle. Lastly, I am interested in what officials produced or blocked in terms of photographs, illustrations, and text. To conclude the chapter, I analyze how people "define[d] the criteria for decid[ing] which [were] appropriate images" in relation to how the Frelimo government defined and controlled what people viewed and how they looked at the nation's history and political affairs.[8] The bureaucratic and activist impulses of Frelimo's leadership conflicted with each other.[9]

TRANSITIONAL PHOTOGRAPHY

That independence had come was not apparent to populations living in Mozambique after the military coup. Mia Couto is an acclaimed Mozambican novelist and the son of Fernando Couto, a highly respected newspaper editor and journalist at the colonial-era newspaper *Notícias da Beira*.[10] Having left his medical studies to work for the press and fight for Mozambique's independence, the younger Couto witnessed the ramifications of the military coup in Lisbon against the fascist government of Marcello Caetano. Known as 25 de Abril (and the "Carnation Revolution"), the day marked a turning point in Portugal's involvement in colonial wars in Africa. Couto believed that independence for Portugal from a fascist regime did not necessarily guarantee Mozambique's independence. In a 2004 editorial published in *Le Monde Diplomatique*, he defended his decision not to write a piece in 1999 celebrating the coup's twenty-fifth anniversary. He stated,

> But Africans cannot be expected to celebrate 25 April [1974] as the Portuguese do. It is an important anniversary for us, and we celebrate it. But, we do so with the respectful attitude of a guest, not the exhilaration of a host. We don't expect the Portuguese to celebrate our independence day, 25 June 1975, the way we do.[11]

From Couto's point of view, Portuguese soldiers in Mozambique surrendered their weapons, and political factions protested the Portuguese government's decision to initiate conversations with Frelimo about Mozambique's possible independence. There was no victory for the liberation movement to declare.

On September 7, 1974, less than five months after 25 de Abril, the liberation movement Frelimo and Portugal's government announced a transition agreement regarding control over Mozambique.

The taking and viewing of photographs were critical to how people living in Mozambique, like Couto, had viewed the aftermath of the Carnation Revolution. For example, the photographer and filmmaker João Costa ("Funcho") had photographed student protests against the university rector and the political unrest that occurred in the *suburbios*, areas on the outskirts of the colonial capital where mostly nonwhite populations lived.[12] Supporters of independence, such as Couto and Funcho, found themselves working for the Mozambican press and reporting on the transition. From the perspective of journalists, Mozambique was not independent, but still at war.

Newspapers were one of the major venues where people viewed photographs and written reports about Mozambique's status as a colony and the events surrounding possible decolonization. People such as Couto, Funcho, and the writer Luís Bernardo Honwana, who lived in Mozambique's major cities, including the colonial capital Lourenço Marques and the trading port Beira, recalled viewing in news publications photographs by Ricardo Rangel, his contemporary Kok Nam, and many other photographers.[13] For Honwana, who had worked directly with Rangel at the colonial-era newspaper *A Tribuna*, Rangel's and Nam's published photographs were about raising people's "social consciousness" of colonialism's injustices, and not about "nationalism."[14] Honwana explained that Rangel and Nam took photos of, for example, "an old lady selling something and eventually there [was] a tendentious intentional defense and some empathy—how do these blacks folks live [like this]?"[15] However, for the younger Couto, Funcho, and other members of the student-led independence movements, Rangel's and Nam's photographs were precisely about "nationalism" and not "social consciousness," a road map for how independence at that moment could both be represented and ultimately achieved.[16]

The weekly publication *Tempo* was an important venue for viewing photographs in the colonial era, and from April 25, 1974 until June 25, 1975, when the future of independence was uncertain.[17] *Tempo*'s readership consisted of city-based readers and student activists like Funcho and Couto. According to Couto, colonial-era newspapers, such as *Notícias* and *Notícias da Beira*, treated photojournalism as a puppet and photographs as accessories.[18] Couto remarked, "In this [context, colonial] photography was something secondary, completely accessory. . . . [What] Rangel did was against this current . . .

which was to see photography as something else."[19] On the point of photojournalism as a puppet and accessory, Funcho remarked,

> [Newspaper editors at *Notícias*] did not represent the people of Mozambique at the time. If you opened a magazine or newspaper in the colonial times, [there were] only white people [in printed photographs]. [You looked] to the newspaper to only see white people. Even here in town, it [was] only white people. At night, only white people. Black people work[ed] as servants . . . things like that. Life outside of the town in the suburbs, of course it was completely different than now, like the pictures [that I took while] at university.[20]

Funcho expanded on Couto's perspective of Rangel going against the "current" and seeing photography as "something else" by alluding to how Rangel's photographs inserted nonwhite populations into a colonial reality made to look white through the censoring of photographs.[21] Couto and Funcho reassessed the importance of photography and the significance of the images of Rangel and Nam among the other photographs they viewed inside and outside of the press context. In advance of the coup, both Couto and Funcho had entered the professional arena of print journalism and photojournalism, respectively, where they worked not only alongside Rangel and Nam but directly with the photographs that resulted from their coverage of the transition.

Even if the Carnation Revolution did not result in Mozambique's independence, the event marked the emergence of a new creative platform for viewing photographs in press publications such as *Tempo*. New interest existed in a different image of the time period. Funcho stated, "25 de Abril [had] influence . . . here [in Mozambique] everybody start[ed] to be more free. For the press, there was no censorship in that time."[22] In Rangel's specific case, *Tempo* provided the space to publish photographs that the colonial state had censored. Around the publication of photographs, photographers like Rangel along with print journalists confronted competing views of independence. Also, they experimented with how to represent the historical moment visually. The story behind the delayed publication of photographs in figure 29 is a case in point.

As I argued in chapter 1, the colonial state in Mozambique, in conversation with the Portuguese authoritarian state, had established certain institutional regulations to produce an image of Mozambique as an extension of Portugal. Almost seven months after the Carnation Revolution, *Tempo* served as one platform through which editors and photographers published images that

Engraxadores brancos e engraxadores negros.
A mesma poeira para tirar dos sapatos

Velha ardina numa rua de Lisboa. Imagem des-
conhecida em Moçambique

terra eram forçados a lutar contra os seus irmãos numa guerra fratricida. Um governo pode ser reaccionário e retrógrado. Mas o povo *nunca* é reaccionário. O povo português deu essa prova no dia 25 de Abril.

O dia da chamada revolução das flores foi o grito dos portugueses contra a guerra colonial, contra a fome, contra a miséria, contra o analfabetismo, contra o desemprego, contra a prostituição da mulher portuguesa, contra o abismo a que o fascismo arrastava o país. E aqueles que não confundiam pátria com governo demonstraram o quanto amavam a sua pátria.

POVOS IRMÃOS

O povo moçambicano é irmão do povo português. Ambos foram vítimas do mesmo sistema político. A exploração que se fazia nas colónias não era ao povo português que beneficiava, mas aos elementos de um clube fechado que tinha os seus sócios nos latifundiários, nos capitalistas monopolistas ou não, e nos elementos do governo de Salazar-Caetano.

Assim como o povo moçambicano sofre de fome, sofre de analfabetismo, sofre de grande mortalidade infantil, sofre de falta de condições de habitação, sofre de falta de assistência mé-

Figure 29. Albino Magaia with photographs by Ricardo Rangel, "As pedras da terra não têm cor" ("The stones of the earth do not have color"). *Tempo*, No. 217, 24 Novembro 1974, 37, Biblioteca Nacional de Moçambique, Maputo, Mozambique, accessed through interlibrary loan at Bard College.

the colonial administration had previously banned, images initially produced to challenge the unified vision crafted by Portugal and the colonial state. In 1971, Rangel had traveled to Portugal on assignment for *Tempo*. The trip gave him the opportunity to photograph the legendary American jazz musician Dizzy Gillespie.[23] In Lisbon, while walking the streets, Rangel viewed scenes that contradicted the image conveyed by photographs of Portugal that the Mozambican press had circulated prior to the military coup. Under a headline that sought to capture the hypocrisy and falsehoods behind Portuguese racial hierarchies, "The Stones of the Earth Do Not Have Color," Rangel published the street scenes that he had photographed in Portugal three years before the magazine published them in November 1974.[24]

Administrative attempts to intervene in the circulation of images prevented people in colonial Mozambique, and also Portugal, from seeing certain historical events and social conditions. Life in colonial Mozambique and Portugal were similar in many ways. The publication of Rangel's photographs of Portugal and Mozambique side by side illustrates how the press censored these similarities and the different types of photographs viewed across the Portuguese Empire. Rangel's presence in Lisbon quite possibly mystified pedestrians, who themselves could have never imagined seeing a self-identified black photographer from one of Portugal's overseas provinces interested in taking their pictures. A woman allowed Rangel to photograph her holding copies of the newspaper *Diário de Lisboa* (figure 29). The scene Rangel photographed was no different than what pedestrians in Mozambique viewed every day. A reproduction of the image appeared in *Tempo* with the caption, "An old woman in the street of Lisbon. An image not unknown in Mozambique."[25] On the same page, two images of shoeshiners appeared, one of a man in Lourenço Marques and the other of a man in Lisbon with his back to the camera waiting for customers. The caption associated with figure 29 stated, "White shoeshiners and black shoeshiners. The same dust to take away from shoes."[26] The *Tempo* article presented one of many commentaries that emerged in the press in 1974 about the relationship between photography and written text along with photography's ability to ignite political critiques.

As was the practice with newspapers in colonial Mozambique and other parts of the world, editors assigned print journalists and photographers to cover specific stories. In the case of the article that accompanied figure 29, the Mozambican novelist and print journalist Albino Magaia wrote about a set of photographs that had varied production and publication histories. Rangel had previously published some of the photographs reprinted in

Tempo in other colonial-era publications and exhibitions (see Introduction and chapter 1 for examples). Then there were some photographs either that the colonial administration had censored or that Rangel had photographed without intending them for news publication. Magaia's text read more like a photo essay than a traditional news article. He underscored the function of published photographs (i.e., halftones) in relation to the written word. Magaia wrote,

> The photographs that we published [here] are more eloquent than our words. They [the photographs] say that exploitation does not know race and only the geographical condition of [colonial] territories introduces these kinds of errors in [opinion]. The words of the proletariat and oppressed do not know race [just as] the inhumanity of certain governments is not colorblind. It [the government of Portugal] is blind. Regardless of skin color of the unfortunate, [the government] oppresses.[27]

Magaia celebrated Rangel's photographs for making subtle and critical statements about prior attempts by the Portuguese authoritarian state and its colonial state to overlook and dismiss race in the larger context of colonial rule. In so doing, he referenced photography's ability to convey a condition of similarity. Based on the content of the photographs and the title of the *Tempo* issue where the article featured, "Exploração não têm cor" ("Exploitation does not have color"). The concept of "Exploração não têm cor" differs from standard definitions of colorblindness, which is often considered a virtue and based on the ability to make judgment irrespective of race and/or skin color. The combination of text and photograph reveal the insidiousness and divisiveness associated with the condition of colorblindness that Portugal purported. Magaia directly referenced Portugal's policy of the indivisibility of the metropole and the colonies in Africa, and the authoritarian state's belief that the Portuguese people had the same racial lineage as populations on the continent of Africa. The pairing of photographs, in the case of figure 29, could illustrate a shared experience of poverty regardless of the territorial and racial distinctions imposed by the Salazar and Caetano governments in Portugal. Magaia's writing reinforced what the pairing of photographs attempted to make visible to viewers; one photo caption stated that white and black shoeshiners removed the same dust whatever the racial identities assigned to them and their geographic location in Portugal's empire. The pairing of Rangel's photographs from his published and unpublished archive of images

from colonial times showed populations in Mozambique what they had long known about life in Portugal and the abuses committed by the Portuguese authoritarian and colonial states.

Portugal's own administrative and institutional treatment of photography had sought to introduce elements of blindness (i.e., the similarities between metropole and colony), which Magaia and Rangel criticized in text and image. The laws and rights in Portugal and the colony differed to the point where they favored whites in both locations. *Tempo* editors' pairing of Rangel's photographs taken in Mozambique and Portugal conveyed the sameness between the people of the metropole and colony, who in effect found themselves on different sides of imperial laws governing race and rights to citizenship (see chapter 4 for more). One caption in figure 29 mentioned the location where the woman was selling newspapers, and that the image was "known" in Mozambique. In interviews, Rangel mentioned specifically the photographs of the shoeshiners and their publication in *Tempo*.[28] From Rangel's perspective, the colonial state had censored images that showed white settlers without shoes or clothes.[29] The colonial administration's censorship of his photographs had informed what he knew about Portugal long before he traveled there in 1971. Rangel stated that censoring "cheated people here in Mozambique."[30] In fact, his images of the colonial era placed major state-run newspapers in conflict with the colonial state, leading him and his colleagues to realize that Portugal and its colonial state apparatus did not want populations in Portugal and Mozambique to see themselves as equals, let alone to see the same images. In response to censorship, Rangel had identified the colonial state as an intended audience, and he cultivated a practicing philosophy that involved him showing how white settlers in Mozambique were not separated from the realities experienced by black workers.[31] Rangel elaborated on the intent of his colonial-era photographs: "[the Portuguese government] may live in town and your workers in the suburbs, but if any day a big disease such as cholera [broke] out in the suburbs, you [would] be affected because your workers [lived] there."[32] Once again, Rangel sought to photograph scenes that the colonial state was unwilling to print in the press. The transition period following independence allowed Rangel to reclaim ownership of the photographs that the colonial state had censored or that editors had published without bylines. Part of the reclaiming process involved dispensing with the practicing philosophy of juxtaposition that entailed showing the widely ignored view of colonialism from the colonial capital's *suburbios* and the perspective of nonwhite populations. Instead, Rangel and his fellow

press colleagues appear to have embraced an approach of sameness, one that entailed using published and unpublished photographs to depict life in the metropole and colony alongside each other. During the transition, journalists and photographers associated with the press found themselves undoing the editorial norms and viewpoints imposed by the Portuguese authoritarian state and the colonial state apparatuses.

While the editorial reworking discussed above was under way, editors and state officials sometimes misused Rangel's photographs from before and even during the transition period. From 1974–1975 in particular, *Tempo* editors relied on Rangel's vast colonial-era archive to report on developments around the transition, topics that Rangel and other members of the photographic section were not in a position to report on. Two months before Mozambique's official independence from Portugal on June 25, 1975, *Tempo* published an article with the headline "Let Us Finish with Prostitution," alerting readers that the transition government had removed women from the popular street Rua Araújo and relocated them to re-education camps in the countryside.[33] Editors apparently lacked photographs that showed the military detaining and relocating the women. Instead, editors resized and cropped photographs of Rua Araújo that Rangel took starting in the 1950s and continued until independence in 1975. Rua Araújo was a popular street frequented by Rangel and his contemporaries, who worked nearby; men and women of all races congregated there at night to listen to jazz music, dance, and talk. The photographs (figure 30) reprinted in *Tempo* included a street scene of unidentified individuals walking under fluorescent lights, close-ups of women, and a man and woman walking down the street. In the photograph of the man and woman, the women turned her head away from the camera but the man looked directly at Rangel and his camera. The caption read, "Above from left, Rua Araújo is the ideal locale for South Africans to forget racism by buying women. The Rands, the money, commands prostitution inside of the capitalist systems. In Mozambique, it is necessary to definitely kill this type of exploitation."[34] The publishing and captioning of Rangel's photographs contradicted the original circumstances under which the photographed sitters presented themselves before Rangel's camera. Rangel, whose grandmother raised him, and whose Greek father abandoned his black mother, never referred to his female sitters as "prostitutes."[35] Furthermore, neither Rangel nor his female sitters ever expected news editors to publish and caption their images as they did in 1975.

Tempo's printing of Rangel's Rua Araújo images reveals the limitations and adverse effects of photographic reproduction within a space of supposed

"freedom" and "no censorship."[36] Before the transition, *Tempo* and other colonial news publications never published photographs of Rua Araújo. Rangel's private archive includes a photograph dated 1973 of Rangel standing in front of a photograph from the photo series at a solo exhibition in Lourenço Marques.[37] Stamped on the photograph's back was the word *Cortado*, or "Cut" in English, a reference to the Commisão do Censura's decision to ban the photograph from press publication.[38] Additionally, for many of Rangel's sitters, posing and the act of being photographed was an element of the practice of photography that was highly significant, more so than actually acquiring the photograph.[39] Rangel's camera was a constant witness to the smoking, dancing, and conversing happening inside bars and on the street. While daylight allowed the viewer to see black shoeshiners at work, the darkness of night presented its own opportunities and challenges for picturing colonialism. To compensate for the poor lighting inside bars and outside in the street, Rangel used his flash. For many of his sitters, the cover of darkness presented opportunities to watch films banned by colonial censors, to listen clandestinely to Radio Frelimo broadcasts, and to defy the racial segregation that persisted despite colonial state policy.[40] The publication of the images displayed in figure 30 marked a radical turn from the editorial practices adopted in the colonial era and the first time that readers viewed the pictures printed in a news publication like *Tempo*. However, Rangel and his sitters had intended for the photographs to highlight alternative notions of independence amid colonial rule—in effect, alternative modes of looking at oneself and other people. The 1975 reproductions (figure 30) ignored the nuances of representation adopted by Rangel in favor of the naming capacities of photographs. Furthermore, the mere existence of Rangel's Rua Araújo series was used to justify the removal of women from urban areas by Frelimo soldiers. As a result of state action, Rangel's published prints were quite possibly the only photographs of the female sitters ever available.[41] The varied publication histories associated with the Rua Araújo series revealed how the emerging independent state assigned negative meanings to colonial-era modes of image production and viewing without any apparent reservations.

Photographers like Rangel, and the various editors and print journalists that they worked with over the course of their careers before 1974, had a profound understanding of the efficacy of images and photographs. Progressive journalists aimed to illustrate the contradictions that characterized colonial life in Mozambique. The transition of 1974 and 1975 gave some print journalists and photographers, like Couto and Funcho, the impression of unre-

"ÀS VEZES NÓS NÃO QUEREMOS IR COM UM HOMEM, HÁ OUTRO QUE GOSTAMOS MAIS. AQUELE QUE NÃO FOI ESCOLHIDO COMEÇA LOGO A REFILAR: SUA PRETA AGORA VOCÊS ATÉ SE DÃO AO LUXO DE ESCOLHER..."

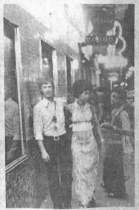

Na página à esquerda: *Debaixo da esplendorosa decoração luminosa tem lugar um modo de vida decadente. Ajuntamentos de homens e mulheres na procura de meia dúzia de minutos de "prazer" em troca de duas ou três "notas".*

Em cima, à esquerda: *A Rua Araújo é o local ideal para os sul-africanos esquecerem o racismo pela compra de uma mulher. Os randes, o dinheiro, é quem comanda a prostituição dentro dos sistemas capitalistas. Em Moçambique, é preciso liquidar definitivamente com este tipo de exploração.*

Em cima, ao centro: *A idade não conta. Só o corpo....*

rua Araújo. Todo o indivíduo que quer beber muito, que quer realmente embebedar-se, só o pode fazer nos «bares» daquela rua. Várias razões podem ser apontadas para este facto. Porque as bebidas nesses bares são muito mais baratas que nos Cabarés. Num Cabaré um simples refrigerante custa 15 escudos, uma cerveja pequena 25. Quem quiser beber em doses industriais terá de o fazer nos bares, e uma meretriz só pode ser arranjada num «bar» também. No cabaré há o problema das «fichas» e o horário que ela tem de cumprir. Estes aspectos contribuem para a grande aglomeração dos clientes e promotores da prostituição naquela rua.

Grande aglomeração, álcool por todos os lados e a mais pequena palavra agressiva, cena de pancadaria.

Uma autoridade de serviço a um cabaré confiou-nos: «Por noite chegam a haver umas dez cenas de pancadaria. A maioria das brigas acontecem derivadas do excesso de álcool que os intervenientes consomem. Por vezes saem dos bares e vêm para os clubes com bebida a mais, começando-se a meter com todas as mulheres, acompanhadas ou não. Depois aparece algum que não gosta da brincadeira e pronto, já estão à pancada.»

Outro local bastante escolhido para o tipo de cenas que estamos a referir é junto aos táxis. Se faltam táxis e, por acaso há dois casais para um só Táxi é quase garantido que os dois homens se vão pegar à pancada. Aqui a bebida também é factor preponderante.

DROGAS

«Tens stuff? Queres fumar comigo?» «Queres vir chupar passa? É nice pá, anda comigo.»

Frases como estas são vulgares. Mulheres viciadas, procurando as pessoas pela droga, por um cigarro de suruma, tornou-se um hábito na rua Araújo. Também os viciados encontram naquela rua o local ideal, para através das meretrizes viciadas fazerem às suas compras em termos demasiadamente confidenciais ou de «mais baratos».

«Elas passam a vida a drogarem-se. Nas esquinas mais escuras, nos becos, e às vezes até nos próprios bares elas se drogam. Vão passando o cigarro de umas para as outras, depois riem-se, bebem mais cerveja, riem ...Enfim é uma festa.» Confidenciou-nos um empregado de um «bar».

RACISMO

O racismo é ainda frequente na rua Araújo. Todo

Figure 30. "Vamos acabar com a prostituição" ("Let us stop prostitution"). *Tempo*, No. 238, 20 Abril 1975, 35, Biblioteca Nacional de Moçambique, Maputo, Mozambique, accessed through interlibrary loan at Bard College.

stricted freedom. The developing, cropping, and publication of photographs either previously published or previously censored defined one aspect of news reporting in the transition period.

At the time, journalists and photographers such as Couto, Funcho, Magaia, and Rangel ascended to the very editorial positions once occupied by colonial administrators who had censored the press, and they were left to grapple with how to represent the historical moment's political upheavals. Editors and photographers alike republished colonial-era photographs without the permission of photographed sitters. In one respect, the editorial decisions to reuse colonial-era photographs situated photographed sitters, like those pictured in figure 30, at the center of criticism of clothing and lifestyle choices associated with colonialism.[42] In another respect, the practice of republishing colonial-era photographs misrepresented why sitters allowed Rangel and other photographers to picture them and distorted the significance they assigned to seeing a photographer take their picture. Until now, I have focused on the republishing of Rangel's photographs of colonial life in the period of the transition, but the transition was also a newsworthy event that news publications required photographers such as Rangel, Nam, and Funcho to document.

Tempo editors appeared to be more comfortable reprinting photographs from the colonial era and less certain about how to picture the transition as it was taking place. Even for someone like Rangel, who had photographed the announcement of Goa's independence in Mozambique and the settler protests that followed, the transition was a different kind of photographic subject. Anthropologist Pamila Gupta argues that the transition period in Mozambique involved dismantling the colonial infrastructure and the physical relocation of people and goods from Mozambique to Portugal, South Africa, and Brazil.[43] Situating the transition period in Mozambique as a moment in a larger history of global decolonization, she proposes to consider "the daunting task and sheer physicality of decolonization in moving people and things across oceans and territories in a very heightened and rapid manner."[44] I would add that the taking, publishing, and viewing of photographs was fundamental to the documentation of the transition period, and to the ways in which "certain individuals had to interpolate larger state processes at a more personalized level."[45] Editors at *Tempo* relied on Rangel's photographs from the colonial period to tell a story and to compensate for the limitations of printed text. Somewhat in contrast, Rangel's own photographic archive depicts how he grappled with the editorial processes associated with turning photographs into words and vice versa.

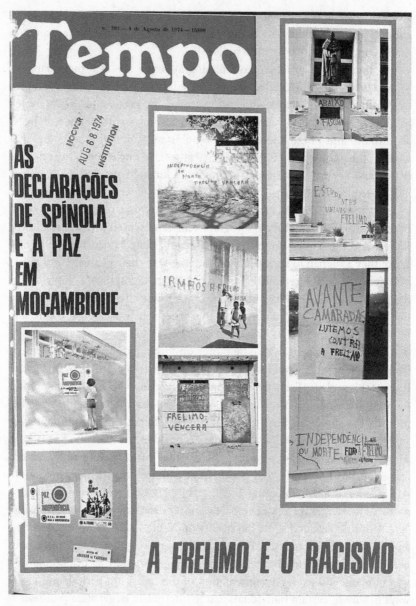

Figure 31. "A nossa capa" ("Our cover"). *Tempo*, No. 202, 4 Agosto 1974, Biblioteca Nacional de Moçambique, Maputo, Mozambique, accessed through interlibrary loan at Bard College.

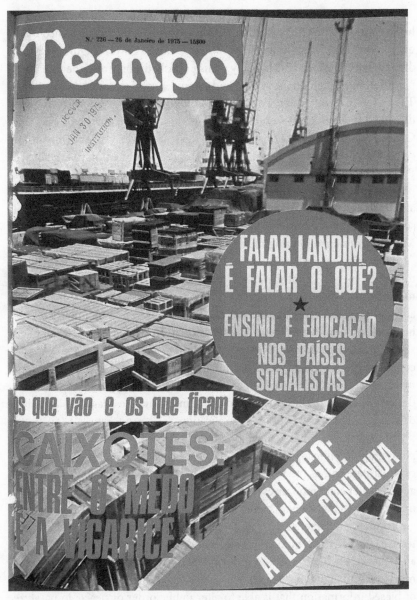

Figure 32. "A nossa capa" ("Our cover"). *Tempo*, No. 226, 26 Janeiro 1975, Biblioteca Nacional de Moçambique, Maputo, Mozambique, accessed through interlibrary loan at Bard College.

Alongside the images he published in *Tempo*, Rangel photographed what he later titled "The Other Destiny of Heroes" and also "LM (Lourenço Marques)—1975: The Dismantling of Symbols of Colonial Power" (figure 33). More dramatically and formally than any of his published work from the transition period, Rangel pictured men gathered around a rope at the base of a statue. The statue is recognizable from other photographs of the troop ceremonies discussed in chapter 1.[46] Rangel and his photojournalist contemporaries, like Carlos Alberto Vieira, frequently visited the square when on assignment for colonial state-run newspapers. Photographing troop ceremonies established Portugal's military presence, and within the press, they overshadowed the photographs of anticolonial resistance that Rangel photographed during and after his assignments (figure 30). In the foreground of figure 33, a man stood separate from the group staring at the removed panel, which depicted black Mozambicans encountering their white Portuguese colonizers.[47]

Mozambique's colonial history was being effaced at the hands of the photographed men. Unpublished photographs such as figure 33 make it possible to view the changes unfolding. Many of the photographed sitters had probably not seen Rangel's published photographs, and were unfamiliar with the histories of colonial display and occupation associated with the dismantled statue. The association the photographed sitters made between the state and colonialism was probably in relation to the photo identification that the colonial state had required people to carry (the subject of chapter 4). To travel to the area of the statue's location after 9:00 p.m., nonwhites classified as native, or *indigena*, had to carry photo identification.[48]

In the instant of taking the photograph, Rangel managed to dismantle the photographic philosophies that he had cultivated when photographing the colonial state and its monuments. The spatial backdrop against which Rangel and his other contemporaries had photographed changed fundamentally (figure 33). In a matter of hours after the formal announcement of the transition government on September 25, 1974, anti-independence riots erupted. In protest, reactionaries occupied the radio station in Lourenço Marques.[49] Weeks after the unrest, the transition government announced plans to jail "rumor mongers" and "agitators" for acts that involved "deliberately spread[ing] false or biased information that is able to alter public order or peace, to paralyze economic and professional activities, to cause the unnecessary intervention of the public authorities, or by whatever means to cause public alarm."[50] Behind the scenes, the transition government's security apparatus identified and expelled individuals who, according to one newspaper headline, had

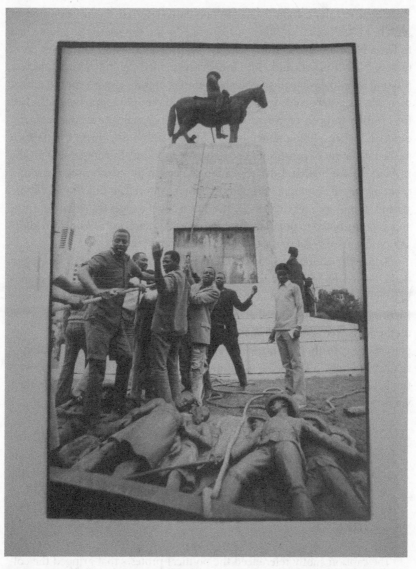

Figure 33. Ricardo Rangel, 1974–1975, "LM [Lourenço Marques]—The Dismantling of Symbols of Colonial Power." Lourenço Marques, Caixa: Rangel: Tropa Colonial, Centro de Documentação e Formação Fotográfica, Maputo, Mozambique.

"hindered decolonization."[51] People popularly referred to the expulsion of settlers as "24 horas, 20 kilos," a reference to the time selected people had to leave Mozambique and the allotted baggage authorities permitted them to have.[52] Newspapers and radio broadcasts named the individuals selected. Missing from the reporting were photographs of individuals expelled and of their physical departure from Mozambique. Press photographers searched for creative ways to represent the nuance and complexity of the moment, especially when photographers were not on hand to document events such as the relocation of prostitutes or "24 horas, 20 kilos." To compensate for the inability to see firsthand the relocation of certain population segments and other historical developments, photographers pictured graffitied walls (figure 31) and shipping crates (figure 32). The picturing of images shown in figures 31 and 32 contributed to populations viewing events such as "24 horas, 20 kilos" as significant events discussed in both speech and text.

Before the announcement of the transition government and the rioting that followed, Rangel expressed in his published work a desire for photographs to become a form of writing. The cover of the August 4, 1975, issue of *Tempo* (figure 31) featured nine small photographic prints that depicted walls. Painted on the walls were slogans in capital letters, reading "Frelimo will win," "Independence or death, Frelimo will win," and "Forward comrades, let us fight against Frelimo."[53] The inside page included another four photographs with the headline, "When the Walls Talk," a reference to people expressing their views through text written on the walls. The inside caption read:

Four photos of the images were taken in João Belo by our comrade Ricardo Rangel. [This is] similar to what happened in Lourenço Marques where in the suburbs, just after 25 de Abril, on the cement walls of canteens, on the zinc of backyards, and even on abandoned old cars[, there appeared] phrases in support of Frelimo . . . written in chalk, ink, and charcoal. . . . The images are illustrative.[54]

The caption subtly referenced the political protests that gripped the colony after the military coup in Portugal and attempts by people living in the city outskirts to articulate their views in the moment, some of which included expressions of support for Frelimo. In each individual frame, the texts and expressions of different opinions have been modified from the original graffito. In one detail, someone had changed the previous text, *contra* ("against") Frelimo, to read *para* ("for") Frelimo. In his personal archives Rangel docu-

mented the physical dismantling of colonial monuments (figure 33). In figure 31, Rangel photographed the text on the walls; based on the perspective of his photographs, Rangel appears not to have observed people write the text or the modifications made to the text. The published prints reveal the presence of Frelimo supporters within the city limits in advance of the transition government. Furthermore, the photographic medium generated exorbitant and unspecific information that photographers, newspapers, and state officials struggled to make into something explicit and precise for public viewing. Thus, the prints also display a particular tension that characterized the photographic medium in that moment: photographers had to use text or the photographing of text to precisely interpret the visual image for the viewer.[55]

The explicitness and transparency evident in figure 30, and to a certain extent figure 31, disappeared after the announcement of the transition government. During "24 horas 20 kilos," Rangel produced a series of photographs, some of which *Tempo* published, that anthropologist Pamila Gupta situates at the center of her analysis of decolonization in Lusophone Africa.[56] The shipping crate was a prominent feature of the transition period and in Rangel's photographic archive, but it is a rather peculiar photographic subject. *Tempo* printed an image produced from a color slide by Rangel of the crates at the colonial capital's shipping port (figure 32). The headline read, "Those Who Go and Those Who Stay: The Crates, between Fear and a Scam." Journalistic reporting recounted how the crates themselves were part of a scam.[57] Unidentified companies used wood to make the crates, sold them to clients for shipping their belongings, and then required clients to disassemble the crates after they arrived in Portugal and return the wood for reuse.[58] The crates symbolized the infrastructure of boats, cranes, bridges, and roads that Portugal's authoritarian state and colonial state had built to attract settlers. People leaving Mozambique went to great lengths to pack and ship their crates, sometimes lying about their contents and offering bribes to shipping businesses.[59]

The publication of Rangel's crate photographs (figure 32) highlighted the representational limits of the photographic medium and introduced an element of opacity into the coverage of the transition. Informed by the writings of philosopher Edouard Glissant, art historian Krista Thompson defines photographic opacity as "highlighting the materiality of the photograph's surface, the process and physiological effects of its making, the inability of photography to capture its subjects transparently."[60] Rangel's camera could not see inside the crates. His photographs were of no use to custom officials' attempts to identify crate contents. Also, writing that appeared on the crates had the

potential to mask their actual contents. Based on the article text, writing (and not the photographic image) was the only suitable medium for clarifying the activities in the transition government's response to settler departures. Photographs created confusion. In fact, the photographs Rangel published from 1974 to 1975 were of value to him only as illustrations to a newspaper story, and not as documentation of the events of history. Figures 31 and 32, as anthropologist Rosalind Morris stated about photographs of the king of Thailand, illustrated the vulnerability of power. Nonetheless, the ability to control the reproduction and reprinting of photographs (figures 29 to 33) was of particular use during the transition period to laying the foundation for the political ascent of the liberation movement Frelimo.[61]

THE EMERGENCE OF THE PHOTOGRAPHIC BUREAUCRACY

In the days after the announcement of the transition government, Frelimo officials and soldiers found themselves standing in front of an unfamiliar camera and photographer. The transition period tested Frelimo's views and uses of photography that were cultivated from exile during the liberation war. According to Jorge Rebelo, who oversaw Frelimo's propaganda apparatus at the time of the armed struggle and would become Mozambique's first head of the Ministério da Informação,

> I think it [i.e., the suspicion of photography] comes from a guerrilla mentality. You are suspicious of any foreign enemy movement. And after independence, as I told you, we did not know who [was] who and we were highly aware of the importance of information. There was the risk that some journalist who [the Portuguese secret police PIDE had arrested] was against independence and [would] produce some article that would damage the image of Frelimo. And [at] independence, we felt that we had to control the media, which we did.[62]

Frelimo became anxious about the Mozambican press and its coverage of the transition. The Ministério da Informação and the transition government that Frelimo's Comité Central had appointed were particularly attuned to the risks associated with unaffiliated journalists documenting its rise, such as Couto, Funcho, Nam, and even Rangel. The press card was not enough to identify media professionals. Frelimo soldiers recognized neither photographers as

Figure 34. Ricardo Rangel, 1970, "Praia Oasis" ("Oasis Beach"). Caixa: Rangel: Tempo Colonial, Centro de Documentação e Formação Fotográfica, Maputo, Mozambique.

working on behalf of the state nor the significance of the photograph as a historical document. In reality, soldiers viewed photographers not only as foreign, but as threats. During the transition, Frelimo press and political units had to learn to present the armed struggle and its history to unfamiliar populations through photographic images.

Photographs from the liberation struggle were an important component of the transition process. There was value in reprinting photographs of the liberated zones in the Mozambican press. Photographs of the armed struggle allowed Frelimo to reframe how the colonial state institutions that it assumed control over used photography, and to show unfamiliar audiences how the liberation front fought and "won" the war against Portugal. In the process, the Ministério da Informação introduced elements of the photographic bureaucracy that allowed Frelimo as a ruling party to exercise its control after independence.

Early in its war effort against Portugal, Frelimo's diplomatic and political representatives recognized that a single image could be subject to a host of misinterpretations. To illustrate the war's progression, Frelimo officials incorporated images by urban-based photographers such as Ricardo Rangel and Carlos Alberto Vieira into its display of the liberation struggle.[63] From Frelimo's perspective, Rangel and Vieira photographed "white people seeing a sailing competition" and "Mozambique as nice"—pictures that showed "the whole of white society . . . [and] convey[ed] the political message of oppression [and] discrimination."[64] José Oscar Monteiro, a Frelimo diplomatic representative in Algeria and Italy, recalled showing Rangel's and Vieira's photographs (like figure 34) at international conferences. He remarked, "Take

the picture [by either Rangel or Vieira] and show it to another audience who knows colonialism. They say 'My god. They live like this.' When they see the blacks with bell-bottoms and nothing else working. . . . This is raw colonialism."[65] Monteiro introduced photographs by Frelimo photographers into the context of "raw colonialism" to "document evidence of [Frelimo's] struggle" and "to show discrimination and colonialism."[66] Frelimo officials achieved more stable meanings through seriality and juxtaposition.

As its capacity to produce photographs expanded after 1969, Frelimo's leadership and government ministers confronted the representational value of its photographs of the liberation war. Frelimo had attempted somewhat unsuccessfully to establish a clandestine network of supporters in urban centers such as Lourenço Marques.[67] In 1971, journalists at *Tempo* had received copies of the Frelimo publication *A Voz da Revolução*. Once, *Tempo* journalists returned to their offices to find that the envelope where they kept Frelimo photographs had been opened, and they suspected that the colonial state's security had searched their offices.[68] As a precaution, editors made photocopies of the photographs and then destroyed the originals.[69] When *Tempo* journalists realized that Frelimo's rise was imminent, they published photographs from the photocopies with the headline, "Who Is Frelimo?" Calane da Silva, a *Tempo* journalist, laughed when he explained his amazement at how many people at *Tempo* knew of Frelimo before 1975.[70] The publication in *Tempo* of images previously published in Frelimo-produced bulletins nonetheless marked the first time readers in cities such as Lourenço Marques viewed a picture of Frelimo officials, soldiers, and populations who lived in the liberated zones. Readers of publications such as *Tempo* and other colonial-era publications, who supported Mozambique's independence, had developed strategies for identifying photographs by Rangel, Nam, and other colonial-era photographers. Urban populations lacked the strategies needed to correctly interpret photographs of Frelimo. Furthermore, the publication and viewing of liberation-struggle photographs during the transition did not reflect the representational and anticolonial aesthetic cultivated through the prior publication of Rangel's and Vieira's photographs among an urban readership.

Display of liberation-struggle images did not always produce the image of control that Frelimo's transition government sought. There was minimal space in the Mozambican press for Frelimo leadership and officials who fought in the war to define and contextualize the movement and its power as a liberation front in relation to the colonial state. *Tempo*'s editorial strategy of reprinting photographs from the colonial-era with bylines contradicted

Frelimo's own approach to photography. For ideological reasons, representatives of Frelimo's Departamento de Informação e Propaganda (DIP) had left photographs of the liberation struggle uncaptioned and without bylines. Jorge Rebelo, head of DIP until 1975, offered the following explanation: "The question of authorship, as you call it, didn't arise. In fact, we fought this question [and] mentality [of] 'I did this'. . . . at that time [of the war], it was [a] Frelimo production. [It didn't] matter who took the photographs, who wrote this text. It was collective production for authorship."[71]

. Frelimo's leadership confronted the potential threat and power of its image of liberation in relation to the issue of dress. People living in Lourenço Marques expressed their views on the political changes under way after 25 de Abril through clothing.[72] Graphic T-shirts featured images of the famed Mozambican football player Eusébio, the cowboys seen in the movie *They Call Me Trinity*, and political slogans in support of 25 de Abril and Frelimo.[73] Amid the circulation of graphic images on a range of paraphernalia, rumors spread that Frelimo required men and women to wear traditional clothing such as loincloths and *capulanas*.[74] Women were scared to leave their homes due to uncertainty over what to wear.[75] There were public disagreements over what men and women should wear and whether vendors should reproduce Frelimo's image on shoes, bags, and other forms of clothing. One person questioned the style of dress of Frelimo members and whether vendors were in a position to know what was appropriate, while another individual suggested that the proliferation of Frelimo's image was "not disrespectful but on the contrary [was] a sign of acceptance."[76] One person quoted in a news report went so far as to suggest that photographers who produced headshots should document incidents where people illegally sold paraphernalia with Frelimo's logo and image.[77]

Questions of dress were familiar to high-ranking officials, who at the transition had exchanged their military fatigues for suits.[78] As it negotiated independence with Portugal between May and September 1974, the representational nature of Frelimo's power shifted. After September 25, 1975, and the announcement of the transition government, Frelimo's leadership and the transition government it had installed no longer needed to show themselves as a unified guerrilla movement but instead as a political party. In response to a question about how Frelimo remade its image, Rebelo stated,

Internationally, and not only internally of course, after independence there was no reason to continue to project him [Samora Machel] as the military, he

was now the President of the Republic. So [he was] this leader of all people not only the guerrillas. So, that is why. I don't [know] if it was a shift. It was a new way of showing him as [the] real leader of the country.[79]

The transition was a bit of a balancing act for Frelimo leadership and military cadres with respect to projecting its power and an image of its leaders. Machel was not the president of Mozambique until independence on June 25, 1975. In the interim, Joaquim Chissano served as the transition government's prime minister. No longer could Frelimo afford to leave photographs of the liberation struggle without text. Monteiro and other officials' circulation of liberation-struggle photographs, juxtaposed with pictures by Rangel and Vieira, was no longer a viable filter for the movement to demarcate itself and its power.

To produce a new image, representatives of Frelimo's transition government formalized its alliance with photographers and print journalists, with whom it had previously had limited contact and who had worked for colonial-era news publications. In advance of the announcement of the transition government, in the summer of 1974, DIP and Frelimo's Departamento de Relações Exteriores (DRE) had invited journalists, photographers, and other cultural producers of significance to visit its military and political headquarters in Tanzania. Frelimo's military officers posed for photographs with visitors such as photographer Rangel; the print journalist Fernando Margalhes, who Rangel worked with at *A Tribuna*, the painter Valente Ngwenya Malangatana; and the poet José Craveirinha.[80] In one image from a 1974 visit (figure 35), Rangel dressed in military fatigues and stood holding his camera in the presence of Frelimo's president Samora Machel. For Rangel and the print journalists he worked with, photographs like figure 35 had a particular import.

One journalist Rangel worked with, Calane da Silva, explained how a photograph (like figure 35) had allowed Rangel and him to perform their reporting duties during the transition period.[81] Confronted with opposition from Frelimo soldiers as they traveled Mozambique on assignment for *Tempo*, Rangel showed a photograph of his visit with Machel. According to da Silva, "the checkpoints opened as if by magic wherever we went, and we managed, therefore, to create images of this incredible time in the transition of our country to independence."[82] On the one hand, the photograph in question gave Rangel the recognition he needed to photograph the events surrounding the departure of Portuguese settlers (figures 31 to 33). On the other hand,

Figure 35. Unknown photographer, 1974, untitled. Nachingwea, Tanzania, Caixa: Luta Armada, Centro de Documentação e Formação Fotográfica, Maputo, Mozambique.

photographs like figure 35 served several strategic purposes for the Frelimo administration. First, the picture was a way to situate civilian photographers, journalists, and cultural producers as part of its organizational body. Second, the photograph accompanied the transition government's own internal process of identifying what print and photo journalists with no prior affiliation knew about the organization and its war against Portugal.[83] Third, the photograph was a substitute for the press card, a means to control how civilian journalists reported on the transition. Fourth, and finally, few people outside press and government circles viewed figure 35, indicative of the power Frelimo exerted over who photographed and how its image appeared publicly.[84]

The power of the liberation image was no longer in its public display, but rather in its ability to help Frelimo's leadership consolidate its power over the colonial state governing apparatus. Initially, photographs of the liberation struggle appeared alongside editorial coverage of some of the early and more controversial reforms instituted by Frelimo after 1975, including the nationalization of private industry, the acquisition of abandoned businesses (which included photography studios), and the development of re-education

camps.[85] On the one hand, the publication of photographs in venues such as *Tempo* gave Frelimo's president and his cabinet members motivation and justification for the political reforms instituted. On the other hand, government agencies such as the Ministério da Informação exerted control of the press, and in the process generated a certain political power by setting the terms and context for the reproduction and circulation of liberation-struggle images. For example, on May 26, 1974, the transition government passed a law prohibiting the commercial reproduction of "texts, images, symbols, names, emblems, insignias, or slogans of Frelimo or its prominent elements or those considered related without authorization of the Ministério da Informação."[86] The law made no mention of photography, and it characterized "texts, images, and symbols in general of Frelimo" as "an integral part of the historical process of the liberation of the country."[87] The law instructed people to submit their requests for image reproduction to local officials, who then sent them to the Ministério da Informação, where officials determined whether reproductions violated the law.[88] The Ministério da Informação also reserved the right to assess fines in terms of the damage done to the "prestige of Frelimo" and the "monetary advantages" gained from the violation.[89]

Photography was not only a means to visually represent Frelimo; it was one of the ways in which leaders of various government agencies, specifically Ministério da Informação and Ministério do Interior (the subject of chapter 4), took control of the bureaucratic apparatus that Portugal left behind. The transition involved Portugal literally handing over to Frelimo's Comité Central control of state institutions, some of which handled issuing photo identification to populations and censoring photographs in the press. *Tempo* and other news publications printed photographs of Portuguese and Frelimo representatives making public pronouncements and signing documents (figure 36). Two months before independence, *Tempo* published a photograph of the high commissioner of Portugal and the prime minister of the transition government and Frelimo representative Joaquim Chissano. In advance of the issue, *Tempo* also published photographs of colonial state functionaries at their desks surrounded by papers and filing cabinets, appearing to work.[90] The accompanying article addressed whether the pictured workers were permitted to stay and continue working after the handover of power.

An overlooked aspect of the transition was Frelimo's interweaving of the program of the camera with the program that permitted photographers to take pictures.[91] Press publications displayed a new way to look at the state, as well as the act of looking that the state itself performed. The colonial state did

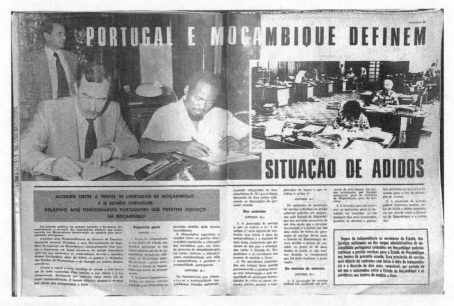

Figure 36. "Portugal e Moçambique definem situação de adidos" ("Portugal and Mozambique define the situation of the officers"). *Tempo*, No. 242, 18 Maio 1975, 38, Biblioteca Nacional de Moçambique, Maputo, Mozambique, accessed through interlibrary loan at Bard College.

not show its workers as bureaucrats. Rather, it elected to publish photographs of parades, official state visits, and military ceremonies (see chapter 1). Press photographs published in *Tempo* and other news publications, such as figure 36, juxtaposed the work of the photographer, the act of taking photographs, and the state and its representatives writing and handling papers. The picture of Chissano and his counterpart from Portugal illustrated the signing of a document that determined the terms and conditions under which bureaucrats from Portugal stayed in Mozambique after the handover of power and independence. Through acts of drafting, writing, and reading, Frelimo challenged bureaucratic procedures enforced by the Portuguese authoritarian state and the colonial state, and it regulated how photographers pictured the state. During an assessment of the state apparatus and its various functions, Frelimo's transition government and its limited staff determined that the colonial state had prohibited bureaucrats from filling out forms for populations.[92] According to news coverage, the failure of bureaucrats to complete forms was a type of corruption, because many Mozambicans were illiterate and relied

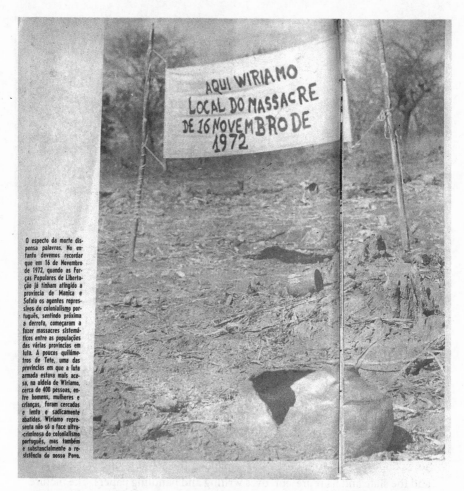

O especto da morte dispensa palavras. No entanto devemos recordar que em 16 de Novembro de 1972, quando as Forças Populares de Libertação já tinham atingido a província de Manica e Sofala os agentes repressivos do colonialismo português, sentindo próxima a derrota, começaram a fazer massacres sistemáticos entre as populações das várias províncias em luta. A poucos quilómetros de Tete, uma das províncias em que a luta armada estava mais acesa, na aldeia de Wiriamo, cerca de 400 pessoas, entre homens, mulheres e crianças, foram cercadas e lenta e sadicamente abatidas. Wiriamo representa não só a face ultra-criminosa do colonialismo português, mas também e substancialmente a resistência do nosso Povo.

Figure 37. "Samora: Do Rovuma ao Maputo" ("Samora: From Rovuma to Maputo"). *Tempo*, No. 247, 22 Junho 1975, 8–9, JSTOR Aluka: Struggles for Freedom—Southern Africa, accessed through interlibrary loan at Bard College.

on other people to complete government documents.[93] The agreements that pictures depicted government ministers signing, such as the one in figure 36, determined what equipment would be available to photographers and governing institutions after 1975. In figure 36, the photographer documented the actors and processes characteristic of the transition period. In so doing, the picture equates the work of the photographer with that of the state and its bureaucrats, who presumably only handled paper. Photographers such as

Rangel and Kok Nam, who worked at *Tempo*, regularly took pictures in the style and vein of figure 36, but they found little use for this imagery as they increasingly exhibited aspects of their private photographic archives from the 1980s until their respective deaths. For the Ministério da Informação and Gabinete da Presidência, photographs like figure 36 provided new visual contexts to represent the work of the state apparatus—a defining feature of the photographic bureaucracy that officials were in the process of creating.

Weeks before independence in 1975, the president of Frelimo traveled to Mozambique from exile in Tanzania. The journey introduced Machel to the breadth of image-making institutions installed by the colonial state. The occasion marked the first time that the inhabitants of rural areas saw Machel and the other leaders of Frelimo. Machel viewed with fascination the cameras of reporters invited from Mozambique's major newspapers to cover the event, which became known as "From Rovuma to Maputo," the cities where Machel started and ended his trip.[94] From the perspective of the photographer Funcho, who worked at *Notícias*, Machel was particularly interested in providing Frelimo photographers with cameras similar to the manual 6x6-format Rolleiflex that he had used.[95] Machel recognized the potential power of his image. The accompanying photographers produced a set of images that allowed the Frelimo leader and those in his delegation to identify the visual aspects through which to display Frelimo's rise to power and Mozambique's history. For example, during the liberation war, Portugal's military faced claims that it had killed 400 Mozambicans in what is called the Wiriyamu Massacre.[96] In its defense, Portugal's government said the event did not happen, because no photographic evidence existed. The absence of photographic evidence had also posed complications for Frelimo's military and political units. During the journey from Rovuma to Maputo, a *Tempo* photographer depicted a banner with the text (figure 37), "Here is the location of the Wiriyamu Massacre of November 16, 1972."[97] The banner actually did mark the site of the massacre, which previously had eluded photographic documentation. The image of the banner and the accompanying text were part of a larger revelation that unfolded in the transition: photography's ability to display something about the past and even to revise past historical narratives. Photographers and journalists had faced transportation delays during the journey from Rovuma to Maputo, which impeded their arrival at specific events and the delivery of their reports for publication. There were also delays between taking the photograph and its circulation; gratification was not instant. During this time, Frelimo's president and those in his traveling

delegation expanded and refined their notions of the power of Machel's image and that of the future ruling party. By playing with photography's ability to represent time, the press under guidance from Frelimo's leadership was able to dispute accounts of Portuguese colonialism.

Following independence, infrastructural and material limitations continually plagued the circulation of Machel's image and preoccupied different agencies that the Ministério da Informação oversaw, including the Instituto Nacional de Cinema (INC). After his arrival in Maputo, Machel frequently traveled to the countryside in the presence of filmmakers and photographers. One of the rural areas Machel visited was in Cabo Delgado, where Frelimo's military had launched Mozambique's war for independence and struggled to maintain influence during the war. The journey to the region included a visit to colonial-era cinemas. In a 1976 report about the visit, INC officials criticized the colonial state for building cinemas because they had nothing to do "with the reality and necessity of populations."[98] Nonetheless, the report concluded that the abandoned cinemas were useful to Frelimo's government as a tool to spread its political message. Cinemas could function as important gathering spaces "to organize and meet dispersed populations" and as sites that produced "social and political experiences."[99] On the same visit, filmmakers discovered that they lacked enough film to document "the events of political importance" that happened during the visit, and that their cameras were unable to record scenes of Machel stopping in the streets to speak with children and workers.[100] Human contact was central to the creation of a revolutionary language. Much to the displeasure of the ruling party, the available equipment prevented filmmakers from "grasp[ing] the historical moment in the act—in its pulsations."[101] However, through the articulation of certain technological failures and ambitions, such as synchronized sounds, 35 mm film projects, and manual 6x6 Rolleiflex cameras, institutions like the INC established the foundation of the photographic bureaucracy, aspiring to produce an image that "grasp[ed] the historical moment in the act—in its pulsations."[102]

Initially, the photographic bureaucracy resulted from a series of administrative and legal attempts by Frelimo's transition government to assume control over a disorganized, understaffed, and under-resourced colonial state apparatus. Part of the restructuring effort involved government leaders, such as the minister of information and those charged with overseeing the INC and state-run media, recognizing the limitations of printing photographs from the liberation struggle. Unlike the colonial state, Frelimo's transition

government embraced the instrumental value of photography. Images of the liberation struggle allowed Frelimo's leadership to gain control over how photographers and the viewers of their photographs pictured the liberation front as it assumed control over colonial-era governing institutions. The ability to hide the image of the liberation struggle and to control how photographs appeared in the public realm enhanced the mystical and secretive nature of representing history traditionally associated with the photographic medium. Editors and government leaders alike established the political power and legitimacy of the new government by removing photographs of the liberation struggle from the public realm after 1975.

PHOTOGRAPHY AND BUREAUCRATIC LABOR

During the liberation struggle, Frelimo's leadership and membership had neither the time nor the resources to evaluate their use of photography. As part of its initiative to operationalize the photographic bureaucracy, Frelimo's Ministério da Informação, with the support of the Gabinete da Presidência, gathered the state's media personnel.[103] The public meetings resulted in the creation of working groups on topics such as the function of the press and the political disposition of specific news publications. After 1975, writing, not just taking and archiving photographs, was a component of Frelimo's instrumentalization of photography. Writing about photography entailed defining what constituted photography, drafting guidelines for how officials selected and used photographs, and creating planning and monitoring systems that state officials, journalists, photographers, and filmmakers collectively implemented.

Government ministers and presidential advisers recognized the need to produce photographs, but three years into independence expressed uncertainties about who was prepared to serve in the capacity of official photographer. Part of the state's uncertainty stemmed from its inability to identify photographers. This uncertainty resulted in press photographers accusing state representatives of preventing them from photographing. In 1977, many of the colonial state's information structures remained in place, performing "modes of work of the artisanal type, without the dignifying quality of an information organization of a sovereign nation."[104] In spite of concerns by the state about the publication and circulation of photographs, there was a sentiment that photographers should continue to take pictures for archival purposes.

Frelimo officials charged with operating the photographic bureaucracy, such as those on the Comité Central, Gabinte da Presidência, and Ministério da Informação, faced unprecedented material constraints. There is also a need here to theorize photography on the basis of equipmentality, not merely political ideology.[105] The devaluation of the national currency along with embargoes on goods imported from South Africa and Rhodesia (current-day Zimbabwe) restricted the importation of photographic supplies that had been available to commercial markets in colonial times.[106] The presence of various brands of photographic materials posed difficulties in terms of "repairing equipment" and "the quality of images."[107] The state had also placed unreasonable demands on news organizations for photographs. To compensate for the technological and institutional quandaries that surfaced, a working-group report advocated for a new division of labor and further state takeover of nonoperational and "improperly used" laboratories.[108] The report also proposed that the office of the presidency establish its own press office.[109] There was the sense in the press that the procurement of certain photographic brands would compensate for the low "quality of images."[110] Interestingly, from the perspective of the INC, which hosted committees and debates on the image-making capacities of government agencies, the technological challenges that its staff and the press experienced simultaneously were more "political" than truly technological. For example, a 1977 INC report titled "General Meeting of Workers" includes a summation of a blistering statement by the filmmaker Américo Soares, who framed the perceived technical difficulties at the INC as "false solutions" to problems that "were essentially political." To paraphrase, Soares believed that even if machines functioned properly, the INC would not have regularly produced films of the highest technical and visual quality.[111] Access to technology complicated how officials, including the state's press and film units and government ministries, operated and used the photographic bureaucracy.

Regarding difficulties in acquiring and using image-making technologies, government officials, photographers, and filmmakers articulated and corrected their views on photography's ability to represent the nation's history and ongoing political events. Officials involved in photojournalism considered photographs as part of a broader set of images distributed through cinema and television, and proposed the position of archivist who would "organize the material produced in the past, in the present, and in the future."[112] Then another committee of officials classified photographs in the same category as posters, caricatures and satirical designs, and emblems and symbols,

and noted that these forms of images "owed [their] efficacy to [their] easy perception," which required little reading skill.[113] Supposedly a good caption could convey the content of a good speech.

While photographs could substitute for text, by 1980 the sense had increased that filmmakers had misused images gathered from state archives. A report prepared for the African Seminar of Audiovisual Archives characterized Mozambican cinema as "essentially of documental character" and involving "great material from the archive."[114] The report claimed that "the necessity of circumstances" had ruined archival images by manipulating them for political purposes. By the late 1980s, the historians Jacques Depelchin and Alexandre José had reached the following conclusion about the representational significance of photographs of the liberation struggle: "[O]ne of the most important lessons of the armed struggle in Mozambique was to point out that the most important aspect of the struggle was not just to produce counter-images, but also how [they were produced], who [produced them], for whom, and for what [purpose]."[115] The struggle for both the state and image makers, according to Delpelchin and José, was to resist producing "images and histories" as consumable commodities, but instead to defend the "principle of letting the producers remain the masters of their images and their histories."[116]

Members of Frelimo's Comité Central and key government agencies, like the Ministério da Informação, had interpreted their party as "the producers" and "masters" of images of the liberation struggle and the nation's history.[117] The political protests and unrest that came with the transition and independence increased pressure on the Ministério da Informação to strengthen the government's control over the press and image-making institutions left behind by the colonial state. The vision of President Machel and his other deputies prioritized and reaffirmed the need for a state-controlled press unit when the Frelimo formalized in 1977 its standing as the ruling party and adopted a Marxist-Leninist platform. According to Rebelo, the party was the ideological guide for the nation and its government.[118] Photography was one aspect of a larger information-gathering system and technology that needed to serve the party. He stated,

> The main challenge [at the time of independence] was to make sure that information would serve the interest of the party. Why the party? Because the party was the ideological guide of the country. From [the] liberated zones [came] a certain set of principles, ideals, rules which we wanted to

be followed. In the period after independence, information should be the vehicle, the instrument to spread these principles [and] these values. It was the party that guide[d] us, parliament and government . . . The party would work to disseminate this plan and convince people to . . . follow [and] to implement it.[119]

Agencies within the Ministério da Informação, including DNPP, and working groups organized by the ministry issued clarifications about how images were to function as publicity and propaganda. These entities also produced directives for how the Ministério da Informação could bring image-making institutions like the INC further under its control. For example, Rebelo addressed the workers of the printing and photography industries, telling them that they and the work they performed ensured socialism's success.[120] The work of the state under the party was no longer only about Frelimo's technical capacity to produce images. Rebelo's statements reflected a larger shift in terms of the work of state bureaucrats to reframe and manage the relationships populations developed in relation to Frelimo's printed image. For Frelimo officials charged with the gathering and use of information during the 1970s and 1980s, a productive tension existed between visual evidence and textual attempts to control not only what appeared in the picture frame but also how audiences received images.

The removal of advertisements created space in newspapers for the press to publish content that reinforced the state's control over how photographs and other illustrated images circulated. Colonial-era commercial studios, which had advertised their products and services in newspapers, closed at independence. The planning of editorial content helped compensate for technical mishaps such as nonoperational printers and the lack of photographic and printing supplies. The new government objected when *Tempo* printed violent photographs along with illegible, poor-quality, poorly planned, and violent comic strips.[121] Editors received written instructions to select advertisements on the basis of whether they promoted "bourgeoisie tendencies," whether they used "revolutionary expressions" to describe "superfluous products," and whether they depicted "a very stylized image" accessible to limited audiences.[122] Instructions also specified the selection of photographs that depicted "the working environments of the working and peasant class."[123] Party officials blamed journalists and photographers' political dispositions when they failed to follow the political line; technical failures with cameras

and other photographic materials were not considered valid excuses. Party officials' exchanges with media professionals over news content only generated more reports on the miscommunication between journalists and photographers. State officials determined a lack of collective work and inconsistent working hours for those who produced newspapers' photography sections.[124] In order to address these perceived issues, planning documents advocated for the production of manuals that included information on concepts of Marxism-Leninism, history, and economy.[125]

Endless supply shortages afflicted the press and printing industry. Frelimo's Ministério da Informação and Gabinete da Presidência found ways to celebrate and define the work of the state while rationing photographic materials. In 1977, at the time it adopted a Marxist-Leninist platform, Mozambique's national printing press managed to publish its first photography book, featuring photographs organized around the themes of colonial war, the armed struggle, independence, the creation of the party, and an alliance between workers and peasants. The writer and presidential adviser, who worked with Ricardo Rangel and recommended him as a photographer to President Samora Machel, Luís Bernardo Honwana, said there were conversations under way in 1977 about "the necessity of photography as [a] process whereby communities assert themselves" along with "a movement" to assemble photographs into albums.[126] For Honwana, all things involving photography were not "political," but instead part of a larger project to encourage photographers "to portray a new reality."[127] Some people's only contact with the book was a series of three articles published in *Tempo*. The articles characterized the book of photographs as "a treasure," "a thesis, school, and door," and a "literacy manual."[128] Accompanying the articles were never-before-seen photographs of the printing press, scenes that depicted photographs as replacing text. The article's text elaborated on the belief that photographs reduced the quantity of text printed. The text juxtaposed "disorganization, absences, and lines [of people]" with the state's own capacity to govern in spite of technological deficiencies.[129] For example, during the printing phase, workers discovered spelling errors even after officials reviewed the final proofs.[130] Nevertheless, the project supposedly remained uncompromised. There were plans for a second edition for international distribution. Rhetorical pronouncements surrounding the photobook were no different from the internal efforts of government ministries and those of state-run media to produce photographs and to intervene in how people viewed photographs in their daily lives.

WHAT DID THIS ALL LOOK LIKE?

Frelimo's Ministério da Informação attempted to control the media using ideologies and photographs that it had developed in the context of the liberation movement. At the time of its war with Portugal, Frelimo's DIP and DRE offices had understood that photographers and the subject matter of their pictures served the organization's ideological advancement and developed certain classifications for the treatment of photographs (as outlined in chapter 2). In retrospect, some Frelimo leaders, such as Jorge Rebelo, believed that photographs should have been labeled for the benefit of historical perspective.[131] At the time of the war, what was important was the future, and the future was independence.

The photographs of the liberation war had functioned as propaganda, but independence demanded different ways of looking back at the struggle's history. Thus, photographs of the liberation struggle were not merely photographic prints that Frelimo's DIP had produced under extreme conditions. Processes of visualization, writing, and speaking generated images of the liberation struggle long after the war, determining how people in Mozambique viewed the nation's history long after independence. The chapter's final section addresses the photographs and illustrations generated by state officials' use of the photographic bureaucracy, and the views that photographers crafted in response to how officials filtered images of the liberation struggle into and out of public view.

Between 1975 and 1981, photographers and their editors had developed new ways of seeing that challenged the state's bureaucratic impulses and aesthetic preferences. Public uproar and government outrage surfaced around a series of photographs by José Cabral published in *Tempo*'s April 1978 issue under the headline, "This is how we are born."[132] The feature (figure 38) included nine photographs of a childbirth, one of which showed a child coming out of the mother's vagina. Despite expressing some apprehension about publishing the series, the extended caption noted that women consented to having their photographs taken and expressed "astonishment" at seeing their images.[133] *Tempo* initially justified the publication of the photographs on the basis that they had helped women and men alike to see what they only knew abstractly. Cabral himself said he had tried to show "how people were born."[134]

The magazine sold out before the state could take it off the newsstands. Two weeks after the publication, *Tempo*'s director retracted the story and described Cabral's photographs as "shocking" and "aggressive," especially due

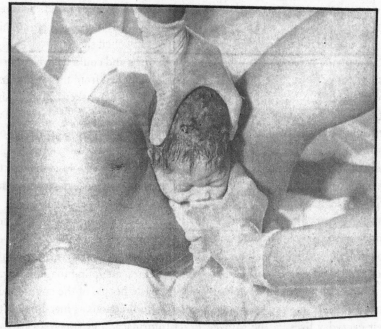

É ASSIM QUE NASCEMOS...

Apontamento fotográfico de José Cabral

Tinham-nos dito. Duvidámos um bocado, e experimentamos. O Cabral fez as fotos e mostrámo-las a algumas mulheres. De facto era verdade... A reacção foi de espanto, de admiração, na maioria delas. Não sabiam que era assim, que nascemos. Afinal sai assim... depois vira-se... Mesmo mulheres que já tinham tido filhos... E os homens... Era bom experimentarem... Já que não podem, é bom verem, para ficarem com uma ideia... Por isso resolvemos publicar as fotos.

TEMPO N.º 391 — pág. 27

Figure 38. José Cabral, "É assim que nascemos . . ." ("This is how we are born . . ."). *Tempo*, No. 391, 2 Abril 1978, 27, accessed through Arquivo Histórico de Moçambique, Maputo, Mozambique, accessed through interlibrary loan at Bard College.

to their "crudeness," and how readers' "reactions to the photographic works" revealed "the subjectivity" and "anti-scientific" nature of reporting.[135] For readers, including many members and sympathizers of the Frelimo state and its socialist project, what a person could view with his or her eyes was not always suitable to see through the photographic medium.[136] For the quoted readers, photography required greater caution than writing. Readers believed that photographers should not have photographed particular images and that editors needed to publish photographs that did not elicit shock.[137]

The public response arose from cultural norms and could have been predicted. Public outrage at Cabral's photographs extended from the notion that it was "taboo" to see "where you came from."[138] When asked whether she thought the photographs were beautiful, Narcésia Massango, who worked at *Tempo* as an archivist at the time of the controversy, expressed the opinion that the images were better suited for a scientific or medical publication.[139] She added, "What was I supposed to do if my three-year-old son came to me and said, 'Mama, what is this?'"[140] The response from Massango, and the larger public in Maputo, was part of a larger history of visual literacy.

In the years after independence, the state had used cartoons and other visual media to mobilize public support and to instruct the public in how to look at images. Image-making institutions such as the INC discovered that people misread posters for the building of latrines, assuming that the X was an affirmative and not a negative symbol.[141] Also, people of the countryside interpreted arrows used on posters to point out directions as meaningless to their everyday lives.[142] The Ministério da Informação developed a cartoon, *Xiconhoca*, which acted as a filter and corrective to photographs published in newspapers and the magazine *Tempo* and was intended to help readers act in the service of the state.[143] The word *Xiconhoca* consisted of two words, *Xico*, an abbreviation for the word *Xico-Feio*, a popular phrase referring to a collaborator of the Portuguese state,[144] and *Nhoca*, which translates as "cobra" in many eastern and southern African languages. The character Xiconhoca was readily identifiable to viewers as an overweight male figure who sometimes wore suits and at others times was not fully clothed, and he carried an opened bottle of alcohol and a soruma leaf (i.e., marijuana) in his pocket.[145] Xiconhoca was a gossip and rumor-monger.[146] The cartoon appeared in newspapers and government bulletins and depicted scenes of government offices, ration shops, and the countryside. In one example (figure 39), the state subjected itself to critique by depicting bureaucrats as "Xiconhocas" who worked in offices surrounded by paper. Xiconhoca held pieces of paper in front of a

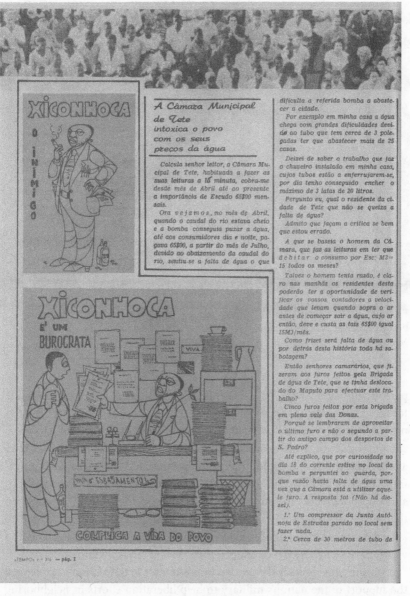

Figure 39. "Xiconhoca." *Tempo*, No. 316, 24 Outubro 1976, No. 316, 2, Instituto Nacional de Cinema, Maputo, Mozambique, accessed through Arquivo Histórico de Moçambique, Maputo, Mozambique and interlibrary loan at Bard College.

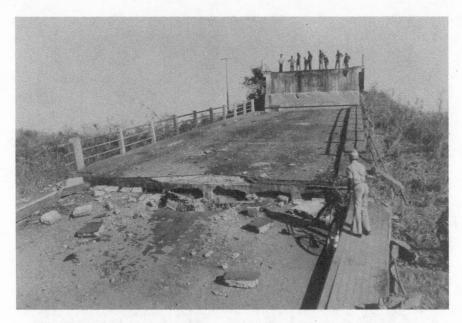

Figure 40. Ricardo Rangel, undated, "Guerra da destablização" ("War of destabliza-
tion"). Caixa: Guerra Civil, Centro de Documentação e Formação Fotográfrica, Maputo,
Mozambique.

person who stood with his hands folded as if begging for something. The
text read, "Xiconhoca is a bureaucrat. He complicates the life of people" (fig-
ure 39). Another scene illustrated how people used the act of seeing to iden-
tify unproductive workers and to address situational problems such as lines
and overcrowding.[147] People frequently appropriated the term "Xiconhoca"
into everyday parlance, and used it to label behaviors such as theft, bribery,
and unproductivity. The state issued directives in the form of captions on
the impact of using the word in daily conversations. Xiconhoca served to
keep the public reception of circulated images aligned with state agendas and
views. Photographers too developed their own approaches and outlooks.

Mozambique quickly descended into war after 1975. Frelimo had pledged
the support of the nation's military to help liberation efforts in neighboring
Rhodesia. Photographers such as Ricardo Rangel found themselves picturing
the aftermath of retaliatory attacks launched by Rhodesia's prime minister Ian
Smith. Thirty-five years after the war, Rangel spoke about the photographs
he produced from 1975 to 1980. He characterized his explicit concerns and

responses to the constructedness and representational nature of Frelimo's power in the following terms:

> My life changed [with independence in 1975]. It was euphoria of freedom, we could talk about anything, take pictures of anything . . . but it didn't last long. Censorship, that didn't exist outside now existed inside [of] us. I used to say: You won't be able to write in a censorship-free media. That's what happened. In my case, I always shot what I saw, if it got cut, too bad! But my drama was that afterwards, I couldn't denounce the government. Who am I supposed to criticize? I'm a guy [in a] war of intervention . . . but whenever I saw a destroyed bridge, I couldn't take a picture for the enemy not to find out . . . what was that for?[148]

Rangel had understood the transition, the handover of rule of Mozambique from Portugal to the liberation movement Frelimo, in two respects. First, the colonial state had prohibited him from taking many photographs. Independence presented new opportunities for publishing previously censored pictures and to continue in the social documentary tradition that he crafted. However, to publish photographs from years past, Rangel had to allow the press apparatus that was slowly coming under the control of Frelimo to caption prints as officials saw fit. The captioning of photographs involved adding text that was not necessarily in line with Rangel's own political views and aesthetic philosophies. For journalists and officials aligned with Frelimo, Rangel and other photojournalists' pictures were of great interest for their documentary qualities. However, the photographs of Rangel and others did not always show Frelimo in the ways that the Ministério da Informação and the Gabinete da Presidência wanted to depict the party's power.

Rangel considered his photographs from the first years of independence to be in direct conflict with what he characterized as an implicit policy not to photograph certain scenes. In the context of his own photographic archive, he developed and responded to the growing sense of self-censorship, keeping prints of photographs of bridges, for example, which newspapers did sometimes publish, but not regularly. For Rangel, photographs like figure 40 introduced certain historical revelations that prompted forms of reinterpretation and redress. Rangel believed that the practice of self-censorship diminished his ability to critique, which directly connected to his understanding of independence as the ability to speak and take pictures freely. Rangel used the widespread act of self-censorship among many photojournalists in the late

1970s and early 1980s to question the political project at hand. In contrast, Rebelo characterized self-censorship as a sign of loyalty:

> The interesting phenomenon . . . [was that] because of [the] new climate, the journalists [began] to identify with Frelimo and with Frelimo ideology. So, they themselves produced some kind of self-censorship, *auto-censura*. So, if there was an article, the [editorial] board would feel this would not be agreeable to Frelimo, would create a bad image, [so] they themselves [the photographers] would cut it.[149]

Rangel had positioned his photographs of subjects such as bridges in opposition to the official and accepted historical narrative of the time. In so doing, he also raised the possibility that Frelimo ideology impeded photojournalists from picturing the land war then under way.

Rangel's observations, along with study of José Cabral's birth photographs and Xiconhoca, put forward new conceptual models for understanding the filters that state officials generated and enacted through the operation of the photographic bureaucracy. The reframing of popular ideas about what constituted photography introduced another set of questions about what type of evidence photographs of destroyed bridges were. The state was left to determine what it would do with such images, especially because attacks continued with increasing frequency after Zimbabwe's independence in 1980. How did photographs that came to represent periods of counterinsurgency, or as their titles stated, "destabilization," fit into the narrative of liberation that was both foundational and fundamental to the claims of power that Frelimo's government and party realized through its use of the photographic bureaucracy? How did photographs inhabit state bureaucracies and influence image-making practices? How did state bureaucrats along with civilian populations come to see and interact with photographs long after their initial production? The next two chapters address these questions, first from the perspective of identification documents and then that of the news-wire agency Agência da Informação de Moçambique.

ID'ing the Past

There was an overlooked, and ironic, aspect to nationalization in Mozambique. At the transition in 1974, government laws prohibited departing studio owners from taking their photographic equipment. Departing settlers had to abandon their commercial photography businesses. The state's acquisition of photographic studios, cameras, films, and darkrooms laid the foundation for state officials to develop a "photographic bureaucracy," and reflected a change in how state and nonstate actors alike were able to use photography. The rapid expansion of the state's photographic capacities failed, however, to compensate for the urgent need to identify and register populations. Officials charged with operating the photographic bureaucracy lacked the capacity to produce headshots for identification. After 1975, the responsibility for producing headshots rested squarely with photographers who roamed the streets or with photography studios that operated with the help of government assistance.[1]

In advance of Mozambique's official independence in 1975, the interchange between official and unofficial photography ended. From 1974 onward, studio-based photographers would no longer provide state-run press units with photographs for publication. Frelimo, which came to power in 1975, had its own photographers and understood the power of photographs very differently than civilian populations in urban centers. Due to popular demand and supply shortages, studio-based photographers would have to cease making family photographs and full-body shots. They had to adjust their services to provide customers with the headshots necessary for government-issued identification. The disappearance of colonial-era markers of official and unofficial photography generated a complicated political and social situation in Mozambique.

Despite issuing a range of identification papers based on race, the colonial state had left many black populations without identity cards and passports.[2] A marginal segment of Mozambique's black population, classified by

the colonial state as *assimilados*, had documents that functioned something like the passbooks used in neighboring South Africa.[3] Because these forms of identification were irregular and varying, the state apparatus under Frelimo in 1975 lacked individual files and registries for most Mozambicans. Furthermore, the various government agencies charged with issuing documentation, including the Ministério do Interior and Ministério do Trabalho, found little use for the family photographs that people previously used for colonial-era identification.[4] Thus, the majority of people living in Mozambique at the time of independence were not only undocumented, they lacked photographs of use for government documentation processes. Between 1975 and 1994, people presented themselves in front of cameras because they needed photographic headshots. In the context of taking and viewing headshots, people, including photographers, confronted the surveillance practices deployed by the postcolonial state and its predecessor.[5] This chapter explores changes in photographic portraiture after independence and how populations in Mozambique experienced and responded to the issuing of government identification once they needed to produce their own headshots.

Even though it failed to provide populations with individual headshots, the Ministério do Interior and the other government agencies under its command, such as the Registo Civil, introduced a series of identification documents from 1975 to 1982. The newly introduced forms of identification had their origins in the liberation struggle and ranged from the *guias-de-marcha* to the *cartão do trabalho* to the *cartão do residente*. During the times of famine and war that gripped Mozambique after independence, state officials relied on these forms of documentation as a type of filter to distinguish people as workers, unemployed, residents, and nonresidents. For example, in 1983, the Ministério do Interior launched a large-scale relocation scheme called Operação Produção, seeking to remove undocumented persons from overcrowded cities like the capital Maputo. The verification of documents in people's possession from 1983 onward served to identify people without proper documentation, and it involved officials at the national and local levels touching and looking at people's documents.[6] This chapter charts the forms of identification that the Frelimo state introduced from 1975 to 1994, and addresses the book's overall themes of filters and filtering by exploring state use of photographs to identify populations and to broadcast its authority, especially in light of the 1986 death of Mozambique's first president, Samora Machel.

Documents had to be verified by state officials. But after 1983, as the state embarked on a controversial relocation scheme, Frelimo representatives at

the local and national levels failed to give people the documentation they needed, even when people had been identified based on expired or missing documents. The absence of photo identification became apparent, and had consequences for state structures, the media, and people's lives. Press photographers charged with photographing members of the state and government reforms produced some of the only visual records of popular attempts to obtain documents and state efforts to relocate populations. The circulation of these particular images had varying effects on how populations were able to view the Frelimo state and how the state asserted its power after independence. In the end, the ruling Frelimo party and government found itself in a position of replicating the surveillance practices and modes of seeing adopted by its colonial predecessor, Portugal, and the colonial state Portugal had established in Mozambique.

A history of photographic portraiture and studio photography in independent Mozambique is needed, especially when one considers how government agencies under Frelimo's direction relied on the presence or absence of headshots to make populations and state power more legible. The transition period of 1974 to 1975 brought into view the highly contingent and long-standing processes of identification and documentation employed by both the colonial state and Frelimo in their respective fights over Mozambique. The chapter's first section considers how populations used identity documents along with photographs of them at the end of Portuguese rule to express certain grievances over colonialism, and how popular use of headshots from 1974 to 1975 and officials' demands to see them exposed the surveillance practices adopted by the colonial state. For most of the liberation struggle, Frelimo lacked headshots of its members and the populations it represented. Frelimo's Departamento de Informação e Propaganda (DIP) had used its photographers to produce a collective image of liberation, not a collection of individual images. In the months before the announcement of the transition government, Frelimo's president, Samora Machel, paraded the liberation movement's enemies before the public and media in Tanzania. As the second section illustrates, Frelimo's public and in-person presentation of its enemies was one of many factors during the transition that marked the repositioning of portraiture as a mode of self-expression in the broader context of the history of photography and surveillance that unfolded in Mozambique.

How Mozambicans viewed images of themselves radically changed from 1975 to 1994. Frelimo officials used portraiture oppressively, moving people from urban to rural areas based on the absence of identity documents. The

third section looks at how government officials at the local and national levels used identity documents in the forced removal program Operação Produção and how people responded in the context of the lines where they stood for identity documents and food. Two years into Operação Produção, President Machel and members of his cabinet died in a plane crash. The production and reproduction of Machel's image in the wake of his death, the topic of the fourth section, granted portraiture a more "honorific" quality. Joaquim Chissano, who Frelimo's Central Comité installed as president of the party and in effect Mozambique, and Chissano's cabinet used portraiture to redeem the fallen Machel and re-elevate the state of the Frelimo party. The circulation of Machel's image by Frelimo and decisions of Frelimo's Comité Central to memorialize its first president, Eduardo Mondlane, resituated and reasserted the party's control over the realm of the visual and marked a new stage in the party's control over Mozambique.

It is easy to forget that after 1980 and in advance of Operação Produção, Mozambique was at war with neighboring South Africa. Also, within Mozambique, an internal opposition to Frelimo was gaining steam with support from South Africa. The Rome Peace Accords of 1992 and the first democratic elections of 1994 marked the war's official end. In the final section of the chapter, I will discuss how the long years of war and repeated dislocation of populations across Mozambique created a situation where people lacked photographs of their loved ones. In the absence of photographs and identification, people lined up for voter cards to cast their votes in the first elections. Here, photography and bureaucracy came together like never before. The final section of the chapter explores the terms under which civilian populations and the state under Frelimo's control came to identify each other at the end of the war.

FROM THE ASHES

The secret police force, Polícia Internacional e Defesa do Estado (PIDE), used photographs in their surveillance work in Portugal's colonies. PIDE's activities entailed working with government officials and civilians across Portugal's overseas provinces to identify populations, to monitor the issuing and use of identity documentation, and to prosecute individuals, including photographers, for criminal acts. As part of this work, PIDE collected photographs and organized them into individual albums.[7] The photographs ranged from pictures of group gatherings at restaurants to studio portraits.[8] Among the

latter, there were *retratos*, pictures done for personal use that depicted sitters with tilted heads and smiling, and *fotografia*, the term used to refer to photographs associated with identity documents.[9] A characteristic of *fotografia* was that sitters directly faced the camera, showing both of their eyes, and with a neutral facial expression. It is possible that the images considered *fotografia* were duplicates of prints intended for state-issued documentation. The collected pictures vary in size and content, suggesting that PIDE neither took the photographs nor had a staff photographer. The organization of the prints in an album demonstrates how PIDE's identification processes intersected with popular modes of photographic representation and viewing.

The military coup of April 25, 1974, thrust PIDE's internal photographic collections and their use into public view. Three weeks after the coup, Portugal's *O Primeiro de Janeiro* printed the headline "Visit to the Installations of the Sub-delegation of PIDE/DGS," and reported the discovery of the files. According to the article,

> Thousands, many thousands of files were under investigation, where the private life of each citizen [was] dissected to the most insignificant detail. All of this [was] supported in large volumes of paper with photographs— not only of those previously investigated but also people considered potentially dangerous.[10]

As PIDE officials in Portugal and in parts of Portuguese-speaking Africa anxiously burned files, destroying evidence of their visual economies of surveillance, rumors about PIDE activities in Lisbon fueled a public outcry about the authoritarian, intrusive state.[11] Portuguese citizens initiated a conversation about the necessity of disconnecting police practice from the routine bureaucratic production of identity documents.[12] Meanwhile, in Mozambique, state officials and a new generation of photographers made photography a central plank of a state in transition from colonial rule to independence.

Journalists in Portugal discovered photographs previously used by PIDE, while their counterparts in Mozambique produced a new set of photographs, not based on found pictures, but rather on Frelimo priorities such as inverting the colonial narrative that had criminalized Mozambican nationalists and black Africans. Political prisoners were released, and two days later the local Mozambican newspaper *Notícias* reported, "They all believe in the future of this land: Moments of happiness and emotion underscore the return to liberty of political prisoners."[13] A two-column front-page photo depicted a man

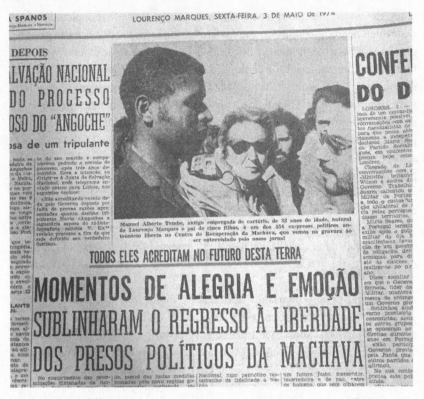

Figure 41. "Todos eles acreditam no futuro desta terra" ("They all believe in the future of this land"). *Notícias*, 3 Maio 1974, 1, Biblioteca Nacional de Moçambique, Maputo, Mozambique.

with a microphone near his face as others listened (figure 41). The caption identified the man as one of 554 political prisoners and as thirty-three years old with five children. Published photographs of this moment showed men, women, and children with their backs to the camera in front of the prison doors.[14] In another photograph, people shook hands, a popular method of introduction.[15]

In the flurry of the transition and the release of former political prisoners, no one worried about consent to being photographed. Instead, photographers emphasized new lines in a visual story. Photographs printed in daily newspapers imposed the label "ex-political prisoner" on the photographed subject. These were new national heroes. Published prints showed onlookers standing in the background, some of whom were merely present to meet the

prisoners. The black-and-white film stock and the camera's intrusive position imposed a color line. Blacks, who had microphones to their faces, hugged and looked on; they appeared to be former prisoners or people waiting for their loved ones. Whites, on the other hand, looked as though they were there to offer a helping hand. But as the uncovering of PIDE activities in Portugal and popular memory in Mozambique illustrated, whites too were under PIDE investigation and were imprisoned.[16] The black-and-white *Notícias* prints brought these modes of identification, or color lines, into relief. The new state encouraged photographers and journalists to invert the racial priorities of the colonial state.

Following the prisoner release in 1974, the less-publicized "Operation Zebra" resulted in the identification and arrest of over two hundred PIDE-affiliated individuals. The discovery of two hundred deaths during colonial times precipitated questions about PIDE's mandate.[17] Frelimo's and Portugal's military arrested PIDE officials.[18] This act allowed the public to place names to faces and faces to names. After surveying PIDE facilities, journalists reappropriated photographs of the colonial state to identify PIDE agents. In 1974, the weekly magazine *Tempo* ran a three-part story on PIDE activities, featuring photographs of empty jail cells, the infirmary, an empty document repository, and PIDE agents.[19] According to the series' bylines, the staff photographers Ricardo Rangel, who PIDE arrested in the 1940s, and Kok Nam photographed the published prints.[20] The writer of the stories, Calane da Silva, recalled how he along with Nam and Rangel frequented the "bars" and "cabarets" of the Rua Araújo (discussed in chapter 3), where many PIDE agents and officials of the colonial government met for "a cup of beer" or a "show."[21] To da Silva's amusement, Rangel frequently traveled with his camera on these outings, secretly photographing colonial officials.[22] There were about thirty pictures, which Rangel took between 1972 and 1973, and da Silva stored them at his mother's house.[23] In a sign of the impact of these photographs and the tensions that marked the years leading up to 1974, da Silva suspected his mother's house cleaner had seen the pictures and promptly disappeared.[24] In his words, "it was a scandal."[25] Many people did not realize that they had either known or interacted with PIDE agents.

In August 1974, *Tempo* printed the headline "Two Hundred PIDEs on the Loose . . . Who Has Complaints against Them?"[26] Included with the article were thirty-six pictures of PIDE agents in the style of both *retratos* and *fotografia*. Another photograph was a close-up of the ex-DGS director. Editors produced this portrait-like image of the ex-director by cropping his face

from a picture of him standing next to other people at an official state cere-
mony. The publication of these photographs helped identify PIDE agents and
aided in popular efforts to prevent them from fleeing the country. Journalists
and other nonstate actors had used the PIDE's tactics to get back at them, but
with a twist. The *Tempo* article stated:

> With regard to PIDE agents, we think it [is] necessary to render a good ser-
> vice to the authorities (if they have good intentions as they said) and second
> publish a few dozen photographs of agents and other elements of the extinct
> PIDE-DGS who [were] freed. In order for justice to be served and above all
> for the tranquility of our consciousness, they [PIDE] should stay here. . . .
> [A]ny crime committed by any of the photographed individuals [should im-
> mediately be addressed by] the military authorities.[27]

In other words, identification should not lead to "popular justice," but to
taking former PIDE agents to state authorities. The developing independent
state and the fascist state in Portugal used similar photographic practices to
identify "enemies." Printed photographs included markings from stamps,
suggesting their possible use related to colonial-state-issued documents, and
to local practices of studio photography. Journalists in Portugal uncovered
similar types of photographs, but of individuals under PIDE investigation.[28]
Interestingly, newspaper editors and photographers in Mozambique repur-
posed the very images generated through the photographic complex asso-
ciated with *fotografia* (discussed in chapter 1) to identify PIDE agents and
other individuals associated with the colonial state. The archiving and polic-
ing that PIDE agents performed through collecting and viewing *retratos* did
not escape photographic documentation.

Following April 25, 1974, journalists in Portugal and Mozambique uncov-
ered the destruction of the photographs and paper archives that PIDE had
amassed.[29] In Portugal, photographs sometimes escaped destruction, but
most did not.[30] In Mozambique, a new photographic image of prisoners jailed
by PIDE was possible with their release and the arrest of former PIDE agents.
On seeing the PIDE prison on the outskirts of the colonial capital and observ-
ing the arrest of PIDE agents, the former political prisoner Aurelio Amércio
Mondjane reflected,

> I was deeply grateful to witness at the prison the arrest of the agents outside
> of the door that during four years prevented me from seeing the landscape

of Lourenço Marques. It amazed me to see the wives of the officers of the police refuse to be photographed, saying that [the photograph] was to present a misery that had passed. What surprised me was, that during these years, they [the wives] had never realized the miseries that their husbands did to us [the prisoners], and only now, when they suffer just punishment, they realize. But it appears that few have realized.[31]

Mondjane valued the opportunity to see and have photographed the arrest of the PIDE agents, who denied him his life outside of prison and the possibility to see his image outside of the context of his arrest and imprisonment. Attempts by PIDE agents and their loved ones to withdraw from the photographic frame surprised Mondjane. For Mondjane, photographs of arrested PIDE agents held the promise of uncovering past injustices, and were more important than his own photographic image. Multiple understandings of portraiture and ways of looking at past histories of colonialism surfaced around Mondjane's and others' popular and journalistic attempts to see and to use photographs of PIDE agents. The uses Mondjane and others assigned to photographs in this period of transition conflicted with the ideologies and appropriations of photography adopted in the same period by the liberation movement Frelimo.

LIBERATING PORTRAITURE

As a liberation movement, Frelimo had little use for the image and language of portraiture. Before Frelimo's Departamento de Informação e Propaganda (DIP) arranged to train its soldiers as photographers, DIP head Jorge Rebelo traveled to sites where Portugal's soldiers surrendered or deserted with a camera.[32] Rebelo stated, "I used to take photographs. It [the Olympus] was good because it could take seven photos at a time. Very small but when enlarged, the quality was very good."[33] Rebelo took photos of Portuguese military deserters to highlight the military's weakness and its failure to hold on to the colonies and compel sacrifice. Also, Frelimo's DIP used photography to influence how native Mozambicans identified with the liberation movement before and after the struggle. This process of enlarging photographs of itself left Frelimo's political elite to contemplate and articulate the movement's ideological views of portraiture.

Until independence, Frelimo's DIP and its Departamento de Relações

Exteriores (DRE) had lacked the technical capacity to produce individual portraits of its leadership. In the first years of the liberation war, DRE relied on an Asian-owned studio in Dar es Salaam, the Studio Hiros, to produce the portrait of its first president, Eduardo Mondlane, and to develop film gathered by its members, such as Rebelo.[34] This "honorific" use of photography aimed to make leaders recognizable and brought them nearer to the public, despite their being in exile. Printing delays also prevented Frelimo from delivering an image of its leader to the liberated zones in a timely and consistent fashion.[35] In one respect, DRE's experiences with the Studio Hiros raised organizational suspicions of espionage. To cut costs and delays, Frelimo's DIP, with the help of DRE and the organization's solidarity network, established its own photo laboratory.[36]

The concept of portraiture in the form of a full-body photograph or headshot as an image of the self conflicted with the liberation movement's ideological platform and political agendas. This view of portraiture resonated with Frelimo's socialist sensibilities as a movement and the collectivist ethos they promoted. They were building the nation, creating shared identity, without disrupting the fragile racial, ethnic, and gender coalitions that defined its membership. Individual photographers and their identities as such took a back seat. Photographs were not signed or marked with the name of the photographer. Instead, the movement claimed authorship of the images. Rebelo underscored the primacy of the movement in propaganda:

> We were aware [that collective production] help[ed] our cause. For us to succeed, we need[ed] the participation of everybody. My role [was] small. In the general context, what I do as [a] question [was] not so important. But, if I manage to produce something useful [or] good, I don't need to say I, Rebelo, did this.[37]

When issues of authorship surfaced, Frelimo's leadership developed suspicions about its enemies. In this we see that collectivism shaped aesthetics as much as production practices.

Frelimo's military and diplomatic arms wanted to use photography to show strength in numbers, not to count heads and impose taxation like its Portuguese enemy. Frelimo's DIP disregarded the names of photographers, instead choosing their photographers based on their familiarity with specific regions inside Mozambique. The liberated zones were isolated. According to José Oscar Monteiro, another member of Frelimo's propaganda and diplo-

matic unit who worked with Rebelo, a person could be with ten people or five hundred and still have no awareness of the war's "progress."[38] Visually, Frelimo wanted to disrupt what Monteiro called a "colonial iconography," one that showed a white society, and not a black one.[39] Photographs by Frelimo attempted to displace colonial imageries to allow people to recognize, "this is my school, this is my military base, there are the soldiers," and to blur the distinctions between the liberation movement Frelimo and the future independent Mozambican state.[40] One way that DIP achieved such a vision of Frelimo—a way that made for good politics and a "strong message" and did not require members to have individual headshots—was when Frelimo photographers filled their images with female combatants and civilians.[41]

In advance of independence, Frelimo's DIP revisited and reconfigured the modes for identifying its enemies that it had developed during the liberation struggle in relation to its own expanding capacity to access and use photography (figure 42). Frelimo was more restricted and muted than the Portuguese military and colonial state in its photographing of the enemy. During the colonial war, Portuguese soldiers had photographed themselves and their comrades; they also used their cameras and films in the context of recreation and reconnaissance to photograph populations native to Mozambique, some of whom had abandoned Frelimo. The military printed the gathered photographs on pamphlets, which soldiers distributed by airplanes. The aim was to encourage local populations to abandon Frelimo. In contrast, Frelimo's enemy was not only the Portuguese authoritarian and colonial states, but also internal elements in Mozambique that disagreed with the organization's political platform. For example, Lázaro Nkavadame was a Frelimo head in Cabo Delgado, but after disagreements over military strategy he joined the Portuguese in their fight; he featured in Portuguese propaganda as an example of Frelimo desertions. Similarly, Uria Simango, after being passed over for the presidency after the killing of Frelimo president Eduardo Mondlane, wrote a report critical of Frelimo, and faced suspension before his ultimate dismissal.[42] Frelimo used photography to excise Simango from the leadership, not by destroying old photographs, but by taking new photographs of its leadership.[43] In the words of Rebelo, a time came when it was unnecessary to show Simango.[44] Frelimo soldiers also photographed Portuguese military deserters and those it had captured, and these photographs served to confirm that Frelimo did not kill the Portuguese. These specific pictures helped in negotiations with Portugal and the international community to establish a cease-fire and a transition government.[45]

FRELIMO MILITANTS EXPOSE TRAITORS

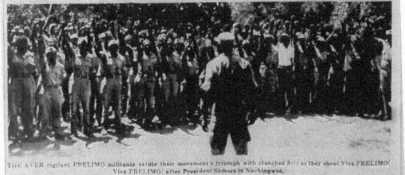

Figure 42. Marcelino Komba, "Frelimo Militants Expose Traitors." *Daily News* (Tanzania), March 30, 1975, Centros Estudos Africanos, Universidade Eduardo Mondlane, Maputo, Mozambique, accessed through interlibrary loan at Bard College.

Interestingly, three months before independence, while in exile, the Frelimo president, Samora Machel, paraded "traitors" in front of international journalists.[46] Machel himself confronted the "traitors," who included Nkavadame and Simango, on their accounts of their roles in the liberation struggle. At one point, Machel corrected Nkavadame for saying he was not involved in Mondlane's death and that he learned of Mondlane's death over the radio.[47] Audiences responded with laughter to Machel's comments and gazed at the subjects before them.[48] The journalist for Tanzania's *Daily News* used the language of portraiture to describe how the looks of these "traitors" corresponded to their regrets about the past, and concluded that one of the traitors wanted to be somewhere else, an observation that suggested that he and possibly the others displayed had little say in their being photographed.[49] The news publication of six "traitors" (figure 42) with their names explicitly contradicted the self-fashioning dimensions generally associated with portraiture. In other African nations at independence, photography was democratized, and it proliferated.[50] In this instance in Mozambique's history, at a moment when it was neither a colony nor an independent nation, Frelimo's military cadre and the journalists present introduced a gaze of censure and surveillance that was akin to that of the PIDE picture album. Furthermore, history would show that Frelimo's political apparatus killed Simango.[51] In this instance, Frelimo's political leaders privileged photography. In the process, it was through this use of photography that they masked the more secretive elements of exercising control and asserting power, such as the display and killing of perceived enemies.

The liberation movement's concern over identifying its enemies acquired new ideological urgency, and hence photographic dimensions, as Frelimo appointed a transition government to assume control in late 1974 over Mozambique's administrative bureaucracy. Frelimo confronted political opposition in the form of protest, and there were also mass departures. The use of identification documents elevated civilian and government anxiety. Mozambique was also subject to the anxiety over surveillance that surfaced in Portugal around state-issued identification. At the time of the transition and in the immediate years afterward, populations who had settled in Mozambique used colonial-era documentation to establish their right to citizenship in Portugal. Simultaneously, Frelimo's Ministério da Informação and Ministério do Interior discovered that many populations classified under the Portuguese regime as *indigena* were without photo documentation and had never seen a headshot of themselves.[52] Independence and the bureaucratic

reforms that Frelimo instituted afterward involved Frelimo addressing its recognition of colonial-era documentation and issuing directives regarding its positions. Civil servants working for the Frelimo government rejected identification issued by Portugal and its colonial state. In response, the Ministério da Informação acknowledged the validity of colonial-era documentation as a form of identification, but not as proof of nationality.[53] Only identity cards issued after independence proved nationality.[54] The reuse of colonial documentation generated more uncertainty, and exemplified the challenges that Frelimo faced when registering populations, who were keenly aware of the colonial legacies of documentation.

Frelimo situated and defended its political standing by changing how civilian audiences viewed a person's identity through photographs and by reorienting the public's desire to be photographed. Following its rise to power, Frelimo faced attacks from neighboring Rhodesia over its support of other southern African liberation movements. Concurrently, Frelimo discovered people affiliated with the colonial Portuguese regime working for state agencies and feared that they would flee Mozambique to assist the Rhodesians.[55] Without articulating any rationale, Frelimo's government assigned a larger role to commercial photographers within the broader context of state projects: it relied on them to produce *retratos*, or portraits, of civilian populations for identification purposes. To alleviate any political repercussions, Frelimo ordered that the names and photographs of the *comprometidos*, or "compromised," the term assigned to former colonial agents, be posted at residences and workplaces.[56] The state required those identified as *comprometidos* to supply their own headshots, which in effect required them to pay a commercial photographer to take their image. Simultaneously, the photographers who photographed the *comprometidos* faced new state and popular demands for headshots for identification documents. In response, commercial photographers focused their services on producing headshots and not the photographs of weddings, baptisms, and other family celebrations traditionally associated with the genre of *retratos*. Anxiety surfaced over having one's photograph posted.[57] The posting of the *retrato* gave visibility, and a new context, to fraught histories of colonialism that people had previously refrained from speaking about. Within workplaces, the compromised had admitted to their crimes, and those who suffered because of the actions of the compromised shared their stories.[58] Using the headshot to identify for others something not spoken but visible served as the basis for popular vigilance—a critical component of Frelimo's power as a ruling political party in the immediate years after independence.

The Comité Central along with party officials introduced supplementary methods of identification for identity cards and passports as the Frelimo party attempted to strengthen its control over the state apparatus and to formalize popular engagement with the state amid increased migration from rural to urban areas. One supplementary mode of identification entailed the *guias-de-marcha*—a relic of the liberation struggle—and the *cartão do partido* ("the party card"). During the liberation war, military and civilian requests for documentation had remained unfulfilled. In lieu of membership cards, Frelimo had issued traveling members *guias-de-marcha*, typed documents without photographs that noted the document holder's standing with Frelimo, reasons for travel, and requests for hospitality (for more, see chapter 2). Traveling personnel presented these documents when moving across the borders with Mozambique's neighbors and when traveling between the liberated zones in Mozambique and the military and political offices located in Tanzania. The reintroduction and reuse of the *guias-de-marcha* sought to intervene in people's increased movement from rural to urban areas due to food shortages and security risks. To travel, people required the signature of the representative of the neighborhood where they lived and then presented the document on arrival at their destination for another signature. People followed the same procedure on their return.

The *cartão do partido* followed the *guias-de-marcha*, and was a way for Frelimo, after its adoption of a Marxist-Leninist platform in 1977, to identify its members. By 1977, Frelimo had the ability to issue a form of documentation that had eluded it during the liberation struggle. Unlike the *guias-de-marcha*, not everyone was guaranteed a *cartão do partido*. The *cartão do partido* also lacked a photograph, but both documents required their holders to present themselves before the state and, in the process of using them, reconfigured to what ends people used cameras and presented themselves for photographing. For example, print and photo journalists believed that the state used the *cartão do partido* to influence their reporting and to police their behavior and political views.[59]

For the first years of independence (1974–1977), Frelimo attempted to formalize and standardize the use of identity documents through the reuse of colonial-era documents and the supplementary use of the *guias-de-marcha* and *cartão do partido*. In 1978, Frelimo introduced the *cartão do trabalho* ("the worker's card"), and in 1982, amid increased rural-to-urban migration as a result of famine and increased warfare, the *cartão do residente* ("the residency card").[60] The *cartão do residente* and the *cartão do trabalho* were not interchangeable; the former identified where a person lived and the latter

where a person worked, not unlike the myriad documents issued by the colonial state. The *cartão do residente* had broader public appeal and reach, as it sought to identify where people lived independent of their employment and to control access to community resources. People anticipated that the card would reduce neighborhood crowding, poverty, and crime.[61] Additionally, after a series of failed attempts, the state would use the *cartão do residente* to perform a national population census. However, its introduction only revealed how many people lacked government-issued documentation.

The varied methods of identification marked a complete turn for the former liberation movement, which initially questioned and doubted portraiture's relevance as a tool of political legitimacy and governance. After independence, Frelimo relied on individual headshots to identify potential enemies and issued documents without photographs that required people to present themselves before state officials. The headshot was part of a larger range of identification documents and strategies, and appeared to be relatively unimportant. The state displaced the burden of obtaining the headshot onto civilian populations and commercial photographers. The introduction of the *cartão do trabalho* and the *cartão do residente* exposed the larger bureaucratic challenges that Frelimo faced in registering populations and issuing documents. For example, government offices at the provincial and district levels discovered people regularly misplaced documents and requested second copies.[62] District offices sent requests for documents to provincial and national capitals, and in addition to opening up administrative sections geared to reuniting people with lost documents, workers stopped issuing criminal records and death certificates to handle document requests. Also, officials denied requests for a *cartão do trabalho* on the grounds that the state rejected certain forms of labor as legitimate employment, such as offering traditional forms of healthcare.[63] Ultimately, the inability to produce headshots coupled with the supplementary forms of identification blurred the boundaries and structures that previously distinguished *retrato* from *fotografia*.

The state seemingly strengthened its grip with these forms and regimes of documentation. However, one direct result was lines, or *bichas*, as they were called in popular Mozambican parlance.[64] On the one hand, standing in lines was the direct result of the economic and political pressures that the state confronted and that it displaced onto civilian populations through pressures to get identification documents without guaranteeing that such documents would be available. On the other hand, people organized themselves into lines when using or seeking identification documents, which the state required to

access food rations and even to purchase clothing. Standing on lines framed people's contact with the state and informed how they viewed themselves in relation to the state. These lines increasingly dominated public spaces and appeared regularly in photographs published in newspapers. Press photographers photographed the lines because that was the only way for them to document the more secretive and less visible aspects of state development.[65] The element of choice disappeared whether one was standing in a line or looking at lines through the camera's lens. People had no choice but to stand in line to get necessary things, including food rations, individual headshots, and government documentation. The state could no longer ignore the prevalence of lines in public spaces, and faced public pressure to make them disappear. Furthermore, people became more deliberate and careful with how they presented themselves in front of the photographer and camera, which they viewed as an extension of a failing state. Lines eroded what little public confidence there was in state-issued identification such as the *cartão do trabalho* and *cartão do residente*.

LINING UP

After independence, Frelimo military and political officials gathered women they considered to be prostitutes along with people in need of political training, and sent them to re-education camps in the countryside. Frelimo's Comité Central and political leadership believed that people would change their behaviors and political views if they worked. At the same time, Frelimo anticipated that this mobilization of the labor force through relocation would develop the nation's countryside and jump-start a flailing economy. One glaring problem of a political project that centered on identification and not necessarily registration was that the state and the agencies under its control neglected to identify the people removed from cities and to register them and their specific movements through bureaucratic documents such as files, population registries, and photo identification.

By 1983, South Africa's effort to support an opposition movement in Mozambique paid dividends, and led to the migration of populations back to cities as they fled the ensuing violence. There was a buildup of lines inside of cities for food, and Frelimo's security and political apparatus had no choice but to act. Frelimo hatched the plan that newspapers referred to as Operação Produção (Operation Production) or Limpeza da Cidade (Cleaning of the

City), which were intended to relieve cities of their overcrowding and allevi-
ate some pressures on state services for more food rations.[66] Previously, iden-
tification regimes had involved a combination of reuse of photo identifica-
tion along with two documents, which often lacked a space for headshots. In
terms of Operação Produção, the state under Frelimo required populations to
carry a *cartão de residente, cartão do trabalho, bilhete de identidade* ("identity
card"), and in the case of foreigners, a passport, and it reserved the right to
verify these documents.[67] In instances where the documents were unverifi-
able, an "irregular situation" developed and the state reserved the right to
remove populations and send them to Niassa, a province where from the time
of the liberation war Frelimo had struggled to establish its authority and to
develop economically.[68] The state needed to clear the endless lines; to achieve
this goal it capitalized on its inability to issue photo identification.

There were societal stigmas and economic pressures associated with not
having identity documents. The architects of Operação Produção seized on
this social condition, and initiated the relocation program with a voluntary
phase. Overcrowding and scarcity troubled households. Ration cards pro-
vided families with food according to the people listed on the document.[69]
However, households cared for many more people than their ration cards
stated. The state wagered that people would volunteer for relocation on the
basis of wanting to escape malnourishment and unemployment, but unfamil-
iarity with final destinations and uncertainty over work obligations elicited
only a tepid public response.[70] After two weeks, Operação Produção entered
the compulsory phase, requiring the state apparatus to rely on both state and
nonstate actors to identify populations for removal.

Government personnel responsible for implementing Operação Pro-
dução expanded state power by turning identification documents into a
negative political tool. The first step of relocation involved identifying peo-
ple without documents, and then taking them to verification centers, where
officials determined whether they were eligible for relocation. To identify
people, state officials relied on nonstate actors such as neighborhood-watch
groups. False accusations fueled document searches and verifications. Men
considered women who stayed at home to be unemployed, or used the pos-
sibility of relocation as an opportunity to punish their daughters for dating.[71]
Neighborhood-watch groups accompanied police on home visits, where
the police verified people's documents and confirmed that they lived at the
correct residences (figure 43). Document verification required officials to
look and touch documents, thereby extending state power and its authority

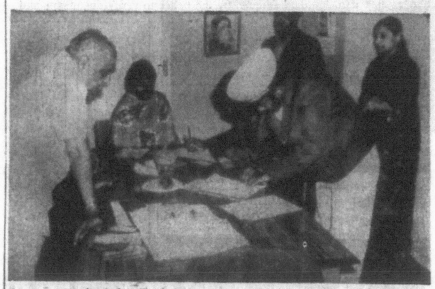

Figure 43. "Aspecto da verifição de uma das casas no Bairro do Alto Maé" ("An aspect of the verification of houses in the barrio of Alto Maé"). *Notícias*, 2 Agosto 1983, accessed through Mozambique History Net and Schomburg Center for Research in Black Culture, New York, New York.

to issue identification into what visual theorist Tina Campt refers to as the realm of the "haptic register."[72] The photographic headshot attached to documents and other forms of photographic documentation, such as family photographs, were of little use in enforcing verification and in efforts to register people's status in relation to their possible relocation (figure 43).

In the absence of administrative files and photo registries, verifying documentation involved district and local officials challenging the veracity of identity documents and dismissing the modes of self-representation previously associated with photographic portraiture. Nonstate actors found that headshots and other forms of photographic documentation could not be used to dispute police findings. A matter of weeks after the start of Operação Produção's compulsory phase, state officials in conjunction with neighborhood-watch groups began performing home searches. Newspaper photographers (figure 43) observed and documented these visits, bringing

into relief the techniques adopted by the police to verify documents and the textual and photographic information that these visits generated. In one news report, a photograph (figure 43) shows two people writing down undisclosed information; around them stand people who are presumably the occupants of the house. According to the historian Colin Darch, who lived in Mozambique at the time of Operação Produção, officials placed identity documents next to a person's head but invalidated them on the premise of bureaucratic errors, such as when an official stamp was next to rather than on top of a signature.[73] People's failure to renew and modify issued photo documentation allowed verification brigades to raise questions about marital and work status, matters beyond the original function of identity cards.[74] The juxtaposition of officials writing down information versus the portrait photograph on the wall alludes to the various registries that officials created when verifying documents. This form of registration was an alternative to the state's need to create an official archive of photographs. The photograph that hung on the wall resembled the image of one of the people standing in the room. Self-portrayal in the form of resemblance had no bearing on state officials' decision-making. Women were more likely to be considered undocumented, as the *cartão do trabalho* failed to account for domestic labor, and ration cards could only be used in the absence of husbands. Photographs were of no use when trying to address bureaucratic failures to issue documentation or when disputing bureaucratic errors in the issuing and policing of documents. Verification brigades needed to hear from a woman's father or her husband in order for her to be released from detention.[75]

The state's decision to task studio photographers with producing headshots not only limited popular access to *retratos* but changed how the state could picture itself in relation to Operação Produção. Photographers associated with the photographic bureaucracy at the level of the press produced the only visual and public records documenting Operação Produção. The images were in lieu of identity files and other state registries. For a photograph of a person identified for relocation to appear in the press, the physical ID, as an image and an object, had to be missing. Two months after the start of Operação Produção, a *Tempo* headline read "'Operação Produção': Nampula in the Time of Success" (figure 44). A multicolumn photograph appeared under the headline with an extended caption that distinguished state officials from "unproductives" and the evacuated, labels assigned to people identified for relocation. Clothing and positioning revealed subtle distinctions between state officials and those relocated. Another photograph showed that the pho-

"Operação Produção"
Nampula
em tempo de acertos

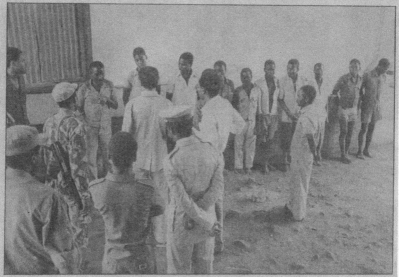

Texto de Filipe Ribas ● Fotos de Danilo Guimarães

A Provincia de Nampula conseguiu já evacuar a maior parte dos improdutivos que pululavam na sua cidade capital, em outras pequenas cidades e sedes distritais, tendo procedido ao seu enquadramento nas diversas unidades de produção. Actualmente, a tarefa prioritária da provincia é melhorar as condições de instalação dos ex-improdutivos, assegurar-lhes todo o apoio material e moral, bem como rever os casos que constituam irregularidades.

Uma brigada do Comando Central Operativo, chefiada pelo 2. Vice-Ministro do Interior, Teodato Hunguana, visitou recentemente a Provincia de Nampula, com o objectivo de viver no próprio local os problemas emergentes da «Operação Produção».

A visita constituiu um momento de reflexão e de bálanço sobre o que foi a«Operação Produção» naquele ponto do País e perspectivar uma melhor actuação, tomando em

22

Figure 44. Danilo Guimarães, 1983, "'Operação Produção': Nampula em tempo de acertos" ("'Operation Production': Nampula in the Time of Success"). *Tempo*, No. 673, 4 Setembro 1983, 22, accessed through Mozambique History Net and interlibrary loan at Bard College.

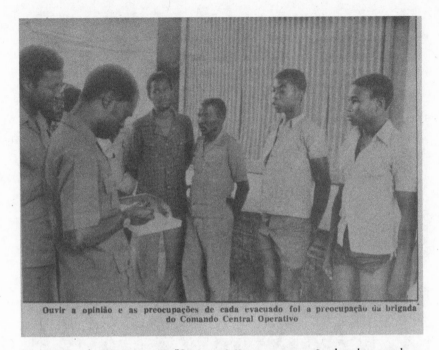

Ouvir a opinião e as preocupações de cada evacuado foi a preocupação da brigada
do Comando Central Operativo

Figure 45. Danilo Guimarães, 1983, "Ouvir a opinião e as preocupações de cada evacuado
foi a preocupação da brigade do Comando Central Operativo" ("To hear the opinion and
the preoccupations of each evacuee was the preoccupation of the brigade from the Central
Command Operation"). *Tempo*, No. 673, 4 Setembro 1983, 26, accessed through Mozam-
bique History Net and interlibrary loan at Bard College.

tographer positioned himself between the state officials and the unproduc-
tives (figure 45). The caption informed readers that state officials listened to
the experiences of the relocated. Another look at the photograph reveals one
official writing down what he heard. Acts of seeing, listening, and writing
accompanied each other, and influenced the state's decision-making. Fur-
thermore, relocation required the state to organize unproductives into lines,
which were one reason Operação Produção was implemented. Within the
context of Operação Produção, state-affiliated photographers produced an
image that pointed to practices of identification and recognition that the
state deployed when the state and citizens interacted at various points before,
during, and after relocation.[76] These interactions were on full display in the
Mozambican press.

The verification processes state and nonstate actors deployed to identify populations for relocation merged the photographic bureaucracy's biometric and documentary impulses—its ability to name and move bodies—with the need to picture itself.[77] From a logistical standpoint, lines were necessary not only to relocate civilian populations, but to separate itself from the unproductives and to frame how people viewed Operação Produção's progress. To show the unproductive, state-affiliated press photographers assumed a position behind the state officials present (figure 44). The photographer also stood to the side or in line with the unproductives to photograph state officials (figure 45). Lines allowed the state to position the unproductives in front of the camera, and in so doing to impose certain silences on how the unproductives spoke and interacted with state officials. Photographic depictions of these lines suggest that unproductives were better seen than heard. Even within the context of the line, unproductives remained unidentified. While lines were often photographed as part of Operação Produção surveillance, officials charged with operating and maintaining the photographic bureaucracy ignored lines because their existence did not conform to the image they wanted to convey of Frelimo's leaders and the government's political reforms. Further exemplifying this point and the political situation, a 1983 article in *Notícias* ran the headline, "With Operação Produção, a City Begins to Stay Clear," with one photograph positioned above another, creating a before-and-after juxtaposition.[78] The photographs were in the same location, photographed within weeks of each other. The article attempted to show the progress of Operação Produção in terms of the removal of lines, so editors published one photograph with people crowded in the foreground,[79] and the one below showing the same location with fewer people. On the one hand, lines visually conveyed nuances associated with state identification and surveillance. On the other hand, published photographs tried to erase lines and crowds. Nevertheless, the displaced civilians reappeared in line in front of crowds of state officials through photographs published in the press (figures 44 and 45). Thus, certain questions related to state power surfaced in the context of photographs of Operação Produção.

Published press photographs of a person holding a worker's card (figure 47) and during home searches (figure 43) represented the collision of certain modes of self-portrayal and representation of state power. People were not in a position to produce forms of identification that officials in charge of the photographic bureaucracy recognized and accepted. Even if they presented documentation, state representatives created uncertainty, either by not pro-

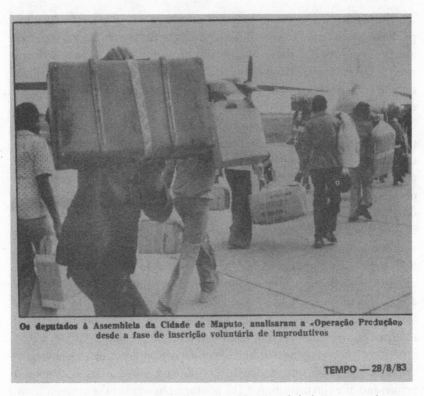

Os deputados à Assembleia da Cidade de Maputo, analisaram a «Operação Produção» desde a fase de inscrição voluntária de improdutivos

TEMPO — 28/8/83

Figure 46. Francisco Munia, "Os deputados à Assembleia da Cidade de Maputo, analisaram a 'Operação Produção' desde a fase de inscrição voluntária de improdutivos" ("The deputies of the Assembly of the City of Maputo, analyzed 'Operation Production' since the phase of voluntary registration of the unproductives"). *Tempo*, No. 672, 28 Agosto 1983, 22, accessed through Biblioteca Nacional de Moçambique, Maputo, Mozambique and interlibrary loan at Bard College.

viding the social services guaranteed by documentation or by subjecting people to further verification independent of the documents they carried (figure 45). Some people accepted Frelimo and the photographic bureaucracy that it deployed as the only means of being photographed and identified.[80] In lines, people allowed state-affiliated photographers to photograph them, sometimes for the first and only time. Other people refused to engage with the photographic practices adopted by those charged with operating the photographic bureaucracy. Sometimes, through documented acts (figure 46), people anticipated adverse uses of photographs. There were also fears of the stigmatization associated with relocation and family separation (figure 46). Public faith in

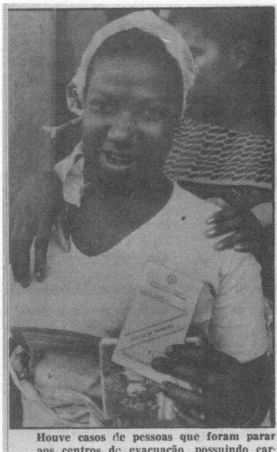

Houve casos de pessoas que foram parar aos centros de evacuação, possuindo cartão de trabalho. Foram soltas

Figure 47. Danilo Guimarães, "Houve casos de pessoas que foram parar aos centros de evacuação, possuindo cartão de trabalho. Foram soltas" ("There were cases of people who were stopped at the evacuation centers, possessing the worker's cards. They were released"). *Tempo*, No. 667, 24 Julho 1983, 18, accessed through Biblioteca Nacional de Moçambique, Maputo, Mozambique and interlibrary loan at Bard College.

and willingness to use identification such as the *cartão do trabalho* and *cartão do residente* eroded. Within the physical space of the line, people spoke, and within this discursive context, they identified ways to address the absence of identity photographs and other photographic documentation.[81]

People found little reason either to show their identity documents or to apply for them—a reality that published press photographs and text reinforced. For example, in one photograph the presence of the photographer was unknown to all except one person who stood in line to board the plane in the background (figure 46). In the foreground, a man stepped out of the

line and placed his suitcase in front of the camera, obstructing its view. In this instance, he removed himself and the others standing in the line from the documentary frame that characterized the photographic bureaucracy. In another photograph (figure 47), a woman holds her *cartão do trabalho*, one of the documents accepted to confirm a person's identity and to avoid relocation. Both photographs included captions. The first completely ignored the person's refusal to be photographed; instead, the caption noted attempts by local authorities to monitor Operação Produção, and the other admitted to the state's failure and the ultimate release of detainees with their *cartões do trabalho* (figure 47).[82] In advance of Operação Produção, people complained of street photographers stealing their money and images.[83] Nonetheless, a matter of weeks into the compulsory phase, *Tempo* published a series of photographs that showed people sitting for their headshot with people looking on—a popular photographic style that dated to the colonial era and attempted to reframe societal norms about black populations in Mozambique (see Introduction).[84] The photograph depicted that it was publicly acceptable, or perhaps a matter of social and political necessity, to appear in the streets in front of or next to a camera, even though there was no guarantee of receiving individual headshots or even government-issued identification after having a headshot. Such styles of photographs displayed the challenges associated with obtaining and using headshots, and in many ways only elevated public anxiety over state identification systems. Ironically, such photographs concealed the more negative uses that officials representing the photographic bureaucracy applied to identity documents. The preservation of the image of the nation's leader and the power of the state came with a cost represented by these forms of identification that could be put to negative uses.

REDEEMING THE LEADER

Dating to the time of the liberation struggle, Frelimo's president, Samora Machel recognized the importance of his image in several respects. The circulation of Machel's image was a way to connect with populations who lived in the liberated zones. At the transition, Frelimo's DIP in consultation with newspaper editors based in the colonial capital was more careful to show Machel living in exile and not inside of Mozambique, to avoid escalating tensions surrounding the government handover and settler departures. In these instances pertaining to Machel's image, Frelimo officials, ranging from the

Comité Central to the Ministério da Informação, cultivated and reframed a sense of the government's own surveillance powers.

In the years immediately following independence, various agents charged with operating the photographic bureaucracy, such as the press and other government ministries, converted the image of Mozambique's leader into an image of power, but the state and its citizens accessed different modes of photographic portraiture. The state increasingly located its power in the realm of photographic portraiture, relying on commercial and street photographers to compensate for the photographic bureaucracy's inability to produce and issue individual headshots. The photographers who produced civilian ID headshots, however, did not photograph Machel either for his official portrait or as part of news coverage; the press undertook this task. Machel images, which hung in state agencies that issued identification and other social services, established a type of political power through which Frelimo justified its use of force and reforms such as Operação Produção. Such a source of power changed with Machel's tragic death in 1986. Portraiture was quite possibly as suffocating and restrictive for the state as it was for civilians in need of headshots.

Frelimo's leadership preferred photography's indexicality over painting's likeness to replicate, mass produce, and circulate Machel's image. *Tempo* featured the "official photograph" of the "President of Mozambique Samora Machel" a little over a year after independence (figure 48). The timing of the publication of the photograph revealed a delay between its taking, printing, and circulation—a characteristic feature of photographic production in Mozambique before and after independence. Little is known about the author of Machel's photographic portrait. Even though Frelimo had its own photographers, Machel frequently asked who was the "best" photographer in Mozambique to photograph him when he hosted foreign dignitaries. The published portrait showed Machel wearing a pinstriped suit, white shirt, and dark tie. He turned to face the camera, as if the photograph were for an identity document. The published photographs took up three-fourths of the page. The appearance of the photograph in *Tempo* was important on several accounts. First, the photograph shows that the state allocated limited supplies to photograph its leader, even though headshots were needed by others for photo identification. The publication notified readers that state offices received the photograph first. Second, the publication of Machel's image in *Tempo* facilitated widespread public viewing without diminishing the state's control over who had the image and over how audiences encountered the

Através de um comunicado do Ministério da Informação, foi divulgada na passada semana a fotografia oficial de Sua Excelência o Presidente da República Popular de Moçambique.
Aquele comunicado informava ainda que todos os serviços e entidades interessadas poderiam obter a fotografia, em caixilho próprio e com as dimensões de 40,6 × 50,8, na sede do Instituto Nacional do Livro e do Disco em Maputo, Avenida 24 de Julho, n.º 1921 — R/C e 1.º andar.
O Instituto Nacional do Livro e do Disco está a enviar através dos seus canais de distribuição para todas as províncias a fotografia oficial de Sua Excelência o Presidente da República Popular de Moçambique. Na aquisição da fotografia será dada prioridade às estruturas do Estado.

«TEMPO» n.º 301 — pág. 1

Figure 48. Photographer unknown, untitled. *Tempo*, No. 301, 11 Julho 1976, accessed through the Instituto Nacional de Cinema, Maputo, Mozambique, and courtesy of interlibrary loan at Bard College.

picture. Lastly, the delay between the photograph's taking and its actual circulation within state structures and beyond the state realm exhibited Frelimo's power to control the imaginative aspects through which to tell Mozambique's history. This delay between production and circulation enhanced the state's own understanding of the mystical aspect of the camera, removing the element of instant gratification.

Frelimo's Ministério da Informação and Gabinete da Presidência aimed to keep the production of Machel's image outside the realm of the secular. Machel traveled from 1975 to 1986 with his official photographers, Daniel Maquinasse and Artur Torohate, both of whom photographed Machel during the liberation war. Frelimo assigned members of the press the responsibility to produce images of Machel for broader public consumption. Even members of the press experienced restrictions.[85] Within the broader public, there was the sense not only that the state prohibited anyone from photographing Machel, but that photographers, regardless of their professional standing, were under public attack. In a commentary dated December 27, 1980, and titled "A Photographic Proposition: Our History through Images," the journalist Willy Waddington expressed amazement at the public's "obtuse attitude" that "[forbade] the photographer, amateur or professional, national or foreign, from taking photographs of our evolution since independence until today."[86] Waddington argued that photographers documented the founding of the Mozambican nation, and that central to this documentation was the image of Frelimo's first president Eduardo Mondlane and his successor, Machel.[87] A foreign photographer, according to the opinion piece, photographed for future generations an image of the "many moments of various meetings" between Machel and Mondlane (figure 49).[88] Creating the image of Frelimo required distinctions and restrictions, which contradicted the conditions of production that had produced the liberation-struggle photographs.

Photographing Machel was part of the training and professional advancement of photographers, and it introduced its own technical and logistical burdens. Machel frequently presented himself standing in front of photographers who worked for the photographic bureaucracy and who frequently traveled with him around Mozambique's countryside and abroad.[89] To ensure that the photograph presented the image he wanted, Machel frequently walked through an entryway multiple times before a press conference.[90] Also, he summoned journalists, photographers, and government officials to express concerns over the quality of photographs of him printed in newspapers.[91] Press photographers feared state officials would question their adherence to

A PROPÓSITO DE FOTOGRAFIA

A NOSSA HISTÓRIA PELA IMAGEM

Abordámos na edição de ontem a intempestividade de um anúncio lesivo dos direitos dos fotógrafos, amadores ou profissionais, nacionais ou estrangeiros. Prometemos voltar ao assunto para combater e denunciar outros aspectos negativos imperantes entre nós, nos domínios da actividade do fotógrafo, seja ele amador ou profissional, nacional ou estrangeiro.

como Nachingueia, como Tunduru, como as bases da Beira e outras, assim como a variada actividade de alfabetização, da emancipação da Mulher, da criação do Homem Novo.

Também através das fotografias, tiradas por amadores e profissionais, nacionais e estrangeiros, foi possível viver os grandiosos momentos do regresso à sua terra do incontestado dirigente do Povo, o

Figure 49. Willy Waddington, "Comentário: A propósito de fotografia: A nossa história pela imagem" ("A photographic proposition: Our history through images"). *Notícias*, 27 Decembro 1980, accessed through Mozambique History and courtesy of Colin Darch and Schomburg Center for Research in Black Culture, New York, New York.

Frelimo's political and aesthetic ideologies when they saw undesirable and bad photographs.[92] Supply shortages coupled with poor film quality ruled out shot selection and continuous high-speed photographing. Photographers struggled to transfer Machel's image from negatives to paper because of the overexposed films they collected.[93] There was also the fact that Machel was shorter than many foreign leaders. Photographers faced the expectation that they would picture Machel from angles that show him to be as tall or taller than his guests.[94]

As Mozambique's war with Rhodesia ended in 1980, another one began. Machel's image was essential to navigating the fraught geopolitical landscape that gripped Mozambique in the early 1980s. Frelimo representatives positioned Machel's portrait above the bureaucratic counters where bureaucrats issued photo documentation. Populations found themselves vulnerable to assault not only because the state that Machel oversaw left them without identification, but because by 1981 they confronted a growing opposition in Mozambique armed by apartheid South Africa. In response, Machel regularly traveled abroad in an effort to win the support of Western allies and to convince them of South Africa's violations of Mozambique's sovereignty. Security risks limited Machel's travel inside of Mozambique. Over the course of Operação Produção, which unfolded from 1983 to 1988, Machel never appeared in photographs with those subjected to document verification and relocation, practices that occurred in Mozambique's provinces. After a state and party reorganization, Machel dispatched his deputies and government ministers to the provincial level, where they oversaw Operação Produção and appeared in photographs in lieu of Machel.[95] At the same time, Machel found himself photographed in the presence of enemy combatants, who he claimed South Africa supported in an effort to destabilize Mozambique. Machel had made overtures to neighboring South Africa, and in exchange for Frelimo ending its support of the antiapartheid group the African National Congress, South Africa agreed to the 1984 signing of the Nkomati Accord to halt its support of the internal opposition provisionally referred to as the Mozambican National Resistance (MNR, later called Resistância Nacional Moçambicana, Renamo). In spite of this, destabilizing attacks inside of Mozambique continued and reflected poorly on Machel, bolstering those inside of Frelimo's Comité Central and other organs of the party who opposed Machel's decision to negotiate with South Africa. Newspapers once again started to publish with greater regularity photographs of Frelimo enemies (similar to figure 42). State use of the realm of portraiture was intended to defend and preserve the power

of Machel, and by proxy Frelimo's image. Machel frequently appeared alongside the presented enemy combatants.[96] As a liberation movement Frelimo had used the *retratos* of its enemies to justify not killing them (figure 42). Suddenly, in these cases of the early- to mid-1980s, photographs of Frelimo's enemies were used to justify their execution. State-affiliated photographers would never document these executions.[97]

Inside the photographic frame, Machel found himself either surrounded by diplomatic officials as part of war negotiations, or inside Mozambique alongside enemies of the state. His images quickly evolved to picture him alone.[98] Portraiture no longer offered Machel and the state he represented the protections necessary to govern and to stay in power. Returning from a diplomatic mission in Zambia, as part of his broader efforts to win regional support for his effort to expose South Africa's territorial violations and atrocities, Machel and his traveling delegations died in a plane crash. Machel himself was almost unrecognizable, and experienced a number of processes of identification at the hands of the South African state and Frelimo officials.[99] Machel's body traveled the city in a coffin and hearse donated by Zimbabwe.[100] The closed coffin denied the public the opportunity to see Machel in bodily form before his funeral, and it denied the state any physical evidence to justify retaliation in the wake of its lost leader. According to the photographic record (figure 50), Machel's official portraits were removed from the walls of government ministries and put into the hands of people who stood on the streets to mourn what they saw as the killing of Machel at the hands of the apartheid regime. There was a particular irony at this time, because people lacked the photographic equipment to document this moment and largely still lacked any form of photo identification, and were therefore at risk of relocation because of Operação Produção. Nonetheless, these people became more visible to the photographic bureaucracy with Machel's image literally in hand. Around the display and transportation of the dead leader (figure 51), changes in political orientations and histories of identification occurred.

To demonstrate stability amid an ongoing war, Frelimo's Comité Central quickly worked to select a person from inside of the political party to replace Machel. Frelimo selected the foreign minister, Joaquim Chissano. After he and other members of Frelimo's political and military arms laid Machel to rest, Chissano and his newly selected cabinet gathered at city hall and stood under a portrait of Machel. The photograph (figure 51) of this moment appeared on November 5, 1986, in the newspaper *Notícias* under the headline "Historic Photo." The published image suggested that Chissano and his newly

Figure 50. José Cabral, 28 Outubro 1986, untitled. Caixa: Deslocados/Refugiados, Centro de Documentação e Formação Fotografica, Maputo, Mozambique.

Foto histórica

Figure 51. Photographer unknown, "Foto histórica" ("Historic photo"). *Notícias*, 5 Novembro 1986, Biblioteca Nacional de Moçambique, Maputo, Mozambique, accessed through Mozambique History Net and courtesy of Schomburg Center for Research in Black Culture, New York, New York.

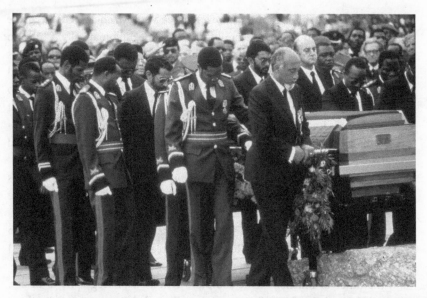

Figure 52. Guy Tillim, October 19, 1986, untitled. Series: Samora Machel Funeral, Identifier: islandora:8174, accessed through University of Cape Town Library and courtesy of University of Cape Town and Guy Tillim.

empowered government established legitimacy from Machel and his political legacy. The image presents the appearance of unity and continuity. However, the halftone is misleading.

Behind the scenes, in advance of Chissano's selection, military veterans expressed concern over the selection of Frelimo's next party leader and de facto president of Mozambique, criticizing Machel for his multiracial vision and his mistreatment of the military.[101] There was also uncertainty about whether to pursue a diplomatic or military solution to the wars with South Africa and inside Mozambique. According to Guy Tillim, the South African photographer who documented Machel's funeral while on assignment for the international wire service Reuters, Machel's death presented the world with an opportunity to condemn South Africa for not ending apartheid and its military incursion into other southern African nations.[102] Tillim's color photograph (figure 52) showed the pallbearers dressed in suits and military regalia, sartorial expressions of the divisions of civilian and diplomatic solutions to war versus a military one that marred the ruling party Frelimo internally. Chissano dismissed many of the high-ranking officials pictured in Tillim's photograph, replacing them with officials considered indigenous or native

to Mozambique. Chissano did, however, agree with Machel's belief that the ongoing war had to be resolved militarily and not diplomatically. Chissano and his government were not actually drawing its legitimacy from Machel, as the "Historic Photo" suggests; instead, the state under Chissano established itself in relation (or even in opposition) to Machel's Mozambique. Chissano and members of the government presented themselves in the shadow of Machel and his image (not looking at it), and did so dressed in suits, not military uniforms—a contrast to the military image that Machel had presented regularly before his death (figure 51).

Machel's photographic images lost their capacity to convert the state's image into one of power. The inability to use photographs to reproduce Machel's likeness, a particular feature of portraiture, exposed the fractures that separated the fallen leader from his successor. The state under Chissano commissioned the Democratic Republic of Korea (present-day North Korea) to make two sculptures, one of Frelimo's first president, Eduardo Mondlane, and the other of Machel.[103] The sculptors relied on photographs to design poses characteristic of each figure and that allowed visitors to recognize them at a distance. In the case of Mondlane, photographs portrayed a man dressed in a suit holding papers. Photographs proved of no use when replicating Machel's image, however, because nothing "showed him with an absolutely serious or taciturn expression."[104] Instead, designers and sculptors studied film footage of Machel. Ultimately, they depicted him saluting in fatigues in an attempt to represent a leader close to his people. By 1988, there were no specific laws that governed how Machel's image appeared in public after his death. Photographs such as Machel's 1976 portrait (figure 48) had limited effect in controlling the reproduction of his image in other artistic media. Between independence and his death, the state deemed it unnecessary to change Machel's official portrait. Machel's death was one of the factors contributing to changes in how Frelimo displayed its political power, and Frelimo called for a new image, one that addressed popular responses to the lack of headshots and state-issued documentation.

THE CHOICE

Unbeknown to Chissano, a photograph (figure 53) existed of him seated with his feet on a pillow in front of two photographers taking his portrait. The caption identified the photographers who took the photos of Chissano

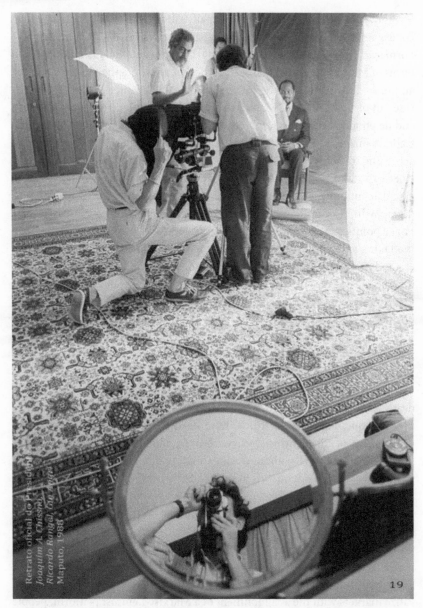

Retrato oficial do Presidente
Joaquim A. Chissano.
Ricardo Rangel Gin Angri.
Maputo, 1988

19

Figure 53. José Cabral, 1988, "Retrato oficial do Presidente Joaquim A. Chissano. Ricardo Rangel e Gin Angri" ("Official portrait of President Joaquim A. Chissano. Ricardo Rangel and Gin Angri"). In *Espelhos Quebrados: Fotografias por José Cabral* (Maputo, 2012) and courtesy of Jose Cabral and Alexandre Pomar.

as renowned Mozambican photojournalist Ricardo Rangel and his Italian colleague at the national photography school, Centro da Documentação e Formação Fotografica (CDFF), Gin Angri—contextual details unavailable in terms of Machel's portrait (figure 48). Another photographer, José Cabral, the author of the birthing photographs (introduced in chapter 3), stood off to the side out of the view of Chissano and the two other pictured photographers, and he photographed the scene. Below the camera was a mirror that brought Cabral's image into the photographic frame. Once again, there was a delay, according to Cabral's photograph, between the selection of a new president (1986), the taking of his picture (1988), and the release of his photograph (specific date unknown). This was another image common to the history of photography in Mozambique: a photo of photographers taking pictures. Cabral's image points to a new photographic space and set of protocols that governed the taking and display of Chissano's image—there was more than one camera and one photographer on hand. The date attached to the caption, 1988, marked the end of Operação Produção. The sovereign leader of Mozambique, Chissano, occupied the position seated in front of the camera, similar to the positions civilians occupied when trying to obtain their headshots for identification documents. The mirror literally reflected the ways that people came into the photographic frame and viewed themselves in relation to photography and the state.

With regard to the availability of headshots, little changed after Machel's death and Chissano's selection as Frelimo party president and president of Mozambique. People were still without headshots. There were any number of instances of misidentification and bureaucratic malfeasance. Some people had learned to live without documentation; others continued to seek out government-issued documents in spite of delivery failures. The South African photographer Santu Mofokeng abandoned press photography in the 1980s while South Africa was at war with the rest of southern Africa, including Mozambique.[105] Mofokeng argued that ID headshots and other photographs produced in the studio context critiqued state forms of reporting and identification.[106] The case of Mozambique tells a different story. Even after Machel's death and despite Frelimo's attempts to open commercial markets and privatize markets with the abandonment of a Marxist-Leninist platform, people struggled to obtain the portraits traditionally associated with studio photography. In the absence of photographs, people wrote to the weekly magazine *Tempo* in search of the whereabouts of their loved ones. Letters published under the title "Who Helps to Locate?" included the person's name, the date

and location of the last sighting, and an address to send to with any informa-
tion.[107] The featured dates referenced the systematic displacement and relo-
cation that resulted from the state's negative use of identity documents. The
absence of photographs in these requests was a reminder that certain practic-
ing conditions and state priorities continued to prevent people from having
photo identification. A certain indifference developed to having one's identity
document stolen, and questions surfaced about whether it was possible to
be "Mozambican" without any government-issued documentation.[108] In the
absence of studio photography and *retratos*, these types of responses acted as
criticism of the stolen images of identification and documentary photogra-
phy that Mofokeng referenced.[109]

Shifts were happening outside the picture frame that Frelimo sanctioned,
and that required the attention not just of Chissano but of Frelimo as a polit-
ical party. After Machel's death, Frelimo continue to pursue a failed military
strategy to win the war at hand. As the war persisted, Frelimo realized that a
diplomatic solution was needed. For much of the 1980s, as chapter 5 shows,
the Frelimo government neither named nor acknowledged in the press an
internal opposition. To acknowledge Frelimo's enemy, popularly known as
either the MNR or Renamo, Frelimo had to revise old forms and protocols of
identification and remove its own troops and foreign troops from areas close
to Renamo.[110]

As Frelimo's political leadership officially and publicly recognized its
longtime enemy as a group with whom it had to negotiate to bring peace,
there was less need to identify populations as unproductive and unem-
ployed and to supposedly track their movements as it had done before. In
1991, Frelimo backtracked on old forms of documentation, announcing the
end of the *guias-de-marcha*.[111] According to the Ministério do Interior, the
decision supposedly stemmed from the introduction of a new constitution,
not bureaucratic and popular misuse.[112] The announcement did not mention
the document's prior function and the original reason for its introduction.
Instead, the state elected to clarify that in lieu of the *guias-de-marcha*, peo-
ple would use identity cards to travel inside Mozambique, and passports for
international travel.[113] The worker's and residency cards remained in place.
The state noted that a *cartão do trabalho* controlled movement into and out
of workplaces, while the residency card helped to determine where people
lived.[114] In response to this decision, one *Tempo* reader requested a return to
the passbook that colonial Portuguese officials issued to native populations.[115]
Regardless of the document's prior history of use in oppression, the passbook

Figure 54. Sérgio Benzane, 1994, "Desmobilização de tropas/Massingir 1994" ("The demo-
bilization of troops/Massingir 1994"). Caixa: Demobilização, Centro de Documentação e
Formação Fotográfica, Maputo, Mozambique.

substituted for the need for a *cartão do trabalho* and *cartão do residente*. The
state did not accept the suggestion; it still felt that it had to have the potential
to control how people presented themselves in public. This debate did not
escape photographing and printed documentation. There was recognition
that those sitters photographed by photographers, often photographers asso-
ciated with the press, did not see their images in print.

Part of Frelimo's recognition of Renamo involved demobilizing Mozam-
bique's countryside, where the two parties had engaged in direct military
combat and where populations displaced by the war and Operação Produção
lived a precarious existence. Renamo only agreed to negotiate a cease-fire
and a long-term peace agreement, ultimately called the 1992 Rome Accord,
after Frelimo removed its own and foreign troops from areas near Renamo
bases and once Frelimo agreed to create a national army rather than there
being separate armies for Frelimo and Renamo. This process of demobiliza-
tion, which the United Nations oversaw, was a telling metaphor for under-
standing the changes the photographic bureaucracy underwent after Machel's
death in terms of how photographs functioned as documentary evidence and
identification.

Little had changed in terms of population registration, and photographs of demobilization show state representatives still relying on the written record for information (figure 54). The people who stood in front of them were in an in-between state, neither quite soldiers nor civilians. The intake of information and its transferring to paper through writing was quite possibly the first time the men in the army had seen their identities written down and in paper form. The person who received this information used faxes and telephones to share the collected details with Frelimo and Renamo representatives to determine whether to keep the soldiers in question or to discharge them to civilian status. The photograph of the demobilization stood in for the actual identity documents, which discharged soldiers struggled to obtain. In this context, handing over the uniform underscored the reworking of certain photographic norms, displays, and interpretations that dated to the liberation struggle. There was a certain demilitarization of the very photographic image that the photographic bureaucracy crafted of the state, particularly the military visions established through picturing captured weapons and enemy combatants.

The culmination of the peace process and end goal was Mozambique's first multiparty presidential election. The electoral campaign presented new opportunities for the state to register populations and for people to obtain photo identification. The premise of the election was to select a leader of a party to govern Mozambique. One aspect of this process involved identifying the electorate through a voter's card, referred to in Portuguese as a *cartão de eleitor*. A 1995 United Nations election report noted that people came forward in mass to obtain voter's cards.[116] State officials and candidates, like President Chissano and his wife the first lady of Mozambique, participated in this process alongside the electorate.[117] People came forward because there was no need to wait for the voter's card, since election volunteers used Polaroid cameras to produce a person's headshot, took a fingerprint, and then placed the black-and-white photograph on security paper and covered it in plastic.[118] Then too, as history would show, state officials recognized the voter's card as a legitimate form of documentation in lieu of identity cards.[119] The distribution of voter's cards illuminated concerns over people being able to visit registration sites because of land mines and voting officials knowing how to fill out forms. Then too, there was recognition that the number of possible voters and their specific locations made it possible to ensure adequate voting facilities.

The voter's card allowed people to see their image in relation to that of the next possible president of Mozambique. The response to voter registration forced Frelimo and the other parties permitted to participate in the election

to seek support from the very areas where Frelimo's security and police forces had relocated populations. Over the course of the forty-eight days allotted for campaigning, people took to the streets with photographs of candidates and wore clothing like the *capulana* (once a controversial piece of cloth; see chapter 3) printed with the faces of candidates and the logos of their respective political parties.[120] No rules appeared to regulate how Frelimo's and other parties' images appeared. The ability to see oneself and the choice associated with that opportunity was never clearer than with regard to the election ballot. On the official ballot was a list of the names of candidates, and to the right of their names, each candidate's photograph. Voters had the option of either marking an "X" with a pen next to their preferred candidate or stamping a box with an inked finger.[121]

Frelimo's political leadership never sought solutions to its long-standing problem of providing populations with photo documentation. Instead, in an attempt to define its image, it elected to perpetuate the problem. The very premise of Operação Produção hinged on the absence of identification and the state's ability to call into question the documentation that populations had gotten their hands on. The modes of identification that the state adopted and the forms of verifying this documentation that state officials enacted restricted how the state saw itself and the populations it governed. Increasingly, officials had to touch and look at documents, and prioritized writing even though photographs provided one of the few material records outside of historical memory. Frelimo was not a surveillance state per se, but one that was continually conflicted over its documentary and identification capacities. The state did not produce fakes, but instead, as historian Fred Cooper argued, was faking it.[122] In the process, photography lost its reproductive functions, which ultimately altered how the state and populations appeared before the camera through photographs, and the meanings assigned to photo identification.

After Machel's death, to continue to exist, Frelimo no longer could be the sole occupant and overseer of the realm of photographic portraiture. In fact, Frelimo's leadership's only choice was to photograph themselves in modes of self-representation and identification similar to those that the public subjected themselves to. There was a recognition of the need for people to view their images alongside those of the state. These practices and histories associated with photographic portraiture and identification complicate readings of documentary traditions such as those practiced by the news-wire service Agência da Informação de Moçambique, the subject of the next chapter.

Naming Mozambique's Dead Photographs

After 1975, the Mozambican government offered its support to liberation movements in neighboring countries. This commitment placed Mozambique and its civilian populations at the center of wars in southern Africa. An independent black nation like Mozambique threatened the legitimacy of white minority regimes in Rhodesia and South Africa. Between 1975 and 1980, Frelimo's Ministério da Informação, in collaboration with different state-run news agencies, developed public relations strategies to report on the multi-front war and to combat the Cold War rhetoric of the white minority regimes and their Western backers. The Ministério da Informação developed the wire service Agência da Informação de Moçambique (AIM) to provide international news agencies with articles and photographs. But the production and distribution of stories did not ensure that they would be published widely and inform public opinion, which challenges key assumptions of the value of photography.

At the outset of independence, AIM journalists pursued the possibility of opening a photography department, which were critical features of wire-service and news agencies across the globe. They allowed news organizations such as Reuters, the Associated Press (AP), the *Washington Post*, the *Los Angeles Times*, and Agence France Presse (AFP) to purchase photographs from freelance photographers based all over the world. Wire-service photographs gave news organizations prepared content in the form of image and text, and allowed journalists in other parts of the world to report on developments in distant places such as Mozambique. In the case of AIM, however, lack of equipment, expertise, and photographers impeded institutional efforts to mount a Mozambican wire-service operation. Nonetheless, these image-making ambitions, coupled with AIM journalists' efforts to establish Mozambique's international profile, positioned the news agency at the center

of the ideological debates over how media professionals represented Mozambique's multifront wars, the first of which was with Rhodesia from 1975 to 1980. Then, in 1983, AIM received a donation of photography supplies, which provided additional momentum for renewed efforts to open a full-service photography section.[1] Initially under the direction of the Swedish solidarity activist Anders Nilsson, the photography wire service trained and employed a team of photographers, including Joel Chiziane, António Muchave, Alfredo Mueche, Sérgio Santimano, and Ferhat Vali Momade.[2] The tasks of photographers were not just to cover state and national affairs, but to produce images acceptable to international media outlets.

By 1983, AIM's newsroom prioritized, more than any local news publications, presenting an image of Mozambique and its war with South Africa to the outside world. AIM's photography wire service prepared packages of five, ten, or fifteen photographs, and the photographs became the story. Photographers traveled the length of Mozambique, not always with a particular story in mind, and when they returned to the newsroom, dedicated laboratory technicians processed their films. After processing, photographers consulted with section and news editors to select the photographs to print. Then, the laboratory technician(s) printed up to forty-five copies of one particular image. Someone other than the photographer typed a caption in English, including a date, the name of photographer, and a short description. After a few years of operation, officials began using a stamp and then wrote information on the back of the photograph. After assembly, AIM distributed the packages to news organizations and solidarity groups across the globe.[3]

AIM sent packages of photographs to international wire services, leading AIM photographers to believe that their pictures had circulated widely. However, receipt of AIM images by these wire services did not guarantee they would be published.[4] There is no evidence that the international newspapers purchased AIM photographs. In fact, international newspaper coverage of Mozambique from 1983 to 1994 suggests that international wire services preferred to hire South African photographers to cover events in Mozambique.[5] Many international news agencies viewed AIM photographs to be of minimal use for their business models and journalistic practices. Quite possibly, Western media outlets perceived AIM photographs as propaganda, instruments of the Mozambican state to influence public opinion and further a Cold War agenda. Then too, aging fax machines along with telephone disruptions diminished the quality of the photographs sent to news agencies like the AP and Reuters.[6]

The availability of headshots and the need to obtain them determined the circumstances under which people positioned themselves before the camera. The picturing of Mozambican populations by press photographers, including personnel affiliated with AIM, acquires new meaning when one considers that many people had never seen their own image or were unable to retrieve their headshots and government-issued photo documentation. As chapter 4 argues, the ability of both state officials and civilian populations to obtain headshots determined the content of press photographs. Rather than consider filtering in terms of the repurposing and resurfacing of particular images, I am interested in what happens when there is conflict in the value of the photographs as they are filtered through different ideologies. Rarely does the literature on photography in Africa, or photographic studies more generally, consider the possibility that certain images are never publicly viewed or have little value in terms of reproduction and republication. In fact, the reproducibility of photographs is never guaranteed. The lack of widespread use of AIM photographs by international media annulled any capacity to reproduce them and any public value. It killed the power of these photographs. I refer to AIM photographs as "dead"—irreproducible photographic objects that took up space in newsrooms in Mozambique and abroad, regardless of their actual publication in the press.

AIM photographs created headaches for the Ministério da Informação and the political policies pursued by the ruling party. The Frelimo government maintained that South African apartheid forces violated the nation's territorial sovereignty through destabilizing military attacks. From the perspective of AIM photographers and their colleagues at other press outlets, the state's position was increasingly difficult to verify after 1983. The geopolitical reality was that the South African government did not station troops inside of Mozambique as it had done in Angola. Instead, the apartheid regime armed a local opposition that would evolve into the Resistância Nacional de Moçambique (Renamo). From the perspective of AIM journalists and photographers, what was apparent and easily documented were scenes that resulted from Mozambicans killing other Mozambicans. State agencies had intended AIM photographs to support the policy line that the conflict was a creation of South Africa, a matter of destabilization and not a civil war. AIM photographs, sometimes of dead victims, did the complete opposite. At a moment that can't be precisely specified, a picture of civil war surfaced. AIM photographs of the dead weakened and undermined state action against South Africa.

I organize the chapter into four sections, each of which emphasizes a different perspective on what I am interpreting as dead photographs. The first section considers the norms and standards developed around the picturing of dead bodies in the wake of Mozambique's postindependence struggles. This discussion entails an analysis of how newspaper and magazine readers reacted to photographs of dead bodies. The second section unpacks the ways that members of AIM and other local media sought to distinguish Mozambique's war from other regional conflicts against white minority rule in southern Africa. Here, dead photographs were no longer about showing the dead, but the perpetrators of death. The first two sections offer a historical context for the opening of AIM's photography wire service.

Closer study of AIM's photography wire service from 1983 to 1994 shows how photographers grappled with picturing a war of destabilization where enemy lines were unclear. AIM mass-produced photographs that took up space in international newsrooms but that, often, the world never saw. AIM photographs had little news value for international news agencies, rendering them nonusable, like placeholders—another aspect of dead photographs. To cover events in Mozambique, news agencies turned to South African photographers. AIM photographers and South African freelancers photographed the same scenes, and the fourth section addresses how these photographs, or "duplicates," by South Africans circulated in relation to those produced by AIM, and how they brought into view the internal opposition Renamo. To conclude, I consider postwar exhibitions of AIM's dead photographs and the interpretative values that AIM photographers assigned to the images that they exhibited outside of the press.

PICTURING THE DEAD

The result of the merging of colonial-era newspapers, AIM opened in 1976 against the backdrop of an emerging war between Mozambique and its neighbor Rhodesia. Initially, AIM had a national focus, but over time news agencies such as the AP and AFP contracted AIM journalists as international correspondents. Photographs of dead bodies and destroyed bridges surfaced as part of local and international war reporting.[7] For example, the same year AIM opened, and at a time when the press was transforming into an extension of the state, the weekly magazine *Tempo* uncharacteristically published photographs of dead bodies on the front page with the headline "Massacre

de Nyazónia" ("Nyazónia Massacre") (figure 55).[8] As the intensity of the war between Mozambique and Rhodesia rose, a highly divisive and controversial conversation surfaced in the Mozambican press over how to represent and picture dead bodies. Despite recognizing the importance of war reporting, the ruling party Frelimo struggled to control not only how photographs presented dead bodies but the vision of war crafted by foreign news agencies and governments. In its prior life as a liberation movement, Frelimo had avoided publishing photographs of itself and its Portuguese enemies, but after 1975, few if any alternatives existed to picturing the war. To understand the implications of the printing and viewing of photographs of dead bodies from 1975 until 1980, when Zimbabwe achieved independence, is to understand the context of changing political, visual, and public discourses.

Dead bodies were a part of the popular imagination in 1975. Shortly after independence, the ruling party Frelimo nationalized doctor's offices, law firms, and funeral homes. In a public address, Machel referenced the figure of the dead body, criticizing funeral homes as fixtures of urban areas and decrying the financial burdens funerals imposed.[9] Machel joked that most people wanted their loved ones to die on payday so they could afford their funerals.[10] Furthermore, from his perspective, people visited cemeteries to see who was treated as first or second class. In the humor and hyperbole of the moment, Machel shifted the burden of funerals from individuals to the state.[11] He said, "The state is going to have the responsibility of this, the government is about to take responsibility of this. . . . We do not want to bury class but we want to bury bodies. The state will fix a price, a price for all classes."[12] Machel's decision to nationalize the ritual of funerals handed the state the responsibility to show and care for the dead.[13] Almost a year after the speech and the nationalization of funeral homes, the first photographs of dead bodies surfaced in the local press.

In response to Frelimo's support of independence efforts in Rhodesia, the Rhodesian army led by Prime Minister Ian Smith targeted refugee camps in central Mozambique. At the time of the attack and in the years afterward, different photographic images with varying degrees of legibility and credibility surfaced in Mozambique and abroad. *Tempo*'s August 22, 1976, edition featured photographs of bodies piled in a mass grave or lying face down; they were without captions, as if the photographs spoke for themselves. The editors had labeled photographs of individuals offering medical assistance to a survivor, and of a destroyed bridge. Then four years after Nyazónia, and in the wake of continued Rhodesian attacks on Mozambique, the International

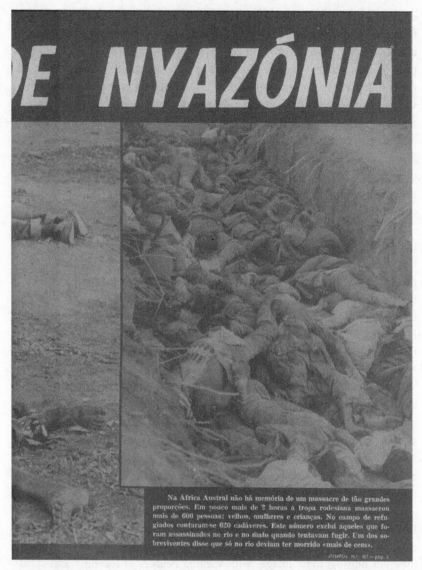

Na África Austral não há memória de um massacre de tão grandes proporções. Em pouco mais de 2 horas a tropa rodesiana massacrou mais de 600 pessoas: velhos, mulheres e crianças. No campo de refugiados contaram-se 620 cadáveres. Este número exclui aqueles que foram assassinados no rio e no mato quando tentavam fugir. Um dos sobreviventes disse que só no rio deviam ter morrido «mais de cem».

«TEMPO» N.º 307 — pág. 3

Figure 55. "Massacre de Nyazónia" ("Nyazónia Massacre"). *Tempo*, No. 307, 22 Agosto 1976, accessed through JSTOR ALUKA Struggles for Freedom—Southern Africa and courtesy of interlibrary loan at Bard College.

Defense and Aid Fund for Southern Africa (IDAF) distributed a poster titled "African States under Attack," which displayed a photograph of a mass grave similar to the one pictured in *Tempo* (figure 56). The other photographs on the poster depicted the refugee camps that the Frelimo government established in central Mozambique. Unlike the *Tempo* photograph (figure 55), the poster featured the caption, "Mass grave of Zimbabwean refugees killed by Rhodesia troops in attack on Nyazónia camp, Mozambique, August 1976." Bylines from the AP and United Nations Commission on Human Rights (UNCHR) accompanied the other photographs, suggesting a range of photographers, some of whom were not affiliated with the Mozambican press, were on hand to picture the aftermath of Nyazónia.

The Ministério da Informação and other arms of the government involved in diplomacy, including the Ministério do Interior and Gabinete da Presidência, found little utility for the photographs published in *Tempo* as it sought to mobilize international support against Rhodesia and to raise awareness of the attacks. In one instance, at a 1976 gathering of nonaligned nations, the Frelimo delegation presented photographs of the attacked refugee camp by French and British journalists.[14] Audiences responded with disbelief and skepticism, calling into question the representational and political value of photographs of dead bodies. One person asked, "Who says that this is of a refugee camp?"[15] Another person asserted, "I was not there in order to see."[16] Only after the UNCHR released a report on its visit to Nyazónia did foreign officials believe that Rhodesian military forces had attacked a refugee camp.[17] Photographs of the conflict, regardless of authorship, were not sufficient evidence, which limited their ability to compel foreign intervention. On the one hand, the inability of viewers to readily decipher photographs of the attacked camp and mass graves encapsulated the long-standing difficulties Frelimo diplomats faced in terms of the optics of presenting the liberation movement's armed struggle in relation to those of other independence efforts in southern Africa.[18] Figure 56 was a case in point. Text in the form of captions revealed that the dead bodies pictured were Zimbabweans by nationality and not Mozambican. On the other hand, the display and use of photographs of dead bodies and refugee camps in diplomatic proceedings only drew the Frelimo government and Mozambican people further into the regional conflicts that developed in southern Africa over white minority rule.[19]

Death required no explanation in the Mozambican press. It was not considered as outrageous to view the end of life as it was to view the beginning of life. As Rhodesian forces continued to attack Mozambique, news publications

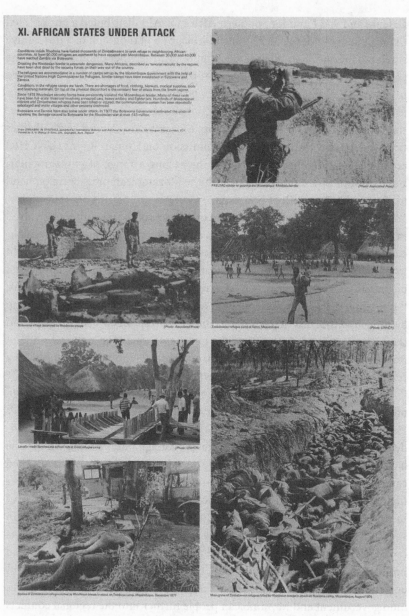

Figure 56. International Defense and Aid Fund for Southern Africa (IDAF), "XI. African States under Attack." Series: Zimbabwe in Struggle, ca. 1980, Basler Afrika Bibliographien, Basel, Switzerland.

such as *Tempo* expanded their coverage of regional and international wars, and created new opportunities for readers to see photographs and to respond to editorial content. In 1978, José Cabral's photographs of childbirth (discussed in chapter 3) had appeared alongside international news coverage and photographs of dead bodies and destroyed bridges. Readers described the photographs of childbirth as counterproductive and deviating from the state's fight against pornography.[20] In contrast, readers of *Tempo* submitted poems and messages expressing support for the war and predicting Mozambique's victory.[21] With the aim of winning public backing for Mozambique's support of Rhodesian independence, a year before the Cabral controversy *Tempo* published an article on AP photographer John Ross Baughman, who had documented the torture of civilian populations by the Grey Scouts Cavalry.[22] The featured photographs showed a military officer holding a gun to the head of a half-clothed figure, one of a group of six men doing a push-up.[23] According to the caption, the scene was of a prisoner interrogation that "appear[ed] in dozens of journals from around the world."[24] The article deemed the taking of the photographs as more important than the photographer's "ethical responsibility" to protect his photographed sitters.[25] There were never reader requests to educate populations on wartime images and to prepare audiences for their gruesomeness, as there were when it came to the childbirth pictures.

Readers of the Mozambican press interpreted photographs of dead bodies as a political necessity, while Mozambican print journalists and press photographers grew uneasy with such depictions. Photographs of dead bodies posed their own set of complications, because the nationality of the subjects was unclear; this had implications for the ruling party's ability to mobilize support for its decision to close the Mozambican border with Rhodesia and to station troops on the border. Photographs of destroyed infrastructure resulted from press photographers' own attempts to respond to the state's increased involvement in the press and the culture of self-censorship that prevailed.[26] While photographs of infrastructure served as proof of attacks, they also presented Mozambique and its government as weak and defenseless.[27] Media professionals' own perception of what was "real" or "factual" at the time soon conflicted with the published image of war, which in some instances fueled the Mozambican government's argument in favor of the use of military force and the arming of Zimbabweans.

AIM journalists were all too familiar with the ideological and professional struggles their peers faced in other state-sanctioned press units.[28] Journalists in Mozambique largely covered the war from inside the country and from the

perspective of the ruling party's leadership and government ministers, not the military. No opportunities existed for Mozambican journalists to cover the war from the perspective of the Rhodesian military or populations living inside Rhodesia.[29] This type of embeddedness worked to the benefit of AIM journalists, who frequently received reporting assignments from foreign news agencies.[30] According to AIM journalist Fernando Lima, reporting from inside of Mozambique as a foreign correspondent differed from reporting by national news media outlets. He remarked,

> If you would do a stupid reporting, a very narrow-mind[ed] reporting, your stories would not go abroad. So, I was working for South African media, for Portuguese media, for American media. So, I need[ed] to write pieces of information, pieces of journalism, that had a minimum of credibility. If I would write in a BTA [Bulgarian News Agency] or TASS [Russian News Agency] news agency style, my pieces would be sent to a wastebasket.[31]

International news media adhered to reporting standards different from those of the Mozambican press. Adopting international reporting protocols over those endorsed by local media allowed Lima to secure work outside of the Mozambican press, which favored the state media's agenda of creating new possibilities for international audiences to learn about the war from a local and seemingly more "accurate" perspective.

After 1976, tensions surfaced between the Ministério da Informação and Mozambican journalists whose stories featured in foreign news outlets. As Lima understood it, in the eyes of the ruling party, there were good journalists who relayed Frelimo's point of view to foreign audiences. Notwithstanding the potential for good publicity, officials at the Ministério da Informação along with Frelimo party officials working in press units still wondered how the names of Mozambican journalists appeared in the international press.[32] Lima recounted,

> Today I can talk about [these tensions between the state and journalists] in a relax[ed] manner. But of course, you would have discussions that if [a Mozambican journalist's] byline appeared in South Africa, are they in bed with the enemy? So, this was questioned all the time, all the time. So, if those journalists are able to write in Western media, are they spies? Are they with the enemy? Are they . . . what turned them special? Why are they accepted? Is that because they are not communist? Is that because they are liberal? What? So, there was always this question mark.[33]

Reporting on Mozambique's war in Rhodesia came with risks. Local and international media coverage had implications for how audiences viewed the war and the policy positions the Mozambican government pursued. Journalists based in South Africa developed a sense of a race war developing. For the South African journalist A. J. Venter, who has controversially written about the proxy war South Africa and the United States fought in southern Africa, the photographs of dead bodies coming out of Rhodesia confirmed "that [the black guerrillas] were not the 'freedom fighters' they professed to be."[34] Initially, the news agency AIM offered journalists and state officials a platform for influencing public opinion regarding the war and to express any professional grievances regarding news coverage. By 1979, however, AIM had closed its national desk and focused on international affairs.[35] AIM started to produce its own reporting, including feature pieces in English or French, photographs, and telefaxes. The other part of AIM's operation involved collecting and circulating news reporting between international and local news agencies. The lack of a dedicated photography laboratory hindered agency efforts to distribute photographs. As Zimbabwe's independence approached in 1980, Frelimo's Ministério da Informação used AIM's contact networks to foster regional cooperation and to advocate for the role of the press in building African nations.

PICTURING DESTABILIZATION

By 1980, Zimbabwe's independence had shifted the location and dynamics of a long-standing war against white minority rule in southern Africa. The enemy remained the same; it just crossed borders. South Africa, under the control of an apartheid regime, offered refuge to the white nationalists and military and security forces who fled Zimbabwe after the nation's independence. Left with few options to thwart mounting regional and international pressure to end white rule, South Africa's government launched military operations to destabilize the borders of its neighbors. South Africa's military strategy toward Mozambique differed from the one it practiced in Namibia and Angola, where it had stationed troops for a ground war.[36] South Africa conducted air raids and armed a local opposition in Mozambique in lieu of deploying troops. In Mozambique, destabilization was the name of the game.

In the absence of a fully operating photography wire service from 1976 to 1983, the AIM newsroom served as an important player in the Mozambican media landscape and as a backdrop for persistent questions about photogra-

phy's evidentiary capacities. Carlos Cardoso, who started as an AIM journalist and later became director, deemed the interplay between text and image as a powerful weapon in the media war that took on new life after 1980.[37] Nonetheless, ideological tensions always seemed to surface when state officials used AIM reporting to establish South Africa as the enemy and as a platform to dictate the terms journalists used to report on the conflict. Journalists and the state fought over their different views of the same enemy. Collected AIM pictures only worsened the situation. In one respect, over the first years of the 1980s, there was a gradual shift away from the mass grave to the *retrato*, from a public image of death to a more private one.[38] In another respect, the rhetoric and visual images mobilized by international antiapartheid activists offered no means to differentiate which elements of the war were internal to Mozambique, or to recognize South Africa's violation of Mozambique's sovereignty.[39]

Chaos characterized the Mozambican government's media response to South African military attacks. At play was an internal struggle over how to respond to a rapidly changing news cycle, and how to use the state's own audiovisual capacities to dispute South African aggression in real time. Days after the launch of the 1983 forced relocation scheme Operação Produção (discussed in chapter 4), South African Defense Forces bombed Matola, a town near the capital city Maputo.[40] While Mozambican journalists had heard and seen the attack from Maputo, foreign journalists representing the BBC and *Notícias da Portugal* were the first to the scene.[41] By the time local media had arrived, the South African government had sent a fax to international news agencies stating that it had attacked activists affiliated with the antiapartheid group the African National Congress (ANC) and not Mozambican civilians.[42] Photographs gathered by AIM or other foreign news agencies were of little use in disputing the apartheid regime's claims. The government's heightened scrutiny of journalists and shutdown of communication networks in that moment left the state's local media establishment, including AIM, to depict Frelimo officials holding press conferences where they used maps and diagrams, not photographs, to explain the attack.[43]

The politicization of death that had defined the liberation struggle and early years of independence shifted after the Matola attack. Absent from public relations responses was the republication of images from the liberation struggle as had been practiced in years past (see chapter 3).[44] At the funeral for the victims of the Matola attack, Marcelino dos Santos, the former vice president of the liberation movement and a high-ranking party official, articulated his thoughts on the power of photography, and in the process invoked

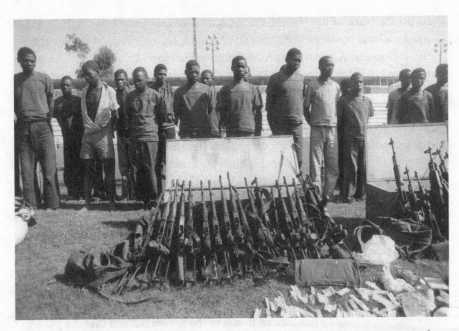

Figure 57. Ricardo Rangel, 1984, "As armas capturados de Renamo" ("The weapons captured from Renamo"). Caixa: Guerra Civil, Centro de Documetação e Formação Fotográfica, Maputo, Mozambique.

an image of death in defending the revolution that apartheid threatened.[45] One newspaper report quoted dos Santos as saying, "Photography is going to permit children when they are adults to know and understand the paths covered in the defense of revolution."[46] In the moment of death and as a form of remembrance, he wanted victims' families to have photographs, or *retratos*, of their loved ones. Ironically, though, *retratos* were hard to come by due to the supply shortages photographers experienced. Furthermore, identity photographs were in high demand, even though they were often unavailable, and these photographs took over *retratos*. Dos Santos's remarks reflected the tension that gripped both the state's response to Matola and its use of photography in that moment. At the time, the state was using the presence or absence of photo identification to remove people from overcrowded cities. The fine line disappeared between photographs for posterity and photographs of the war that the Frelimo state used to defend Mozambique. A new form of photographic display and a new way to portray death were needed, to show who exactly was doing the killing.

In the wake of the Matola attacks, a new image of war and death developed via local media newsrooms and photographic archives and in the pages of newspapers. According to AIM journalist Salmão Moyana, a new enemy appeared, and "from the point of view of photography, [the enemy] was forgotten, very dirty [in terms of his appearance]."[47] In 1983 and 1984, journalists and photographers associated with state media would periodically receive orders to appear at a stadium on the outskirts of the capital, where they viewed men standing behind military equipment (figure 57). The stadium had once been used to celebrate national holidays named after key moments in the liberation struggle. Now, Frelimo's Comité Central and its security apparatus used the setting to present men, referred to as *bandidos armados*, armed bandits, who it claimed had been involved in South Africa's destabilization efforts.[48] Frelimo government officials had trusted the realist and documentary qualities of photography to portray the war's external dynamics. From Moyana's perspective, Frelimo presented the armed bandits "as they were," as if they had just come from the countryside (i.e., the war front), not from a prison.[49] This strategy of presentation, combined with photographic documentation, served to produce an image of the armed bandits that the public could recognize and use to identify such threats in their own communities. Moyana noted, "You could never present them as clean and organized people. It would apparently suggest something else."[50]

A crisis of representation was at play with such "realistic" depictions of the enemy. Two years after opening, the Sunday weekly *Domingo* underwent editorial changes, which included the appointment of AIM director Mia Couto as editor in chief.[51] In terms of content, editors shifted cultural and recreational news to the front pages and reserved the inside pages for "hot situations," such as reporting on the capture of enemy combatants.[52] State officials elected never to share the names or other biographical details of the presented men, instead advising print journalists and press photographers to refer to them as *bandidos armados*, armed bandits. In terms of written discourse, the terminology reinforced the men's and the weapons' connections to the apartheid regime in South Africa and countered, if only temporarily, the impression that a civil war was developing.

Photographically representing this discourse of *bandidos armados* presented its own set of problems. For example, *Domingo* showed the armed bandits under police guard, walking through crowds.[53] Published photographs manufactured a vision of war whose dynamics remained unknown, which left Mozambican journalists feeling as if the government was using

them for purposes of propaganda.[54] In the published pictures, populations demanded that the Frelimo military arm them as a measure of self-defense and called for the killing of the enemy, shouting the Portuguese word for death, *mortos*.[55] Little else was reported on the armed bandits after their public presentation. The published halftones were quite possibly the last images of them alive. Newspapers reported on the killing of armed bandits during military operations, but never showed actual photographs of them being killed.[56] Thus, there was an element of erasure associated with press publication of photographs of armed bandits as agents of destabilization.

By March 1984, the terms under which the ruling party Frelimo could portray South Africa's involvement in Mozambique had radically changed. In 1983, the ruling party Frelimo and the South African apartheid regime initiated behind-the-scenes negotiations to end the conflict. The result was the signing in March 1984 of the Nkomati Accord. The Frelimo government agreed to withhold support for the ANC in exchange for the apartheid regime ceasing its support of the *bandidos armados*. Nkomati brought international media attention to Mozambique, even leading to a documentary on the peace accords by the Chilean filmmaker Rodrigues Gonçalves.[57] Nevertheless, in the months after Nkomati, the enemy continued to surface in daily life and in the lenses of press photographers. During this period, images of the armed bandits carried new import. Amid the continued attacks, Mozambique's president Samora Machel had to justify signing the agreement while trying to characterize South Africa's involvement.[58] The latter was especially difficult, because Nkomati offered the apartheid regime cover to declare that the armed bandits had taken on a life of their own—a position that grossly undercut the Frelimo government's claim to legitimacy and power.

An antiapartheid aesthetic developed in advance of Mozambique's independence that would frame how sympathetic audiences viewed developments in Mozambique after 1984. One of the first antiapartheid boycotts involved photography. In 1971, the black workers of the Polaroid Corporation formed the Polaroid Revolutionary Workers Movement to protest the company's dealings with the South African government. Four years later, international filmmakers, including Jean Luc Godard, Rui Guerra, and Américo Soares, gathered to develop Mozambique's national film institute. One of their activities involved debating whether Kodak films inaccurately rendered "black" subjects.[59] The photographic displays of protests and boycotts generated by filmmakers such as Godard, Guerra, Soares, and also the Polaroid workers' movement, mobilized a type of political force that opposed

the apartheid forces in South Africa but not the violence that South Africa's apartheid regime inflicted on its neighbors.[60] The political stances adopted by these groups were not representative of how populations in Mozambique, and for that matter southern Africa more broadly, accessed and used photographic technologies.[61] Part of the problem was that antiapartheid groups in Europe, South Africa, and North America prioritized South Africa over Mozambique. In a 1984 lecture, AIM's director Carlos Cardoso argued that antiapartheid groups misrepresented apartheid by framing apartheid's dominance in terms of "an inferiority complex," where "whites accepted the myth that Europeans were superior."[62] The lack of acknowledgment of apartheid's heterogeneity and fragmentary nature, Cardoso claimed, was detrimental to antiapartheid movements and the causes they sought to advance. He believed that antiapartheid movements fell into a black-versus-white dichotomy and, as a result, were left to measure their achievements in relation to a color line controlled by the apartheid regime.

TRAVELING THE DISTANCE OF EMBARRASSMENT

In the context of the larger debates over how to label the enemy and over the misrepresentation of apartheid that surfaced inside AIM, the development of the AIM photography wire service gained new momentum by 1983. New AIM photography trainees discovered the war's changing speeds and directions and faced criticism over the poor quality of their images. Local and international demands for more AIM photographs increased. AIM photographers' professional roles and tasks were complicated by perceptions of AIM as a state agency, by the limited equipment at photographers' disposal, and by journalists' own uncertainty. Photographers' attempts to reconcile their training and the demands of international news organizations with the war's changing dynamics resulted in photographs that were printed in large quantities but had no reproduction value for international news agencies—another aspect of dead photographs.

At the beginning of their careers, AIM photographers situated themselves at what they called "the distance of embarrassment," a point far from the intended photographic subject.[63] International news wire-service standards required photographers to be close to their subjects. As AIM photographers traveled "the distance of embarrassment," photographers started to take photographs of injured and dead bodies. There were neither guns nor

military operations to picture; people appeared to be defenseless, and no opposing sides were evident. AIM photographers rejected the politics of self-censorship adopted by their peers at other local media outlets; refusing to take photographs was never an option.[64] The more difficult scenes to photograph were those where the war was felt but did not visibly manifest through the presence of tanks and guns.

AIM photographers' careers were the product of independence.[65] Mozambique's independence had presented new opportunities to practice photography, along with the professions of journalism, filmmaking, and teaching.[66] To fill civil service vacancies, government ministries tested secondary students before placing them in the sectors of education and information. These placements contributed to the development of AIM's photography wire service. For example, AIM photographer António Muchave received orders to join the field of education.[67] Unable to purchase a suit for a trip to Russia, he was reassigned to the Ministério da Informação before shifting to AIM.[68] Sérgio Santimano and Alfredo Mueche joined AIM's photography department after learning how to use fax machines.[69]

As part of their training, members of AIM's photography wire service covered Mozambique's president, Samora Machel. The purpose of teaching the trainees how to photograph Machel and other situations of "high responsibility" was to introduce them to the protocol associated with their profession as wire-service photographers and to familiarize them with the international standards of news photography.[70] According to their instructor, the Swedish volunteer Anders Nilsson, "If you [sent] AP, Reuters, or AFP pictures that [were] too much out of the bounds in a way from the general view of what international photography [was at the time], then you would not have a chance to get in, because they [i.e., the pictures] would be deemed unusual."[71] Photographers had to adhere to these standards to ensure the circulation of images deemed critical to reporting on the war.

AIM's directorship and news editors believed that photographs would raise the profile of Mozambique in the international press. However, President Machel was an unfamiliar subject not only to international audiences, who associated the leader with the Cold War, but to AIM photographers-to-be who had come from the countryside. To take Machel's photograph, photographers had to wear a suit and dark tie.[72] Such a restriction posed challenges for the newly selected media professionals. Clothing was expensive. Unlike many of his press colleagues, AIM photographer Sérgio Santimano owned a suit, and as a result was able to photograph Machel early in

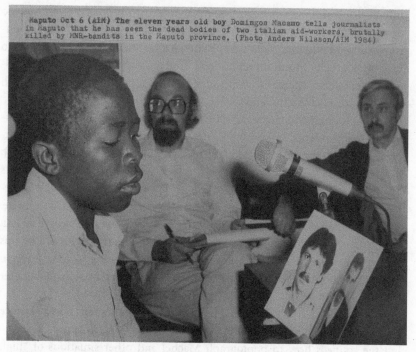

Maputo Oct 6 (AIM) The eleven years old boy Domingos Macamo tells journalists in Maputo that he has seen the dead bodies of two italian aid-workers, brutally killed by MNR-bandits in the Maputo province. (Photo Anders Nilsson/AIM 1984)

Figure 58. Anders Nilsson, October 6, 1984, "The eleven years old boy Domingos Macamo tells journalists in Maputo that he has seen the dead bodies of two Italian aid workers, brutally killed by MNR-bandits in Maputo province." Caixa: AIM, Centro de Documentação e Formação Fotográfica, Maputo, Mozambique.

his professional career.[73] Many AIM trainees lacked Santimano's experience, and, when given the chance, photographed government representatives from a distance.[74] AIM's editorial staff deemed these photographs unusable.

News organizations in Mozambique had received and sometimes even reprinted photographs by the AIM wire service. Anders Nilsson, who AIM photographers credited for their technical training, produced a large number of the available photographs. The presence of Nilsson's photographs in Mozambique illustrates his influence on AIM and the international standards that he tried to impart to AIM photographers. By way of example, a photograph dated 1984 (figure 58), a year into the photography wire service's formal launch, showed a boy in front of a microphone. The boy looked at two photographs of men. In the background, two men turned to a scene behind the young boy, one that was not visible in the photographic print. The top of

the photograph included a typed caption, which informed the viewer that the boy was eleven years old and had viewed the dead bodies of two Italian aid workers. The text also included a phrase different from the prescribed one of "armed bandits," instead accusing MNR bandits of killing the aid workers. Revisiting the photograph after reading the caption, one interprets the boy as having used the photographs of the aid workers to recall their whereabouts. But by 1984, local news outlets had little use for Nilsson's photographs. Publications also had their own photographs. For example, the Sunday weekly *Domingo* used a photograph of the press brief by another photographer.[75] The halftone showed the young boy speaking before a room full of journalists. The pictures of the aid workers appeared as a separate print, not in the hands of the boy.

The photographic print (figure 58) as a stand-alone object conveyed the closeness of the photographer's position to his subjects and represented Nilsson's interpretation of "the distance of embarrassment." He advised members of the photography wire service to go to their "distance of embarrassment," and then step forward to the point where they felt as though they violated the space of the person they intended to photograph. Regarding the origin and impact of this distance of embarrassment, Nilsson explained:

> I think [the distance of embarrassment] may [have been] a cultural issue between two different societies. If you talk about the Mozambican society at that time and the Western society, especially photo editors at international news agencies, it [was] a question of respect that existed here [in Mozambique and] that [was] kind of far away from any consideration in the news agency. . . . [Y]ou had [a] much longer distance in terms of how an individual kind of area or integrity [was] defended or established. It was necessary, I think, to break that down [and] to come through general suspicion, I would say, among the international agencies.[76]

Nilsson's photograph signified a departure from past reporting on events associated with the war's casualties. Also, the photograph reflected the tensions between the war's development and existing modes of reporting. The scene behind the boy draws the attention of the journalists in the background. This scene was visible to the photographer but perhaps not deemed worthy to photograph. The print provides no indication of what was happening. Then there is the caption of the photograph. The name of the photographer and the date photographed were new elements in the classification and interpretation

of photographs. Nilsson's close proximity to the witness allowed his camera to bring the boy into view alongside the photographs of aid workers and the journalists on hand at the press conference. There is no indication that the approaches advocated and practiced by Nilsson guaranteed local or international circulation of AIM photographs or broke down perceived stereotypes that impeded the global media's recognition of events in Mozambique. In fact, while adhering to these techniques and traveling the "distance of embarrassment," AIM trainees-turned-photographers confronted tensions between what they saw through their camera lenses and what they saw in their daily lives when not photographing.

In 1984, the expectations of the Ministério da Informação and AIM's editorial staff conflicted not only with international reporting standards but also with AIM photographers' own day-to-day experiences. From the time of their training in 1983 and over the course of their careers until 1994, AIM photographers experienced a different set of representational politics than the ones practiced by international news agencies and the media policies enforced by the Ministério da Informação. For example, Joel Chiziane mentioned the "distance of embarrassment" to talk about how after his placement at AIM he switched from the print section to the photography department.[77] He found it easier to express himself with images than with words.[78] Chiziane's colleague, Alfredo Mueche, found the "distance of embarrassment" less limiting, but quickly after joining the department noticed how taking pictures attuned him to newsroom dynamics.[79] Mueche discovered that one did not need to be a member of the Frelimo political party to work successfully for state-run news media.[80]

Notions of freedom and the implications of being a photographer varied for AIM personnel.[81] Photographers recognized that their editors would not publish all of their photographs. Also, they did not photograph soldiers and the police, to avoid having their films confiscated.[82] However, for Mueche, the starkest reminder of the limitations of his profession came when he was off duty.[83] Recalling the significance and irony of working at AIM, Mueche stated,

> You [had] money, but there was nothing to purchase. There were endless lines to purchase food. . . . There was no fixed food. You did not have the possibility to choose. I remember in this period America sent a lot of cheese. How do you eat cheese without bread? We went to [stores that] sold the same thing to everyone.[84]

Mueche's limited food choices were analogous to the availability of photographed subjects. Photographers and potential sitters identified differently with each other. As in purchasing food, the element of choice was missing when photographing during the ongoing war. The camera was not an excuse to freely photograph.[85]

Over time, AIM photographers dismissed international reporting standards along with the widespread journalistic practice of self-censorship. Even if their pictures indicated otherwise, AIM photographers placed themselves and their careers at the center of Mozambique's war with South Africa. They often spoke about how the suffering of the war resembled that of other conditions, such as natural disasters.[86] Journalists and photographers alike had adopted self-censorship in order to avoid arousing arrest and harassment.[87] For AIM photographers, self-censorship was not an option. Their professional obligations centered on amassing photographs. As Muchave stated, one could always second-guess oneself but the only option was not to have doubts.[88] Mueche and Muchave claimed to have resolved to photograph "life" as it was, documenting the scenes where people ate cheese without bread, rather than improvising moments where people found substitutes for bread.[89] Mueche and Muchave, in particular, valued adhering to photography's documentary aspects.

Editors, photographers, and government officials used AIM photographs to construct views *of* and perspectives *on* the war. One 6x4 AIM print (figure 59) featured a woman standing in front of a thatched-roof hut. The blurred background removed from view details specific to the setting and location. From the perspective of the print, it was unclear whether the woman had left the hut or walked past it. The woman had a baby on her back and was dressed in traditional *capulana* clothing. On the back of the photo a typed caption indicated no date but included the photograph's author, António Muchave, and the text, "Maputo, May (AIM). People displaced by the war in Ile, Zambezia Province." From an editorial standpoint, there were advantages and disadvantages to photographs like figure 59. Nilsson, who oversaw the photography wire service, understood such photographs to show scenes of daily life during war.[90] The photograph also reflected the relationship of AIM photographers to the war front, their varying degree of embeddedness. According to Nilsson, there were instances where AIM photographers were on hand to document the victims of military attacks, like the Matola raid; however, scenes of "dead bodies and [attack] victims" were not the "dominating feature" of the archive.[91] Instead, AIM photographers often traveled

Figure 59. Alfredo Mueche, undated, "People displaced by the war in Ille, Zambezia Province." Caixa: AIM, Centro de Documentação e Formação Fotográfica, Maputo, Mozambique.

to sites where they had heard of an attack happening or other war-related event. Nilsson, who himself photographed while directing AIM's photography wire service, traveled the country under restrictions that did not apply to the Mozambican members of the wire-service team. Referring to this experience and the role of the wire service, he recalled,

> The general trend was to reflect, reflect on the situation in the country during the period of war and that meant now and then violent pictures, the consequences of violence appeared. Working [from] Maputo, [journalists] portray[ed] ongoing life, because the structure of the war was also unpredictable. For example, I had a conflict with the Swedish Embassy. . . . During the war there were sort of regulations for Swedish citizens, how you could and should move around the country, and I was constantly breaking these rules. . . . [I] was never part of any real ambush. A couple of times, I felt a certain kind of threat.[92]

Editorial interpretations of figure 59 as not a scene of the war served to diffuse newsroom tensions over the use of photography in news coverage.

After March 1984, South Africa continued to violate the Nkomati Accord. Frelimo officials at the Ministério da Informação as well as security and police units grew anxious over how photographs portrayed the war. This anxiety was a contradiction in itself. First, the Mozambican public tolerated and grew to accept violent pictures. Second, Frelimo's diplomatic and political officials, sometimes under the direction of the Ministério da Informação, had used photographs of the South Africa–backed rebels to mobilize local and international support for its military actions. State interest in photography bordered on paranoia. Military officials sometimes confiscated and destroyed AIM photographers' film because they wanted to see the content before they were printed.[93] In this context, military officials perceived AIM photographs as potentially threatening, but also useful because they allowed them to see photographs of themselves and their activities. If processed and printed, AIM photographs were also the topic of critiques over their poor visual quality and accuracy.[94]

The government's involvement with the press provided journalists, like those at AIM, with certain advantages, including occasional access to the war zones.[95] In the wake of the Nkomati Accord and the continuation of internal unrest, AIM journalists regularly lobbied state officials about how they were in the best position to cover the war from the point of view of Frelimo's mili-

tary. Initially, AIM photographs toned down perceptions of the war's violent nature, but in so doing, the printed pictures violated the requirements for accuracy and timeliness of international news agencies.[96] For example, AIM photographers took pictures before and after attacks, not during them, which was what international news agencies wanted pictures of in the mid-1980s.[97] Ultimately, members of the Mozambican media used AIM pictures to construct a vision of embeddedness in response to government anxieties. AIM photographers developed their own interpretations of and responses to these editorial efforts.

AIM photographers traveled the reverse of the route President Machel took when he returned from exile to celebrate Mozambique's independence. On these journeys, sometimes without military escorts, AIM photographers encountered and photographed what Muchave characterized as unedited scenes of "hunger and corruption."[98] While taking these photographs, AIM photographers tried to conceal their identities. Muchave traveled with two forms of identification, his press card and the *guia-de-marcha*.[99] He was careful not to show his press card because he did not want people to know he was a photographer.[100] The *guia-de-marcha* included no indication of his profession. Whether he was looking through a camera lens or simply traveling in a minibus, it was unclear to Muchave and the other AIM photographers who was a *bandido armado* and who was a civilian with no political affiliation.[101] To conceal his identity, he located himself at a distance from his subjects.[102] Nonetheless, the glances of photographed subjects (figure 59) drew an awareness of AIM photographers into the picture frame.

Especially as the war advanced into uncertain territory after 1986 with the death of Mozambique's president, AIM photographers guarded some of their pictures in their negatives. In the process, they removed certain scenes from public circulation. I presented Chiziane with a series of photographs he had selected for a 2002 retrospective on Mozambican photography.[103] He said the gallery prints had been produced as part of his professional duties at AIM. Chiziane's reflections revealed that AIM photographers did not always print from their negatives after developing their films; by contrast, news editors and government officials wanted pictures to create a timeline and document the war.[104] As the war persisted, AIM photographers realized that their pictures contradicted the positions and policies of the ruling party.

Chiziane's photographic archive shows that in 1988 the war had reached the very street where his father lived. Left behind on the street was a pair of shoes.[105] Chiziane said an attack had occurred on the street, and the shoes

belonged to an individual from the enemy side, a member of the opposition group Renamo.[106] The unidentified person had died the day before. The dark spots in the print were bloodstains left by the killing, and not the result of poor lighting or an equipment malfunction. The body of the deceased and any sign of other inhabitants were missing from the pictured scene. When speaking about the blood on the shoes, Chiziane clarified that someone had taken away the body and left the shoes behind. The shoes were all that was left to photograph.[107]

Photographing the shoes was an effort to create a poignant image. Chiziane's inclination was to photograph people. He remarked, "It [was] not good to take a photograph of a store or place that [did] not have people."[108] When I asked why, he said, "Because [the picture did] not have life."[109] The absence of the body and the presence of the shoes created "a disappearance," killing the "life" of the photograph.[110] Looking back at the picture, Chiziane elaborated on how the choice to photograph the scene stemmed from the rationale that "no one else was going to."[111] Focusing on the shoes meant an unfocused background. The shoes were the definitive subject, unlike in the other "spontaneous" scenes Chiziane and his colleagues at AIM photographed of soldiers surveying the damage after attacks. The shoes offered a space to reflect on the war.

Two years before 1988, the war in Mozambique had taken a different turn. Tensions between South Africa and Mozambique had empowered and armed a local opposition. At the same time, international correspondents traveled with increasing frequency to Mozambique. AIM photographers found themselves in the same spaces as foreign journalists. Without even seeing Machel's dead body after his death in a plane crash, Mozambicans took to the streets in protest for weeks and months afterward. Many people held South Africa responsible for the killing of Machel and a sizeable portion of his ministerial cabinet.[112] AIM photographers and foreign correspondents pictured protestors destroying the Malawian flag and standing outside of South Africa's embassy in Maputo.[113] The photographs of these protests represented a political change.[114] The population used signs to articulate their political views and positions against Malawi and South Africa. In the images gathered by local and foreign media, people destroyed the symbols that tied Mozambique and South Africa together; these symbols had framed how local and international audiences viewed the conflict in Mozambique. If AIM photographs found their way into apartheid or antiapartheid propaganda, they were often captioned as having been taken in South Africa. In the instance of Mozambi-

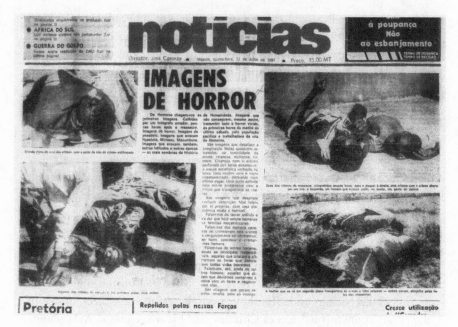

Figure 60. "Imagens de horror" ("Images of horror"). *Notícias*, 23 Julho 1987, Arquivo Histórico de Moçambique, Maputo, Mozambique, accessed through Schomburg Center for Research in Black Culture, New York, New York.

can protest against Malawi, international media organizations such as the AP elected to print images from its correspondent instead of Chiziane, who represented AIM and had almost the same image.[115] The destruction Chiziane had documented did not guarantee the international publication of his photographs.[116] The dismissal of Chiziane's view and the publication of another similar photograph reflected the pluralization of perspectives on events in Mozambique.

AIM photographers spoke of how they regularly pictured dead and injured bodies. After 1986, the very AIM photographs that the international press and even the Mozambican government had deemed inappropriate found their way into the local Mozambican press. Part of the reason for this style of image publication was the philosophical and structural breakdown of the documentary practices that the state had previously advocated for documenting the war. On July 23, 1987, the newspaper *Notícias* displayed four images of dead bodies under the headline "Images of Horror" (figure 60).[117]

One of the photographs showed a man bending down to look at bodies on the ground.[118] The caption read, "Some of the victims of the massacre. In the first plane, a woman."[119] AIM's photography wire service circulated a similar print that excluded the name of the photographer but included the caption, "Maputo, June (AIM). A survivor of the MNR attack on Homoine trying to identify his family among the dead. Photo/AIM 87."[120] *Notícias* attributed the published photographs to an amateur photographer. The AIM print neither confirmed nor acknowledged *Notícias*'s claim regarding authorship. The inability to distinguish whether AIM reproduced the image by the amateur photographer suggested a change in the process of filtering that state officials and journalists had used AIM's photography wire service to perform. Furthermore, photographers not recognized by the state's press units apparently used their personal cameras to document raids and car bombings.[121]

Unlike the reporting on Nyazónia, the photographs of dead bodies in 1987 had extended captions. During the colonial war, Portugal's authoritarian state had advised readers of its propaganda not to look at photographs of the dead.[122] *Notícias* had a different opinion. Editors believed that photographs could challenge text and that they could "talk" on their own. The accompanying text stated the crimes committed were so heinous they seemed inhuman.[123] The article concluded with a word about photographs and their capacity to depict evidence: "They [the printed photographs] are images that generate revulsion, revolt, and hatred of the enemy."[124]

In the days after coverage of the attack, *Notícias* published a photograph of a mass grave (figure 61).[125] *Notícias* credited the photograph to *Tempo* photographer Jorge Tomé. The picture showed men and women carrying and placing dead bodies into an open grave. The photographer here is witness to the act of burial, a subject not documented photographically in prior coverage of massacres dating to 1976 with Nyazónia. The photographed subjects did not acknowledge the presence of the photographer. Instead, they looked at the bodies they carried. Here in the photograph, those still living are left to bury the dead, regardless of Machel's promise in 1976 to create fair prices for burial. The grave is open, and it is a grave for many people, not just one. The dead are facing the photographer, sometimes with closed eyes. These glances, along with living photographed subjects' engagement with the dead bodies, call into question photography's ability to document what exactly occurred. For AIM photographers and journalists, photography posed certain challenges in showing who the enemy was and how those pictured died. Fer-

Figure 61. Jorge Tomé, untitled. *Notícias*, 24 Julho 1987, Arquivo Histórico de Moçambique, Maputo, Mozambique, accessed through Schomburg Center for Research in Black Culture, New York, New York.

nando Lima, an AIM journalist who worked closely with the agency's photography department, stated:

> Especially towards the [war's] end, things became confusing because you start[ed] having doubts if the government army was really fighting for the purpose they were fighting, for the purpose they said, and you start having difficulties labeling Renamo as a South Africa–backed enemy army because when most of the ties from South Africa have been cut off, Renamo was still [a] force.[126]

Photographs of the dead are not only about the dead.[127] One could no longer distinguish the enemy just by looking. What one saw in a photograph was not what the dead had seen. Furthermore, within the spaces pictured and not visible to the viewer, there were land mines that could detonate at any moment.[128] As this section argues, the photographic print might not always show what it purported to show—it might be, in effect, a lie. AIM images are thus dead not only because of their limited publication value but because of their ability, when printed, to fill space and to have misleading effects.

THE VIEW FROM SOUTH AFRICA

Initially, in the late 1970s and early 1980s, AIM sent reports and photographs to South African media outlets while the Ministério da Informação tried to ban South African journalists from entering Mozambique.[129] By 1984, South African print and television journalists were on hand during presentations of the *bandidos armados*.[130] Starting in 1986, South African photographers visited Mozambique on assignment for international news agencies.[131] Literature on South African apartheid and antiapartheid photography overlooks these visits, which came during the early stages of the careers of South Africa's important documentary photographers.[132] International media were interested in Mozambique, but they preferred the work of South African photographers over Mozambique's press apparatus. South African photographers selected for assignment in Mozambique had viewed AIM photographs.[133] Mozambican photographers claimed familiarity with the work of South African photographers, but remembered having little contact with their South African contemporaries.[134]

In 1986, Reuters selected Guy Tillim to work as a freelancer. This was one of Tillim's first international freelance assignments, and it involved traveling to Mozambique to cover the funeral of President Samora Machel. Days before, a suspicious plane crash had killed Machel and other high-ranking cabinet members. Machel's funeral was an international spectacle of particular interest to foreign news agencies.[135] Leaders had traveled from all parts of the globe. In crude terms, the funeral provided leaders with a photo op to display their opposition to South Africa's apartheid regime and to display solidarity with Mozambique and antiapartheid efforts.[136]

Tillim followed the funeral procession throughout the capital city of Maputo. He faced difficulties keeping up. He recounted, "I followed [my gut] . . . I followed the noise. [I] photographed what was in front of me."[137] One of the impediments Tillim faced was that he was using two cameras to document the same scenes. The South African photography collective, Afrapix, which Tillim represented, had clients who wanted color slide prints. One of Tillim's color prints was the photograph (see figure 52) of Frelimo's leadership, some in military clothing and some in civilian clothing, carrying Machel's coffin. Reuters requested black-and-white prints. The use of color films was not extraordinary for Tillim; it was part of the assignment. But only black-and-white film was available to Mozambique's press corps and AIM. The fact that news-wire services and news agencies requested and circulated color and black-and-white photos determined the range of photographs of

Figure 62. Guy Tillim, 1986, untitled. Series: Samora Machel Funeral, Identifier:8399, accessed through University of Cape Town Library and courtesy of University of Cape Town and Guy Tillim.

Mozambique and South Africa that audiences across the world viewed, which reflects the influence of the wire services on photography. South African audiences may have seen color images of Mozambique, but Mozambicans almost always only saw black-and-white photographs printed in the media.

Local and international press coverage brought into view a range of photographic productions for Machel's funeral. AIM, Tillim (figure 62), and the AP all had similar photographs of Machel's funeral.[138] Each photograph showed weeping troops dressed in combat fatigues. In the background of Tillim's print and the *Los Angeles Times*'s halftone, a photographer can be seen. In Tillim's, the photographer stood looking toward Tillim; he held two cameras around his neck. The *Los Angeles Times* photograph was black and white; it showed a photographer behind the crying troops taking photographs similar to those of Muchave and Tillim. I am unable to make out whether the photographer in figure 62 is affiliated with AIM or another Mozambican news outlet. The *Los Angeles Times* purchased its photograph of Machel's funeral from the AP and not Reuters, where Tillim worked. South African photographers' affiliations with international wire services did not guarantee that their photographs would be published.[139] Additionally, it is interesting to consider

how the AIM photograph did not depict the other press photographers on hand to document the funeral.[140] International news publications like the *Los Angeles Times* were quick to dismiss AIM photographs. However, the photographs they did select, possibly Tillim's and the one from the AP, exposed how international wire services marginalized Mozambicans' perspectives on the war.

The photographing of Renamo, Frelimo's opposition, was another facet of South African photographers' visits to Mozambique. Frelimo's Comité Central in coordination with Ministério da Informação and Ministério do Interior were hesitant to refer to Renamo by name. To undermine Renamo's legitimacy and recognition as a "party" or "movement," the Ministério da Informação believed it was better to use the term "armed bandits," and had prohibited members of the state-run press, including AIM photographers and journalists, from traveling to Renamo-occupied areas. The only time Mozambique's press encountered Renamo before 1986 was when Frelimo presented captured Renamo members in highly secured environments (figure 57).

In 1987, the South African photographer and founding member of Afrapix Paul Weinberg traveled to a Renamo-occupied area in the Zambezia Province. Weinberg was on assignment for the German magazine *Der Spiegel*.[141] He entered Mozambique through its land border with Malawi. The formal qualities of the photographs he took and published are striking. In one image (not available for republication here), the men stood at attention. The men were dressed in civilian clothing, not military uniforms.[142] They stood in a heavily forested area, hugging their guns. The men's mouths were open, as if they were speaking in unison. The figures did not make eye contact with Weinberg's camera. Their eyelids appeared half-closed, and their eyes focused in various directions. The camera angle conveyed a sense of uneasiness. Weinberg's photographs featured in an article titled, "'We Never Learned to Rule a Country': *Spiegel* Reporter Peter Schille on Both Sides of the Civil War Front in Mozambique." The photograph's caption read, "Renamo Camp in Zambezia: We are waging war to liberate the people."[143] The article text paired with Weinberg's formally composed photographs described a chaotic scene. Women had come from Malawi to sell bananas. Weinberg himself, like the article, commented on how the clothes the men wore were taken from the dead bodies of the civilian and military populations Renamo attacked.[144] The objects in their possession came from those who were not in a position to be pictured—they were dead. There was also the element of the weapons, which

Schille characterized as Chinese pistols.[145] The way the photograph depicted the men with their guns contrasted with the configuration and symbolism generated by Frelimo's photographs of guns and heavy artillery from the liberation struggle.

These visual and textual modes of presenting the war refer to a type of violence and fear that was not disclosed through the photograph, but rather concealed or even erased by it. Schille noted how people dropped their water and ran away when they saw the men Weinberg photographed.[146] Weinberg was in a position to see what AIM photographers could not. In fact, to a certain extent, the press unit in Mozambique used AIM photographs to censor and dispute Weinberg's view of the conflict. Weinberg's motivation was to bring attention to the plight of Mozambique. However, in the international sphere, his photographs gave Renamo a public standing and recognition alongside Frelimo's military and political leadership.[147]

Another South African, Cloete Breytenbach, traveled to Mozambique at around the time Weinberg did. Breytenbach interpreted his travels to central and southern Mozambique in relation to the time he spent in Angola with the opposition group the National Union for the Total Independence of Angola (UNITA) and its former leader Jonas Savimbi.[148] What stood out for Breytenbach was how different Afonso Dhlakama, Renamo's leader, was from Savimbi in terms of each leaders' consciousness of the importance of their image.[149] To give a sense of this difference, Breytenbach recalled how Savimbi sent one of his officials to consult with Breytenbach about a book of photographs of Savimbi.[150] The unnamed representative wanted the book to include a photograph of Savimbi with South Africa's Prime Minister P. W. Botha. However, *Time* magazine had the copyrights to the photograph that the official had selected. Instead, Breytenbach and the UNITA official decided to use a photograph of Savimbi with South Africa's foreign minister, Roelof Frederik Botha. Savimbi did not like "the other Botha."[151] After receiving one thousand copies of the photo book, Breytenbach learned that Savimbi had his soldiers rip out that photograph from every book. Breytenbach never saw or heard from the official he worked with. He was left believing that Savimbi's deputy had been killed for selecting the photograph.[152] Dhlakama's press operation paled in comparison to Savimbi's.

Unlike Savimbi and Mozambique's presidents Machel and Chissano, Dhlakama did not travel abroad and hold audiences with foreign leaders such as US president Ronald Reagan. Breytenbach suspected that Dhlakama would have been killed or not allowed to return to Mozambique if he had gone in search of international support.[153] Savimbi, by contrast, had used

these visits to "get mileage out of the war."[154] Images of such visits would not necessarily have served Dhlakama in his effort to represent Renamo. In fact, Dhalakama appeared especially concerned with what Breytenbach called the "mechanization" of war in Mozambique,[155] and resisted portrayals of the war as a battle of tanks and troops.[156] Weinberg's photograph relays this sentiment and approach: soldiers and civilians appeared dressed the same and were indistinguishable from each other.

Compared to Savimbi, Breytenbach felt civilians were drawn to Renamo and its leader. However, Dhlakama was unfamiliar with the importance of his photographic image and what it would mean to show himself to the outside world. After learning of Dhlakama's aspirations for a seat in Mozambique's parliament, Breytenbach asked the leader if he owned a suit.[157] Instinctively, Breytenbach followed the question with the statement that Dhlakama could not go to parliament in the clothes he wore while living in the rural areas.[158] In that moment, one of Dhlakama's subordinates retrieved a flag to use as a background for the photograph Breytenbach took. Breytenbach also advised Dhlakama to learn English to speak to the press.[159]

After Frelimo's and Renamo's political leadership had negotiated and signed the 1992 Peace Accord and were planning the 1994 presidential election, Dhlakama displayed a particular awareness of how the press portrayed him through photographs.[160] After arriving in Maputo for negotiations with Frelimo, Dhlakama expressed displeasure with how newspapers featured a small, dark image of him.[161] One article in *Domingo* reported Dhlakama's reaction, explaining how he had opened his hands to show the space allocated to the then-current leader of Mozambique, Chissano.[162] Dhlakama used the moment to point out how he viewed the media as partial to the ruling party, Frelimo, and remarked that if some newspaper had listened to his complaint, it would have recognized how small his image was.[163] He did not hold photographers at fault. Instead, he believed Frelimo was responsible for the publication of such photographs. Frelimo's officials countered Dhlakama's accusation with a statement about Mozambique's free press.[164] Nonetheless, Dhlakama transformed his concern about his image into a political platform to engage journalists. He told journalists, "to start to grow, start to know the truths, and [that] people will have to trust you. . . . [T]he people need to consume true information."[165] AIM photographers and their photographed sitters inserted themselves into the politics of the international wire service that favored South African photographers. In the process, they discovered ways to localize these politics of representation and to enter into and rearrange the photographic frame.

THE OTHER END OF THE "DISTANCE OF EMBARRASSMENT"

Frelimo and Renamo signed the Rome Peace Accord in 1992, which included a cease-fire agreement and program for demilitarization. The first democratic presidential and parliamentary elections followed in 1994. Shortly after the adoption of a new constitution in 1991, the parliament ratified a law that established a press free of state intervention. Many of AIM's photographers left for other news publications that opened.[166] In this period, new opportunities to exhibit photographs presented themselves to AIM-affiliated photographers. For one of these exhibitions, Joel Chiziane selected photographs from his time at AIM. Other photographers used exhibitions to criticize the photographs printed in newspapers.

I spoke to Joel Chiziane about the photographs he exhibited in a 2002 retrospective on Mozambican press photography.[167] I used the selected photographs as a means to learn about his professional career. It was in this interview that he had introduced the concept of "the distance of embarrassment."[168] By the war's end, he found himself more conscious of "the distance of embarrassment," and felt greater ease at moving closer or farther away from the scenes he intended to picture. He spoke of how he continued to work side by side and in parallel with his South African contemporaries, even as international wire services prioritized photographs by South Africans over those by Mozambicans.[169] This movement within "the distance of embarrassment" presented certain spaces and opportunities for the reproduction and republication of his AIM photographs.

I located one of Chiziane's photographs as an exhibition print, a version included in AIM packets (figure 63), and as a published halftone (figure 64). The picture in question showed two feet dangling over the steps used to enter a train. An opened, upside-down suitcase lay slightly off to the side of a dead body. The photographer is on the ground, looking up into the train. Chiziane took steps back, not forward as his own professional training and international news agency demanded. The dead body along with the setting of the train embodied the unspoken fear and violence that had characterized the war. AIM photographs had allowed Chiziane's South African contemporary Cedric Nunn to see "the grizzly nature of [the] war [in Mozambique] at its grimmest."[170] Nunn traveled to Mozambique in 1990 on assignment for the *Weekly Mail*, now the *Mail & Guardian*. He flew to Mozambique and returned by train. He took the train one way because Renamo attacked train routes that miners traveled on their return to Mozambique.[171] Nunn remarked how he was surprised to see passengers board the train and rush to the window

Figure 63. Joel Chiziane, 1990, "Massacre of Movene." Caixa: AIM, Centro de Documentação e Formação Fotográfica, Maputo, Mozambique.

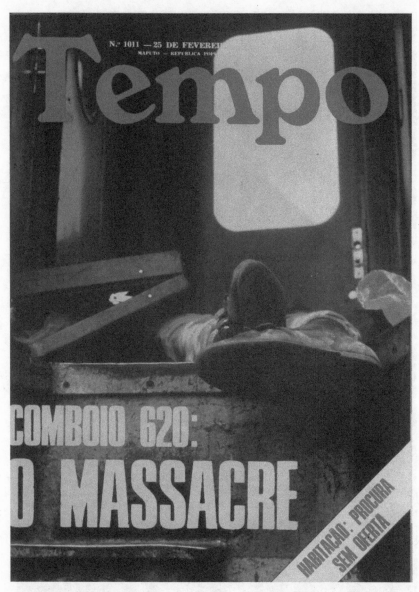

Figure 64. "Comboio 620: O Massacre" ("Train 620: The massacre"). *Tempo*, No. 1011, 25 Fevereiro 1990, Arquivo Histórico de Moçambique, Maputo, Mozambique, and courtesy of interlibrary loan at Bard College.

seats.[172] Presumably, the threat of attack had diminished the window seat's desirability.[173] But, he later learned that passengers sat next to the window to escape if there was an attack.[174]

Ironically, it was the train going toward South Africa and not returning to Mozambique that allowed Chiziane to see Renamo. Chiziane traveled to the scene of his photographs on a rescue train. If it were not for the train, Chiziane claimed, the injured and dead bodies he discovered would not have been photographed.[175] Cedric Nunn recounted that what struck him most about his visit to Mozambique was "the deprivation of Mozambicans" and "the institutionalized terror" that South Africa's involvement inflicted on Mozambique.[176] For Chiziane, South Africa's involvement in the war had become less clear by 1990. What Nunn viewed as "deprivation" offered Chiziane creative possibilities.[177] Rather than standing over the dead body, as if taking a photograph of a body undergoing an autopsy, Chiziane decided to stand in a position where he looked up to the body. He used the sunlight that streamed through the other closed train door. The February 25, 1990, edition of *Tempo* featured Chiziane's photograph on its cover with the headline "Train 620: The Massacre" (figure 64).[178] The article on the inside pages featured photographs of scenes that the state press apparatus had long avoided publishing. For much of AIM's operations, the Ministério da Informação had used the photography wire service to influence international opinions of the war. Chiziane's *Tempo* photographs were one of those rare instances where AIM photographs had importance in depicting the war for local audiences.

In our interview, Chiziane never offered any rationale for why he elected to re-exhibit the photograph of the Movene massacre for the retrospective on Mozambican photography. In the exhibition and catalog print of Movene the image appeared unchanged from the *Tempo* halftone. There was no need to change the angle or how audiences viewed the scene. He literally took the photograph out of the magazine and placed it in a gallery and catalog context. Three years after the retrospective, Chiziane's AIM colleague Alfredo Mueche exhibited his AIM photographs at a solo show hosted by the Associação dos Fotógrafos Moçambicanos. The exhibition review quoted Chiziane, whose statement offers insight into why he, like Mueche, exhibited their AIM photographs in gallery spaces, and the implications of such decisions.[179] The review offered the following summary of Chiziane's sentiment: "This show demonstrates that the exhibitor has not rested since going from there to here. There are photographs, confirmed by Chiziane, that never appeared in journals and that no one knows, revealing [that there] exist[ed] a lot of material of quality,

part of which is on exhibition here."[180] Exhibitions offered opportunities for Mueche and Chiziane to show what no one had seen in newspapers. But the display of figure 64 as an exhibition print illustrated that gallery shows also offered opportunities to display photographs out of their original context.[181] In these moments, exhibition visitors viewed images they had never seen. Also, they viewed photographed subjects that they only knew in person and not through photographs.

I wish to conclude and to summarize the chapter's findings with a story from the 2004 exhibition of Mueche's photographs from his time working at AIM.[182] Paulo Manhique, a journalist from the national radio station, entered the exhibition of Mueche's AIM photographs. There, he viewed a photograph that the exhibition review described "as an old man who was the cattle herder" for his [Manhique's] family.[183] The journalist had believed that he would never see the man again; Mueche had encountered him in Chibuto, a city in Gaza Province, and he recalled that the man carried a lot of weapons along with bags for military soldiers.[184] At the moment of seeing the photograph, Manhique revealed that the man's name was Nwenji M'benzane.[185] The review said the man "died of hunger during the war."[186] In the late 1980s antiapartheid groups had used this image to win international support. In its reproduction, only AIM was mentioned, not the names of Mueche and the subject he photographed.

Another viewer revealed the story behind an exhibited photograph of a man who deserted the military.[187] In recounting the story, the person recognized through the photograph that there was a great deal of misinformation about the war. It was hard to know the "real history" of what was happening at the time.[188] Aware of people's experiences of the war, Mueche left his exhibited photographs untitled. AIM photographs had a place after the war in gallery spaces not because they allowed visitors to appreciate their beauty, but because of their lack of beauty; as one journalist noted, "because more fundamentally [the pictures offered] a portrait of the country."[189] Here, I translated the word "portrait" from the Portuguese word *retratos*. AIM photographs' presence in a gallery space allowed the telling of histories embedded in the photographic form of *retratos*. As photographs, *retratos* were not always accessible to populations in Mozambique, and in their absence many subjects had appeared before the cameras of AIM photographers. What had once been dead photographs, were no longer.

Epilogue

The End?

Historically and up through recent times, populations in Mozambique have encountered numerous uses for and innovations in photography. In a similar way, my use of the passport issued by the US State Department has framed my own encounters with the Mozambican government and its various agents, ranging from archivists, to the police, to customs and immigration officials. The passport and the other auxiliary forms of documentation that I accumulated while researching this book opened spaces for me to consider how state structures, which the ruling party Frelimo oversees and deploys, function like a photographic bureaucracy. Much like the historical actors studied in the preceding pages, I have adopted a range of strategies to navigate and access the state bureaucracy in Mozambique. Such approaches revealed the Frelimo state's uneven and varied use of photography as a tool to construct an image of itself and to control the people it has sought to govern. In the process, I came to see how taking photographs, issuing photo identification, exercising the ability to view photo identification, and being pictured in front of or near a camera (figure 65) were bureaucratic practices imposed by the state, and also the modes of photographic representation that civilian populations crafted in response to the photographic bureaucracy.

I traveled to Mozambique for research in 2008, and then in 2009, 2010, 2011, 2012, 2013, and most recently 2016. On each visit, my hosts wrote letters of affiliation, a requirement for long-term entry and a travel visa. On arrival, people reminded me to carry my passport.

To this day, police in Maputo and other Mozambican cities reserve the right to check people's identification without warning—a practice that was most apparent when the ruling party enacted the 1983 forced removal scheme,

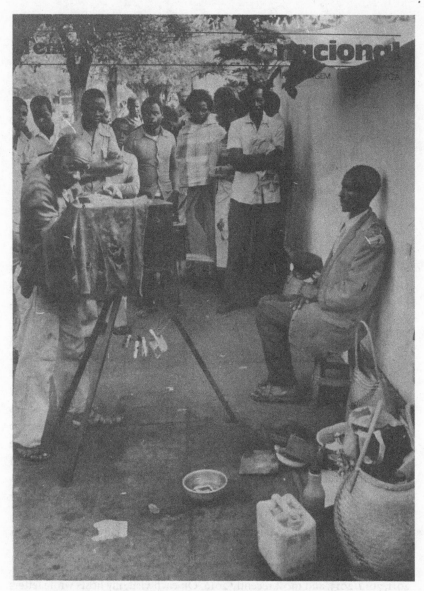

Figure 65. Kok Nam, "Aula de simplicidade" ("The class in simplicity"). *Tempo*, No. 667, 24 Julho 1983, Biblioteca Nacional de Moçambique, Maputo, Mozambique, and courtesy of interlibrary loan at Bard College.

Operação Produção. Back then, not only the police but certain civilian elements had state authorization to verify government-issued documentation. Not unlike the men and women forced to show their documentation to prove residency in cities from 1983 to 1988, I found myself regularly having to present my passport and visa documents for verification.

Even before setting foot in state-run archives, where I would seek to explore modes of photographic documentation, my hosts advised me to obtain notarized copies of my passport's identification page and my entry visa. Photocopies of my passport and visa did not guarantee their authenticity, but they did prevent me from being without my passport. A notary stamp confirmed that the documents were in fact reproductions of official state-issued documents. I often used copy services near public notaries to obtain copies before going for the stamp.

The public notary that I normally used was located in Maputo on Avenida Vladimir Lenine, and was always filled with people. A counter divided the notaries from the people seeking their services. There always seemed to be complete disorder. People crowded both sides of the counter and exchanged documents at a rapid pace. Chatter and the sound of stamping filled the room. The system for obtaining the notary stamp was intuitive. I had to find an available attendant standing behind the counter, to whom I provided the photocopies along with money. Looking back on these exchanges, I don't remember having to show the original passport; copies appeared sufficient. The attendant passed the documents over to a person seated at a desk with the stamp and ink pad. The person at the desk briefly inspected the documents and stamped them. The attendant returned them. There was no handwritten or computerized system that officials used to register that I had notarized the documents.

I have to admit, after my visits to Mozambique in 2008, 2009, and 2010, I abandoned the notarizing of my visa documents altogether. Part of my rationale for this transgression was out of a sense of inconvenience and because the notary stamp was never a point of contention with the police. The notary was not always near where I stayed. Xeroxing documents was oftentimes difficult due to nonfunctioning machines or long lines. Then, I was not even sure that the police and other immigration officials noticed the black stamps issued by the notary; they blended so easily with the other stamps on the photocopied passport page of my Mozambican tourist or residency visas. To avoid the hassle of producing additional paperwork for the notary stamps, I decided to bring a copy of the passport and visa before arriving in Mozambique or to obtain a photocopy of the passport sometime in the first days after

arriving. Regardless, I went without notarized documents and was willing to risk the implications.

On numerous occasions, I had run-ins with custom officials and the police regarding my documents. When I was traveling to Mozambique for more than one month, I found that it was easier to work with the Mozambican embassy in DC than to deal with immigration officials in Mozambique. One time, I received my visa from the Mozambican embassy in DC, and I noticed a discrepancy in terms of the visa's duration. I returned to the embassy the day afterward to have a new visa issued. What resulted was a dispute with the consular official over the dating of six months. The different interpretation of what constituted a six-month span of time was critical to me being able to obtain a permanent multi-entry residency visa, which in itself took months to secure. The process for a residency visa was made harder in 2010 when the Mozambican government announced new visa fees and regulations. These changes brought greater difficulties in obtaining entry and residency visas, along with increased fines for people who immigration officials discovered were without proper entry visas or expired visas.

On my 2010 visit to Mozambique, there was no shortage of incidents where police stopped me and requested to see my documents. These actions often came with requests for money, despite my having the required visa documentation. To avoid encounters with the police, I devised personal strategies to avoid police searches. At night, I rode in taxis. When I saw police gathered on the street or setting up a checkpoint, I walked in the opposite direction or crossed the street. My own experiences, and possibly the strategies I adopted, resembled those of Mozambicans, who were not immune to similar searches.

In parallel with these experiences, I conducted interviews with photographers, journalists, newspaper editors, and government officials. These interviews detailed the history of photography in Mozambique, and they included questions about headshots and identity documents. The people I interviewed never pulled out their headshots or photo identification, which were unimportant to the conversations about the history of photography. In hindsight, it was evident that people deemed it appropriate to show these forms of identification in some situations but not in others, such as the interview setting. However, the press pages from the colonial era into the independence period portrayed a story where populations were subjected to irregular and ad hoc systems of identification that possibly informed popular use of photography.

Halftones in newspapers printed in colonial and independent Mozambique displayed clients seated in front of cameras next to a person they may

have or may not have known, and showed people looking on while a person had a headshot taken. Once they had been taken, it was not inevitable that photos would be processed and printed.[1] In many of the instances pictured and published in newspapers, photographers failed to give their clients the headshot because of failing technology. Then too, photographed sitters did not view it as necessary to display their headshots, which were often not printed and reproduced. Headshots have their own storied and complicated history in Mozambique, and their absence meant that press photographers often pictured undocumented populations. Figure 65 reflects the shifting terms under which daily life was documented photographically and viewed through photographs. In fact, images like figure 65 were part of press photographers' attempts during extended periods of war after independence to adapt to the photographic conditions where it was no longer feasible to document certain scenes of daily life. Widespread use of photographs of people having their headshots taken informed people's understanding of the function of photography while reinforcing certain editorial norms that governed the "picturing" of Mozambique's history—what I refer to as the irreproducibility of certain types of photographs. Not every photograph taken by a press photographer was intended for publication. Furthermore, supply limitations and demands for headshots restricted the types of photographs that commercial photographers produced. Thus, the idea of filters and processes of filtering is analytically useful when thinking about photography's reproducibility and irreproducibility, as are ideas about the forms of photographic practice and modes of documentation that developed in response.

In my daily professional and personal life, I quickly learned that individual headshots were of more value than the reproductions of my passport and visa documents. When trying to enter government institutions where photographic collections were held, such as the Agência da Informação de Moçambique and Rádio de Moçambique, I initially needed my passport copy. But in the case of institutional archives such as the Arquivo Histórico de Moçambique (AHM), they issued their own forms of identification. To receive the documentation, I needed a headshot.

I faced having to provide printed headshots for any range of registration processes, including for the visa application and cell phone registry to name a few. I accumulated copies of headshots because administrative offices, especially the Embassy of the Republic of Mozambique in Washington, DC, or the US State Department, often required only one or two of the four that I received after having my picture taken in the United States.[2] Some offices did

not keep copies of headshots for themselves, but instead placed them directly on the documents they were responsible for issuing. Officials issuing the documents never voiced concern that the photographs I submitted were not recent. Small details about my facial countenance had changed from the time I took the headshots—I had new glasses, or I had grown a beard or decided to get a short buzz cut. Regardless of my appearance in real life, the presence of the headshot was enough to confirm a particular document's authenticity and validity.

One's need to produce headshots for documentation and readiness to show one's passport and visa were regimes of identification different from those I experienced in the United States. However, these practices of retrieving and showing photographic images were not so different from those of Mozambicans during my visits and in the periods studied in this book. In the United States, my passport is not as important as my state-issued driver's license. I use my driver's license to confirm my identity as a driver. At stores, I show my driver's license for merchants to verify that I am old enough to purchase alcohol or as an additional measure of security to verify my unsigned credit card. I also use my driver's license to travel domestically by plane. In Mozambique, merchants did not check that the signature on the credit card matched that of my identity document. I also found that my library and other administrative documents were of greater utility than the driver's license. Showing the AHM card revealed my affiliation with a local entity and helped to give me access to other archival depositories at the Instituto Nacional de Cinema and Televisão de Moçambique. In the process of using the AHM card and experiencing police searches, I became less protective of my driver's license.

Another aspect to these experiences with enforced regimes of documentation occurred in 2010, when the Mozambican state announced its use of the biometric chip. The state contracted the services of a Belgian company called Semlex. The agreement stipulated that Semlex would provide the Mozambican government with the expertise and equipment to issue biometric chips on national identity cards and passports. In interviews, studio-based photographers told me that the biometric tracking system marked the death of their profession.[3] At that time, I found it difficult to identify studio-based photographers to interview. Many of the once-famous studios had closed, and the fabled photographers who had roamed the streets disappeared. The owners of the opened studios that I visited in Maputo and Beira longed for the lines from the early years after independence well into the early 1990s.

They recalled how people had once waited to have their photographs taken, and how lines disappeared in the early 2000s with the arrival of the cellphone camera. The state-issued biometric identity documents were the nail in the coffin. The introduced system no longer required people to obtain a headshot before going to government offices. The biometric system allowed state officials to take a picture when the person submitted a document request and place the image directly on the state-issued documentation without ever having to produce a negative or print of the headshot.

Embedded in this experience of the disillusionment and disappointment of studio-based photographers was a critique of the postcolonial state that had surfaced in the early years of independence. Many studio-based photographers initiated their practice at independence. Independence gave way to a professionalization of photography as the ruling government relied on nonpress photographers to take headshots for identity documents. Many photographers that the Frelimo state had relied on at independence had practiced photography when not working in the mines of neighboring South Africa or had worked as laboratory assistants in colonial-era studios. By 2010, the state no longer required the services of these photographers.[4]

From 1975 until the early 1990s, people had expressed anxiety over retrieving their headshots and photo identification. By the mid-1980s, however, people accepted the unavailability of headshots and photo identification. This acceptance was a recognition of a type of visibility that resulted from the loss of the headshot or individual attempts to pair the headshot with identity documents. In the rare instance that a person could obtain photo identification, it was still possible for state representatives to question the document's validity (see chapter 4). Then and now, the state was never in a position to issue everyone proper photo identification. It could not even make copies of the documents it had issued. If people lost their documents, they would have to begin the application process again.

Studio business was so slow in 2010, 2011, and 2016 that I never had to make interview appointments with studio-based photographers. I frequently visited studios during working hours. Every now and then, clients came in to request services such as the retaking or reprinting a photograph. Photographers asked me to wait. These requests made it possible for me to look around studios and to observe photographers at work. By then, photographers had dispensed with the analog technologies of years past and had fully embraced digital equipment. The digital technology used by studio photographers harked back to the automatic film-processing services initially introduced to

Mozambique in the late 1980s.[5] In retrospect, several aspects of Mozambicans' relationships to the photographic process were on full display.

The announcement of the official launch of the biometric identity documents came when the president dismissed several members of his cabinet, including the heads of the interior and agriculture ministries. Police officers came in pairs or small groups to one studio on the outskirts of the city center requesting headshots for the new departmental identification they required. The studios I regularly visited in and around Maputo were filled with boxes, which included negatives that people had left behind in favor of their paper prints. Some studios where the negatives were had previously operated as film-processing laboratories. Others were merely informal studios with no developing facilities. Even if the police officers had kept their negatives of previous headshots, there was nowhere to develop them. Long beforehand, photographs had transitioned to digital formats. After electronically developing the digital image, photographers deleted the image to free space on their memory cards. The irreproducibility of an image such as the headshot generated new photographs and left behind old ones in different formats.

In 2010, people were unsure about when they would require the new biometric documents. There were also questions over whether the documents in their possession were still valid. Another reason for public concern was costs—to break even, the state charged US$100 for the passport. The cost of the identity document increased from 50 cents to US$6. The state refused to subsidize identity documents as it had gasoline and bread.[6]

The contractual agreement between Semlex and the ruling party Frelimo drew public scrutiny. Newspapers published investigative reporting that claimed corruption. However, this kind of partnership between the government and a company had a precedent. During the liberation struggle, Frelimo's Departamento de Relações Exteriores and Departamento de Informação e Propaganda (DIP) developed similar connections to integrate photography into state-formation practices and to achieve international recognition. After independence, the nationalization of private industry ended colonial-era contracts between local studios and the distributors of Fuji, Kodak, Agfa, Ferrania, and Canon camera equipment. Frelimo's Ministério da Informação used international alliances dating to the liberation war to access photographic equipment and to pursue grand image-making ambitions. The difference in 2010 was that a sovereign nation decided to work with a private corporation. This agreement reflected the neoliberal order that reframed the parameters of state activities. A Semlex representative spoke to this issue when he explained

how a nation like Mozambique confronted the need to conform to new global security regulations introduced by the United States and its European allies after the events of September 11, 2001, in New York City.[7] I would add, that like other governments across the world, the Mozambican state saw great advantages to the digital collection and organization of data on populations that lived in the country and crossed its borders.

From inside government, there were calls to return to the programs of past years. In 2007, Armando Guebuza, the president of Mozambique, launched his campaign for a second term. He faced questions over his policies, and in response to the criticism Guebuza faced, the Frelimo parliamentarian Lina Magaia suggested that the government bring back a form of Operação Produção. Magaia was a member of Frelimo's military during the liberation struggle and a prominent woman writer. She claimed that criminality posed problems for Guebuza's governing agenda, and she correlated the overcrowding of cities with criminality, so she proposed a new operation.[8] Guebuza had been responsible for overseeing Operação Produção and the highly controversial removal in 1975 of Portuguese settlers who Frelimo had deemed adversaries of its agenda.

In the same year that Magaia called for another operation, Frelimo's Ministério do Interior took steps to implement the biometric tracking system. Already present in certain institutions and governing structures was the ability to return to older forms of documentations such as the *cartão do trabalho* (worker's card) and *cartão do residente* (residency card). In the early 1990s, the state abolished the *guia-de-marcha*.[9] However, the directive allowed different ministries to determine at any point in the future whether to continue with the *cartão do trabalho* or the *cartão do residente*. In 2016, there were unsubstantiated rumors that state officials wanted to reintroduce the *guia-de-marcha*.[10] Mozambicans remember these histories of documentation and the processes of verification that accompanied them.

Until the introduction of biometric technology, the Mozambican state was never in a position to maintain a database of headshots and identity documents. The computerized biometric system would not only take a headshot, it would create a digital database of the individual's personal details. Dating back to independence, officials at the national and district levels had confronted difficulties in collecting and archiving this information. Paper needed to print document request forms was in short supply. In the late 1970s and over the course of the 1980s, officials at the Registo Civil frequently lost people's documents, sometimes sending them to the wrong administrative offices

or attaching the incorrect postage. In the end, many people were without documentation or had to use expired documents. For that reason, the honorific and oppressive usages assigned to the headshot were unworkable.

Semlex proposed to use biometric identity documents as a way for the Frelimo government to rebuild trust in its governing institutions.[11] However, this idea was not innovative and new for a place like Mozambique. The histories of surveillance and photography in Mozambique are intimately entangled. Civilian populations in Mozambique understand these entangled histories through their individual need to retrieve headshots and through the presence or absence of certain identity documents. People connect the histories of photography and surveillance because of how they used their identity documents or because of the strategies they adopted in the absence of certain forms of documentation. Bureaucratic processes incorporate and archive the actual photographic print in different ways, and what photographic processes do with and to the printed image also varied. Furthermore, photographers' own roles in the documentary regimes accessed and deployed by state structures constantly changed. As a result, the Mozambican state and populations situated themselves in relation to each other through physical, visual, and oral discourse. With these parameters, certain options were possible and others were not.

The Ministério do Interior terminated the Frelimo government's contract with Semlex in 2017.[12] Frelimo representatives justified the decision in terms of Semlex's failure to produce enough documents. Semlex had constructed a computerized database, but the organization of the database did not allow enough character space for officials to enter the complete names of applicants. Additionally, the printing system misprinted the Mozambican flag on identity cards.

The question is not when Frelimo will select another company.[13] In the words of theorist Ariella Azoulay, the "potential" for the use of headshots and photo documentation of the sort has continually marked state and popular use of photography in Mozambique since long before independence in 1975.[14] Before ending its contract with Semlex, parliamentarians affiliated with the Frelimo party expressed interest in changing the format of the identity cards, including rethinking the material used to make them. One reason for this was to adapt to broader regional security requirements. Previously, many Mozambican miners had experienced difficulties using their Semlex-issued documents to enter South Africa.

Part of governance in Mozambique has involved the state apparatus

designing visual strategies and technologies to identify populations, to exert control over its image and populations, and to operate on a day-to-day basis. These forms of governance involving photography serve to compensate for the state's inability to provide identification documents to each of the nation's citizens. Before and after independence, civilian populations in Mozambique identified ways to make certain claims on the state in the absence of photographic headshots and photo identification. These modes of identification in the presence and absence of photographic prints are always changing, and always connected to the past. There is a continuity between the past and present in terms of the state's need to issue photo identification and people's abilities to obtain headshots of themselves, which will persist in Mozambique into the foreseeable future, with no end in sight.

NOTES

INTRODUCTION

1. "A pose para a posteridade é comum a todas as pessoas e a todas as idades. Atentos e graves, dos clients encaram a lente da objectiva," *A Tribuna*, 3 Outubro 1964, Arquivo Histórico de Moçambique, Maputo, Mozambique.

2. In 1964, Portugal entered a war with the liberation movement Frente da Libertação de Moçambique (Frelimo) for control over Mozambique. That same year, the Portuguese bank that funded the colonial project in Mozambique purchased shares in *A Tribuna*. Such action brought *A Tribuna* under the colonial administration's control and thwarted the newspaper's anticolonial and proindependence coverage.

3. Luís Bernardo Honwana, interview by author, Maputo, Mozambique, July 2008.

4. According to its official narrative, on September 25, 1964, Frelimo combatant Alberto Chipande fired gunshots that killed a Portuguese soldier and marked the start of Frelimo's armed struggle for Mozambique's independence. For more on the role of certain events in the construction of the liberation narrative, see João Borges Coelho, "A Loosening Grip: The Liberation Script in Mozambican History," *Kronos*, Vol. 39, No. 1 (2014): 20–31.

5. José Oscar Monteiro, interview by author, Maputo, Mozambique, July 2008.

6. Ibid.

7. Ibid.

8. "A pose para a posteridade é comum a todas as pessoas e a todas as idades. Atentos e graves, dos clients encaram a lente da objectiva," *A Tribuna*, 3 Outubro 1964, Arquivo Histórico de Moçambique, Maputo, Mozambique.

9. The filmmaker Ahmed Ali recalled an incident shortly after 1975. He had traveled to Cabo Delgado, the province where Frelimo launched the war for independence. During the screening of a documentary, a man stood and pointed at the screen. The man had never seen himself before. The man turned to Ali for an explanation for how his picture appeared on the screen. For Ali, the experience was one of "those interesting moments [that revealed that people] did not know their image and had had no contact with images." Almost five years later, the newspaper *Notícias da Beira* published a reader's letter that criticized the failure of a photography studio to deliver her headshot. The clerk had retrieved the client's photographs based on the appearance of her face. The letter writer, who identified herself as L. Manjate, noted how she knew her face

and the clothes she wore the day of the photograph. The attendant backed away from the assertion that "this face is yours" and declared, "So your photos were burned. Take another photograph. Or, do you want the money [back]?" Popular responses to images, whether cinematic or photographic, were not limited to the years of 1975 and 1980 but were part of a historical continuum and everyday experiences in postindependent Mozambique. The people of Mozambique found images to be controversial in ways that might be unfamiliar to Western audiences. See Ahmed Ali, interview by author, Maputo, Mozambique, July 2010, and L. Manjate, "Foto Sandra," *Notícias da Beira*, 8 Março 1980, Arquivo Histórico de Moçambique, Maputo, Mozambique.

10. There is a wide body of literature on the perceived origins of the photographic apparatus and how it traveled to different parts of the world. As a result, perhaps scholars interested in photography in Africa, disciplinarily linked to the fields of art history and anthropology, found themselves compelled to explain the origins of the camera in Africa. Scholars interested in photography on the African continent have relied on certain genre classifications imposed by Eurocentric works to chart trajectories of photography. The result is the framing of scholarship through the binary of similarity and difference. For examples on histories related to early practices of photography, which treated photographs as historical sources and not as historical actors, see Walter Benjamin, "A Short History of Photography," *Screen*, Vol. 13, No. 1 (1972): 5–26; Susan Sontag, *On Photography* (New York: Farrar, Straus and Giroux, 1977); Alan Trachtenberg, *Classic Essays on Photography* (New Haven: Leete's Island Books, 1980). Related to Africa, see A. D. Bensusan, *Silver Images: History of Photography in Africa* (Cape Town: H. Timmins, 1966); Christaud Geary, *Images of Bamum: German Colonial Photography at the Court of King Njoya, Cameroon, West Africa 1902–1915* (Washington, DC: Smithsonian Institute Press, 1988); David Killingray and Andrew Roberts, "An Outline History of Photography in Africa to ca. 1940," *History in Africa*, Vol. 15 (1989): 197–208; Vera Viditz-Ward, "Photography in Sierra Leone, 1850–1918," *Africa*, Vol. 57, No. 4 (1987): 510–518; Beatrix Heintze, "In Pursuit of a Chameleon: Early Ethnographic Photography from Angola," *History in Africa*, Vol. 17 (1990): 131–156.

11. Erin Haney, "Film, Charcoal, Time: Contemporaneities in Gold Coast Photographs," *History of Photography*, Vol. 34 (2010): 119–133; Jennifer Bajorek, "Of Jumbled Valises and Civil Society: Photography and Political Imagination in Senegal," *History and Anthropology*, Vol. 21 (2010): 431–452; Liam Buckley, "Self and Accessory in Gambian Studio Photography," *Visual Anthropology Review*, Vol. 16, No. 2 (Fall-Winter 2000–2001): 71–91; Heike Behrend, *Contesting Visibility: Photographic Practices on the East African Coast* (Bielefeld: transcript Verlag, 2013); John Peffer and Elisabeth L. Cameron, *Portraiture & Photography in Africa* (Bloomington: Indiana University Press, 2013); Lorena Rizzo, "Visual Aperture: Bureaucratic Systems of Identification, Photography and Personhood in Colonial Southern Africa," *History of Photography*, Vol. 37, No. 3 (2013): 263–282.

12. Ibid.

13. The work of Christopher Pinney has encouraged me to not think about photog-

raphy as having a specific start date and geographical origin. The technology of photography may have originated in one place, but the appropriation, modification, and innovation of the medium and practice happened in diverse historical and geographical contexts. Pinney writes, "My suggestion here, following Latour, is that we need a *different* kind of history of photography, one which allows us to escape from the choice of either a technological determinism, on the one hand, or (on the other) a belief in photography's *neutrality* in which what matters are remarkable individual practitioners, or photography's 'Indian-ness' or 'Peruvian-ness' all of which give color to an otherwise blank space." See Christopher Pinney, "Camerawork as Technical Practice in Colonial India," in *Material Powers: Cultural Studies, History, and the Material Turn*, edited by Tony Bennett et al. (London: Routledge, 2010): 146.

14. Eric Allina, "'Fallacious Mirrors': Colonial Anxiety and Images of African Labor in Mozambique, ca. 1929," *History in Africa*, Vol. 24 (1997): 9–52; Filipa Lowndes Vicente, ed., *O Império da Visão: Fotografia no Contexto Colonial Português, 1860–1960* (Lisboa: Edições 70, 2014); Heintze, "In Pursuit of a Chameleon."

15. José Eduardo Agualusa, Inês Gonçalves, Kiluanje Liberdade, and Delfim Sardo, *Agora Luanda* (Lisboa: Edições Almedina, 2007): 43.

16. Allina, "'Fallacious Mirrors'"; António Sopa, "Um país em imagens: O percurso da fotografia em Moçambique," publisher and date unknown: 3–5.

17. Allina, "'Fallacious Mirrors'"; Vicente, *O Império da Visão*; Heintze, "In Pursuit of a Chameleon."

18. Agualusa et al., *Agora Luanda*, 43.

19. Ibid.

20. See Antoinette Errante, "Education and National Personae in Portugal's Colonial and Postcolonial Transition," *Comparative Education Review*, Vol. 42, No. 3 (August 1998): 267–308; Antoinette Errante, "White Skin, Many Masks: Colonial School, Race, and National Consciousness among White Settler Children in Mozambique, 1934–1974," *International Journal of African Historical Studies*, Vol. 36, No. 1 (2003): 7–33; Cláudia Castelo, *O Modo Português de Estar no Mundo: O Luso-Tropicalismo e a Ideologia Colonial Portuguesa (1933–1961)* (Porto: Edições Afrontamento, 1998).

21. Scholars such as Anne Pitcher and Gervase Clarence-Smith document the changing political and economic conditions that motivated Portuguese colonization of Africa. See Anne Pitcher, *Politics in the Portuguese Empire: The State, Industry, and Cotton, 1926–1974* (Oxford: Oxford University Press, 1993); W. G. Clarence-Smith, *The Third Portuguese Empire, 1825–1975: A Study in Economic Imperialism* (Manchester: Manchester University Press, 1985).

22. In tandem, people from China, Goa, and South Africa migrated and settled across Mozambique for political, social, and economic reasons. See Pamila Gupta, "Gandhi and the Goa Question," *Public Culture*, Vol. 23, No. 2 (2011): 321–330; Drew Thompson, "Photo Genres and Alternate Histories of Independence in Mozambique," in *Ambivalent: Photography and Visibility in African History*, edited by Patricia Hayes and Gary Minkley, 126–155 (Athens: Ohio University Press, 2019); Malcolm Corrigall, "Re-

framing Johannesburg's Urban Politics through the Lens of the Chinese Camera Club of South Africa," *Social Dynamics*, Vol. 44, No. 3 (2018): 510–527.

23. For more on Lusotropicalism and its impact on Portugal's colonial activities, see Jeanne Penvenne, "Settling against the Tide: The Layered Contradiction of Twentieth-Century Portuguese Settlement in Mozambique," in *Settler Colonialism in the Twentieth Century: Projects, Practices, Legacies*, edited by Caroline Elkins and Susan Pedersen, 79–95 (London: Routledge, 2005); Cláudia Castelo, "Uma incursão no lusotropicalismo de Gilberto Freyre," *Blogue de História Lusófona*, Ano VI (September 2011): 261–280, accessed 20 August 2019, http://nyemba.unilab.edu.br/wp-content/uploads/2017/03/lusotropicalismo-de-Gilberto-Freyre-HOJE.pdf; Gerald Bender, *Angola under the Portuguese: The Myth and the Reality* (Berkeley: University of California, 1978); Kesha Fikes, *Managing African Portugal: The Citizen-Migrant Distinction* (Durham: Duke University Press, 2009).

24. Sopa, "Um país em imagens," 8–9.

25. Ibid., 8–9.

26. Ibid., 5.

27. Ibid., 5.

28. Technological innovations are a significant part of histories of photography. International manufacturers such as Kodak, Fuji, and Agfa formed contractual agreements with local studios in South Africa, Mozambique, Brazil, and across Asia to sell their products. Economies of photographic production and use developed in colonial Mozambique independently of colonizing authorities. Portugal did not have its own photography manufacturer. Thus, commercial enterprises in Mozambique imported goods from distribution hubs in neighboring South Africa and Rhodesia. Geopolitical uncertainties complicated commercial endeavors. New global political orders ushered forward by liberation wars and decolonization efforts in Africa, Asia, and Latin America coincided with photography's proliferation and innovation. Groups opposed to colonial rule found ways to harness photography to win popular support and document their activities. However, a different economic, political, and social reality greeted liberation movements when they achieved the end of foreign rule and ascended to power. Evidence to support these points can be found in Okwui Enwezor's *The Short Century: Independence and Liberation Movements in Africa, 1945–1994* (New York: Prestal, 2001), and Revue Noire's photographic encyclopedia series on African photography. See also P. M. Saint Léon, *Anthology of African and Indian Ocean Photography* (Paris: Revue Noire, 1999). The most widely documented liberation efforts are antiapartheid movements in South Africa. See Iris Tillman Hill et al., eds., *Beyond the Barricades: Popular Resistance in South Africa* (New York: Aperture, 1989); Okwui Ewenzor and Rory Bester, eds., *Rise and Fall of Apartheid: Photography and the Bureaucracy of Everyday Life* (New York: International Center of Photography, 2013).

29. For example, Kodak users sent their color photo and cinema films to Rhodesia for development. Also, studios purchased operating equipment and photography supplies from South Africa, which was under white minority rule. See João "Funcho" Costa,

interview by author, Maputo, Mozambique, summer 2008 and August 2009; Pedro Pimenta, interview by author, Maputo, Mozambique, December 2010.

30. José António Manhiça, interview by author, Maputo, Mozambique, September and October 2010 and June 2012; António Ramos, interview by author, Maputo, Mozambique, September 2010; and José Machado, interview by author, Maputo, Mozambique, February and March 2010.

31. José António Manhiça, interview by author, Maputo, Mozambique, September and October 2010 and June 2012.

32. Kok Nam, interview by author, Maputo, Mozambique, July 2008.

33. "O que o público desconhece FOCUS: Pioneira da fotografia há vinte e seis anos!," *Tempo*, 17 Fevereiro 1974: 30–31. Also Sopa, "Um país em imagens," 8–9.

34. Joaquim Vieira, interview by author, email correspondence, January 2011.

35. Ricardo Rangel, interview by author, Maputo, Mozambique, summer 2008; Kok Nam, interview by author, Maputo, Mozambique, July 2008; Francisco Cuco, interview by author, Maputo, Mozambique, November 2010; *Sebastião Langa: Retratos de uma Vida* (Maputo: Arquivo Histórico de Moçambique, 2001).

36. Ricardo Rangel, interview by author, Maputo, Mozambique, summer 2008; Kok Nam, interview by author, Maputo, Mozambique, July 2008; Joaquim Vieira, interview by author, email correspondence, January 2011.

37. António Sopa, "Um país em imagens," 11–12.

38. David Huguana, interview by author, Maputo, Mozambique, March 2010.

39. Ibid.

40. José António Manhiça, interview by author, Maputo, Mozambique, September and October 2010 and June 2012; António Ramos, interview by author, Maputo, Mozambique, September 2010; Francisco Cuco, interview by author, Maputo, Mozambique, November 2010.

41. Valente Malangatana Ngwenya, interview by author with Eléusio Viegas Filipe, Maputo, Mozambique, June 2008.

42. With regard to photography, indexicality is a technical term. The concept points to a referent in a simpler, less epistemologically tenuous or challenging way than does painting. I do not wish to assume any single or universal meaning for either the concept or the medium of photography.

43. I am grateful to one of the peer-reviewed reports for raising the cited idea.

44. Patricia Hayes, "Power, Secrecy, Proximity: A Short History of South African Photography," *Kronos*, Vol. 33 (November 2007): 139–162; Santu Mofokeng, "Trajectory of a Street Photographer," *NKA: Journal of Contemporary African Art*, Vol. 11/12, No. 1 (Fall/Winter 2000): 40–47; Patricia Hayes, "Santu Mofokeng, Photographs: 'The Violence Is in the Knowing,'" *History & Theory*, Vol. 48, No. 4 (December 2009): 34–51.

45. For example, see Susan Sontag, *On Photography* (New York: Farrar, Straus and Giroux, 1977); Susan Sontag, *Regarding the Pain of Others* (New York: Farrar, Straus and Giroux, 2003); Abigail Solomon-Godeau, *Photography at the Dock: Essays on Photographic History, Institutions, and Practices* (Minneapolis: University of Minnesota Press,

1991); Alan Trachtenberg, *Classic Essays on Photography* (New Haven: Leete's Island Books, 1980).

46. For works related to the history of photography in Africa, see Erin Haney, *Photography and Africa* (London: Reaktion, 2010); Paul Landau and Deborah Kaspin, eds., *Images and Empires: Visuality in Colonial and Postcolonial Africa* (Berkeley: University of California Press, 2002); Richard Vokes, ed., *Photography in Africa: Ethnographic Perspectives* (Suffolk: James Currey, 2012); Peffer and Cameron, *Portraiture & Photography*; Darren Newbury, *Defiant Images: Photography and Apartheid in South Africa* (Pretoria: UNISA Press, 2009); Hayes, "Power, Secrecy, Proximity." For works related to the history of photography not focused on Africa, see Ariella Azoulay, *The Civil Contract of Photography* (New York: Zone Books, 2008); Ariella Azoulay, *Civil Imagination: A Political Ontology of Photography* (London: Verso, 2015); Allan Sekula, "The Body and the Archive," *October*, Vol. 39 (1986): 3–64; John Tagg, *The Burden of Representation: Essays on Photographies and Histories* (Minneapolis: University of Minnesota Press, 1988).

47. Scholarship on state formation in colonial and independent African nations presumes that building schools and hospitals was more pressing than training photographers and circulating photographs. Interestingly, though, the literature relies on a discursive language associated with photography without ever considering the interchangeable roles of bureaucrats and photographers among the many state actors. Related to state formation, see James Scott, *Seeing like a State: How Certain Schemes to Improve the Human Condition Have Failed* (New Haven: Yale University Press, 1999); Partha Chatterjee, *The Nation and Its Fragments: Colonial and Postcolonial Histories* (Princeton: Princeton University Press, 1993); Mahmood Mamdani, *Citizen and Subject: Contemporary Africa and the Legacy of Late Colonialism* (Princeton: Princeton University Press, 1996); Achille Mbembe, *On the Postcolony* (Berkeley: University of California Press, 2001). For more on the Mozambican historiography and the world of Lusophone Africa, see Aquino de Bragança and Jacques Depelchin, "From the Idealization of Frelimo to the Understanding of the Recent History of Mozambique," *African Journal of Political Economy*, Vol. 1 (1986): 162–180; Anne Pitcher, *Politics in the Portuguese Empire: The State, Industry, and Cotton, 1926–1974* (Oxford: Oxford University Press, 1993); Margaret Hall and Tom Young, *Confronting Leviathan: Mozambique since Independence* (Athens: Ohio University Press, 1997); António Cabrita, *The Tortuous Road to Democracy* (New York: Palgrave, 2000); Jeanne Penvenne, *African Workers and Colonial Racism: Mozambican Strategies and Struggles in Lourenço Marques, 1877–1962* (Portsmouth: Heinemann, 1995); Yusuf Adam, "Trick or Treat: The Relationship between Destabilization, Aid and Government Development Policies in Mozambique, 1975–1990," PhD dissertation, Roskilde Universitet, 1996.

48. Sekula, "The Body and the Archive"; Tagg, *The Burden of Representation*.

49. John Tagg, "Evidence, Truth and Order: Photographic Records and the Growth of the State," in *The Photography Reader*, ed. Liz Wells (London: Routledge, 2003): 260.

50. I attribute the point with regard to language and literacy to my reading of the peer-reviewer reports and feedback from participants at forums where I presented this work.

51. See Brian Larkin, *Signal and Noise: Media, Infrastructure, and Urban Culture in Nigeria* (Durham: Duke University Press, 2008); Brian Larkin, "The Politics and Poetics of Infrastructure," *Annual Review of Anthropology*, Vol. 21 (2013): 327–343; Scott, *Seeing Like a State.*

52. Frederick Cooper, *Africa since 1940: The Past of the Present* (Cambridge: Cambridge University Press, 2002): 18.

53. Ibid.

54. See David Birmingham, *A Concise History of Portugal* (Cambridge: Cambridge University Press, 1993); David Birmingham, *Portugal and Africa* (Athens: Ohio University Press, 1999); Paulo de Medeiros, "Hauntings: Memory, Narrative, and the Portuguese Colonial Wars," in *The Politics of War and Commemoration*, edited by T. G. Ashplant, Graham Dawson, and Michael Roper, 201–221 (London: Routledge, 2000).

55. Eduardo Frietas da Costa, Departamento de Informação e Opinião Pública, Apontamento, No. 93, 1 Agosto 1960, SR. 29: Moçambique (GIFOP), Arquivo Histórico Diplomático, Lisbon, Portugal.

56. Discussant remarks by Patricia Hayes, University of Western Cape Contemporary History Seminar, Cape Town, South Africa, August 2016.

57. Studies of national liberation struggles and nationalism are weak in terms of their consideration of aesthetic practice and bureaucratic transition. Benedict Anderson, *Imagined Communities: Reflections on the Origin and Spread of Nationalism* (London: Verso, 2006); Partha Chatterjee, *The Nation and Its Fragments* (Princeton: Princeton University Press, 1993); Odd Arne Westad, ed., *The Global Cold War: Third World Interventions and the Making of Our Times* (Cambridge: Cambridge University Press, 2007); Jocelyn Alexander, JoAnn McGregor, and Blessing-Miles Tendi, eds., "Special JSAS Conference Issue: Southern Africa Beyond the West: The Transnational Connections of Southern African Liberation Movements," *Journal of Southern African Studies*, Vol. 43 (2017): 1–20.

58. Ros Gray, "Cinema on the Cultural Front: Film-making and the Mozambican Revolution," *Journal of African Cinemas*, Vol. 3, No. 2 (March 2012): 130–160; Ros Gray, "'Haven't You Heard of Internationalism?'," in *Postcommunist Film: Russia, Eastern Europe and World Culture: Moving Images of Postcommunism*, edited by Lars Kristensen, 53–74 (London: Routledge, 2013).

59. Margaret Dickinson, "Flashbacks from a Continuing Struggle," *Third Text*, Vol. 25, No. 1 (2011): 129–134.

60. There is a connection to be made with Patricia Hayes's work on Afrapix and antiapartheid documentary photography in South Africa. Hayes argues that the formation of Afrapix turned photography in the direction of the antiapartheid movement after Steve Biko's secret murder and how that allowed the apartheid state and police to obscure what had happened. See Hayes, "Power, Secrecy, and Proximity."

61. Anonymous peer review for Drew Thompson, "Constructing A History of Independent Mozambique, 1974–1982: A Study in Photography," August 2012.

62. The colonial and postindependence state structures in Mozambique rejected the modes of identification and systems of surveillance established in neighboring South

Africa, the main focus of the existing literature on migration, photography, and state control in southern Africa. See Keith Breckenridge, *Biometric State: The Global Politics of Identification and Surveillance in South Africa, 1850 to the Present* (Cambridge: Cambridge University Press, 2014); Rizzo, "Visual Aperture"; Paul N. Edwards and Gabrielle Hecht, "History and the Technopolitics of Identity: The Case of Apartheid South Africa," *Journal of Southern African Studies*, Vol. 36, No. 3 (2010): 619–639.

63. Discussant remarks by Aditya Sarkar, Panel: Media, Technology, and Labor, International Conference on Labor History, New Delhi, India, March 2018.

64. For example, as a liberation movement, Frelimo lacked international recognition. At the time of the liberation war and in the years afterward, Frelimo's leadership and those who staffed administrative offices used photography as a mediating infrastructure (to borrow the term from anthropologist Brian Larkin)—directed both inward and outward. See Larkin, *Signal and Noise*.

65. See Marissa Moorman, *Intonations: A Social History of Music and Nation in Luanda, Angola, from 1945 to Recent Times* (Athens: Ohio University Press, 2008); Hayes, "Power, Secrecy, Proximity"; Hayes, "Santu Mofokeng, Photographs."

66. See Ariella Azoulay, "What Is a Photograph? What Is Photography?," *Philosophy of Photography*, Vol. 1, No. 1 (2010): 9–13; James Hevia, "The Photography Complex: Exposing Boxer-Era China (1900–1901), Making Civilization," in *Photographies East: The Camera and Its Histories in East and Southeast Asia*, ed. Rosalind C. Morris (Durham: Duke University Press, 2009): 80–81.

67. Azoulay, "What Is a Photograph?," 12.

68. Ibid.

69. Ibid.

70. Ibid.

71. Sopa, "Um país em imagens," 18–19.

72. Many photographers were born in Mozambique, but to families from Europe and Asia. Hence, I use the term "nonwhite" to capture the racial and ethnic diversity that characterized Portuguese colonialism in Mozambique. Terms such as "African" and "black" overshadow the complex race relations of the colonial period in Mozambique. For more, see Gupta, "Gandhi and the Goa Question"; Thompson, "Photo Genres and Alternate Histories"; Corrigall, "Reframing Johannesburg's Urban Politics"; Penvenne, *African Workers and Colonial Racism*.

73. Mia Couto, interview by author, Maputo, Mozambique, August 2010.

74. The group of *A Tribuna* editors included some of Mozambique's most prominent cultural intellectuals, including Luís Bernardo Honwana, José Craveirinha, José Luís Cabaço, Fernando Margalhes, and João Reis.

75. For more on the specific history of *Tempográfica* and *Tempo* within the broader context of the Mozambican press, see Emídio Machiana, *A Revista "Tempo" e a Revolução Moçambicana: Da Mobilzação Popular ao Problema da Crítica na Informação, 1974–1977* (Maputo: Promédia, 2002).

76. Literature on the press in Africa tends to exclude illustrated magazines such as

Drum, Bingo, and *Tempo.* Scholars in photographic studies have characterized the photographs printed in news publications as a form of press photography. Even then, Mozambique is rarely mentioned. See Darren Newbury, *Defiant Images*; Raison Naidoo, *The Indian in Drum Magazine in the 1950s* (Cape Town: Bell-Roberts Publishing, 2008); Jennifer Bajorek, "'Ça bousculait!': Democratization & Photography in Senegal," in *Photography in Africa: Ethnographic Perspectives,* edited by Richard Vokes, 140–165 (Suffolk: James Currey, 2012).

77. African studies has produced a variety of scholarship on how press accounts have their own history and how to consider the press as a type of historical source. These writings situate the production and consumption of press accounts within the broader social and political landscapes that characterize African societies over the course of colonialism and independence. For more, see Derek R. Peterson, Emma Hunter, and Stephanie Newell, eds., *African Print Cultures: Newspapers and Their Publics in the Twentieth Century* (Ann Arbor: University of Michigan Press, 2016); Karin Barber, ed., *Africa's Hidden Histories: Everyday Literacy and Making the Self* (Bloomington: Indiana University Press, 2006); Karin Barber, *The Anthropology of Texts, Persons and Publics: Oral and Written Culture in Africa and Beyond* (Cambridge: Cambridge University Press, 2007). With regard to Mozambique more specifically, Emídio Machiana, *A Revista "Tempo" e a Revolução Moçambicana*; Jeanne Penvenne, "João dos Santos Albasini (1876–1922): The Contradictions of Politics and Identity in Colonial Mozambique," *Journal of African History,* Vol. 37, No. 3 (1996): 419–464.

78. Teresa Sá Nogueira, "Ricardo Rangel, poeta da imagem," *M de Moçambique,* Maio and Junho 2012: 31–36; Carlos Calado, interview by author, Maputo, Mozambique, March and July 2010; and Luís Souto, interview by author, Maputo, Mozambique, April and November 2010.

79. Inspired by the writings of Elizabeth Edwards, visual historian Patricia Hayes proposes treating photographs as "first drafts of history." See Hayes, "Power, Secrecy, Proximity," 151; Elizabeth Edwards, "Photography and the Performance of History," *Kronos,* Vol. 27 (November 2001): 15–29.

80. By and large, few family photographs and full-body photographs existed in 1980s Mozambique. The state apparatus placed unprecedented demands on studio and street photographers to produce headshots. People required headshots to obtain government-issued identification.

81. Hevia, "The Photography Complex," 18.

82. Ibid.

83. Ibid.

84. Jorge Rebelo, interview by author, Maputo, Mozambique, July 2008.

85. Ibid.

86. Ibid.

87. Walter Benjamin, "The Work of Art in the Age of Mechanical Reproduction," in *Illuminations,* edited by Hannah Arendt, 1–26 (New York: Schocken Books, 1969).

88. Ibid., 4.

89. Ibid., 4.

90. I am grateful to Lecia Rosenthal for helping me to understand Benjamin's idea of reproducibility in relation to my own understanding of how filters and processes of filtering characterize global histories of photography.

91. Ricardo Rangel, interview by author, Maputo, Mozambique, summer 2008; Kok Nam, interview by author, Maputo, Mozambique, July 2008; Joaquim Vieira, interview by author, email correspondence, January 2011.

92. Toward the end of 1964, the year the anticolonial war started in Mozambique, Rangel had learned that the colonial state had purchased *A Tribuna*. He returned to the newsroom one evening, to attempt to retrieve whatever negatives he could. His archive, then, is an incomplete collection of the images he took over the course of his career. See Grant Lee Neuenburg, interview by author, Maputo, Mozambique, May 2010.

93. There is a large literature in African history on the role of oral history. See Elizabeth Tonkin, *Narrating Our Pasts: The Social Construction of Oral History* (Cambridge: Cambridge University Press, 1992); Luise White, *Speaking with Vampires: Rumor and History in Colonial Africa* (Berkeley: University of California Press, 2000); Jan Vansina, *Oral Tradition as History* (Madison: University of Wisconsin Press, 1985); Luise White, Stephan F. Miescher, and David William Cohen, eds., *African Words, African Voices: Critical Practices in Oral History* (Bloomington: University of Indiana Press, 2001).

94. Fernando Lima, interview by author, Maputo, Mozambique, June 2010.

95. Ibid.

96. Ibid.

97. Christopher Pinney, *Camera Indica: The Social Life of Photographs* (Chicago: University of Chicago Press, 1997).

98. The year 1994 marked the official end of the civil war in Mozambique and the first democratic elections. In anticipation of the war's end and the nation's political transformation from single to multiparty rule, journalists in Mozambique and the Frelimo party agreed to an independent press. Until this time, the ruling party Frelimo had controlled the press.

99. Mia Couto, "'Thirty Years Ago They Smiled': Carnation Revolution," *Le Monde Diplomatique* (April 2004), accessed July 2016, https://mondediplo.com/2004/04/15mozambique

100. William Minter, *Apartheid's Contras: An Inquiry into the Roots of War in Angola and Mozambique* (London: Zed Books, 1994); Hall and Young, *Confronting Leviathan*; Glenda Morgan, "Violence in Mozambique: Towards an Understanding of Renamo," *Journal of Modern African Studies*, Vol. 28, No. 4 (1990): 603–619; Alice Dinerman, *Revolution, Counter-Revolution and Revisionism in Postcolonial Africa: The Case of Mozambique, 1975–1994* (London: Routledge, 2006).

CHAPTER 1

1. Alexandre Ribeiro da Cunha, Apontamento No. 106.A., 23 Agosto 1960, SR 159: Apontamentos Confidências, Gabinete dos Negócios Políticos, Arquivo Histórico Diplomático, Lisbon, Portugal.

2. Ibid.

3. Cunha had viewed an American Committee on Africa pamphlet on the Kenyan political activist Tom Mboya.

4. Ibid.

5. Ibid.

6. See Antoinette Errante, "Education and National Personae in Portugal's Colonial and Postcolonial Transition," *Comparative Education Review*, Vol. 42, No. 3 (August 1998): 267–308; Antoinette Errante, "White Skin, Many Masks: Colonial School, Race, and National Consciousness among White Settler Children in Mozambique, 1934–1974," *International Journal of African Historical Studies*, Vol. 36, No. 1 (2003): 7–33.

7. Ibid.

8. See Afonso Ramos, "Angola 1961, o horror das imagens," in *O Império da Visão: Fotografia no Contexto Colonial (1860–1960)*, edited by Filipa Lowndes Vicente, 399–434 (Lisboa: Edições 70, 2014).

9. Patricia Hayes, discussant remarks, Contemporary History Seminar, Center for Humanities Research, University of Western Cape, August 2016.

10. Ibid.

11. "Porque não há: Documentos fotográficos da invasão de Goa?," *Diario de Notícias*, 1 Janeiro 1962, Biblioteca Nacional de Portugal, Lisbon, Portugal, 1.

12. Ricardo Rangel, personal archive, Centro de Documentação e Formação Fotográfica, Maputo, Mozambique.

13. See "Jardim: Um agente do imperialism rodeado de lacaios," *Tempo*, No. 314, 10 Outubro 1973: 33, Biblioteca Nacional de Moçambique, Maputo, Mozambique.

14. Eduardo Frietas da Costa, "Apontamento, No. 93," 1 de Agosto do 1960, SR. 29: Moçambique (GIFOP), Gabinete Negícios Políticos, Arquivo Histórico Diplomático, Lisbon, Portugal.

15. Comando Militar de Moçambique, "Serviço de Informações Militares," 1960, PT-TT-SCCIM-30, Arquivos Nacional Torre do Tombo, Lisbon, Portugal.

16. Debates about visibility and invisibility frame the literature on infrastructure, much like scholarship on bureaucracy and state formation, yet the practice of photography remains an understudied component. In her seminal essay "The Ethnography of Infrastructure," Susan Star writes, "People commonly envision infrastructure as a system of substrates—railroad lines, pipes, plumbing, electrical power plants, and wires. It is by definition invisible, part of the background for other kinds of work. It is ready-to-hand." Anthropologist Brian Larkin challenges Star's notion of infrastructure as entirely visible. He argues that infrastructure such as electricity acquires and relies on varying gradations of invisibility over time. See Star, "The Ethnography of Infrastructure," *American Behavioral Scientist*, Vol. 43, No. 1 (1999): 380; Brian Larkin, "The Politics of Infrastructure," *Annual Review of Anthropology*, Vol. 21 (2013): 327–343.

17. An incredible number of photobooks exist on the Portuguese colonial war in Africa, but there are few articles about the actual production of these photographs, including biographies of specific photographers. See Renato Monteiro and Luís Farinha, *Guerra Colonial: Fotobiografia* (Lisboa: Publicações Dom Quixote, 1990); João de Melo,

Os Anos da Guerra 1961–1975: Os Portugueses em África (Lisboa: Publicações Dom Quixote, 1998); Diamantino Faria, *Destino: Mucaba* (Lisboa: Edição do autor, 1962); Paulo Madeira Rodrigues, eds., *4 Países Libertados: Portugal, Guiné-Bissau, Angola, Moçambique* (Lisboa: Círculo de Leitores, 1975).

18. Filipa Lowndes Vicente, ed., *O Império da Visão: Fotografia no Contexto Colonial Português, 1860–1960* (Lisboa: Edições 70, 2014); Eric Allina, "'Fallacious Mirrors': Colonial Anxiety and Images of African Labor in Mozambique, ca. 1929," *History in Africa*, Vol. 24 (1997): 9–52; Beatrix Heintze, "In Pursuit of a Chameleon: Early Ethnographic Photography from Angola," *History in Africa* 17 (1990): 131–156; Erin Haney, *Photography and Africa* (London: Reaktion, 2010); Paul Landau and Deborah Kaspin, *Images and Empires: Visuality in Colonial and Postcolonial Africa* (Berkeley: University of California Press, 2002); Richard Vokes, ed., *Photography in Africa: Ethnographic Perspectives* (Suffolk: James Currey, 2012); John Pfeffer and Elisabeth L. Cameron, *Portraiture & Photography in Africa* (Bloomington: University of Indiana Press, 2013).

19. Marie-José Mondzain, *Image, Icon, Economy: The Byzantine Origins of the Contemporary Imaginary* (Palo Alto: Stanford University Press, 2005).

20. Ibid.

21. Birgit Meyer, *Sensational Movies: Video, Vision, and Christianity in Ghana* (Berkeley: University of California Press, 2015).

22. The visual historian Patricia Hayes recalled a former anticolonial activist presenting her with these photographs in book form. From her perspective, in terms of their content the photographs "made the horrors of Abu Ghraib dwindle in comparison." See Patricia Hayes, discussant remarks, Contemporary History Seminar, Center for Humanities Research, University of Western Cape, August 2016.

23. For more on events that transpired and the politics associated with their unfolding, see Pamila Gupta, "Gandhi and the Goa Question," *Public Culture*, Vol. 23, No. 2 (2011): 321–330; Caio Simões de Araújo, "Diplomacy of Blood and Fire: Portuguese Decolonization and the Race Question, ca. 1945–1968," PhD dissertation, The Graduate Institute of International and Development Studies, 2017.

24. "Porque não há," 1.

25. Ibid., 1.

26. Ibid., 1.

27. Apontamento para Presidência do Conselho, 11 Janeiro 1962, 2, SR 22: China, Política Internacional, Gabinete dos Negócios Políticos, Arquivo Histórico Diplomático, Lisbon, Portugal.

28. Presidência do Conselho, 5 Janeiro 1962, 2, SR 22: China, Política Internacional, Gabinete dos Negócios Políticos, Arquivo Histórico Diplomático, Lisbon, Portugal.

29. See Processo no. 2006-CI(2): Indianos nas províncias ultramarinas, Nt 7152, PIDE/DGS, Arquivo Nacional Torre do Tombo, Lisbon, Portugal.

30. Cartã para Preisidência do Conselho, 5 Janeiro 1962, 2 SR 22: China, Política Internacional, Gabinete dos Negócios Políticos, Arquivo Histórico Diplomático. Lisbon, Portugal.

31. Ibid.

32. Ibid.

33. Anthropologist Pamila Gupta addresses figure 3 in her respective studies of the photographer Ricardo Rangel and Mozambique's decolonization. See Gupta, "Autoethnographic Interventions and 'Intimate Exposures' in Ricardo Rangel's Portuguese Mozambique," *Critical Arts: South-North Cultural and Media Studies*, Vol. 29, No. 1 (2015): 166–181; Gupta, "Decolonization and (Dis)Possession in Lusophone Africa," in *Mobility Makes States: Migration and Power in Africa*, edited by Darshan Vigneswaran and Joel Quirk, 169–193 (Philadelphia: University of Pennsylvania Press, 2015); Gupta, *Portuguese Decolonization in the Indian Ocean World* (London: Bloomsbury, 2018).

34. Ricardo Rangel, contact sheets, Caixa: Rangel: Tempo Colonial, Centro de Documentação e Formação Fotográfica, Maputo, Mozambique.

35. Ibid.

36. Ibid.

37. Secretariado Nacional de Lisboa, *Genocídio Contra Portugal* (Lisboa: Edição Secretariado Nacional de Lisboa, 1961): 1.

38. Joaquim Vieira, interview by author, email correspondence, May 2011.

39. Rangel and Vieira frequently disagreed with each other and with the colonial state over the publication of their respective photographs. Vieira was Rangel's superior. In the 1950s, Rangel left the photo laboratory Focus to work in the newsroom *Notícias* and its afternoon edition, *Notícias da Tarde*. Vieira and Rangel disagreed over which of Rangel's films to publish. In one example, Rangel had photographed a swimming competition and wanted to print a photograph of the swimmer in the final sprint. Vieira determined that an image of the trophy ceremony was more appropriate. Vieira preferred to adhere to technical accuracy, whereas subject matter and the moment of the photograph were of greater priority to Rangel. See Beatrice Rangel, interview by author, Maputo, Mozambique, April 2010; Joaquim Vieira, interview by author, email correspondence, May 2011.

40. Vieira was born in Mozambique but grew up in Portugal. On one assignment, the Chamber of Commerce in the colonial capital of Lourenço Marques invited Vieira to the annual holiday party, but not his colleague, the writer and print journalist José Craveirinha. Vieira determined that race was the reason for the Chamber of Commerce's actions. In response, he decided not to cover the event, which according to Vieira's son produced harsh repercussions. See Joaquim Vieira, interview by author, email correspondence, May 2011.

41. Ricardo Rangel, untitled photographs, Caixa: Rangel: Tempo Colonial, Centro de Documentação e Formação Fotográfica, Maputo, Mozambique.

42. Calane da Silva, "Corpo alma das pessoas: Do teatro das sombras ao 'clic' quase mágico," *Domingo*, 1999, available at Centro de Documentação e Formação Fotográfica, Maputo, Mozambique.

43. Ibid.

44. There was an expectation for news from within Portugal and the colonies it gov-

erned. The journalist Artur Maciel wrote about accompanying Portugal's troops in Angola and published the book *Angola Heróica: 120 Dias Com Os Nossos Soldados* about his experiences. He recalled learning over the telephone how a United Nations airplane had almost collided with an air force fighter plane and landed to await a resolution to the air confrontation. While waiting under the stars, when the sky was empty of weapons firing, he wondered, "Would not the newspapers of the following day be able to clarify all the rumors that ran about the plane? And how would it be for that night?" See Artur Maciel, "Informação e contra-informação: Armas do nosso tempo," in *Angola Herórica: 120 Dias com os Nossos Soldados* (Lisboa: Livraria Bertrand, 1963): 35.

45. Secretariado Nacional de Lisboa, *Genocídio Contra Portugal*.

46. Ibid.

47. Ibid.

48. This is an example where the image is used as an instrument of violence against populations native to the colonies. See "Jardim: Um agente do imperialism rodeado de lacaios," *Tempo*, No. 314, 10 Outubro 1973: 33, Biblioteca Nacional de Moçambique, Maputo, Mozambique.

49. Ibid.

50. Maciel, "Informação e contra-informação," 36.

51. See Mègre Pires, Assunto: "O que se sabe do ultramar português?," Apontamento No. 204, 12 Janeiro 1962, Sr 22: China, Politica Internacional, Gabinete dos Negócios Políticos, Arquivo Histórico Diplomático. Lisbon, Portugal.

52. Photographer unknown, untitled, PT/AHM/DIV/F110/B7/MD/14/21, Arquivo Histórico Militar, Lisbon, Portugal.

53. S. J. McIntosh, PT/AHM/FE/110/J6, Fototeca, Arquivo Histórico Militar, Lisbon, Portugal; Moçambique, PT/AHM/FE/110/B7, Fototeca, Arquivo Histórico Militar, Lisbon, Portugal.

54. S. J. McIntosh, PT/AHM/FE/110/J6, Fototeca, Arquivo Histórico Militar, Lisbon, Portugal.

55. Modelo de Ficha de Interrogatório, Comando Militar de Moçambique, PT-TT-SCCIM-30, Arquivo Nacional Torre do Tombo, Lisbon, Portugal.

56. Ibid.

57. Ibid.

58. Photo caption, *Notícias*, 11 Outubro 1970, Arquivo Histórico de Moçambique, Maputo, Mozambique.

59. Coluna em Marcha, *Notícias*, 11 Agosto 1973: 2, Biblioteca Nacional de Moçambique, Maputo, Mozambique; Coluna em Marcha, *Notícias*, 18 Agosto 1973: 3, Biblioteca Nacional de Moçambique, Maputo, Mozambique; Coluna em Marcha, *Notícias*, 19 Maio 1973: 2, Biblioteca Nacional de Moçambique, Maputo, Mozambique.

60. Ibid.

61. Diana Andringa, a filmmaker born in Angola who moved in her early years to Portugal, claimed that the Portuguese authoritarian state censored photographs of the colonial wars in Lisbon (it permitted the publication of photographs of the Vietnam

War, however). Part of the reason was to influence Portuguese public opinion, which was increasingly against the war in Africa. See Diana Andringa, interview by author, Lisbon, Portugal, April 2017.

62. Coluna em Marcha, *Notícias*, 12 Maio 1973: 1, Biblioteca Nacional de Moçambique, Maputo, Mozambique.

63. Ibid.

64. "Fotografia (para Eva)," Coluna em Marcha, *Notícias*, 27 Outubro 1973: 3, Biblioteca Nacional de Moçambique, Maputo, Mozambique.

65. "Relatórios de interrogatórios de pessoal capturado da ZOT, 1972," Cx. 945 and 946, PT/AHM/FO/063/A/12, Arquivo Histórico Militar, Lisbon, Portugal.

66. Georges Didi-Huberman, "Before the Image, before Time: Sovereignty of Anachronism," in *Compelling Visuality: The Work of Art in and out of History*, edited by Claire J. Farago and Robert Zwijneberg (Minneapolis: University of Minnesota Press, 2003): 33–34.

67. Available wartime communications give no indication that diplomatic and military officials attempted to hire staff photographers and acquire photographic equipment.

68. "Definições e conceitos technicos de informações," PT-TT-SCCIM-1924, Arquivo Nacional de Torre do Tombo, Lisbon, Portugal.

69. Ibid., 1–2.

70. Ibid., 2.

71. Ibid.

72. Ibid., 1–2.

73. "Directiva de Apsic do Ministério do Ultramar," Sr. 61: Moçambique: Acção-Psicológica Conselho Provincia, 30 Caixa, Gabinete dos Negócios Políticos, Historical Diplomatic Archives, Lisbon Portugal.

74. Gabinete Provincial de Acção Psicológica, Informação No. 6, Assunto: Meios materias de acção psicologica a enviar ao Ministério do Ultramar, Sr. 61: Moçambique: Acção-Psicológica Conselho Provincia, 30 Caixa, Gabinete dos Negócios Políticos, Historical Diplomatic Archives, Lisbon Portugal.

75. Carta por Fernando Jorge de Figueiredo para Polícia Internacional e de Defesa do Estado-Delegação em Moçambique, SCCIM 29: Informação sobre anti-espionage personnel e materias, 203, Arquivo Nacional Torre do Tombo, Lisbon, Portugal.

76. Carta por Alvaro de G. Melo para Senhor Ministro do Ultramar, Gabinete dos Negócios Políticos, Sr 29: GIFOP, Gabinete dos Negócios Políticos, Arquivo Histórico Diplomático, Lisbon, Portugal.

77. Ibid.

78. Ibid.

79. "Definições e conceitos technicos de informações," PT-TT-SCCIM-1924, 9–13, Arquivo Nacional de Torre do Tombo, Lisbon, Portugal.

80. Ibid.

81. One of these steps entailed sending diplomatic documents in locked pouches

rather than with a person on board an airplane. See Carta por Eduardo Alberto Silva e Sousa para Governo-Geral de Angola, Informação No. 203/64, SCCIM 29: Informação sobre anti-espionage personnel e materiais, 136, Arquivo Nacional Torre do Tombo, Lisbon, Portugal; and Carta por A. Ivens-Ferraz de Freitas, Assunto: "Troca de correspondência classificada com o Ministério do Ultramar," SCCIM 29: Informação sobre anti-espionage personnel e materiais, 134, Arquivo Nacional Torre do Tombo, Lisbon, Portugal.

82. "Secret Recording Devices," 209, SCCIM 29: Informação sobre anti-espionage personnel e materiais, 203, Arquivo Nacional Torre do Tombo, Lisbon, Portugal; "the Byphone brings back the good old party line . . . but nobody would ever know it," SCCIM 29: Informação sobre anti-espionage personnel e materiais, 212, Arquivo Nacional Torre do Tombo, Lisbon, Portugal; "Continental Bulletin," SCCIM 29: Informação sobre anti-espionage personnel e materiais, 213, Arquivo Nacional Torre do Tombo, Lisbon, Portugal.

83. José Oscar Monteiro, interview by author, Maputo, Mozambique, July 2008; Ricardo Rangel, interview by author, Maputo, Mozambique, summer 2008.

84. Da Costa, "Apontamento No. 93," 1.

85. Ibid.

86. Ibid.

87. José Oscar Monteiro, interview by author, Maputo, Mozambique, July 2008.

88. Carta por Alvaro de G. Melo para Senhor Ministro do Ultramar, Gabinete dos Negócios Políticos, Sr 29: GIFOP, Gabinete dos Negócios Políticos, Arquivo Histórico Diplomático, Lisbon, Portugal.

89. "Definições e conceitos technicos de informações," PT-TT-SCCIM-1924, Arquivo Nacional de Torre do Tombo, Lisbon, Portugal.

90. "Commisão do Censura: Organização, pessoal, material, etc.; Publicações proibido e censura as mesmas; Diversos," 1959–1961, Caixa 572 and 573, Arquivo Histórico de Moçambique, Maputo, Mozambique.

91. Ibid.

92. Ricardo Rangel had received support from editors such as Bispho de Rezende, who edited the daily newspaper *Diario de Moçambique*. The Commisão do Censura frequently banned the publication of Rangel's photographs. Photojournalists and print journalists alike recalled that de Rezende had authorized the printing of a white text box in lieu of selecting other images. In response to this decision, the colonial state closed the newspaper for a day or two. See Ricardo Rangel, interview by author, Maputo, Mozambique, summer 2008; Beatrice Rangel, interview by author, April 2010; Luís Bernardo Honwana, interview by author, Maputo, Mozambique, July 2008; and José Luís Cabaço, interview by author, Maputo, Mozambique, September 2010.

93. Ibid.

94. Teresa Sa Nogueira, "Ricardo Rangel: The Poet of Photography," *Indico* (LAM in-flight magazine) (early 2000s): 18–25, available at the Centro de Documentação e Formação Fotografica, Maputo, Mozambique.

95. Ibid.

96. Portugal and the colonial state struggled to document institutional attempts to foster racial harmony and to depict photographically the ideological and political position that the overseas provinces were extensions of Portugal. In lieu of such images, GIFOP circulated photographs of troop deployments, military operations, and humanitarian operations. See Da Costa, "Apontamento No. 93."

97. Gabinete de Informação e Formação da Opinião Pública, "Anexo 'C' (Fotocópia da proposta de aproveitamento de um panfleto IN e 'Estudo' da Mesma)," Agosto 1967, SR 29: Moçambique (GIFOP), Gabinete dos Negócios Políticos, Arquivo Histórico Diplomático, Lisbon, Portugal.

98. Ibid.

99. Maria Manuela Teneiro, "Military Encounters in the Eighteenth Century: Carlos Julião and Racial Representations in Portuguese Empire," *Portuguese Studies*, Vol. 23, No. 1 (2007): 9–10.

100. See PT-AM-DIV-63-15-954-1, Arquivo Histórico Militar, Lisbon, Portugal.

101. John Berger, "Drawing Is Discovery (August 29, 1953)," *New Statesmen*, 1 May 2013.

102. "Directiva no. 1 de Acção Psicológica para o Distrito do Niassa," Anexo "A" Acta No. 46/68 de 13 Março 1968, SR 29: Moçambique (GIFOP), Gabinete dos Negócios Políticos, Arquivo Histórico Diplomático, Lisbon Portugal.

103. Ibid.

104. "Relatórios de interrogatórios de pessoal capturado da ZOT, 1972," Cx. 945 and 946, PT/AHM/FO/063/A/12, Arquivo Histórico Militar, Lisbon, Portugal.

105. Ibid.

106. "Lourenço Marques confirma: Não existe na província a aldeia de Wiriyamu," *Notícias*, 13 Julho 1973, Biblioteca Nacional de Moçambique, Maputo, Mozambique; "Imprensa mundial continua a dedicar comentários às fantasias publicadas no 'Times,'" *Notícias*, 14 Julho 1973: 1, Biblioteca Nacional de Moçambique, Maputo, Mozambique; "Jornalista británico confirma em Tete: Nem o mais leve indício de que as atrocidades tivessem sido cometidas," *Notícias*, 14 Julho 1973: 1, Biblioteca Nacional de Moçambique, Maputo, Mozambique;

107. Ibid.

108. For more on Wiriyamu and its representation within the public sphere, see Mustafah Dhada, *The Portuguese Massacre of Wiriyamu in Colonial Mozambique, 1964–2013* (London: Bloomsbury Academic, 2016); Robert Stock, "The Many Returns to Wiriyamu: Audiovisual Testimony and the Negotiation of Colonial Violence," in *Re(Imagining African Independence: Film, Visual Arts and the Fall of the Portuguese Empire*, edited by Maria do Carmo Piçarra and Teresa Castro, 87–107 (Oxford: Peter Lang, 2017).

109. "Relatórios de interrogatórios de pessoal capturado da ZOT, 1972," Cx. 945 and 946, PT/AHM/FO/063/A/12, Arquivo Histórico Militar, Lisbon, Portugal.

110. James Pinto Bull, "Autorização para a Execução de Fotografias e Filmagens

Aéreas Solicitada Pelo Governo Geral de Moçambique," Apontamento No. 108.A, 26 Agosto 1960, SR. 29: Moçambique (GIFOP), Arquivo Histórico Diplomático, Lisbon, Portugal.

111. Ibid.

112. Ibid.

113. Da Costa, "Apontamento No. 93."

114. Ibid.

115. SR 61: Moçambique, Acção Psicológica Conselho Provincia, Caixas 1 and 3, Gabinete dos Negócios Políticos, Arquivo Histórico Diplomático, Lisbon, Portugal.

116. Within the broader historical backdrop of Portugal's war over Mozambique and its other territories in Africa, China and Russia formed military and development alliances (discussed in the next chapter) with liberation movements across southern Africa as well as with independent states such as Mozambique's immediate neighbors Tanzania and Zambia. Part of the strategic cooperation involved building roads and railways and renovating communication systems across sub-Saharan Africa. For more, see Jamie Monson, *Africa's Freedom Railway: How a Chinese Development Project Changed Lives and Livelihoods in Tanzania* (Bloomington: Indiana University Press, 2009).

117. Between 1967 and 1971, Portugal had learned that the Chinese presence in Zanzibar consisted of doctors and construction workers and involved building a TV station and distributing television sets. The inclusion of "photographic reproductions of two lithographs" from a Zambian newspaper article on the Chinese in Africa reflected Portugal's concern over this development. The reproduced photographs attached to internal communications showed Chinese men, one standing in a forested area and looking through a topography camera; another showed two Chinese men seated in a boat. The Portuguese officials who circulated the photographs referred to their captions as illustrations of communist mentality. The person assumed that the Chinese, who stood in some photographs next to Tanzanians, spoke about Mao Tse-Tung. See O Estado Maior General das Forças Areas, "Relatório de notícias," SR 090: Penetração Comunista (Chinesa) em Africa, Caixa 2, Arquivo Histórico Diplomático, Lisbon, Portugal.

118. "Meios de comunicação com as massas-Alti-Falantes," 20 Novembro 1967, 1–3, SR 29: Moçambique: GIFOP, Gabinete dos Negócios Políticos, Arquivo Histórico Diplomático, Lisbon Portugal. Also see S. R. Governo-Geral de Moçambique: Gabinete de Informação e Formação da Opinião Pública, "Acta No. 43/68-Reunião de 24 Jan 68: Alti-Falantes," 31 de Janeiro 1968, 2, SR 29: Moçambique: GIFOP, Gabinete dos Negócios Políticos, Arquivo Histórico Diplomático, Lisbon, Portugal.

119. Carta por o Secretário-Geral para CCM e ao Presidente da Commisão do Censura, "Utilização da palavra 'Portugal' nos meios de comunicação com as massas," SR 61: Moçambique, Acção Psicológica, Gabinete dos Negócios Políticos, Arquivo Histórico Diplomático, Lisbon, Portugal.

120. "Assunto: Material Impressão," GIFOP, LMARQUES, 20 Nov 67, SR 29: Moçambique, Gabinete dos Negócios Políticos Arquivo Histórico Diplomático, Lisbon, Portugal.

121. For more on the historical context of race hierarchies, see Bridget O'Laughlin, "Class and the Customary: The Ambiguous Legacy of the *Indigenato* in Mozambique," *African Affairs*, Vol. 99 (2000): 5–42; Jeanne Penvenne, "João dos Santos Albasini (1876–1922): The Contradictions of Politics and Identity in Colonial Mozambique," *Journal of African History*, Vol. 37, No. 3 (1996): 419–464.

122. "APSIC planeamento e desenvolvimento em Julho," SR 61: Acção Psicológica, Gabinete dos Negócios Políticos, Arquivo Histórico Diplomático, Lisbon, Portugal.

123. Ibid.

124. Ibid.

125. Número 17, Exemplar No. 3, BCAÇ 3868, M Praia, Abril 13, 1972, AP 2, Arquivo Histórico Militar, Lisbon, Portugal.

126. "Relatórios de interrogatórios de pessoal capturado da ZOT, 1972," Cx. 945 and 946, PT/AHM/FO/063/A/12, Arquivo Histórico Militar, Lisbon, Portugal.

127. Ibid.

128. Ibid.

129. Ibid.

130. "Instruções sobre a segurança das materiais classificadas," PT-TT-SCCIM-30, 50, Arquivo Nacional Torre do Tombo, Lisbon, Portugal.

131. Ibid.

132. See "Contra a burocracia," *Tempo*, No. 40, 20 Junho 1971: 22–30, accessed through JSTOR ALUKA: Struggles for Freedom—Southern Africa; "Burocracia: Cadeia de papéis sufoca energia criadora," *Tempo*, No. 217, 24 Novembro 1974: 10–16, accessed through JSTOR ALUKA: Struggles for Freedom—Southern Africa; "Burocracia burocratismo," *Tempo*, No. 296, 6 Junho 1976: 22–23, accessed through JSTOR ALUKA: Struggles for Freedom—Southern Africa; "Funcionários," *Tempo*, No. 296, 6 Junho 1976: 16–23, accessed through JSTOR ALUKA: Struggles for Freedom—Southern Africa. I also heard this opinion expressed in graduate seminars at the University of Minnesota–Twin Cities. Historian Caroline Elkins documents a similar practice in Kenya during British colonial rule. See Caroline Elkins, "Looking beyond Mau Mau: Archiving Violence in the Era of Decolonization," *American Historical Review*, Vol. 120, No. 3 (June 2015): 852–868; Caroline Elkins, "Alchemy of Evidence: Mau Mau, the British Empire, and the High Court of Justice," *Journal of Imperial and Commonwealth History*, Vol. 39, No. 5 (2011): 731–748.

CHAPTER 2

1. Mozambican historian João Borges Coelho refers to historical details such as the start of the liberation war and a chronology of its activities as a "liberation script." He argues that there are certain characters, dates, and narratives, such as the firing

of gunshots, that give rise to a liberation narrative. Coelho believes that the ruling party Frelimo, which currently governs in Mozambique, uses the "liberation script" as a continual source of legitimacy and power. See João Borges Coelho, "Politics and Contemporary History in Mozambique: A Set of Epistemological Notes," *Kronos*, Vol. 39 (2013): 20–31.

2. Jorge Rebelo, interview by author, Maputo, Mozambique, July 2008.

3. Mariano Matsinha to Studio Hiros, 10 October 1963, DRE 29-C, Arquivo Histórico de Moçambique, Maputo, Mozambique; J. Chissano, education secretary, for Studio Hiros (Dar es Salaam), 25 July 1964, DRE 29-C, Arquivo Histórico de Moçambique, Maputo, Mozambique.

4. Margaret Dickinson, interview by author, Maputo, Mozambique, September 2010; Jorge Rebelo, interview by author, Maputo, Mozambique, July 2008.

5. In her article "International Shaping of a Nationalist Imagery," Alba Martín Luque cites the PhD thesis of Raquel Schefer to determine when Frelimo's DIP opened a photography section. See Alba Martín Luque, "International Shaping of a Nationalist Imagery? Robert van Lierop, Eduardo Mondlane and *A Luta Continua*," *Afriche e Orienti*, Vol. 19, No. 3 (2017): 125; Raquel Schefer, "La forme-évément: Le cinema révolutionnaire mozambicain et le cinéme deliberation," PhD dissertation, Université Sorbonne Nouvelle, Paris 3, 2015.

6. Susan Buck-Morss, "Visual Empire," *Diacritics*, Vol. 37, Nos. 2/3 (Summer-Fall 2007): 171–198.

7. Uria T. Simango to Mr. M. Milenkovic, Socialist Republic of Yugoslavia, 16 May 1969, DRE 29, Arquivo Histórico de Moçambique, Maputo, Mozambique; correspondence from G. S. Magombe to the vice-president, Frelimo, 28 September 1968, DRE 29, Arquivo Histórico de Moçambique, Maputo, Mozambique; letter from Uria Simango to the executive secretary, African Liberation Committee, 11 March 1969, DRE 29, Arquivo Histórico de Moçambique, Maputo, Mozambique; Khartoum, Confidencial, Janeiro 1969, DRE 29-M, Arquivo Histórico de Moçambique, Maputo, Mozambique.

8. Buck-Morss, "Visual Empire."

9. Michael G. Panzer, "Building a Revolutionary Constituency: Mozambican Refugees and the Development of the FRELIMO Proto-State, 1964–1968," *Social Dynamics*, Vol. 39, No. 1 (2013): 5–23. Also see Michael G. Panzer, "Pragmatism and Liberation: FRELIMO and the Legitimacy of an African Independence Movement," *Portuguese Journal of Social Science*, Vol. 14, No. 3 (September 2015): 323–342.

10. Panzer, "Building a Revolutionary Constituency."

11. Luque, "International Shaping of a Nationalist Imagery?"

12. Just a year before the liberation movement Frelimo formed, Tanzania (at the time called Tanganikya) had achieved independence from Great Britain. Tanganikya's president at the time, Julius Nyerere, had invited Frelimo along with other southern Africa–based liberation movements to operate from inside of the nation's borders. Dar es Salaam played host to other liberation groups, including Movimento Popular de Libertação de Angola (MPLA), Zimbabwe African National Union (ZANU), and the Af-

rican National Congress (ANC), along with the African Liberation Committee, which provided liberation groups with military and humanitarian support along with political representation. The Departamento de Informação e Propaganda (DIP) confronted the need to dissociate Frelimo's activities from those of other liberation movements. According to Jorge Rebelo, who headed DIP from around the time of the war's start until its end in 1974, "Mozambique was very different [from] other [liberation] movements. We already [were] engaged in an armed struggle and most of the other [African liberation movements] were [still] organizing themselves. We would produce our [own] materials and each of them would produce theirs." See Jorge Rebelo, interview by author, Maputo, Mozambique, July 2008.

13. Morss, "Visual Empire"; Louis Marin and Anna Lehman, "Classical, Baroque: Versailles, or the Architecture of the Prince," *Yale French Studies*, No. 80 (1991): 167–182.

14. Margaret Dickinson, interview by author, Maputo, Mozambique, September 2010.

15. Janet Mondlane was the wife of Frelimo's president, Eduardo Mondlane.

16. Margaret Dickinson, interview by author, Maputo, Mozambique, September 2010; Prexy Nesbitt, interview by author, Skype, October 2009; Bill Minter, interview by author, Washington, DC, May 2011.

17. "Prendas," in Pessoas Par DAR, DRE 29-M, Arquivo Histórico de Moçambique, Maputo, Mozambique.

18. Paul Silveira, interview by author, Maputo, Mozambique, June and September 2010; Margaret Dickinson, interview by author, Maputo, Mozambique, September 2010.

19. DIP and other Frelimo offices had received funds that they could use only for printing plates, ink, and paper. In the late 1960s and early 1970s, Tanzania, the site of Frelimo headquarters, experienced paper shortages. In response, DIP used funds allocated by foreign donors in order to purchase printing paper from neighboring Kenya. See "Material burocrático existente—20/11/72," Administração, Caixa 4, Frelimo, Arquivo Histórico de Moçambique, Maputo, Mozambique. Also see Paul Silveira, interview by author, Maputo, Mozambique, July 2008 and June 2010.

20. Margaret Dickinson, interview by author, Maputo, Mozambique, September 2010.

21. See Eduardo Mondlane, *Struggle for Mozambique* (London: Zed Books, 1983); Thomas Henriksen, *Revolution and Counterrevolution: Mozambique's War of Independence* (Westport: Greenwood Press, 1983); Allen and Barbara Isaacman, *Mozambique: From Colonialism to Revolution: 1900–1982* (Boulder: Westview Press, 1983); Paul Fauvet, "Roots of Counter-Revolution: The Mozambique National Resistance," *Review of African Political Economy*, Vol. 11 (1984): 108–121; John Saul, "Frelimo and the Mozambique Revolution," *Monthly Review*, Vol. 24, No. 10 (1973): 22–52.

22. The literature on photography interprets state use of photography as a form of propaganda. This is why much of the global literature on photography ignores the uses of photography in liberation movements like Frelimo. See Susan Sontag, *Regarding the Pain of Others* (New York: Farrar, Straus and Giroux, 2003); Susie Linfeld, *The Cruel Ra-*

diance: Photography and Political Violence (Chicago: University of Chicago Press, 2012); Geoffrey Batchen, Mick Gidley, Nancy K. Miller, and Jay Posser, eds., *Picturing Atrocity: Photography in Crisis* (London: Reaktion Books, 2012); and Ariella Azoulay, *The Civil Contract of Photography* (New York: Zone Books, 2008). With regard to photography in Africa and the focus on postcolonial photography and South Africa, see Jennifer Bajorek, "Of Jumbled Valises and Civil Society: Photography and Political Imagination in Senegal," *History and Anthropology*, Vol. 21 (2010): 431–452; Liam Buckley, "Self and Accessory in Gambian Studio Photography," *Visual Anthropology Review*, Vol. 16, No. 2 (Fall-Winter 2000–2001): 71–91; Heike Behrend, *Contesting Visibility: Photographic Practices on the East African Coast* (Bielefeld: transcript Verlag, 2013); Patricia Hayes, "Power, Secrecy, Proximity: A Short History of South African Photography," *Kronos*, Vol. 33 (November 2007): 139–162.

23. Scholars of photography have frequently cited Susan Sontag's metropolitan and universalist idea of a "global photography." Sontag's work fails to consider the nuances and different historical trajectories of photography, especially from the context of the Global South and the perspective of a liberation movement such as Frelimo, which fought for Mozambique's independence from exile and managed to use photography quite effectively. See Sontag, *Regarding the Pain of Others*. For a critique of Sontag's reading of the relationship between the gun and photography, see Paul Landau, "Empires of the Visual: Photography and Colonial Administration in Africa," in *Images & Empires: Visuality in Colonial and Postcolonial Africa*, edited by Paul S. Landau and Deborah D. Kaspin, 141–171 (Berkeley: University of California Press, 2003).

24. Sontag, *Regarding the Pain of Others*.

25. I appreciate the anonymous peer-review report for helping me to articulate my argument here.

26. Letter from Lourenço Mutaca, deputy secretary general to Czechoslovak Co-Op News, 7 March 1963, DRE 29-B, Arquivo Histórico de Moçambique; letter from Silver R. Nungu, administrative secretary to the Korean Committee for Afro-Asian Solidarity (Korea), 18 September 1964, DRE 29-B, Arquivo Histórico de Moçambique, Maputo, Mozambique.

27. Letter from Lourenço Mutaca, deputy secretary general to Czechoslovak Co-Op News, 7 March 1963, DRE 29-B, Arquivo Histórico de Moçambique.

28. Letter from Lourenço Mutaca, deputy secretary general to Czechoslovak Co-Op News, 7 March 1963, DRE 29-B, Arquivo Histórico de Moçambique; letter from Silver R. Nungu, administrative secretary to the Korean Committee for Afro-Asian Solidarity (Korea), 18 September 1964, DRE 29-B, Arquivo Histórico de Moçambique, Maputo, Mozambique.

29. For more on MANU and the organization's relation to the Mozambican liberation struggle of Frelimo, see Joel Tembe, "*Uhuru na Kazi*: Recapturing MANU Nationalism through the Archive," *Kronos*, Vol. 39 (2013): 257–279.

30. See R da Gama Pinto to Marcelino dos Santos, 4 March 1964, DRE 29, Arquivo Histórico de Moçambique, Maputo, Mozambique.

31. Ibid.

32. Ibid.

33. The annexation of Goa from Portugal was critical to Frelimo's anticolonial efforts in Mozambique, just as the event appears to have been for urban populations in Lourenço Marques and across the Portuguese Empire. While the Portuguese authoritarian state struggled to gather images of Goa's annexation (see chapter 1), a larger practice of image making and sharing was unfolding through Frelimo's armed struggle and the alliances the liberation front established. See R da Gama Pinto to Tom Mboya, 5 March 1964, DRE 29, Arquivo Histórico de Moçambique, Maputo, Mozambique.

34. Eduardo Mondlane para Sérgio Vieira, 27 Agosto 1963, DRE 29, Arquivo Histórico de Moçambique, Maputo, Mozambique.

35. Ibid.

36. Valeriano Ferrão, interview by author, Maputo, Mozambique, April 2010; José Oscar Monteiro, interview by author, Maputo, Mozambique, July 2008.

37. Valeriano Ferrão, interview by author, Maputo, Mozambique, April 2010.

38. Ibid.

39. Eduardo Mondlane para Sérgio Vieira, 27 Agosto 1963, DRE 29, Arquivo Histórico de Moçambique, Maputo, Mozambique.

40. Sérgio Vieira traveled with an Algerian passport under the name Mustapha Benziad. José Oscar Monteiro, who directed Frelimo's diplomatic and political office in Algeria after the departure of Chissano, studied law in Lisbon and traveled on a passport issued by Niger under the name Yahia Ousman. See Carta por Uria T. Simango ao To Whom It May Concern, 7 February 1968, DRE 29-N, Arquivo Histórico de Moçambique, Maputo, Mozambique. Also Valeriano Ferrão, interview by author, Maputo, Mozambique, April 2010; José Oscar Monteiro, interview by author, Maputo, Mozambique, July 2008.

41. When passports expired, document holders sometimes requested the permission of the DRE office to apply for Algerian and not Tanzanian passports. Even then, there were some complications. The Algerian government was slow in issuing passports. In 1967, José Oscar Monteiro, the head of Frelimo's diplomatic and political office in Algeria, proposed that Frelimo's diplomatic and military corps seek documentation from the Embassy of Senegal in Algiers. Also see letter from Pascoal Mocumbi, Chefe de Representação para Camarada Marcelino dos Santos, Chef do Departamento do Relações Exteriores da Frelimo, 12 Junho 1967, 2–3, DRE 29-N, Arquivo Histórico de Moçambique, Maputo, Mozambique.

42. Letter from Silverio Nungu, administrative secretary to the Immigration Office, Passport Office, 24 August 1964, DRE 29, Arquivo Histórico de Moçambique, Maputo, Mozambique; letter from Eduardo Mondlane to the Principal Immigration Officer, 10 January 1964, DRE 29, Arquivo Histórico de Moçambique, Maputo, Mozambique; letter from Uria Simango, vice president, to the Secretary, Soviet Solidarity Committee (Moscow), 3 July 1964, DRE 29, Arquivo Histórico de Moçambique, Maputo, Mozambique.

43. Letter from Silverio Nungu, administrative secretary to the Immigration Office, Passport Office, 24 August 1964, DRE 29, Arquivo Histórico de Moçambique, Maputo, Mozambique; letter from Eduardo Mondlane to the Principal Immigration Officer, 10 January 1964, DRE 29, Arquivo Histórico de Moçambique, Maputo, Mozambique.

44. J. Chissano, education secretary, for Studio Hiros (Dar es Salaam), 25 July 1964, DRE 29-A/B, Arquivo Histórico de Moçambique, Maputo, Mozambique; letter from J. Chissano, Secretary of Education, to Studio Hiros, 16 July 1964, DRE 29-A/B, Arquivo Histórico de Moçambique, Maputo, Mozambique; Mariano Matsinha to Studio Hiros (refugee), 10 October 1963, DRE 29-C, Frelimo, Arquivo Histórico de Moçambique, Maputo, Mozambique.

45. Chissano described Frelimo's purpose as "a liberation front which [was] preparing and organizing all Mozambicans from Rovuma to Maputo to fight by all means for their freedom." With regard to the popular belief that entrance to Frelimo guaranteed a scholarship, Chissano wrote, "A member may be sent to attend a scholarship program or military training or to any kind of job not because he has chosen to do so but only because the Comité Central [felt] that he must do that for the benefit of the struggle." See letter from J. Chissano, Secretary, Education and Culture, to Mr. H. Mhlanga, 25 June 1964, DRE 29, Arquivo Histórico de Moçambique, Maputo, Mozambique.

46. Correspondence from Joao Munguambe to embassy of Yugoslavia (Dar es Salaam), 16 October 1965, DRE 29, Arquivo Histórico de Moçambique, Maputo, Mozambique.

47. Julio Ramos, Administração do DD ao Camarada Ambrosio Labuquene, 11 Julho 1967, Administração, Caixa 4, Arquivo Histórico de Moçambique, Maputo, Mozambique.

48. Pascoal Mocumbi (Substituto do Secretário Relações Exteriores) to Alberto Sithole, 9 April 1964, DRE 29, Arquivo Histórico de Moçambique, Maputo, Mozambique; P. Mocumbi para Missão Permanente da Frelimo na Zambia, 19 Maio 1964, DRE 29; Arquivo Histórico de Moçambique, Maputo, Mozambique; Silver Nungu, administrative secretary para Representante da Frelimo (Zambia), 20 Agosto 1964, DRE 29, Arquivo Histórico de Moçambique, Maputo, Mozambique.

49. Pascoal Mocumbi (Substituto do Secretário Relações Exteriores) to Alberto Sithole, 9 April 1964, DRE 29, Arquivo Histórico de Moçambique, Maputo, Mozambique.

50. Jorge Rebelo, interview by author, Maputo, Mozambique, July 2008.

51. Ibid.

52. Ibid.

53. Ibid.

54. Ibid.

55. Ibid.

56. "Foi há cinco anos: A maior e mais vergonhosa derrota do exército colonial," *Tempo*, No. 269, 30 Novembro 1975: 33, Instituto Nacional de Cinema and accessed through JSTOR ALUKA: Struggles for Freedom—Southern Africa.

57. Ibid.

58. Letter from Erikki Liikannen and Camilla v. Bonsdorff to the Presidential Council, 15 November 1969, DRE 29-D, Arquivo Histórico de Moçambique, Maputo, Mozambique.

59. Ibid.

60. Ibid.

61. Ibid.

62. Paul Silveira, interview by author, Maputo, Mozambique, June and September 2010.

63. Ibid.

64. Teresa Sá Nogueira, "Cinema Moçambicano: Artur Torohate, cineasta guerrilheiro," *Tempo*, No. 830, 7 Setembro 1986: 44–45, Arquivo Histórico de Moçambique, Maputo, Mozambique; and José Oscar Monteiro, Maputo, Mozambique, July 2008.

65. Ibid.

66. Paul Silveira, interview by author, Maputo, Mozambique, June and September 2010.

67. Paul Silveira, interview by author, Maputo, Mozambique, July 2008 and June and September 2010.

68. Ibid.

69. Ibid.

70. Ibid.

71. Ibid.

72. Fernando Ganhão, "Nossas observações e sugestões sobre o livro de história de Moçambique," DRE 29-Z, Arquivo Histórico de Moçambique, Maputo, Mozambique.

73. Ibid.

74. Ibid.

75. Ibid.

76. Carta por Judas Alexandre Honwana ao Secretário de Relações Exteriores, 1 Fevereiro 1968, DRE 29, Arquivo Histórico de Moçambique, Maputo, Mozambique; Feliciano Guandana ao Administração, 10 Setembro 1964, Administração, Caixa 4, Arquivo Histórico de Moçambique, Maputo, Mozambique; and Samora Machel ao Departamento de Administração, 12 Dezembro 1966, Administração, Caixa 4, Arquivo Histórico de Moçambique.

77. Ibid.

78. Paul Silveira, interview by author, Maputo, Mozambique, June and September 2010.

79. Carta por Judas Alexandre Honwana ao Secretário de Relações Exteriores, 1 Fevereiro 1968, DRE 29, Arquivo Histórico de Moçambique, Maputo, Mozambique; Feliciano Guandana ao Administração, 10 Setembro 1964, Administração, Caixa 4, Arquivo Histórico de Moçambique, Maputo, Mozambique; and Samora Machel ao Departamento de Administração, 12 Dezembro 1966, Administração, Caixa 4, Arquivo Histórico de Moçambique.

80. Paul Silveira, interview by author, Maputo, Mozambique, June and September 2010.

81. Ibid.

82. Torres Rodrigues, "Daniel Maquinasse: Guerrilheiro-fotógrafo: 'Numa emboscada não pensava na máquina fotográfica,'" *Domingo*, 8 Julho 1984, 16, Arquivo Histórico de Moçambique, Maputo, Mozambique.

83. Ibid.

84. José Soares, interview by author, Maputo, Mozambique, January 2011; Carlos Djambo, interview by author, Maputo, Mozambique, August 2009.

85. Administração, Caixa 4, Frelimo, Arquivo Histórico de Moçambique, Maputo, Mozambique.

86. Susan Buck-Morss, "Aesthetics and Anesthetics: Walter Benjamin's Artwork Essay Reconsidered," *October*, Vol. 62 (Autumn 1992): 18.

87. "Niassa: Chiwindi memória da luta armada," *Tempo*, No. 480, 23 Dezembro 1979, Instituto Nacional de Cinema, Maputo, Mozambique.

88. Ibid.

89. José Oscar Monteiro, interview by author, Maputo, Mozambique, July 2008.

90. Jorge Rebelo, interview by author, Maputo, Mozambique, July 2008; José Soares, interview by author, Maputo, Mozambique, January 2011; Carlos Djambo, interview by author, Maputo, Mozambique, August 2009.

91. Jorge Rebelo, interview by author, Maputo, Mozambique, July 2008.

92. Carlos Djambo, interview by author, Maputo, Mozambique, August 2010.

93. Ibid.

94. Rodrigues, "Daniel Maquinasse," 16. Also see Albano Naroromele, "Fui sempre jornalista e quero continuar a ser," *Domingo*, 3 Novembro 1985: 3, Arquivo Histórico de Moçambique, Maputo, Mozambique.

95. Ibid.

96. Supposedly a rain shower ruined Maquinasse's camera before he joined Frelimo and participated in military training. See Rodrigues, "Daniel Maquinasse," 16.

97. Hilário Matusse, "Artur Torohate: De guerrilheiro a homem da imagem," *Tempo*, 22 Setembro 1985: 26, Arquivo Histórico de Moçambique, Maputo, Mozambique.

98. Ibid.

99. Pedro Odallah, interview by author, Maputo, Mozambique, December 2010.

100. Ibid.

101. Albano Naroromele, "Fui sempre jornalista," 3.

102. Ibid.

103. José Soares, interview by author, Maputo, Mozambique, January 2011.

104. Ibid.

105. Albano Naroromele, "Fui sempre jornalista," 3.

106. Ibid.

107. Ibid.

108. Rodrigues, "Daniel Maquinasse," 16. Also see Margaret Dickinson, interview by author, Maputo, Mozambique, September 2010.

109. Rodrigues, "Daniel Maquinasse," 16.

110. Caixa: Luta Armada, Centro de Documentação e Formação Fotográfica, Maputo, Mozambique; Coleção: Luta Armada, Arquivo Histórico de Moçambique, Maputo, Mozambique.

111. Carlos Djambo, interview by author, Maputo, Mozambique, August 2010. For more on the life and work of Djambo as a Frelimo photographer, see *Djambo*, documentary film, codirected by Chico Carneiro and Catarina Simão, Mozambique/Portugal 2017.

112. Carlos Djambo, interview by author, Maputo, Mozambique, August 2010.

113. Ibid.

114. Ibid.

115. In response, Djambo used flash, or opened his aperture from 2.8 to 4 or 5.6, if he knew the image would come out unclear. Also, Djambo recalled that lighting in October made it nearly impossible to photograph, and how, regardless of the time of the year, he took precautions not to disclose the locations where he photographed. See Carlos Djambo, interview by author, Maputo, Mozambique, August 2010.

116. Carlos Djambo, interview by author, Maputo, Mozambique, August 2010.

117. Ibid.

118. Ibid.

119. Ibid.

120. Ibid.

121. Ibid.

122. Ibid.

123. Ibid.

124. Ibid.

125. Carlos Djambo, interview by author, Maputo, Mozambique, August 2010. For more on the role of cinema in Mozambique's liberation struggle, see Ros Gray, "Cinema on the Cultural Front: Film-making and the Mozambican Revolution," *Journal of African Cinemas*, Vol. 3, No. 2 (March 2012): 130–160; Ros Gray, "'Haven't You Heard of Internationalism?,'" in *Postcommunist Film: Russia, Eastern Europe and World Culture: Moving Images of Postcommunism*, edited by Lars Kristensen, 53–74 (London: Routledge, 2013).

126. Ibid.

127. Ibid.

128. Ibid.

129. I am grateful to Dave Miller of the Smithsonian Institution, who back in 2011, helped me to identify the weapons in Frelimo-produced photographs.

130. Jorge Rebelo, interview by author, Maputo, Mozambique, July 2008; José Oscar Monteiro, interview by author, July 2008; José Soares, interview by author, Maputo, Mozambique, January 2011.

131. José Oscar Monteiro, interview by author, Maputo, Mozambique, July 2008.

132. José Soares, interview by author, Maputo, Mozambique, January 2011.

133. Carlos Djambo, interview by author, Maputo, Mozambique, August 2010.

134. Ibid.

135. Diana Andringa, interview by author, Lisbon, Portugal, April 2017.

136. Susan Sontag, *Regarding the Pain of Others* (New York: Farrar, Straus and Giroux, 2003).

137. Ariella Azoulay, *Civil Contract of Photography* (New York: Zone Books, 2008).

138. José Oscar Monteiro, interview by author, Maputo, Mozambique, July 2008.

139. Ibid.

140. José Oscar Monteiro, interview by author, Maputo, Mozambique, July 2008.

141. Frelimo: Proposta do President Mondlane sobre a decoração da Sala das reuniões e do Quadro de anúncios do Escritório, 13 Setembro 1967, DRE 29, Arquivo Histórico de Moçambique, Maputo, Mozambique.

142. Letter from G. S. Magombe, executive secretary at the African Liberation Committee, to the vice president, Frelimo, 28 September 1969, DRE 29-D, Arquivo Histórico de Moçambique, Maputo, Mozambique; Angus Stewart (photographer) to Sirs (Frelimo), 7 July 1970, DRE 29-D, Arquivo Histórico de Moçambique, Maputo, Mozambique; letter from Tadahiro Ogawa to the Executive Committee, 20 May 1970, DRE 29-D, Arquivo Histórico de Moçambique, Maputo, Mozambique.

143. José Oscar Monteiro, interview by author, Maputo, Mozambique, July 2008.

144. Ibid.

145. Ibid.

146. Ibid.

147. Letter from Tadahiro Ogawa to the Executive Committee, 20 May 1970, DRE 29-D/E, Arquivo Histórico de Moçambique, Maputo, Mozambique.

148. Letter from Miguel A. Murupa to Mr. Tadhiro Ogawa, 17 February 1969, DRE 29-D/E, Arquivo Histórico de Moçambique, Maputo, Mozambique.

149. Michael Panzer speaks at length in various articles about the limitations the Tanzanian government imposed on Frelimo. See Panzer, "Building a Revolutionary Constituency"; Panzer, "Pragmatism and Liberation"; and Michael Panzer, "A Nation in Name, A 'State' in Exile: The Frelimo Proto-State, Youth, Gender, and the Liberation of Mozambique, 1962–1975," PhD dissertation, State University of New York at Albany, 2013.

150. DRE 29-I, Arquivo Histórico de Moçambique, Maputo, Mozambique.

151. Eduardo Mondlane de Nairobi ao Camarada Francisco Cufa, Representante da Frelimo em Lusaka, Zambia, 22 Novembro 1968, DRE 29-I, Arquivo Histórico de Moçambique, Maputo, Mozambique. Also see Eduardo Mondlane ao Irmão e Camarada Shafruddin, 19 Junho 1968, DRE 29, Arquivo Histórico de Moçambique, Maputo, Mozambique.

152. Ibid.

153. José Oscar Monteiro, interview by author, Maputo, Mozambique, July 2008.

154. Tadahiro Ogawa, "We Must Learn from the Spirit of the Struggle," *Mozambique Revolution*, April-June 1973: 8, private archives of José Oscar Monteiro and Arquivo Histórico de Moçambique, Maputo, Mozambique.

155. Ibid.

156. José Oscar Monteiro, interview by author, Maputo, Mozambique, July 2008.

157. Ibid.

158. José Oscar Monteiro, interview by author, Maputo, Mozambique, July 2008.

159. Bruna Soncini, interview by author and Francesca Tamburini, Reggio Emilia, Italy, May 2017.

160. De Renzo Bonazzi à Marcelino dos Santos, 20 Mars 1965, Reggio Africa Box 3, Istoreco, Reggio Emilia, Italy. Also see De Marcelino dos Santos à Renzo Bonazzi, 8 Mars 1965, Reggio Africa Box 3, Istoreco, Reggio Emilia, Italy.

161. Reggio Africa Box 11, Istoreco, Reggio Emilia, Italy.

162. Paulo Madeira Rodrigues, eds., *4 Países Libertados: Portugal, Guiné/Bissau, Angola, Moçambique* (Lisboa: Círculo de Leitores, 1975): 85.

163. Ibid.

164. Frelimo photographer (José Soares), November 1971, Untitled, Cabo Delgado, Coleção: Luta Armada, Arquivo Histórico de Moçambique, Maputo, Mozambique.

165. José Oscar Monteiro, interview by author, Maputo, Mozambique, July 2008.

166. Ibid.

167. José Oscar Monteiro, interview by author, Maputo, Mozambique, July 2008.

168. Carta de Uria T. Simango, Vice-Presidente e Secretário das Relações Exteriores ao Jaco Jermias Nyambiri, 10 Janeiro 1963, DRE 29-F, Arquivo Histórico de Moçambique, Maputo, Mozambique.

169. Ibid.

170. Matusse, "Artur Torohate," 26.

171. See "Informação e Propaganda," In Representação da Frelimo na Argelia: Relatório de Fim de Missão, 10 Outubro 1967, DRE 29-M, Arquivo Histórico de Moçambique, Maputo, Mozambique.

172. Pedro Odallah, interview by author, Maputo, Mozambique, December 2010.

173. Ibid.

174. Jorge Rebelo, interview by author, July 2008; José Oscar Monteiro, interview by author, July 2008.

175. Ibid.

176. Ibid.

177. Buck-Morss, "Visual Empire."

CHAPTER 3

1. For context on Frelimo's nationalization policy in relation to Frelimo and the broader decolonizing world, see Margaret Hall and Tom Young, *Confronting Leviathan: Mozambique since Independence* (Athens: Ohio University Press, 1997).

2. Despacho, Ministério da Indústria e Comércio, Boletim da República, 21 Agosto 1976, I Série-Número 98; Arquivo Histórico de Moçambique, Maputo, Mozambique.

3. For more on colonial censorship, see chapter 1.

4. Frelimo assembled working groups of photographers, filmmakers, and journalists who studied how to produce information in the service of the state. See "II Seminário Nacional de Informação: Direcção Nacional de Propaganda e Publicidade," 1979, Instituto Nacional de Cinema, Maputo, Mozambique.

5. Direcção Nacional de Propaganda e Publicidade, untitled report, undated, available at Instituto Nacional de Cinema, Maputo, Mozambique.

6. "II Seminário Nacional de Informação: Relatório dos Profissionais de Fotografia de Informação," 1977, Institutional Nacional de Cinema, Maputo, Mozambique. Institutional reports like this one, available at the INC library, are stored on shelves and in boxes without any access codes.

7. Ibid.

8. Jacques Depelchin and Alexandrino José, "Audio-visual Archives in the Struggle for a Popular and Democratized History of Mozambique," undated, 5, Instituto Nacional de Informação, Maputo, Mozambique.

9. Ibid.

10. Beira was a city in central Mozambique that benefited from trade between Mozambique and its neighbor Rhodesia (present-day Zimbabwe). At the time, Rhodesia was under white rule and many white residents in Beira shared in the view that Mozambique should be independent from Portugal but in the control of whites. Living in Beira exposed Mia Couto to political opinions and social views that directly opposed the liberation movement's vision of an independent Mozambique.

11. Mia Couto, "'Thirty Years Ago They Smiled': Carnation Revolution," *Le Monde Diplomatique* (April 2004), accessed July 2016, https://mondediplo.com/2004/04/15mozambique

12. See Benedito Machava, "Galo amanheceu em Lourenço Marques: O 7 de Setembro e o verso da descolonização de Moçambique," *Revista Crítica de Ciências Sociais*, Vol. 106 (2015): 53–84.

13. Luís Bernardo Honwana, interview by author, Maputo, Mozambique, July 2008; José Luís Cabaço, interview by author, Maputo, Mozambique, September 2010 and July 2016.

14. Honwana described this nationalism as a type of solidarity between or within racial groups against a common enemy. See Luís Bernardo Honwana, interview by author, Maputo, Mozambique, summer 2008; João Mendes, interview by author, Maputo, Mozambique, March and June 2010; Machado da Graça, interview by author, Maputo, Mozambique, March 2010.

15. Luís Bernardo Honwana, interview by author, Maputo, Mozambique, summer 2008.

16. Mia Couto, interview by author, Maputo, Mozambique, August 2010; João Costa, interview by author, Maputo, Mozambique, summer 2008 and August 2009; Luís Souto, interview by author, Maputo, Mozambique, April 2010; Carlos Calado, interview by author, Maputo, Mozambique, April and July 2010; Alves Gomes, interview by author,

Maputo, Mozambique, January 2011; Fernando Lima, interview by author, Maputo, Mozambique, June 2010.

17. Mia Couto, interview by author, Maputo, Mozambique, August 2010; João Costa, interview by author, Maputo, Mozambique, summer 2008 and August 2009.

18. Mia Couto, interview by author, Maputo, Mozambique, August 2010.

19. Ibid.

20. João Costa, interview by author, Maputo, Mozambique, summer 2008 and August 2009.

21. Ibid.

22. João Costa, interview by author, Maputo, Mozambique, summer 2008 and August 2009.

23. Rangel had grown to admire Gillespie's music while socializing after work with his colleagues and other patrons of the colonial capital's bars on the street Rua Araújo.

24. Albino Magaia with photographs by Ricardo Rangel, "As pedras da terra não têm cor," *Tempo*, No. 217, 24 November 1974: 37, Biblioteca Nacional de Moçambique, Maputo, Mozambique.

25. Ibid.

26. Ibid.

27. Ibid.

28. Ricardo Rangel, interview with Allen Isaacman and author, Maputo, Mozambique, July 2008; Ricardo Rangel, interview with author, summer 2008.

29. Ricardo Rangel, interview with Allen Isaacman and author, Maputo, Mozambique, July 2008.

30. Ibid.

31. Ricardo Rangel, interview by author, Maputo, Mozambique, summer 2008. Also Luís Bernardo Honwana, interview by author, Maputo, Mozambique, July 2008.

32. Ibid.

33. "Vamos acabar com a prostituição," *Tempo*, No. 238, 20 Abril 1975: 32–39, Biblioteca Nacional de Moçambique, Maputo, Mozambique. Also see João Cabrita, *Mozambique: The Tortuous Road to Democracy* (New York: Palgrave, 2000).

34. "Vamos acabar com a prostituição," 35.

35. Grant Lee Neuenberg, interview by author, Maputo, Mozambique, May 2010; Ricardo Rangel, interview by author with Allen Isaacman, Maputo, Mozambique, July 2008.

36. João Costa, interview by author, Maputo, Mozambique, summer 2008 and August 2009.

37. Rangel's private archive is located at the Centro de Documentação e Formação Fotográfica, the national photography school that he directed from its opening in 1982 until his death in 2009.

38. Ricardo Rangel, untitled photographs, Caixa: Rangel: Tempo Colonial, Centro de Documentação e Formação Fotográfica, Maputo, Mozambique.

39. Elizabeth Edwards, "Photographs and the Sound of History," *Visual Anthropology Review*, Vol. 21, Nos. 1–2 (2005): 34.

40. João de Sousa, interview by author, Maputo, Mozambique, July 2016.

41. Historians João Cabrita and Benedito Machava write about the violence perpetrated by Frelimo's military and police forces during and after the transition period. Both their respective studies note how the ruling party Frelimo failed to equip the state apparatus to track population relocation and to give the relocated women photo identification. See João Cabrita, *Mozambique: The Tortuous Road to Democracy*; Benedito Machava, "State Discourse on Internal Security and the Politics of Punishment in Post-Independence Mozambique (1975–1983)," *Journal of Southern African Studies*, Vol. 37 (2011): 593–609.

42. "Vender ou não vender: As cores da Bandeira da Frelimo," *Tempo*, No. 239, 27 Abril 1975: 21–24, accessed through JSTOR ALUKA: Struggles for Freedom—Southern Africa; "As capulanas falam," *Tempo*, No. 395, 30 Abril 1978: 37–39, accessed through JSTOR ALUKA Struggles for Freedom—Southern Africa.

43. Pamila Gupta, "Decolonization and (Dis)Possession in Lusophone Africa," in *Mobility Makes States: Migration and Power in Africa*, edited by Darshan Vigneswaran and Joel Quirk (Philadelphia: University of Pennsylvania Press, 2015): 169–174.

44. Ibid., 173.

45. Ibid., 174.

46. The statue was of General Joaquim Augusto Mouzinho de Albuquerque. Portugal honored the military figure for capturing and imprisoning Gunguhana, the former leader of the area that comprised the Gaza Province in postindependence Mozambique. This kingdom of Gaza included parts of the present-day provinces of Manica, Inhambane, and northern Maputo.

47. José Cabral, "Untitled-Maputo 2002," in *Moçambique* (Lisbon: XYZ Books, 2018): 107.

48. Eduardo Matlombe, interview by author, Maputo, Mozambique, June 2010; Francisco Cuco, interview by author, Maputo, Mozambique, November 2010.

49. Benedito Machava, "Galo amanheceu em Lourenço Marques"; Ricardo Rangel, Caixa: 7 de Setembro, Centro de Documentação e Formação Fotográfica, Maputo, Mozambique.

50. "Dois a oito anos de prisão maior para boateiros e agitadores," *A Tribuna*, 11 Novembro 1974: 1. Also see "Expulsos de Moçambique por prejudiciarem descolonização," *A Tribuna*, 14 Dezembro 1974; "Marcelino dos Santos deplora partida de elementos da população branca," *A Tribuna*, 7 Novembro 1974, courtesy of Benedito Machava.

51. Ibid.

52. Teresa Cruz e Silva, interview by author, Maputo, Mozambique, July 2016; Carlos da Silva, interview by author, Maputo, Mozambique, June 2016; João de Sousa, interview by author, Maputo, Mozambique, July 2016.

53. "Quando as paredes falam," *Tempo*, No. 202, 4 August 1974: 47, Arquivo Histórico de Moçambique, Maputo, Mozambique.

54. Ibid.

55. Anthropologist Christopher Pinney raised this idea when he commented on a draft of this chapter.

56. Rangel gave the photograph of the crates in his photographic archive the title, "Fuga dos colonos," or "The fleeing of the settlers." Also see Gupta, "Decolonization and (Dis)Possession in Lusophone Africa," which offers an extended discussion of Rangel's series "Fuga dos colonos."

57. José Sá com fotos de Ricardo Rangel, "Os caixotes do medo," *Tempo*, No. 226, 26 Janeiro 1975: 32–39, Biblioteca Nacional de Moçambique, Maputo, Mozambique.

58. Ibid.

59. Ibid.

60. Krista Thompson, *Shine: The Visual Economy of Light in African Diasporic Practice* (Durham: Duke University Press, 2015): 19–20. Also see François Glissant, "For Opacity," in *The Poetics of Relation* (Ann Arbor: University of Michigan Press, 1997), 191. I have found Krista Thompson's interpretation of Glissant's notion of "opacity" especially useful in my thinking and writing on photography.

61. Rosalind C. Morris, "Photography and the Power of Images in the History of Power: Notes from Thailand," in *Photographies East: The Camera and Its Histories in East and Southeast Asia*, edited by Rosalind C. Morris, 120-160 (Durham: Duke University Press, 2009).

62. Jorge Rebelo, interview by author, Maputo, Mozambique, July 2008.

63. José Oscar Monteiro, interview by author, Maputo, Mozambique, July 2008.

64. Ibid.

65. Ibid.

66. Ibid.

67. José Luís Cabaço, interview by author, Maputo, Mozambique, September 2010; Margaret Dickinson, interview by author, Maputo, Mozambique, September 2010.

68. Calane da Silva, interview by author, Maputo, Mozambique, April and November 2010.

69. One day *Tempo* journalists found the envelope where they kept copies of *A Voz da Revolução* opened. They suspected that PIDE, the colonial state's security apparatus, had searched *Tempo* offices.

70. Calane da Silva, interview by author, Maputo, Mozambique, April and November 2010.

71. Jorge Rebelo, interview by author, Maputo, Mozambique, July 2008.

72. "Vender ou não vender: As cores da Bandeira da Frelimo"; "As capulanas falam."

73. "Vender ou não vender: As cores da bandeira da Frelimo."

74. "Capulanas: O modo de Frelimo," *Noticias da Beira*, 18 Março 1975, Arquivo Histórico de Moçambique, Maputo, Mozambique; "Frelimo não necessita o uso de capulana," *Notícias*, 16 Setembro 1974: 2, Arquivo Histórico de Moçambique, Maputo, Mozambique.

75. Ibid.

76. Victor Simba, "À Redacção: Ainda sobre o caso da bandeira da Frelimo nos sapatos e camisolas," *Tempo*, No. 245, 8 Junho 1975: 2, accessed through JSTOR ALUKA: Struggles for Freedom—Southern Africa.

77. "Capulanas: O modo de Frelimo."

78. During the liberation movement, Frelimo's Departamento de Relações Exteriores was careful not to show photographs of Frelimo officials participating in international gatherings to populations living in the liberated zones.

79. Jorge Rebelo, interview by author, Maputo, Mozambique, July 2008.

80. "Embaixada a Dar-Es-Salaam: Regressa Moçambique," *Notícias*, 4 Junho 1974, Arquivo Histórico de Moçambique, Maputo, Mozambique.

81. Calane da Silva, "Homenagem a Ricardo Rangel," in *Iluminando Vidas: Ricardo Rangel e a Fotografia Moçambicana*, edited by Bruno Z'Graggen and Grant Lee Neuenberg (Zurich: Christoph Merian Publishers, 2002): 34.

82. Ibid.

83. Jorge Rebelo, interview by author, Maputo, Mozambique, July 2008.

84. Figure 35 remains in Rangel's private archives. See Luta Armanda, Centro de Documentação e Formação Fotográfica, Maputo, Mozambique.

85. For more on the history of the re-education camps, see Cabrita, *Mozambique: The Tortuous Road to Democracy*; "Inhassune: Centro de reeducação politico-ideológica," *Tempo*, No. 286, 28 Março 1976: 50–59; "Centros de Reeducação (III): Transformar os ofensores da sociedade em defensores da sociedade," *Tempo*, No. 322, 12 Decembro 1976: 38–42; "Reeducação do Vietname," *Tempo*, No. 347, 29 Maio 1977: 12–14; "Centros de Reeducação (II): Os vascilantes reeducam-se," *Tempo*, No. 321, 28 Novembro 1976: 42–49. All *Tempo* articles cited here accessed through JSTOR ALUKA: Struggles for Freedom—Southern Africa.

86. República de Moçambique, "Decreto-Lei 57/65," 31 Maio 1975, *Boletim do República*, Series I, No. 65, 386, Arquivo Histórico Moçambique, Maputo, Mozambique..

87. Ibid.

88. Ibid.

89. Ibid.

90. "Burocracia: Cadeia de papéis sufoca energia criadora," *Tempo*, No. 217, 24 Novembro 1974: 10–16, accessed through JSTOR ALUKA: Struggles for Freedom—Southern Africa.

91. Vilém Flusser, *Towards a Philosophy of Photography* (London: Reaktion Books, 2007): 27.

92. "Resolução de Seminário do Aparelho de Estado: Reforçar a colectização da direcção para integrar as massas no poder," *Tempo*, No. 318, 7 Novembro 1976: 45, Biblioteca Nacional de Moçambique, Maputo, Mozambique.

93. Ibid.

94. João Costa, interview by author, Maputo, Mozambique, summer 2008 and August 2009.

95. Ibid.

96. See chapter 1 for more details about the Wiriyamu Massacre.

97. "Samora: Do Rovuma ao Maputo," *Tempo*, No. 247, 22 Junho 1975: 8–9, accessed through JSTOR Aluka: Struggles for Freedom—Southern Africa.

98. "No. 186, Relatório do equipe cinema que viajou com President Samora ao Cabo Delgado," Maputo, 19 Agosto 1976, Instituto Nacional de Cinema, Maputo, Mozambique.

99. Ibid.

100. Ibid.

101. Ibid.

102. Ibid.

103. See "I Seminário Nacional de Informação discussão dos relatórios dos grupos de trabalhos," *Tempo*, No. 360, 28 Agosto 1977: 7; "I Seminário Nacional de Informação: Últimas reflexões," *Tempo*, No. 365, 2 Outobro 1977: 27–28; Luís Bernardo Honwana, "Contribuição para a análise crítica da informação na R.P.M.," *Tempo*, No. 359, 21 Agosto 1977: 16–19; "Estrutura do I Seminário Nacional da Informação," *Tempo*, No. 355, 24 Julho 1977: 52–54; "I Seminário Nacional de Informação," *Tempo*, No. 364, 25 Setembro 1977: 44–52; all works cited in this note accessed through JSTOR ALUKA: Struggles for Freedom—Southern Africa.

104. "II Seminário Nacional de Informação: Relatório dos profissionais de fotografia de informação," 1–2.

105. I am grateful to anthropologist Christopher Pinney for bringing the issue of equipmentality to my attention.

106. See João Costa, interview by author, Maputo, Mozambique, summer 2008 and August 2009; Pedro Pimenta, interview by author, Maputo, Mozambique, December 2010.

107. "II Seminário Nacional de Informação: Relatório dos profissionais de fotografia de informação," 4.

108. Ibid., 4–5.

109. Ibid., 6.

110. Ibid.

111. "INC: Reunião Geral de Trabalhadores," 7 Maio 1977: 1, Instituto Nacional de Cinema, Maputo, Mozambique.

112. "II Seminário Nacional De Informação: Relatório dos profissionais de fotografia de informação," 1.

113. Ibid.

114. "I Seminário Africano de Arquivos Audiovisuais: Relatório sobre a preservação e salvaguarda das imagens ao movimento na República Popular de Moçambique," undated, 1–5, Instituto Nacional de Cinema, Maputo, Mozambique.

115. Depelchin and José, "Audio-visual Archives in the Struggle," 5.

116. Ibid.

117. Ibid.

118. Jorge Rebelo, interview by author, Maputo, Mozambique, July 2008.

119. Ibid.

120. José Cabral, interview by author, Maputo, Mozambique, March and November 2010; Narcésia Massango, interview by author, Maputo, Mozambique, February 2010.

121. "Reunião Geral de Trabalhadores," 16 Julho 1977, Instituto Nacional de Cinema, Maputo, Mozambique.

122. "Direcção Nacional de Propaganda e Publicidade," undated, no page numbers, Instituto Nacional de Cinema, Maputo, Mozambique.

123. Ibid.

124. See "II Seminário Nacional de Informação: Aditamento ao relatório da revista Tempo," 7 Dezembro 1979, Instituto Nacional de Cinema, Maputo, Mozambique; "II Seminário Nacional de Informação: Relatório do jornal Notícias," 3 Novembro 1979, Instituto Nacional de Cinema, Maputo, Mozambique.

125. Ibid.

126. Luís Bernardo Honwana, interview by author, Maputo, Mozambique, July 2008.

127. Ibid.

128. "Vem aí o livro," *Tempo*, No. 422, 5 Novembro 1978: 16–17, Instituto Nacional de Cinema, Maputo, Mozambique; "Imagens de um discurso," *Tempo*, No. 421, 29 Outubro 1978: 18–19, Instituto Nacional de Cinema, Maputo, 18–19.

129. "Palavras para uma imagem," *Tempo*, No. 424, 19 Novembro 1978: 26, Instituto Nacional de Cinema, Maputo, Mozambique.

130. Ibid.

131. Jorge Rebelo, interview by author, Maputo, Mozambique, July 2008.

132. José Cabral, "É assim que nascemos . . . ," *Tempo*, No. 391, 2 Abril 1978: 27, Arquivo Histórico de Moçambique, Maputo, Mozambique.

133. Ibid.

134. José Cabral, interview by author, Maputo, Mozambique, March 2010.

135. "Cartas dos leitores: Críticas à reportage fotográfica 'É assim que nascemos . . . ,'" *Tempo*, No. 393, 16 Abril 1978: 9, Arquivo Histórico de Moçambique.

136. Ibid., 10.

137. Ibid., 10.

138. Narcésia Massango, interview by author, Maputo, Mozambique, February 2010; José Cabral, interview by author, Maputo, Mozambique, March 2010.

139. Ibid.

140. Ibid.

141. "Imagem/uma arma," undated: 1–23, Instituto Nacional de Cinema, Maputo, Mozambique.

142. Ibid.

143. Scholars have studied *Xiconhoca* in terms of its messages and symbolism but not as a material object meriting visual analysis. The cartoon was the antithesis of a photograph, showing scenes not visible to the camera or easily documented through the photographic apparatus. See Maria Paula Meneses, "Xiconhoca, o inimigo: Narrativas de violência sobre a construção," *Revista Crítica de Ciências Sociais* (May 2015): 9–52; Lars

Buur, "Xiconhoca: Mozambique's Ubiquitous Post-Independence Traitor," in *Traitors: Suspicion, Intimacy, and the Ethics of State-Building*, edited by Sharika Thiranagama and Tobias Kelley, 24–47 (Philadelphia: University of Pennsylvania Press, 2010).

144. "Xiconhoca é boateiro," *Tempo*, No. 303, 25 Julho 1976: 2, Instituto Nacional de Cinema, Maputo, Mozambique.

145. Buur, "Xiconhoca: Mozambique's Ubiquitous Post-Independence Traitor."

146. Ibid.

147. "Xiconhoca o inimigo," *Voz da Revolução*, No. 59, Julho 1978: 22, Instituto Nacional de Cinema, Maputo, Mozambique.

148. Teresa Sá Nogueira, "Ricardo Rangel: O poet da imagen," *M de Moçambique*, Maio e Junho 2012: 31–36, Centro de Documentação e Formação Fotográfica, Maputo, Mozambique.

149. Jorge Rebelo, interview by author, Maputo, Mozambique, July 2008.

CHAPTER 4

1. In the years after nationalization, the state sold off the photography studios it had acquired. However, these purchased studios remained under state control as they relied on the state for photographic equipment. After independence, it was no longer possible for commercial photography studios to independently enter sales agreements with the world's leading photography manufacturers, such as Kodak, Fuji, and Cannon. See José Machado, interview by author, Maputo, Mozambique, 2010–2011; Job Lubukuta, interview by author, Beira, Mozambique, September 2010.

2. For more on this, see Drew Thompson, "Photo Genres and Alternate Histories of Independence in Mozambique," in *Ambivalent: Photography and Visibility in African History*, edited by Patricia Hayes and Gary Minkley, 126–155 (Athens: Ohio University Press, 2019); Drew Thompson "'Não há nada' ('There is nothing'): Absent Headshots and Identity Documents in Independent Mozambique," *Technology and Culture*, Vol. 61, No. 2 Supplement (April 2020): 104–134.

3. See Jean Penvenne, *African Workers and Colonial Racism: Mozambican Strategies for Survival in Lourenço Marques, Mozambique 1977–1962* (Portsmouth: Heinemann, 1995); Raúl Honwana, *The Life History of Raúl Honwana*, edited with an introduction by Allen F. Isaacman (Boulder: Lynne Rienner, 1988).

4. Many people who lived in rural areas had no access to city-based commercial photography studios, and consequently had never viewed a headshot of themselves. In contrast, populations living in cities were more likely not only to have seen images of themselves but to have a collection of family photographs, which were of use when retrieving colonial-era identification. There were instances where members of the Chinese community had the studio Lu-Shih Tung photograph them, and then they cut out the headshot from the photographs printed for recreational and personal use. See Caixa: Colonial: Comunidade Chinesa, Centro de Documentação e Formação Fotografica, Maputo, Mozambique.

5. The newspaper *Domingo* featured a profile of "Master Fumo," who migrated to

Mozambique from South Africa where he had practiced photography on the weekends when not working for the *Guardian* newspaper. At the newspaper, he had delivered photographs to the censorship bureaucracy. According to the article, Fumo eased the "headaches" associated with getting passport photographs. While recalling aspects of his practice, including describing it as a twenty-minute intrusion on people's lives, he remembered "seeing" Portugal's secret police arrest another street photographer, Sr. Langa. The photojournalist, Ricardo Rangel, known for photographing other photographers, also had photographed Sr. Langa in the colonial period. These profiles of studio- and street-based photographers trace the historical erasure that the colonial state orchestrated through its secretive uses of portraiture. See António Marmelo, "Mestre Fumo: Fotógrafo de profissão," *Domingo*, Novembro 1984, Arquivo Histórico de Moçambique, Maputo, Mozambique "O velho homem e a velha máquina," *A Tribuna*, 9 Setembro 1961, Arquivo Histórico de Moçambique, Maputo, Mozambique.

6. Tina Campt, *Listening to Images* (Durham: Duke University Press, 2017).

7. IAN/TT/PIDEDGS, Del. Coimbra, Album MF432P, Arquivo Nacional Torre do Tombo, Lisbon, Portugal.

8. Ibid.

9. Ibid.

10. "Visita às instalações da subdirectoria da PIDE/DGS," *O Primeiro de Janeiro*, 16 Maio 1974: 10, Biblioteca Nacional de Moçambique, Maputo, Mozambique.

11. For example, a journalist equated the "black ashes" to "a symbol of the extinction of a police [force] that spread terror and the mourning of an entire country dominated by fascism." Amid the ashes, journalists found a 1953 picture of Dr. Rui Gomes, a former candidate for Portugal's presidency. The photographic portrait had escaped destruction, lending it a type of shelf life and legitimacy. See "Visita às instalações da subdirectoria da PIDE/DGS."

12. *O Primeiro de Janeiro* reported, "There is no connection between the numbers on identity cards and the PIDE-DGS." The rumors reflected the disorganization that characterized the issuing of identification documents in Portugal. Officials in the capital of Lisbon used computers, while towns issued documents manually. The printed numbers on documents corresponded to the numerical series in circulation, and colored stamps denoted the issuing office. When a series finished, officials arranged for stamps in new colors. The writer concluded that despite having no validity, the rumors reflected popular sentiments regarding surveillance. See "Não há relação entre os números nos bilhetes de identidade e a PIDE-DGS," *O Primeiro de Janeiro*, 22 Maio 1974, 1, Biblioteca Nacional de Moçambique, Maputo, Mozambique.

13. "Todas eles acreditam no futuro desta terra," *Notícias*, 3 Maio 1974: 1, Biblioteca Nacional de Moçambique, Maputo, Mozambique.

14. Ibid.

15. Ibid.

16. "Não há relação entre os números nos bilhetes de identidade e a Pide-DGS," *O Primeiro de Janeiro*, 22 Maio 1974: 1, Biblioteca Nacional de Moçambique, Maputo,

Mozambique; "Visita às instalações da subdirectoria da PIDE/DGS," *O Primeiro de Janeiro*, 16 Maio 1974: 10, Biblioteca Nacional de Moçambique, Maputo, Mozambique; Calane da Silva, interview by author, Maputo, Mozambique, September and November 2010.

17. Fernando Amado Couto, "'Dossier' PIDE/DGS: 206 mortos nas câmaras de tortura," *Noticias*, 16 Outubro 1974: 1, Biblioteca Nacional de Moçambique, Maputo, Mozambique.

18. Many persons previously affiliated with the Portuguese colonial state in Mozambique fled to neighboring Rhodesia and South Africa and would provide critical intelligence and military support to the white-minority regimes of these nations and their efforts to destabilize Mozambique.

19. See "Dossier PIDE/DGS (I): A 'máquina' desmonta-se lentamente sob o controlo das Forças Armadas," *Tempo*, No. 194, 9 Junho 1974: 12–16; "Dossier PIDE/DGS (II): Das sinistras prisões aos campos de concentração em Moçambique," *Tempo*, No. 195, 16 Junho 1974: 42–47; "Dossier PIDE/DGS (III): Organização custava 250 000 contos por ano às finanças públicas," *Tempo*, No. 196, 23 Junho 1974: 9–15; all works cited in this note accessed through JSTOR ALUKA: Struggles for Freedom—Southern Africa.

20. Both of these photographers started their careers as darkroom technicians at laboratories responsible for developing the films of colonial-era newspapers and clients working on the behalf of the colonial state.

21. Calane da Silva, interview by author, Maputo, Mozambique, September and November 2010.

22. Ibid.

23. Ibid.

24. Ibid.

25. Ibid.

26. "Duzentos PIDEs à solta: Quem tem queixas contra eles?," *Tempo*, No. 202, 4 Agosto 1974: 28–34, Arquivo Histórico de Moçambique, Maputo, Mozambique.

27. Ibid.

28. "Não há relação entre os números nos bilhetes de identidade e a Pide-DGS," *O Primeiro de Janeiro*, 22 Maio 1974: 1, Biblioteca Nacional de Moçambique, Maputo, Mozambique; "Visita às instalações da subdirectoria da PIDE/DGS," *O Primeiro de Janeiro*, 16 Maio 1974: 10, Biblioteca Nacional de Moçambique, Maputo, Mozambique.

29. "Moçambique liberta-se dos PIDEs," *Notícias*, 9 Junho 1974: 1, Biblioteca Nacional de Moçambique, Maputo, Mozambique.

30. PIDE officials destroyed documents, possibly following the regulations outlined in chapter 1. The unidentified writer equated the "black ashes" to "a symbol of the extinction of a police that spread terror and the mourning of an entire country dominated by fascism." Amid the ashes, journalists found a 1953 picture of Dr. Rui Gomes, a former candidate for Portugal's presidency. In spite of the impracticality of using an analog camera to reproduce documents, the article featured photographs of visitors reading PIDE files, writing down details, and even using voice recorders to document the experience.

The photographic portrait escaped destruction, which gave it a shelf life and legitimacy that written text or a halftone could convey. Hans Belting in *An Anthropology of Images* writes, "The history of the portrait has generally been written as the history of a picture in which the beholder reads a resemblance to a living model." Belting understood that the sitter for the picture did not have to be alive at the present time, but rather was alive when the photographs was taken. The "history" and value of the photographic portrait found in the ashes had a limited capacity to resemble a living subject at the time of the decolonization and Mozambique's independence. As a result, there was another history of portraiture to be told, one that considered that many either died or disappeared at the hands of PIDE and the photographs in PIDE's possession. See "Visita às instalações da subdirectoria da PIDE/DGS"; Hans Belting, *An Anthropology of Images: Picture, Medium, Body* (Princeton: Princeton University Press, 2014): 62; *48*, directed by Susana de Sousa Dias, screenplay by Susana de Sousa Dias, and produced by Ansgar Schaefer, Alambique Filmes, 2010, film.

31. "Moçambique liberta-se dos PIDEs," 1.

32. Jorge Rebelo, interview by author, Maputo, Mozambique, July 2008.

33. Ibid.

34. Ibid.

35. Paul Silveira, interview by author, Maputo, Mozambique, September 2010.

36. Ibid.

37. Ibid.

38. José Oscar Monteiro, interview by author, Maputo, Mozambique, July 2008.

39. Ibid.

40. Jorge Rebelo, interview by author, Maputo, Mozambique, July 2008.

41. Ibid.

42. Ibid.

43. Ibid.

44. Ibid.

45. José Oscar Monteiro, interview by author, Maputo, Mozambique, July 2008.

46. Marcelino Komba, "Frelimo Militants Expose Traitors," *Daily News* (Tanzania), 30 March 1975, Centros Estudos Africanos, Universidade Eduardo Mondlane, Maputo, Mozambique.

47. Ibid.

48. Ibid.

49. Ibid.

50. Jennifer Bajorek, "Of Jumbled Valises and Civil Society: Photography and Political Imagination in Senegal," *History and Anthropology*, Vol. 21 (2010): 431–452; Liam Buckley, "Self and Accessory in Gambian Studio Photography," *Visual Anthropology Review*, Vol. 16, No. 2 (Fall-Winter 2000–2001): 71–91; Heike Behrend, *Contesting Visibility: Photographic Practices on the East African Coast* (Bielefeld: transcript Verlag, 2013); John Peffer and Elisabeth L. Cameron, *Portraiture & Photography in Africa* (Bloomington: Indiana University Press, 2013).

51. The death and controversy over Uria Simango feature prominently in Mozambican historiography. See Victor Igreja, "Memories as Weapons: The Politics of Peace and Silence in Post-Civil War Mozambique," *Journal of Southern African Studies*, Vol. 34, No. 3 (2008): 539–556; George Roberts, "The Assassination of Eduardo Mondlane: FRELIMO, Tanzania, and the Politics of Exile in Dar es Salaam," *Cold War History*, Vol. 17, No. 1 (2017): 1–19; Benedito Luís Machava, "State Discourse on Internal Security and the Politics of Punishment in Post-Independence Mozambique (1975–1983)," *Journal of Southern African Studies*, Vol. 37, No. 3 (2011): 593–609; João Cabrita, *Mozambique: The Tortuous Road to Democracy* (New York: Palgrave, 2000).

52. Ahmed Ali, interview by author, Maputo, Mozambique, July 2010.

53. Circular do Ministério da Informação, "Os bilhetes de identidade portugueses de que se servem os Moçambicanos ainda são validos," *Tempo*, No. 261, 5 Outubro 1975: 6, Arquivo Histórico de Moçambique, Maputo, Mozambique.

54. Ibid.

55. David Ottaway, "Chinese-Style Public Shaming: Subtle Mozambican Force Used on Ex-Collaborators," *International Herald Tribune*, 9 March 1979, accessed through Mozambique History Net, http://www.mozambiquehistory.net/history/comprometi dos/19790309_chinese-style_public_shaming.pdf. For a historical analysis of this practice of identifying and punishing enemies in Mozambique, see Victor Igreja, "Memories as Weapons: The Politics of Peace and Silence in Post-Civil War Mozambique," *Journal of Southern African Studies*, Vol. 34, No. 3 (September 2008): 539–556; Victor Igreja, "Frelimo's Political Ruling through Violence and Memory in Postcolonial Mozambique," *Journal of Southern African Studies*, Vol. 36, No. 4 (2010): 781–799.

56. "Até ao dia 15 de Dezembro: Fotos e lista dos agentes do colonialism deverão ser afixados," *Notícias da Beira*, 2 Dezembro 1978: 1, Arquivo Histórico de Moçambique, Maputo, Mozambique.

57. Joaquim Vieira, interview by author, Maputo, Mozambique, June 2012.

58. Ottaway, "Chinese-Style Public Shaming."

59. To such ends, the Frelimo state produced a number of administrative reports noting officials' party membership and ideological views. See "INC" ("Instituto Nacional de Cinema"), undated: 20–25, Instituto Nacional de Cinema, Maputo, Mozambique; "Rádio de Moçambique," undated: 1–7, Instituto Nacional de Cinema, Maputo, Mozambique. Also see Machado da Graça, interview by author, Maputo, Mozambique, February and March 2010.

60. See "Vai ser criado cartão de residente," *Notícias*, 14 Junho 1982, accessed through Mozambique History Net, http://www.mozambiquehistory.net/history/operacao_prod ucao/19820614_cartao_de_residente.pdf

61. "Opinião pública: Cartão de residente vai minimizar marginalidade," *Notícias*, 17 Junho 1982, accessed through Mozambique History Net, http://www.mozambiquehisto ry.net/history/operacao_producao/19820617_cartao_de_residente.pdf; "Opinião pública: Cartão de residente disciplinará a cidade," *Noticias*, 18 Junho 1982, accessed through Mozambique History Net, http://www.mozambiquehistory.net/history/operacao_pro

ducao/19820618_cartao_de_residente.pdf; "Opinião pública: Cartão de residente instrument necessário," *Notícias*, 21 Junho 1982, accessed through Mozambique History Net, http://www.mozambiquehistory.net/history/operacao_producao/19820621_cartao_de_residente.pdf

62. "O bem que vem por mal: Avalanche de pedidos de bilhetes de identidade," *Notícias*, 11 Junho 1982, Arquivo Histórico de Moçambique, Maputo, Mozambique.

63. "Curandeiros querem cartão de trabalho," *Notícias*, 11 Agosto 1982, 2, available at Mozambique History Net, http://www.mozambiquehistory.net/history/operacao_prod ucao/19820811_curandeiros_querem_cartoes.pdf

64. "As bichas não começam aqui," *Tempo*, No. 373, 27 Novembro 1977: 52–58; "Onde começam as bichas?," *Tempo*, No. 376, 18 Dezembro 1977: 24–35; "Aumentar a produtividade nas padarias para acabar com as longas bichas," *Tempo*, No. 310, 12 Setembro 1976: 49–53; all sources cited in this note accessed through JSTOR Aluka: Struggles for Freedom—Southern Africa.

65. Alfredo Mueche, interview by author, Maputo, Mozambique, March 2010.

66. "Voluntárias para produção," *Diário de Moçambique*, 24, Maio 1983, Center for Library Research; "Directiva ministerial sobre evacuação das cidades," *Notícias*, 20 Junho 1983, accessed through Mozambique History Net, http://www.mozambiquehistory.net/history/operacao_producao/19830620_directiva_ministerial.pdf; "'Operação Produção' eliminará desemprego," *Notícias*, 15 Julho, 1983, accessed through Mozambique History Net, http://www.mozambiquehistory.net/history/operacao_producao/19830715_op_eliminara_desemprego.pdf

67. "Directiva ministerial sobre evacuação das cidades," 1.

68. Ibid.

69. República Popular de Moçambique Província de Nampula, Supermercado No. 3 Cartão de Identificação, provided by Carlos Quembo.

70. Carlos Quembo, *Poder do Poder: Operação Produção e a Invenção dos "Improdutivos" Urbanos no Moçambique Socialista, 1983–1988* (Maputo: Alcane Editores, 2017); Omar Ribeiro Thomaz, "'Escravos sem dono': A experiência social dos campos de trabalhos em Moçambique no período socialista," *Revista de Antropologia*, Vol. 51, No. 1 (Janeiro–Junho 2008): 177–214.

71. Narciso Castanhaeira, "Sofala: Os passos que a Operação Produção," *Tempo*, No. 682, 6 November 1983: 31, accessed through Mozambique History Net.

72. Campt, *Listening to Images*.

73. Colin Darch, interview by author, Cape Town, South Africa, February 2015.

74. Identity cards identified a person's nationality as Mozambican.

75. Castanhaeira, "Sofala: Os passos que a Operação Produção," 31.

76. Danilo Guimarães, 1983, *Tempo*, No. 673, 4 Setembro 1983: 22, accessed through Mozambique History Net, http://www.mozambiquehistory.net/history/operacao_prod ucao/19830904_tempo_de_acertos.pdf

77. This process of verification functioned like the process of counter-forensics that Thomas Keenan ascribed to the unearthing of mass graves, which "produce[d] evidence, documents individual and specific things, names names, and attaches names to bodies."

See Thomas Keenan, "Counter-forensics and Photography," *Grey Room* no. 55 (Spring 2014): 72.

78. "Com a 'Operação Produção': Cidade começa a ficar desanuviada," *Notícias*, 11 Julho 1983, Arquivo Histórico Moçambique, Maputo, Mozambique.

79. Ibid.

80. Ibid.

81. "As bichas não começam aqui," 52–58; "Onde começam as bichas?," 24–35; "Aumentar a produtividade nas padarias para acabar com as longas bichas," 49–53.

82. Danilo Guimarães, "Houve casos de pessoas que foram parar aos centros de evacuação, possuindo cartão de trabalho. Foram soltas," *Tempo*, 7 Julho 1983: 18, Biblioteca Nacional de Moçambique, Maputo, Mozambique.

83. A. Luís, "Nem fotografias nem dinheiro," *Tempo*, 20 September 1981: 43, Arquivo Histórico de Moçambique, Maputo, Mozambique.

84. Kok Nam, "Aula de simplicidade," *Tempo*, 24 Julho 1983, Biblioteca Nacional de Moçambique, Maputo, Mozambique.

85. For example, Frelimo's Gabinete da Presidência required photographers to wear suits in the presence of Machel and while on assignment. Suits were expensive and in short supply, further restricting who in the press photographed Machel. António Muchave, interview by author, Johannesburg, South Africa, August 2016; Sérgio Santimano, interview by author, Skype, April 2016.

86. "Comentário: A propósito de fotografia: A nossa história pela imagem," *Notícias*, 12 Dezembro 1980, accessed through Mozambique History Net, http://www.mozam biquehistory.net/arts/photography/19801227_historia_pela_imagem.pdf

87. Ibid.

88. Ibid.

89. Luís Souto, interview by author, Maputo, Mozambique, April 2010; Carlos Calado, interview by author, March 2010.

90. Ibid.

91. Alves Gomes, interview by author, Maputo, Mozambique, January 2011.

92. Ibid.

93. Ibid.

94. Ibid.

95. See Margaret Hall and Tom Young, *Confronting Leviathan: Mozambique since Independence* (Athens: Ohio University Press, 1997); Cabrita, *The Mozambique: Tortuous Road to Democracy.*

96. "Bandidos armados são nova calamidade social," *Domingo*, 5 Agosto 1984, Arquivo Histórico de Moçambique, Maputo, Mozambique.

97. For more information on Frelimo's policy on the death penalty, see Igreja, "Frelimo's Political Ruling through Violence and Memory in Postcolonial Mozambique"; Benedito Machava, "State Discourse on Internal Security."

98. Rui Assubuji and Patricia Hayes, "The Political Sublime: Reading Kok Nam, Mozambique (1939–2012)," *Kronos*, Vol. 39 (2013): 66–11.

99. "Mozambique's Leftist Chief Dies in S. African Air Crash," *Los Angeles Times*, 20 October 1986: 1, accessed through ProQuest Historical Newspaper Database.

100. "$30,000 Donated to Machel Funeral," *Herald*, 8 November 1986, accessed through Mozambican History Net, http://www.mozambiquehistory.net/history/mbuzini/4_funeral/19861108_z$30k%20donated_for_funeral.pdf

101. Cabrita, *Mozambique: The Tortuous Road to Democracy*.

102. Guy Tillim, interview by author, Skype, March 2016.

103. Paulo Sérgio, "Erigidas em Maputo: Estátuas imortalizam Samora e Eduardo Mondlane," *Tempo*, 7 Julho 1989: 6, Biblioteca Nacional de Moçambique, Maputo, Mozambique.

104. Ibid.

105. Patricia Hayes, "Santu Mofokeng, Photographs: 'The Violence Is in the Knowing,'" *History and Theory*, Vol. 48, No. 4 (2009): 34–51.

106. Ibid.

107. "Quem ajuda a localizar?," *Tempo*, 19 Junho 1988; "Quem ajuda a localizar?," *Tempo*, 30 Julho 1989; "Quem ajuda a localizar?," *Tempo*, 9 Junho 1991; "Quem ajuda a localizar?," *Tempo*, 18 Junho, 1991; all citations in this note available at Biblioteca Nacional de Moçambique, Maputo, Mozambique.

108. "Pagamento em duplicadas para ter B.I.," *Tempo*, 24 Março 1991; "Que é preciso para obter BI?," *Tempo*, 3 Janeiro 1988: 38; "Quando terei o meu BI?," *Tempo*, 17 Janeiro 1988; "Dois anos a espera do BI," *Tempo*, 17 Janeiro 1988: 36; all citations in this note, Biblioteca Nacional de Moçambique, Maputo, Mozambique.

109. Hayes, "Santu Mofokeng, Photographs."

110. Cabrita, *Mozambique: A Tortuous Road to Democracy*.

111. "Finalmente abolidas guias-de-marcha," *Notícias*, 26 Abril 1991, Arquivo Histórico de Moçambique, Maputo, Mozambique.

112. Ibid.

113. Ibid.

114. Ibid.

115. Antunes Pedro, "Em Chirue: Guias-de marchas foi rehabilitado," *Tempo*, 31 Janeiro 1988. Also see "Galinha precisa de Guia?," *Tempo*, 26 Março 1989, Biblioteca Nacional de Moçambique, Maputo, Mozambique.

116. UNDP, "Assistance to the Electoral Process in Mozambique," April 1995, https://aceproject.org/main/samples/vr/vry_moz1.pdf. According to this UNDP report on Mozambique's first election, there were concerns over possible voting irregularities because of the challenges faced in South Africa with a computerized system.

117. Inácio Laissone with Naíta Ussene, "Censo Eleitoral: A maáquina já arrancou," *Tempo*, 12 Junho 1994, Biblioteca Nacional de Moçambique, Maputo, Mozambique.

118. Officials probably chose the Polaroid because of its capacity to develop and print films instantaneously. Studios in Mozambique sold Polaroid cameras and films before independence. However, Polaroid's business endeavors in South Africa proved more controversial. In the early 1970s, black workers at Polaroid's Cambridge, Massachusetts,

offices formed the Polaroid Revolutionary Movement and advocated that Polaroid cease all business activities in South Africa. This protest led Polaroid to declare that it had not sold an ID system and other equipment to the South African apartheid government.

119. Colin Darch, email correspondence, 2016.

120. Ferhat Vali Momade, 1990s, untitled, Sofala, Moçambique, Centro da Formação e Documentação de Moçambique, Maputo, Mozambique.

121. "Os passos da votação," *Tempo*, 2 Outubro 1994, Biblioteca Nacional de Moçambique, Maputo, Mozambique.

122. Fred Cooper, discussant remarks, Material Documents, Bureaucratic Reason, and the Formation of Political Subjectivities, Columbia University, New York, New York, 19 October 2018.

CHAPTER 5

1. "Suécia coopera com Moçambique no domínio de Informação," *Domingo*, Dezembro 1983, Arquivo Histórico de Moçambique, Maputo, Mozambique.

2. The first group of AIM photographers included Anders Nilsson (director), António Muchave, Sérgio Santimano, Joel Chiziane, and Alfredo Mueche. Ferhat Vali Momade joined AIM in the late 1980s, after Santimano and Nilsson had left.

3. AIM priced these packages for institutional use and individual sale.

4. News services were cognizant of not offending Western audiences by distributing pictures of dead and injured bodies. See Greg Marionovich and João Silva, *The Bangbang Club: Snapshots from a Hidden War* (New York: Random House, 2011).

5. Some of the selected South African freelancers were members of the antiapartheid photography collective Afrapix, which received AIM photographs. Paul Weinberg, interview by author, Los Angeles, California, March 2011; Guy Tillim, interview by author, Skype, March 2016.

6. Marionovich and Silva, *The Bangbang Club*; António Marmelo, "Fotógrafos em mesa—redonda," *Domingo*, 6 Maio 1984: 8–9, Arquivo Histórico de Moçambique, Maputo, Mozambique.

7. Alves Gomes, interview by author, Maputo, Mozambique, January 2011; Kok Nam, interview by author, Maputo, Mozambique, July 2008; Joel Chiziane, interview by author, Maputo, Mozambique, March and June 2010; Alfredo Mueche, interview by author, Maputo, Mozambique, March 2010 and January 2011; Sérgio Santimano, interview by author, Skype, April 2016.

8. "Massacre of Nyazónia," *Tempo*, No. 307, 22 August 1976: 2-11, accessed through JSTOR ALUKA Struggles for Freedom—Southern Africa.

9. "República Popular de Moçambique: Primeira Ofensiva do Governo," *Tempo*, No. 252, 3 Agosto 1975: 11–12, Biblioteca Nacional de Moçambique, Maputo, Mozambique.

10. Such reactions left Machel to wonder whether people were supposed to ask the devil to resuscitate the dead until money was available. See "República Popular de Moçambique," *Tempo*, No. 252, 3 Agosto 1975: 11–12.

11. For more on Machel's rhetoric and performance, see Colin Darch and David Hedges, "Political Rhetoric in the Transition to Mozambican Independence: Samora Machel in Beira, June 1975," *Kronos*, Vol. 39 (2013): 32–65.

12. "República Popular de Moçambique," *Tempo*, No. 252, 3 Agosto 1975: 11–12, Arquivo Histórico de Moçambique, Maputo, Mozambique.

13. Hans Belting, *Anthropology of Images: Pictures, Body, Medium* (Princeton: Princeton University Press, 2014), 97.

14. "'Pega na fronteira e fecha,'" *Tempo*, No. 336, 13 Março 1977: 62, accessed through JSTOR ALUKA: Struggles for Freedom—Southern Africa.

15. Ibid.

16. Ibid.

17. To this point, *Tempo* stated, "It was only when confirmation came from the High Commissioner of the United Nations that Nyazónia was a camp of refugees and that the men, women, and children massacred were civilian Zimbabweans, only in this time, did a good part of the countries help with the closing of [Mozambique's] border [with Rhodesia]. They believed that Nyazónia was, to the contrary of what Smith said, a camp of Zimbabwean refugees. And, we must tell you the truth and why, the help to the Zimbabwean refugees only came after the Nyazónia Massacre and after the Geneva Conference. [This] is to say, [it was only] after the death of 700 people . . . confirm[ed] that they were refugees . . . [that] the armed struggle created conditions for 'a possible resolution for the Zimbabwean problem'" in Geneva. See "'Pega na fronteira e fecha,'" *Tempo*, No. 336, 13 Março 1977: 62, accessed through JSTOR ALUKA: Struggles for Freedom—Southern Africa.

18. Constructing and circulating a photographic image of itself was challenging for the liberation movement Frelimo. Early in the armed struggle against Portugal, Frelimo's Departamento de Informação e Propaganda and Departamento de Relações Exteriores learned that other allied liberation groups had reused and mislabeled Frelimo's photographs. A year before it announced its support for the African National Congress (ANC) and the Zimbabwe African People's Union (ZAPU), an unnamed "Frelimo militant" wrote to the editors of the ANC publication *SECHABA*. On three separate occasions, *SECHABA* editors paired photographs of Frelimo troops marching with articles unrelated to Mozambique. Of these three instances, at particular issue was a photograph of Frelimo troops printed under the ANC flag and in an article about the ANC-ZANU alliance. Because Frelimo was not in an alliance with either group, the official questioned whether a Frelimo photograph was necessary instead of "one of the [V]ietnamese guerrillas." This perceived mischaracterization raised further qualms about why *SECHABA* neglected to praise the efforts of Mozambique's liberation fighters. While acknowledging the shared objectives of the movements, the letter writer warned of the need "to put our activities in their proper place and try to be honest." How to caption and reuse photographs of the liberation struggle by Frelimo in the service of other movements, and without confusing their viewers, plagued the ruling party Frelimo after Mozambique's independence. See Frelimo Militant to the Editor, *SECHABA*, undated (possibly 1967/68 based on contents), DRE-29F, Arquivo Histórico de Moçambique, Maputo, Mo-

zambique; *SECHABA*, Vol. 1, No. 11 (November 1967), accessed through JSTOR ALUKA Struggles for Freedom—Southern Africa.

19. Samora Machel, the president of Mozambique, hosted gatherings in Mozambique to win international recognition of the conflict with Rhodesia. At one of these gatherings, Machel and Robert Mugabe, the leader of the Zimbabwean liberation front and former president of Zimbabwe, argued for the use of military force. The news bulletin for the Southern Africa Committee reports Mugabe as having stated, "Zimbabweans had 'used strikes, sit-ins, and passive resistance. We tried these methods and our people got shot . . . we came to the conclusion that what remained to be tried was the armed struggle.'" Mugabe's and Machel's line of response conflicted with the nonviolent measures proposed by the US representative and civil rights activist Andrew Young. See "Maputo Conference—No U.S. Triumph," *Southern Africa*, Vol. 10, No. 5, June/July 1977: 9, accessed through JSTOR ALUKA Struggles for Freedom—Southern Africa.

20. José Cabral, "É assim que nascemos . . . ," *Tempo*, No. 391, 2 Abril 1978: 27; "Cartas dos leitores: Críticas à reportage fotográfica 'É assim que nascemos . . . ,'" *Tempo*, No. 393, 16 Abril 1978: 9, accessed through JSTOR ALUKA Struggles for Freedom—Southern Africa.

21. See Maria Aldina, "Cartas dos leitores: Contra o banditismo," *Tempo*, No. 301, 11 Julho 1976: 2; Juvenal Bucuane, "Cartas dos leitores: Vamos para o Zimbabwe," *Tempo*, No. 302, 18 Julho 1976: 2; Luciano Sanbane, "Cartas dos leitores: Imagem da liberdade," *Tempo*, No. 302, 18 Julho 1976: 2; Alex Jo Uaiene, "Cartas dos leitores: Seja prudente Smith," *Tempo*, No. 309, 5 Setembro 1976: 2–3; all citations in this note accessed through JSTOR ALUKA: Struggles for Freedom—Southern Africa.

22. "Rhodesia tortura: O testemunho de um fotógrafo," *Tempo*, No. 377, 25 Decembro 1977: 15, accessed through JSTOR ALUKA Struggles for Freedom—Southern Africa..

23. Ibid.

24. Ibid.

25. Ibid.

26. In chapter 3, I quoted the press photographer Ricardo Rangel. He stated that the Mozambican state under Frelimo prohibited the photographing of destroyed bridges. He felt that the state enforced this position out of the belief that such photographs aided Mozambique's enemies. Editorially, there was no basis for Rangel's theory. Photographs of destroyed infrastructure and dead bodies regularly appeared in Mozambique's press coverage of the nation's conflicts with Rhodesia. However, Rangel's views did reflect his own disenchantment after independence and his perceptions that his photographs from 1976 to 1980 challenged state policy.

27. President Samora Machel believed in the necessity of explaining the function of roads. The road was a rhetorical metaphor that Machel had used to disentangle Mozambique from its colonial past and to frame the actions of the Frelimo party and government after independence. In 1977, Machel remarked, "We must—I said—explain to the populations, the objective of the road. We say, many times, that if the population was able to open the roads that permitted the car of the mister administrator to go pick up taxes, if the population was able to open roads that allowed the native soldiers to be at-

tached to forced labor—then why won't they [the roads] open the way to their products. Or, still, in order to bring their children to school, and to bring medicine to the population? We must explain to the people our action and the clear content; to know what objectives that we want to achieve. So, we will mobilize the population." Photographs of roads destroyed by Rhodesian attacks on Mozambique risked unsettling Machel's argument and political aspirations. See "A estrada," *Tempo*, Especial, 11 November 1977: 46, Biblioteca Nacional de Moçambique, Maputo, Mozambique.

28. Fernando Lima, interview by author, Maputo, Mozambique, June 2010.

29. News organizations in North America, Europe, and South Africa were able to travel to Rhodesia and cover the war from the perspective of the Ian Smith government.

30. In addition to Fernando Lima, who worked for the news agency Luso, Paul Fauvet and Iain Christie were affiliated with the Associated Press and Reuters, respectively.

31. Fernando Lima, interview by author, Maputo, Mozambique, June 2010.

32. Paul Fauvet, interview by author, Maputo, Mozambique, April 2010.

33. Fernando Lima, interview by author, Maputo, Mozambique, June 2010.

34. A. J. Venter, "Media Wars," in *Challenge: Southern Africa within the African Revolutionary* (Gilbraltar: Ashanti Publishing), 298.

35. Relatório da Agência de Informação de Moçambique (AIM), 26 Novembro 1979, Instituto Nacional de Cinema, Maputo, Mozambique.

36. See John Liebenberg and Patricia Hayes, *Bush of Ghosts: Life and War in Namibia 1986–1980* (Johannesburg: Umuzi, 2010); Jo Ractliffe, *As Terras do Fim do Mundo = The Lands of the End of the World* (Cape Town: Michael Stevenson, 2010); Jo Ractliffe, *Terreno Ocupado* (Johannesburg: Warren Siebrits, 2008).

37. Carlos Cardoso, "Quando há complex de inferioridade há racismo," *Domingo*, 22 Julho 1984: 2, Arquivo Histórico de Moçambique, Maputo, Mozambique.

38. Belting, *Anthropology of Images*.

39. Previously, antiapartheid networks outside of Mozambique had been critical of efforts to help the ruling party Frelimo pursue the bold endeavor of picturing and filming itself.

40. "Desmontagem de uma agressão: 'Operação Estilhaço' estilhaçou propaganda racista," *Domingo*, 29 Maio 1983: 8–9, Arquivo Histórico de Moçambique, Maputo, Mozambique.

41. Ibid.

42. Frelimo's support for the ANC dated to the liberation war. However, there were long-standing tensions over how foreign allies recognized Frelimo in relation to other liberation movements. For example, at a 1968 leadership gathering, Frelimo pledged its support to the African National Congress and the Zimbabwean African National Union. In advance of this announcement, Frelimo had trouble controlling the entry of non-Frelimo groups into its military camps in southern Tanzania. The Organization of African Liberation (OAU) monitored and facilitated the activities of exiled liberation groups on behalf of the Tanzanian government. The OAU determined that Frelimo had no jurisdiction over who entered its military camps. Frelimo wrote to the camp

in question to notify them of the OAU takeover. The OAU intervention posed further challenges to its delivery of material aid, such as radios, from its allies and required Frelimo to have equipment for both itself and other groups. Such tensions carried over to the postindependence period, specifically with events such as the Matola bombing. See Frelimo Militant to the Editor, *SECHABA*, undated (possibly 1967/68 based on contents), DRE-29F, Arquivo Histórico de Moçambique, Maputo, Mozambique. Also see "Desmontagem de uma agressão."

43. "Desmontagem de uma agressão."

44. After independence, various government agencies along with the press relied on photographs of the liberation struggle to establish the Frelimo party's control. In this postindependence moment of destabilization, the absence of liberation-struggle photographs was striking, considering how ideas of authorship and identification that materialized around their prior use informed Frelimo's own deployment of identification documents (see chapter 4).

45. "Reacções violentas ao ataque 'boer,'" *Diário de Moçambique*, 27 Maio 1983: 1, Center for Library and Research.

46. Ibid.

47. Salmão Moyana, interview by author, Maputo, Mozambique, August 2010.

48. Ibid.

49. Ibid.

50. Ibid.

51. Between 1975 and 1981, newspaper editors as well as content regularly changed. Editorial changes introduced in this period involved the printing of photographs. For example, in September 1981, José Luís Cabaço, then the head of the Ministério da Informação, announced that daily newspapers *Notícias* and *Diário de Moçambique* would cease printing Sunday editions. The Sunday weekly *Domingo* would fill this void. In addition, *Domingo* and *Diário de Moçambique* adopted a tabloid format, allowing the publication of more photographs. In the past, *Tempo*'s magazine format and weekly circulation allowed the public to print more photographs than daily newspapers. The selection of photographer Ricardo Rangel as *Domingo*'s first editor-in-chief was intended to enhance the publication's use of photographs. To this point, the first editorial described the publication's mission as "a risky bet accompanied by new techniques" and announced plans to use an offset printer for high-quality graphics and photo compositions. See "Editorial," *Domingo*, 27 Setembro 1981, Arquivo Histórico de Moçambique, Maputo, Mozambique; "Um novo domingo," *Domingo*, 25 Setembro 1983, Arquivo Histórico de Moçambique, Maputo, Mozambique.

52. "Liquidar bandidos armados," *Domingo*, 18 Março 1984: 1, Arquivo Histórico de Moçambique, Maputo, Mozambique; "Armas nas mãos do povo," *Domingo*, 13 Maio 1984, Arquivo Histórico de Moçambique, Maputo, Mozambique; "De 1 a 20 de Novembro: Forças armadas abateram 150 bandidos," *Domingo*, Dezembro 1988, Arquivo Histórico de Moçambique, Maputo, Mozambique.

53. "Barrios da Liberdade e 'Luís Cabral': Bandidos armados acolhidos com ódio

pela população," *Domingo*, 6 Maio 1984; "Candongueiro igual a bandido armado," *Domingo*, 20 Fevereiro 1983: 1; "Povo faz justiça," *Domingo*, 10 Abril 1983: 1; "Revolução radicaliza-se," *Domingo*, 22 Maio 1983; all citations in this note available at Arquivo Histórico de Moçambique, Maputo, Mozambique.

54. These developments left many print journalists, along with photographers and filmmakers, to question photography's and cinema's evidentiary capacities. Fernando Lima, interview by author, Maputo, Mozambique, June 2010; Salmão Moyana, interview by author, Maputo, Mozambique, August 2010; Fernando Gonçalves, interview by author, Maputo, Mozambique, June 2010; Tómas Mário Vieira, interview by author, Maputo, Mozambique, June 2010. Also see Teresa Sá Nogueira, "Cinema moçambicano: Artur Torohate, a cineasta guerilla," *Tempo*, 7 Setembro 1986, Arquivo Histórico de Moçambique, Maputo, Mozambique.

55. Ibid.

56. *Domingo*, "Liquidar bandidos armados"; "Armas nas mãos do povo"; "De 1 a 20 de Novembro: Forças armadas abateram 150 bandidos."

57. Elaborating on his motivations, Gonçalves stated, "I felt a necessity to make a film that was able to explain, to the outside [world], what I think of Mozambique, what is Mozambique; that these groups of bandits are not isolated, they represent imperialism and all the forces against the liberty of people." See Augusto de Jesus, "Nkomati—O direito de viver em paz: Um poema de imagens para tela de cinema," *Domingo*, 13 Outubro 1985, Arquivo Histórico de Moçambique, Maputo, Mozambique.

58. Mário Ferro e Amadeu Marrengula, "O povo foi à rua vitoriar Samora," *Domingo*, 18 Março, 1984: 2; "Em paz poderemos arrancar com a nossa economia," *Domingo*, 18 Março 1984: 3; "Editorial: Khanimambo Samora," *Domingo*, 8 Abril 1984; "Vibrar golpe mortal nos bandidos armados," *Domingo*, 22 Abril 1984; all citations in this note available at Arquivo de Moçambique, Maputo, Mozambique.

59. I first encountered this debate during presentations at the International Symposium for a History of Cinema in Mozambique, held at the Universidade Eduardo Mondlane in conjunction with the 6th edition of Dockanema, The Documentary Film Festival. Later NPR and the *Guardian* featured articles on the subject. See David Smith, "'Racism' of Early Color Photography Explored in Art Exhibition," *Guardian*, online edition, 25 January 2013, http://www.theguardian.com/artanddesign/2013/jan/25/racism-colour-photography-exhibition; Mandalit Del Barco, "How Kodak's Shirley Cards Set Photography's Skin-Tone Standard," National Public Radio, 13 November 2014, www.npr.org/2014/11/13/363517842/for-decades-kodak-s-shirley-cards-set-photography-s-skin-tone-standard

60. "No Immunity for Mass Murders," *Anti-apartheid News*, September 1979, accessed through JSTOR ALUKA Struggles for Freedom—Southern Africa; Polaroid Revolutionary Workers Movement, "Polaroid and South Africa," pamphlet, early 1971, African Activist Archive, http://africanactivist.msu.edu/document_metadata.php?objectid=32-130-1F7. Also see Polaroid Revolutionary Workers Movement, "Polaroid Colorpack III Imprisons a Black South African Every 60 Seconds," pamphlet, 1971,

African Activist Archives, http://africanactivist.msu.edu/document_metadata.php? objectid=32-130-362; "Boycott Polaroid," Polaroid Revolutionary Workers Movement, Southern Africa Collective, Sc MG 175, Schomburg Center for Black Culture, New York, New York.

61. Kodak cameras and films were fixtures of colonial-era photographic economies in Mozambique. Also, the Polaroid Corporation widely advertised its camera and film products in local newspapers. After 1975, the availability of photographic equipment in Mozambique radically changed. International boycotts were not solely responsible for the disappearance of these brands. By the late 1970s, Kodak's black-and-white films were as expensive as color ones. The Mozambican government lacked the foreign cash reserves needed to purchase materials. Furthermore, film companies like Kodak internally acknowledged the burdens of conducting business in places like South Africa and Australia. Photographers and filmmakers native to Mozambique came to recognize these aesthetic debates, in addition to access to Kodak film, as exclusive to elite and government circles. For more, see Pedro Pimenta, interview by author, Maputo, Mozambique, December 2010; Eduardo Matlombe, interview by author, Maputo, Mozambique, June and November 2010; George Eastman, correspondence dated 17 September 1902, George Eastman Legacy Collection, George Eastman Museum, Rochester, New York.

62. Cardoso, "Quando há complex de inferioridade há racismo": 2.

63. Ibid.

64. Joel Chiziane, interview by author, Maputo, Mozambique, March and June 2010.

65. The circumstances surrounding Mozambique's independence led the Frelimo government to prioritize photography. Colonial-era race and labor policies had hindered nonwhite populations from pursuing careers as photographers. For more on how race influenced the practice of photography in colonial and independent Mozambique, see Drew Thompson, "AIM, FOCUS, SHOOT: Photographic Narratives of War, Independence, and Imagination in Mozambique, 1950 to 1993," PhD dissertation, University of Minnesota–Twin Cities, 2013; Drew Thompson, "Photo Genres and Alternate Histories of Independence in Mozambique," in *Ambivalent: Photography and Visibility in African History*, edited by Patricia Hayes and Gary Minkley, 126–155 (Athens: Ohio University Press, 2019).

66. Joel Chiziane, interview by author, Maputo, Mozambique, March and June 2010; Sérgio Santimano, interview by author, Skype, April 2016; António Muchave, interview by author, Johannesburg, South Africa, August 2016.

67. António Muchave, interview by author, Johannesburg, South Africa, August 2016.

68. Ibid.

69. Sérgio Santimano, interview by author, Skype, April 2016; Alfredo Mueche, interview by author, Maputo, Mozambique, March 2010.

70. Anders Nilsson, interview by author, Maputo, Mozambique, December 2010.

71. Ibid.

72. Celeste MacArthur, interview by author, Maputo, Mozambique, September 2010;

Sérgio Santimano, interview by author, Skype, April 2016; António Muchave, interview by author, Johannesburg, South Africa, August 2016.

73. Sérgio Santimano, interview by author, Skype, April 2016.

74. Anders Nilsson, interview by author, Maputo, Mozambique, December 2010; Joel Chiziane, interview by author, Maputo, Mozambique, March 2010.

75. "Em Setembro, no distrito de Moamba: BA's assassinaram cidadãos italianos," *Domingo*, 7 Outubro 1984, Arquivo Histórico de Moçambique, Maputo, Mozambique.

76. Anders Nilsson, interview by Author, Maputo, Mozambique, December 2010.

77. Joel Chiziane, interview by author, Maputo, Mozambique, March and June 2010.

78. Ibid.

79. Alfredo Mueche, interview by author, Maputo, Mozambique, March 2010 and January 2011.

80. Ibid.

81. Alfredo Mueche, interview by author, Maputo, Mozambique, March 2010 and January 2011; António Muchave, interview by author, Johannesburg, South Africa, August 2016.

82. Alfredo Mueche, interview by author, Maputo, Mozambique, March 2010 and January 2011.

83. Alfredo Mueche, interview by author, Maputo, Mozambique, March 2010.

84. Ibid.

85. See Patricia Hayes, "Santu Mofokeng, Photographs: 'The Violence Is in the Knowing,'" *History & Theory*, Vol. 48, No. 4 (December 2009): 34–51.

86. Alfredo Mueche, interview by author, Maputo, Mozambique, March 2010 and January 2011; Joel Chiziane, interview by author, Maputo, Mozambique, March and June 2010; Anders Nilsson, interview by author, Maputo, Mozambique, December 2010; Sérgio Santimano, interview by author, Skype, April 2016; António Muchave, interview by author, Johannesburg, South Africa, August 2016.

87. Anders Nilsson commented on how Mozambicans' skin color posed difficulties to photographing. In one instance, he mentioned the shadows from the caps worn by military officials. One response was to use flash. From the perspective of one of Nilsson's understudies, Alfredo Mueche, flash destroyed the textures of "the day and person." Learning skills in the darkroom allowed Mueche to recognize the natural lighting outside when the photo was taken and to incorporate that lighting into the processing and printing of the films. These techniques could not, however, shield Mueche and the other AIM photographers from photography's ability to misrepresent the war and the politicized debates over photography that resulted. Government officials criticized Nilsson for printing a photograph of Machel with gray hair. See Anders Nilsson, interview by author, Maputo, Mozambique, December 2010. For additional reference, see Alfredo Mueche, interview by author, Maputo, Mozambique, March 2010 and January 2011; Joel Chiziane, interview by author, Maputo, Mozambique, March and June 2010; Sérgio Santimano, interview by author, Skype, April 2016; António Muchave, interview by author, Johannesburg, South Africa, August 2016.

88. António Muchave, interview by author, Johannesburg, South Africa, August 2016.

89. António Muchave, interview by author, Johannesburg, South Africa, August 2016; Alfredo Mueche, interview by author, Maputo, Mozambique, March 2010 and January 2011.

90. Anders Nilsson, interview by author, Maputo, Mozambique, December 2010.

91. Ibid.

92. Ibid.

93. Alfredo Mueche, interview by author, March 2010 and January 2011.

94. António Marmelo, "Fotógrafos em mesa—redonda," *Domingo*, 6 Maio, 1984: 8–9, Arquivo Histórico de Moçambique, Maputo, Mozambique.

95. Cardoso, "Quando há complex de inferioridade há racismo," 2.

96. Marmelo, "Fotógrafos em mesa—redonda."

97. A condition of embeddedness, a photographer's position on the front lines during combat, was of particular interest to international news agencies. See Susan Sontag, *Regarding the Pain of Others* (New York: Farrar, Straus and Giroux, 2003); Zeynep Devrim Gürsel, *Image Brokers: Visualizing World News in the Age of Digital Circulation* (Berkeley: University of California Press, 2016).

98. António Muchave, interview by author, Johannesburg, South Africa, August 2016.

99. Ibid.

100. Ibid.

101. António Muchave, interview by author, Johannesburg, South Africa, August 2016; Joel Chiziane, interview by author, Maputo, Mozambique, March 2010 and June 2010.

102. António Muchave, interview by author, Johannesburg, South Africa, August 2016.

103. Bruno Z'Graggen and Grant Lee Neuenburg, eds., *Iluminando Vidas: Ricardo Rangel e a Fotografia Moçambicana* (Zurich: Christoph Merian Verlag, 2002).

104. Joel Chiziane, interview by author, Maputo, Mozambique, March 2010 and June 2010.

105. The original photograph was unavailable for republication here. For a reprint, see Joel Chiziane, 1998, "Aftermath of Battle III," Gaza Province, in *Iluminando Vidas: Ricardo Rangel e a Fotografia Moçambicana* (Zurich: Christoph Merian Verlag, 2002).

106. Joel Chiziane, interview by author, Maputo, Mozambique, March 2010 and June 2010.

107. Ibid.

108. Ibid.

109. Ibid.

110. Ibid.

111. Ibid.

112. José Cabral, untitled, 28 Outubro 1986, Maputo, Mozambique, Centro da Formação e Documentação Fotografica, Maputo, Mozambique.

113. Alirio (Joel) Chiziane, 1986, "The Malawian flag being burned outside the Malawian embassy this morning in demonstrations against Malawian involvement in supporting banditry in Mozambique," Caixa: AIM, Centro de Formação e Documentação Fotografia, Maputo, Mozambique; AP Laser Photo, "Mozambique Mob Sacks Embassy," *Chicago Tribune*, 5 November 1986, accessed through ProQuest Historical Newspaper Database.

114. Ibid.

115. AP Laser Photo, "Mozambique Mob Sacks Embassy."

116. Chiziane, "The Malawian Flag."

117. "Imagens de horror," *Notícias*, 23 Julho 23, 1987: 1, Arquivo Histórico de Moçambique, Maputo, Mozambique.

118. Ibid.

119. Ibid.

120. AIM, June 1987, "A survivor of the MNR attack on Homoine trying to identify his family among the dead," Inhambane, Mozambique, Caixa: AIM, Centro de Documentação e Formação Fotográfica, Maputo, Mozambique.

121. See José Cabral, "Atentado bombista contra Albie Sachs," *Notícias*, 5 April 1988, Arquivo Histórico de Moçambique, Maputo, Mozambique.

122. Secretariado Nacional de Lisboa, *Genocídio Contra Portugal* (Lisboa: Edição Secretariado Nacional de Lisboa, 1961): 1.

123. "Imagens de horror."

124. Ibid.

125. Jorge Tomé, untitled, *Notícias*, 24 Julho 1987, Arquivo Histórico de Moçambique, Maputo, Mozambique.

126. Fernando Lima, interview by author, Maputo, Mozambique, June 2010.

127. "Imagens de Horror"; Tomé, untitled.

128. Ferhat Vali Momade, interview by author, Maputo, Mozambique, November 2010.

129. Paul Fauvet, interview by author, Maputo, Mozambique, April 2010.

130. "Bandidos armados são nova calamidade social," *Domingo*, 5 Agosto 1984, Arquivo Histórico de Moçambique, Maputo, Mozambique.

131. Here I am referring to Paul Weinberg, Guy Tillim, and Cedric Nunn.

132. Patricia Hayes, "Power, Secrecy, Proximity: A Short History of South African Photography," *Kronos*, Vol. 33 (November 2007): 139–162; Darren Newbury, *Defiant Images: Photography and Apartheid in South Africa* (Pretoria: UNISA Press, 2009); Okwui Ewenzor and Rory Bester, eds., *Rise and Fall of Apartheid: Photography and the Bureaucracy of Everyday Life* (New York: International Center of Photography, 2013).

133. Paul Weinberg, interview by author, Los Angeles, California, March 2011; Cedric Nunn, interview by author, email correspondence, January 2011; Guy Tillim, interview by author, Skype, March 2016.

134. Kok Nam, interview by author, Maputo, Mozambique, July 2008; Ricardo Ran-

gel, interview by author, Maputo, Mozambique, Summer 2008; José Cabral, interview by author, Maputo, Mozambique, March 2010.

135. Guy Tillim, interview by author, Skype, March 2016.

136. Ibid.

137. Ibid.

138. Due to copyright, not all of these photographs were available for reprinting here. See António Muchave, "Soldiers Weeping at Machel's Funeral," in *Machel of Mozambique*, edited by Iain Christie, photo gallery (Harare: Zimbabwe Publishing House, 1988); Associated Press, "Tribute to a Leader," *Los Angeles Times*, 29 October 1986, accessed through ProQuest Historical Newspaper Database.

139. There is no record that the AIM photograph featured in local press coverage of the funeral. One reason for the photograph remaining unpublished was its depiction of members of the state's military apparatus. I located the photograph in a biography of Samora Machel by Iain Christie, who worked as a foreign correspondent and had collaborated with AIM. His wife, Francis Christie, wrote the English captions for AIM photographs.

140. During the liberation war for Mozambique's independence, Frelimo photographers had pictured other visiting foreign photographers in areas under Frelimo's control. These photographs of foreign delegations served to confirm the validity of photographs of the liberated areas and to demonstrate the outside world's recognition of Frelimo. Such an approach to photography did not apply with regard to AIM photographs.

141. Paul Weinberg, interview by author, Los Angeles, California, March 2011.

142. See Paul Weinberg, untitled, personal archives of Paul Weinberg, Cape Town, South Africa.

143. Peter Schille and Paul Weinberg, "Nie haben wir gelernt, ein Land zu regieren," *Der Spiegel*, No. 47, 1987: 163–172.

144. Paul Weinberg, interview by author, Los Angeles, California, March 2010.

145. Schille and Weinberg, "Nie haben wir gelernt."

146. Ibid.

147. Paul Weinberg, interview by author, Los Angeles, California, March 2010.

148. Cloete Breytenbach, interview by author, Cape Town, South Africa, August 2016. Also see Cloete Breytenbach, *Savimbi's Angola* (Cape Town: H. Timms, 1980).

149. Cloete Breytenbach, interview by author, Cape Town, South Africa, August 2016.

150. Ibid.

151. Ibid.

152. Ibid.

153. Ibid.

154. Ibid.

155. Ibid.

156. Ibid.

157. Ibid.

158. Ibid.

159. Ibid.

160. "Minha fotografia apareceu escura no jornal," *Domingo*, 5 Setembro 1993, Arquivo Histórico de Moçambique, Maputo, Mozambique.

161. Ibid.

162. Ibid.

163. Ibid.

164. Ibid.

165. Ibid.

166. Joel Chiziane and Alfredo Mueche left for Savana, and António Mueche took a job at the South African newspaper *Sowetan*. Back in 1986, Sérgio Santimano had left AIM and Mozambique to study photojournalism in Sweden.

167. Joel Chiziane, interview by author, Maputo, Mozambique, March 2010. See Joel Chiziane, undated, "Passenger Train Attack," Movene Province, in *Iluminando Vidas: Ricardo Rangel e a Fotografia Moçambicana*, edited by Bruno Z'Graggen and Grant Lee Neuenburg (Zurich: Christoph Merian Verlag, 2002).

168. Joel Chiziane, interview by author, Maputo, Mozambique, March 2010.

169. Ibid.

170. Cedric Nunn, interview by author, email correspondence, January 2011.

171. Ibid.

172. Ibid.

173. Ibid.

174. Ibid.

175. Joel Chiziane, interview by author, Maputo, Mozambique, March and June 2010.

176. Cedric Nunn, interview by author, email correspondence, January 2011.

177. Ibid.

178. "Comboio 620: O Massacre," *Tempo*, No. 1011, 25 Fevereiro 1990, Arquivo Histórico de Moçambique, Maputo, Mozambique.

179. "As fotografias de Alfredo Mueche: Horror, ele próprio," *Notícias*, 21 Janeiro 2004: 5, Associação dos Fotógrafos Moçambicanos, Maputo, Mozambique.

180. Ibid.

181. Joel Chiziane, 1990, "Massacre of Movene," Caixa: AIM, Centro de Documentação e Formação Fotográfica, Maputo, Mozambique.

182. Notícias, "As fotografias de Alfredo Mueche," 5.

183. Ibid.

184. Ibid.

185. Ibid.

186. Ibid.

187. Ibid.

188. Ibid.

189. Ibid.

EPILOGUE

1. Theorist Walter Benjamin formulated ideas about photography's innovation in terms of the concept of reproducibility. Benjamin understood reproducibility as the ability of photography to replicate what is seen in front of the camera lens. He argued that photography's reproducibility allowed the reproduction of images at a speed faster than that of the hand, and that, in the case of cinema, it kept up with oral speech. Supposedly, there was nothing that photography could not reproduce. However, he claimed that this reproducibility of the object transformed the object itself and its reproductions into a type of image dislodged from a particular time and space. See Walter Benjamin, "The Work of Art in the Age of Mechanical Reproduction," in *Illuminations: Essays and Reflections*, edited by Hannah Arendt, 217–253 (New York: Schocken Books, 1969).

2. In retrospect, I realized that I never had to have a photographer in Mozambique take my picture for documentation issued either by the government or local commercial/academic institutions.

3. Abibo Selemane, "Modernização tira pão a retratistas," *Domingo*, 21 Março 2010: 18.

4. Because they were photographers, it never occurred to me to ask them whether they had the proper identification that their clients required. Based on their responses to the introduction of the biometric document, it strikes me that photography was a widely recognized public practice. Street photographers, unlike their peers in the press, were able to evade, or at least adapt to, the structures that the state enforced by verifying individual documentation.

5. By 1990, news publications such as *Tempo* showed photographers using automatic cameras without tripods. Two years before, the Mozambican government under the control of Frelimo had abandoned the socialist political platforms it had adopted in 1977. The turnabout paved the way for the return of foreign investment and private business, such as the opening of photography minilabs. The filmmaker Sol Carvalho partnered with Luís Souto, Jorge Almeida, and António Vermelho to open and operate from the late 1980s until the early 1990s the minilab business Cooperative ALPHA. Such automatic film-processing services shifted attention away from the quality of the image to the issue of the money required to provide such services. See "Secção: Factos e fotos," *Tempo*, Outubro 1990, Biblioteca Nacional de Moçambique, Maputo, Mozambique; Sol Carvalho, interview by author, Maputo, Mozambique, April 2010; Jorge Almeida interview by author, Maputo, Mozambique, April 2010.

6. In 2010, the Frelimo government considered doing away with daily life subsidies. It decided not to after the outbreak of riots.

7. Ralph Hajjar, interview with author, email correspondence, December 2014.

8. "Lina Magaia reeditaria 'Operação Produção,'" *Diario de um Sociólogo*, 3 Agosto 2007, https://oficinadesociologia.blogspot.com/2007/08/lina-magaia-e-operao-produo-que.html (accessed 14 Julho 2019).

9. "Finalmente abolidas guias-de-marcha," *Notícias*, 26 Abril 1991, Arquivo Histórico de Moçambique, Maputo, Mozambique.

10. I overheard conversations on this matter during a 2016 visit to Mozambique.

11. Ralph Hajjar, interview with author, email correspondence, December 2014.

12. "Empresa de emissão de documentos de identificação encerra atividades em Moçambique," *Diario de Notícias* (Portugal), 23 Outubro 2017, https://www.dn.pt/lusa/empresa-de-emissao-de-documentos-de-identificacao-encerra-atividades-em-mocam bique-8865388.html

13. After launching a tender, it narrowed down its choices to two companies, one of which was located in Germany.

14. Ariella Azoulay, "What Is a Photograph? What Is Photography?," *Philosophy of Photography*, Vol. 1, No. 1 (2010): 9–13.

BIBLIOGRAPHY

ARCHIVES AND COLLECTIONS

Basel, Switzerland

Basler Afrika Bibliographien
 Poster Collection

Maputo, Mozambique

Arquivo Histórico de Moçambique
 Colonial and postindependence newspapers
 Commisão do Censura (1959–1961)
 Frente da Libertação de Moçambique—documents and photographs
Associação dos Fotógrafos Moçambicanos
Arquivo Nacional da Torre do Tombo
 Polícia Internacional e de Defesa do Estado
 Serviços de Centralização e Coordenação de Informações de Moçambique (1953–
 1975)
Biblioteca Nacional de Moçambique
 Colonial and postindependence newspapers
Centro de Formação e Documentação Fotográfica
 7 de Setembro
 Agência da Informação de Moçambique
 Apartheid
 Bichas
 Colonial: Comunidade Chinesa
 Deslocados/Refugiados
 Governo de Transição
 Guerra Civil
 Guerra Destruições
 Luta Armada-Frente da Libertação de Moçambique
 Massacres
 Nacionalizações

Personal archives of Ricardo Rangel
 Rangel: Tempo Colonial
Instituto Nacional de Cinema

Lisbon, Portugal

Arquivo Histórico Diplomático
 Gabinete dos Negócios Políticos
Arquivo Histórico Militar
 Acção psicológica (Gabinete do Chefe do Estado Maior do Exército [CEME]/
 Secção do Ultramar)
 S. J. Mcintosh
 Publicações e regulamentos (Gabinete do Chefe do Estado Maior do Exército
 [CEME]/Secção do Ultramar)
 Relatórios do Serviço de Informações
Arquivo Nacional da Torre do Tombo
 Polícia Internacional e de Defesa do Estado
 Serviços de Centralização e Coordenação de Informações de Moçambique (1953–1975)
Biblioteca Nacional de Portugal
 Fundo Geral Jornais

New York, New York

Schomburg Center for Research in Black Culture
 Mozambique—Periodicals
 Southern Africa Collective Collection, 1970–1983 Robert Van Lierop Papers, 1965–
 2001

Reggio Emilia, Italy

Biblioteca Panizzi e Decentrate
 Gil archive di Giuseppe Soncini e Franco Cigarini
Istituto per la Storia della Resistenza e della Società Contemporanea
Reggio Africa

INTERVIEWS BY AUTHOR

Ahmed Ali, Maputo, Mozambique, July 2010
Jorge Almeida, Maputo, Mozambique, April 2010
Diana Andringa, Lisbon, Portugal, April 2017
Cloete Breytenbach, Cape Town, South Africa, August 2016
José Luís Cabaço, Maputo, Mozambique, September 2010
José Cabral, Maputo, Mozambique, March and November 2010

Carlos Calado, Maputo, Mozambique, March 2010

Sol Carvalho, Maputo, Mozambique, April 2010

Joel Chiziane, Maputo, Mozambique, March and June 2010

João Costa ("Funcho"), Maputo, Mozambique, summer 2008 and August 2009

Mia Couto, Maputo, Mozambique, August 2010

Teresa Cruz e Silva, Maputo, Mozambique, July 2016

Francisco Cuco, Maputo, Mozambique, November 2010

Colin Darch, Cape Town, South Africa, February 2015

Colin Darch, email correspondence, 2016

Carlos Djambo, Maputo, Mozambique, August 2009 and August 2010

Margaret Dickinson, Maputo, Mozambique, September 2010

Paul Fauvet, Maputo, Mozambique, March, April, and June 2010

Valeriano Ferrão, Maputo, Mozambique, April 2010

Alves Gomes, Maputo, Mozambique, January 2011

Fernando Gonçalves, Maputo, Mozambique, June 2010

Machado da Graça, Maputo, Mozambique, February, March, and June 2010

Ralph Hajjar, email correspondence, December 2014

Luís Bernardo Honwana, Maputo, Mozambique, July 2008

David Huguana, Maputo, Mozambique, March 2010

Fernando Lima, Maputo, Mozambique, June 2010

Job Lubukuta, Beira, Mozambique, September 2010

Celeste MacArthur, Maputo, Mozambique, September 2010

José Machado, Maputo, Mozambique, summer 2008 and various times in 2010 and 2011

José António Manhiça, Maputo, Mozambique, September and October 2010 and June 2012

Narcésia Massango, Maputo, Mozambique, February 2010

Eduardo Matlombe, Maputo, Mozambique, June and November 2010

João Mendes, Maputo, Mozambique, March and June 2010

Bill Minter, Washington, DC, May 2011

Ferhat Vali Momade, Maputo, Mozambique, November 2010

José Oscar Monteiro, Maputo, Mozambique, July 2008

Salmão Moyana, Maputo, Mozambique, August 2010

António Muchave, Johannesburg, South Africa, August 2016

Alfredo Mueche, Maputo, Mozambique, March 2010 and January 2011

Kok Nam, Maputo, Mozambique, July 2008

Prexy Nesbitt, Skype, October 2009

Grant Lee Neuenberg, Maputo, Mozambique, May 2010

Valente Malangatana Ngwenya with Eléusio Viegas Filipe, Maputo, Mozambique, June 2008

Anders Nilsson, Maputo, Mozambique, December 2010

Cedric Nunn, email correspondence, January 2011

Pedro Odallah, Maputo, Mozambique, December 2010

Pedro Pimenta, Maputo, Mozambique, December 2010

António Ramos, Maputo, Mozambique, September 2010
Beatrice Rangel, Maputo, Mozambique, April 2010
Ricardo Rangel, Maputo, Mozambique, Summer 2008
Ricardo Rangel with Allen Issacaman, Maputo, Mozambique, July 2008
Jorge Rebelo, Maputo, Mozambique, July 2008
Sérgio Santimano, Skype, April 2016
Calane da Silva, Maputo, Mozambique, April, September, and November 2010
Carlos da Silva, Maputo, Mozambique, June 2016
Paul Silveira, Maputo, Mozambique, July 2008; and June and September 2010
José Soares, Maputo, Mozambique, January 2011
Bruna Soncini, with Francesca Tamburini, Reggio Emilia, Italy, May 2017
João de Sousa, Maputo, Mozambique, July 2016
Luís Souto, Maputo, Mozambique, April 2010
Guy Tillim, Skype, March 2016
Joaquim Vieira, email correspondence, May 2011
Tómas Mário Vieira, Maputo, Mozambique, June 2010
Joaquim Viera, Maputo, Mozambique, June 2012
Paul Weinberg, Los Angeles, California, March 2011

ONLINE DATABASES

African Activist Archive—Michigan
 Mozambique History Net
JSOR Aluka: Struggles for Freedom—Southern Africa

MICROFILM COLLECTIONS

Center for Research Libraries
 Newspapers—Mozambique

NEWSPAPERS AND PERIODICALS

Diário de Moçambique
Domingo
Indico (LAM in-flight magazine)
Jornal de Notícias (Mozambique)
Jornal de Notícias (Portugal)
Jornal de Notícias da Beira
Mozambique Revolution
O Premeiro de Janeiro
Revista TEMPO
Savanna
Southern Africa

A Tribuna
Voz Africana
A Voz da Revolução

ARTICLES, BOOKS, DISSERTATIONS, MANUSCRIPTS

Adam, Yussuf. "Trick or Treat: The Relationship between Destabilisation, Aid and Government Development Policies in Mozambique 1975–1990." PhD dissertation, Roskilde University, 1996.

Agualusa, José Eduardo, Inês Gonçalves, Kiluanje Liberdade, and Delfim Sardo. *Agora Luanda.* Coimbra: Almedina, 2007.

Alexander, Jocelyn, JoAnn McGregor, and Tendi Blessing-Miles. "Southern Africa beyond the West: The Transnational Connections of Southern African Liberation Movements." *Journal of Southern African Studies* 43, no. 1 (2017): 1–12.

Allina, Eric. "'Fallacious Mirrors': Colonial Anxiety and Images of African Labor in Mozambique, ca. 1929." *History in Africa* 24 (1997): 9–52.

Anderson, Benedict R. *Imagined Communities: Reflections on the Origin and Spread of Nationalism.* London: Verso, 2006.

Assubuji, Rui, and Patricia Hayes. "The Political Sublime. Reading Kok Nam, Mozambican Photographer (1939–2012)." *Kronos* 39, no. 1 (2013): 20–66.

Azoulay, Ariella. *The Civil Contract of Photography.* Translated by Rela Mazali and Ruvik Danieli. New York: Zone Books, 2008.

Azoulay, Ariella. "What Is a Photograph? What Is Photography?" *Philosophy of Photography* 1, no. 1 (2010): 9–13.

Azoulay, Ariella. *Civil Imagination: A Political Ontology of Photography.* London: Verso, 2015.

Bajorek, Jennifer. "Ca Bousculait! Democratization and Photography in Senegal." In *Photography in Africa: Ethnographic Perspectives,* edited by Richard Vokes, 140–165. Suffolk: James Currey, 2012.

Bajorek, Jennifer. "Of Jumbled Valises and Civil Society: Photography and Political Imagination in Senegal." *History and Anthropology* 21, no. 4 (2010): 431–452.

Barber, Karin, ed. *Africa's Hidden Histories: Everyday Literacy and Making the Self.* Bloomington: Indiana University Press, 2006.

Barber, Karin. *The Anthropology of Texts, Persons and Publics: Oral and Written Culture in Africa and Beyond.* Cambridge: Cambridge University Press, 2007.

Batchen, Geoffrey Miller, Mick Gidley, Nancy K. Miller, and Jay Posser, eds. *Picturing Atrocity: Photography in Crisis.* London: Reaktion Books, 2012.

Behrend, Heike. *Contesting Visibility: Photographic Practices on the East African Coast.* Bielefeld: transcript Verlag, 2013.

Belting, Hans. *An Anthropology of Images: Picture, Medium, Body.* Princeton: Princeton University Press, 2011.

Bender, Gerald J. *Angola under the Portuguese: The Myth and the Reality*. Berkeley: University of California Press, 1978.

Benjamin, Walter. "A Short History of Photography." *Screen* 13, no. 1 (1972): 5–26.

Benjamin, Walter. "The Work of Art in the Age of Mechanical Reproduction." In *Illuminations*, edited by Hannah Arendt, translated by Harry Zohn, 217–251. New York: Schocken, 1969.

Bensusan, Arthur David. *Silver Images: History of Photography in Africa*. Cape Town: H. Timmins, 1966.

Berger, John. "Drawing Is Discovery (29 August 1953)." *New Statesman*, May 2013. Accessed online 4 May 2020.

Birmingham, David. *A Concise History of Portugal*. Cambridge: Cambridge University Press, 1993.

Birmingham, David. *Portugal and Africa*. Athens: Ohio University Press, 1999.

Breckenridge, Keith. *Biometric State: The Global Politics of Identification and Surveillance in South Africa, 1850 to Present*. Cambridge: Cambridge University Press, 2014.

Breytenbach, Cloete. *Savimbi's Angola*. Cape Town: H. Timmins, 1980.

Buckley, Liam. "Self and Accessory in Gambian Studio Photography." *Visual Anthropology Review* 16, no. 2 (Fall-Winter 2000–2001): 71–91.

Buck-Morss, Susan. "Aesthetics and Anaesthetics: Walter Benjamin's Artwork Essay Reconsidered." *October* 62 (Autumn, 1992): 3–41.

Buck-Morss, Susan. "Visual Empire." *Diacritics* 37, nos. 2–3 (2007): 171–198.

Buur, Lars. "Xiconhoca: Mozambique's Ubiquitous Post-Independence Traitor." In *Traitors: Suspicion, Intimacy and the Ethics of State-Building*, edited by Sharika Thirangagama and Tobias Kelly, 24–47. Philadelphia: University of Pennsylvania Press, 2010.

Cabrita, João. *Mozambique: The Tortuous Road to Democracy*. New York: Palgrave, 2000.

Campt, Tina M. *Listening to Images*. Durham: Duke University Press, 2017.

Castelo, Cláudia. "Uma incursão no lusotropicalismo de Gilberto Freyre." *Blogue de História Lusófona* 6, no. 1 (Setembro 2011): 261–280.

Castelo, Cláudia. *"O Modo Português de Estar no Mundo": O Luso-tropicalismo e a Ideologia Colonial Portuguesa (1933–1961)*. Porto: Edições Afrontamento, 1998.

Chatterjee, Partha. *The Nation and Its Fragments: Colonial and Postcolonial Histories*. Princeton: Princeton University Press, 1993.

Clarence-Smith, W. G. *The Third Portuguese Empire, 1825–1975: A Study in Economic Imperialism*. Manchester: Manchester University Press, 1985.

Coelho, Borges, João Paulo. "Politics and Contemporary History in Mozambique: A Set of Epistemological Notes." *Kronos* 39, no. 1 (January 2013): 10–19.

Cooper, Frederick. *Africa since 1940: The Past of the Present*. Cambridge: Cambridge University Press, 2002.

Corrigall, Malcolm. "Reframing Johannesburg's Urban Politics through the Lens of the Chinese Camera Club of South Africa." *Social Dynamics* 44, no. 3 (2018): 510–527.

Couto, Mia. "Carnation Revolution." *Le Monde Diplomatique*, 1 April 2004. Accessed online at: https://mondediplo.com/2004/04/15mozambique.

Darch, Colin, and David Hedges. "Political Rhetoric in the Transition to Mozambican Independence: Samora Machel in Beira, June 1975." *Kronos* 39, no. 1 (2013): 32–65.

da Silva, Calane. "Homenagem a Ricardo Rangel." In *Iluminando Vidas: Ricardo Rangel e a Fotografia Moçambicana*, edited by Bruno Z'Graggen and Grant Lee Neuenberg. Zürich: Christoph Merian Verlag, 2002.

de Braganca, Aquino, and Jacques Depelchin. "From the Idealization of Frelimo to the Understanding of the Recent History of Mozambique." *African Journal of Political Economy/Revue Africaine d'Economie Politique* 1, no. 1 (1986): 162–180.

Dhada, Mustafah. *The Portuguese Massacre of Wiriyamu in Colonial Mozambique, 1964–2013*. London: Bloomsbury Academic, 2016.

Dickinson, Margaret. "Flashbacks from a Continuing Struggle." *Third Text* 25, no. 1 (2011): 129–134.

Didi-Huberman, Georges. "Before the Image, before Time: The Sovereignty of Anachronism." In *Compelling Visuality: The Work of Art in and out of History*, edited by Claire J. Farago and Robert Zwijneberg, 31–44. Minneapolis: University of Minnesota Press, 2003.

Dinerman, Alice. *Revolution, Counter-Revolution and Revisionism in Post-Colonial Africa: The Case of Mozambique, 1975–1994*. London: Routledge, 2006.

Edwards, Elizabeth. "Photographs and the Sound of History." *Visual Anthropology Review* 21, nos. 1–2 (2005): 27–46.

Edwards, Elizabeth. "Photography and the Performance of History." *Kronos* 27, no. 1 (2001): 15–29.

Edwards, Paul N., and Gabrielle Hecht. "History and the Technopolitics of Identity: The Case of Apartheid South Africa." *Journal of Southern African Studies* 36, no. 3 (2010): 619–639.

Elkins, Caroline. "Alchemy of Evidence: Mau Mau, the British Empire, and the High Court of Justice." *Journal of Imperial and Commonwealth History* 39, no. 5 (2011): 731–748.

Elkins, Caroline. "Looking beyond Mau Mau: Archiving Violence in the Era of Decolonization." *American Historical Review* 120, no. 3 (2015): 852–868.

Enwezor, Okwui. "Part One: The Uses of Afro-Pessimism." In *Snap Judgments: New Positions in Contemporary African Photography*, edited by Okwui Ewenzot, 11–19. Göttingen: Steidl/Edition7L, 2006.

Enwezor, Okwui. *The Short Century: Independence and Liberation Movements in Africa, 1945–1994*. Munich: Prestel, 2001.

Enwezor, Okwui, and Rory Bester, eds. *Rise and Fall of Apartheid: Photography and the Bureaucracy of Everyday Life*. New York: International Center of Photography; Munich: DelMonico Books/Prestel, 2013.

Fauvet, Paul. "Roots of Counter-Revolution: The Mozambique National Resistance." *Review of African Political Economy* 11, no. 29 (1984): 108–121.

Fikes, Kesha. *Managing African Portugal: The Citizen-Migrant Distinction*. Durham: Duke University Press, 2009.

Flusser, Vilém. *Towards a Philosophy of Photography*. London: Reaktion Books, 2000.

48. Directed by Susana de Sousa Dias. Screenplay by Susana de Sousa Dias. Produced by Ansgar Schaefer. Alambique Filmes, 2010. Film.

Geary, Christraud M. *Images from Bamum: German Colonial Photography at the Court of King Njoya, Cameroon, West Africa, 1902–1915*. Washington, DC: Published for the National Museum of African Art by the Smithsonian Institute Press, 1988.

Glissant, Édouard. "For Opacity." In *Poetics of Relation*, 189–194. Translated by Betsy Wing. Ann Arbor: University of Michigan Press, 1997.

Gray, Ros. "Ambitions of Cinema: Revolution, Event, Screen." PhD dissertation, Goldsmiths College, University of London, 2007.

Gray, Ros. "Cinema on the Cultural Front: Film-Making and the Mozambican Revolution." *Journal of African Cinemas* 3, no. 2 (2012): 139–160.

Gray, Ros. "Haven't You Heard of Internationalism?" In *Postcommunist Film—Russia, Eastern Europe and World Culture: Moving Images of Postcommunism*, edited by Lars Kristensen, 53–74. London: Routledge, 2013.

Gupta, Pamila. "Decolonization and (Dis)Possession in Lusophone Africa." In *Mobility Makes States: Migration and Power in Africa*, edited by Darshan Vigneswaran and Joel Quirk, 169–193. Philadelphia: University of Pennsylvania Press, 2015.

Gupta, Pamila. "Gandhi and the Goa Question." *Public Culture* 23, no. 2 (May 2011): 321–330.

Gupta, Pamila. *Portuguese Decolonization in the Indian Ocean World: History and Ethnography*. London: Bloomsbury Academic, 2019.

Gürsel, Zeynep Devrim. *Image Brokers: Visualizing World News in the Age of Digital Circulation*. Berkeley: University of California Press, 2016.

Haney, Erin. "Film, Charcoal, Time: Contemporaneities in Gold Coast Photographs." *History of Photography* 34, no. 2 (2010): 119–133.

Haney, Erin. *Photography and Africa*. London: Reaktion Books, 2010.

Hayes, Patricia. "Power, Secrecy, Proximity: A Short History of South African Photography." *Kronos* 33, no. 1 (2007): 139–162.

Hayes, Patricia. "Santu Mofokeng, Photographs: 'The Violence Is in the Knowing.'" *History and Theory* 48, no. 4 (2009): 34–51.

Hayes, Patricia, and Gary Minkley, eds. *Ambivalent: Photography and Visibility in African History*. Athens: Ohio University Press, 2019.

Heintze, Beatrix. "In Pursuit of a Chameleon: Early Ethnographic Photography from Angola in Context." *History in Africa* 17 (1990): 131–156.

Henriksen, Thomas H. *Revolution and Counterrevolution: Mozambique's War of Independence, 1964–1974*. Westport: Greenwood Press, 1983.

Hevia, James L. "The Photography Complex: Exposing Boxer-Era China (1900–1901), Making Civilization." In *Photographies East: The Camera and Its Histories in East and Southeast Asia*, edited by Rosalind C. Morris, 79–120. Durham: Duke University Press, 2009.

Hill, Iris Tillman, André Odendaal, and Alex Harris. *Beyond the Barricades: Popular Resistance in South Africa*. New York: Aperture, 1989.

Honwana, Raúl Bernardo Manuel, and Allen Isaacman. *The Life History of Raúl Honwana: An Inside View of Mozambique from Colonialism to Independence, 1905–1975.* Boulder: Lynne Rienner, 1988.

Igreja, Victor. "Memories as Weapons: The Politics of Peace and Silence in Post-Civil War Mozambique." *Journal of Southern African Studies* 34, no. 3 (2008): 539–556.

Igreja, Victor. "Frelimo's Political Ruling through Violence and Memory in Postcolonial Mozambique." *Journal of Southern African Studies* 36, no. 4 (2010): 781–799.

Isaacman, Allen, and Barbara Isaacman. *Mozambique: From Colonialism to Revolution, 1900–1982.* Boulder: Westview Press, 1983.

Keenan, Thomas. "Counter-forensics and Photography." *Grey Room* no. 55 (2014): 58–77.

Killingray, David, and Andrew Roberts. "An Outline History of Photography in Africa to ca. 1940." *History in Africa* 16 (1989): 197–208.

Landau, Paul S. "Empires of the Visual: Photography and Colonial Administration in Africa." In *Images and Empires: Visuality in Colonial and Postcolonial Africa*, edited by Paul S. Landau and Deborah D. Kaspin, 141–171. Berkeley: University of California Press, 2002.

Landau, Paul Stuart, and Deborah D. Kaspin, eds. *Images and Empires: Visuality in Colonial and Postcolonial Africa.* Berkeley: University of California Press, 2002.

Langa, Sebastião. *Sebastião Langa: Retratos de Uma Vida.* Maputo: Arquivo Histórico de Moçambique, 2001.

Larkin, Brian. *Signal and Noise: Media, Infrastructure, and Urban Culture in Nigeria.* Durham: Duke University Press, 2008.

Larkin, Brian. "The Politics and Poetics of Infrastructure." *Annual Review of Anthropology* 42, no. 1 (2013): 327–343.

Liebenberg, John, and Patricia Hayes. *Bush of Ghosts: Life and War in Namibia, 1986–90.* Cape Town: Umuzi, 2010.

Linfield, Susie. *The Cruel Radiance: Photography and Political Violence.* Chicago: University of Chicago Press, 2011.

LUSA News Agency. "Empresa de emissão de documentos de identificação encerra atividades em Moçambique—DN." *Diário de Notícias*, 23 October 2017. Accessed 18 January 2020.

Machava, Benedito Luís. "State Discourse on Internal Security and the Politics of Punishment in Post-Independence Mozambique (1975–1983)." *Journal of Southern African Studies* 37, no. 3 (2011): 593–609.

Machava, Benedito Luís. "Galo amanheceu em Lourenço Marques: O 7 de Setembro e o verso da descolonização de Moçambique." *Revista Crítica de Ciências Sociais*, no. 106 (2015): 53–84.

Machiana, Emídio. *A Revista "Tempo" e a Revolução Moçambicana: Da Mobilização Popular ao Problema da Crítica na Informação, 1974–1977.* Maputo: Promédia, 2002.

Maciel, Artur. *Angola Heróica: 120 Dias Com os Nossos Soldados.* Lisboa: Livraria Bertrand, 1963.

Mamdani, Mahmood. *Citizen and Subject: Contemporary Africa and the Legacy of Late Colonialism*. Princeton: Princeton University Press, 1996.

Marin, Louis, and Anna Lehman. "Classical, Baroque: Versailles, or the Architecture of the Prince." *Yale French Studies*, no. 80 (1991): 167–182.

Marinovich, Greg, and Joao Silva. *The Bang-Bang Club: Snapshots from a Hidden War*. New York: Random House, 2000.

Martin Luque, Alba. "International Shaping of a Nationalist Imagery? Robert van Lierop, Eduardo Mondlane and *A luta continua*." *Afriche e Orienti* 3 (2017): 115–138.

Mbembe, Achille. *On the Postcolony*. Berkeley: University of California Press, 2001.

Medeiros, Paulo de. "Hauntings: Memory, Narrative, and the Portuguese Colonial Wars." In *The Politics of War and Commemoration*, edited by T. G. Ashplant, Graham Dawson, and Michael Roper, 201–221. London: Routledge, 2000.

Meneses, Maria Paula. "Xiconhoca, o inimigo: Narrativas de violência sobre a construção da nação em Moçambique." *Revista Crítica de Ciências Sociais*, no. 106 (2015): 9–51.

Meyer, Birgit. *Sensational Movies: Video, Vision, and Christianity in Ghana*. Berkeley: University of California Press, 2015.

Minter, William. *Apartheid's Contras: An Inquiry into the Roots of War in Angola and Mozambique*. London: Zed Books, 1994.

Mofokeng, Santu. "Trajectory of a Street Photographer." *Nka: Journal of Contemporary African Art* 11/12, No. 1 (2000): 40–47.

Mondlane, Eduardo. *The Struggle for Mozambique*. London: Zed Books, 1983.

Mondzain, Marie-José. *Image, Icon, Economy: The Byzantine Origins of the Contemporary Imaginary*. Palo Alto: Stanford University Press, 2005.

Monson, Jamie. *Africa's Freedom Railway: How a Chinese Development Project Changed Lives and Livelihoods in Tanzania*. Bloomington: Indiana University Press, 2009.

Moorman, Marissa J. *Intonations: A Social History of Music and Nation in Luanda, Angola, from 1945 to Recent Times*. Athens: Ohio University Press, 2008.

Morgan, Glenda. "Violence in Mozambique: Towards an Understanding of Renamo." *Journal of Modern African Studies* 28, no. 4 (1990): 603–619.

Morris, Rosalind C. "Photography and the Power of Images in the History of Power: Notes from Thailand." In *Photographies East: The Camera and Its Histories in East and Southeast Asia*, edited by Rosalind Morris, 121–160. Durham: Duke University Press, 2009.

Naidoo, Riason. *The Indian in Drum Magazine in the 1950s*. Cape Town: Bell-Roberts Publishing, 2008.

Newbury, Darren. *Defiant Images: Photography and Apartheid South Africa*. Pretoria: Unisa Press, 2009.

O'Laughlin, Bridget. "Class and the Customary: The Ambiguous Legacy of the Indigenato in Mozambique." *African Affairs* 99, no. 394 (2000): 5–42.

Panzer, Michael G. "Building a Revolutionary Constituency: Mozambican Refugees and the Development of the FRELIMO Proto-State, 1964–1968." *Social Dynamics* 39, no. 1 (2013): 5–23.

Panzer, Michael G. "A Nation in Name, a 'State' in Exile: The FRELIMO Proto-State, Youth, Gender, and the Liberation of Mozambique 1962–1975." PhD dissertation, State University of New York-Albany, 2013.

Panzer, Michael G. "Pragmatism and Liberation: FRELIMO and the Legitimacy of an African Independence Movement." *Portuguese Journal of Social Science* 14, no. 3 (2015): 323–342.

Peffer, John, and Elisabeth Cameron, eds. *Portraiture and Photography in Africa*. Bloomington: Indiana University Press, 2013.

Penvenne, Jeanne Marie. *African Workers and Colonial Racism: Mozambican Strategies and Struggles in Lourenço Marques, 1877–1962*. Portsmouth: Heinemann, 1995.

Penvenne, Jeanne Marie. "João Dos Santos Albasini (1876–1922): The Contradictions of Politics and Identity in Colonial Mozambique." *Journal of African History* 37, no. 3 (1996): 419–464.

Penvenne, Jeanne Marie. "Settling against the Tide: The Layered Contradictions of Twentieth-Century Portuguese Settlement in Mozambique." In *Settler Colonialism in the Twentieth Century*, edited by Caroline Elkins and Susan Pedersen, 93–108. London: Routledge, 2012.

Peterson, Derek, Stephanie Newell, and Emma Hunter. *African Print Cultures: Newspapers and their Publics in the Twentieth Century*. Ann Arbor: University of Michigan Press, 2016.

Pinney, Christopher. *Camera Indica: The Social Life of Indian Photographs*. Chicago: University of Chicago Press, 1997.

Pinney, Christopher. "Camerawork as Technical Practice in Colonial India." *Material Powers: Cultural Studies, History and the Material Turn*, edited by Tony Bennet and Patrick Joyce, 145–170. London: Routlege, 2010.

Pitcher, M. Anne. *Politics in the Portuguese Empire: The State, Industry, and Cotton, 1926–1974*. Oxford: Oxford University Press, 1993.

Quembo, Carlos Domingos. *Poder Do Poder: Operação Produção e a Invenção dos "Improdutivos": Urbanos No Moçambique Socialista, 1983–1988*. Maputo: Alcance Editores, 2017.

Ramos, Afonso. "Angola 1961, o horror das imagens." In *O Império da Visão. Fotografia No Contexto Colonial Português*, edited by Filipa Lowndes Vicente, 399–435. Coimbra: Edições 70/Almedina, 2014.

Ratcliffe, Jo. *As Terras do Fim do Mundo = The Lands of the End of the World*. Cape Town: Michael Stevenson, 2010.

Ratcliffe, Jo. *Terreno Ocupado*. Johannesburg: Warren Siebrits, 2008.

Rizzo, Lorena. "Visual Aperture: Bureaucratic Systems of Identification, Photography and Personhood in Colonial Southern Africa." *History of Photography* 37, no. 3 (2013): 263–282.

Roberts, George. "The Assassination of Eduardo Mondlane: FRELIMO, Tanzania, and the Politics of Exile in Dar Es Salaam." *Cold War History* 17, no. 1 (2017): 1–19.

Rodrigues, Paulo Madeira. *4 Paises Libertados: Portugal, Guine/Bissau, Angola, Mocambique*. Lisboa: Livraria Bertrand, 1975.

Saint Léon, Pascal Martin, N'Goné Fall, and Frédérique Chapuis. *Anthology of African and Indian Ocean Photography*. Paris: Revue Noire, 1999.

Saul, John S. "FRELIMO and the Mozambique Revolution." *Monthly Review* 24, no. 10 (1973): 22–52.

Schefer, Maria Raquel. "La forme-evénement: Le cinéma révolutionnaire Mozambicain et le cinéma de libération." PhD dissertation, Sorbonne, Paris Cité, 2015.

Schille, Peter, and Paul Weinberg. "Nie haben wir gelernt, ein Land zu regieren." *Der Spiegel*, no. 47 (1987): 163–172.

Scott, James. *Seeing like a State: How Certain Schemes to Improve the Human Condition Have Failed*. New Haven: Yale University Press, 1999.

Secretariado Nacional de Lisboa. *Genocídio contra Portugal*. Lisboa: Edição Secretariado Nacional de Lisboa, 1961.

Sekula, Allan. "The Body and the Archive." *October* 39 (1986): 3–64.

Selemane, Abibo. "Modernização tira pão à retratista." *Domingo*, 21 March 2010.

Serra, Carlos. "Diário de um sociólogo: Lina Magaia reeditaria 'Operação Produção.'" *Diário de Um Sociólogo* (blog), Agosto 2007. Accessed 4 May 2020.

Simão, Catarina. "Cinema, fotografia e no video no arquivo de Moçambique. A reapropriação como alternative à preservação das imagens em perigo de desaparecimento." In *Cinema em Português*, edited by Frederico Lopes, Paulo Cunha, and Manuela Penafria, 37–50. Covilhã: Universidade da Beira Interior.

Simões De Araújo, Caio. "Diplomacy of Blood and Fire: Portuguese Decolonization and the Race Question, ca. 1945–1968." PhD dissertation, The Graduate Institute of International and Development Studies, 2018.

Solomon-Godeau, Abigail. *Photography at the Dock: Essays on Photographic History, Institutions, and Practices*. Minneapolis: University of Minnesota Press, 1991.

Sontag, Susan. *On Photography*. New York: Farrar, Straus and Giroux, 1977.

Sontag, Susan. *Regarding the Pain of Others*. New York: Farrar, Straus and Giroux, 2003.

Sopa, António. "Um país em imagens: O percurso da fotografia em Moçambique." Publisher and date of publication unknown.

Star, Susan Leigh. "The Ethnography of Infrastructure." *American Behavioral Scientist* 43, no. 3 (1999): 377–391.

Stock, Robert. "The Many Returns to Wiriyamu: Audiovisual Testimony and the Negotiation of Colonial Violence." In *(Re)imagining African Independence: Film, Visual Arts and the Fall of the Portuguese Empire*, edited by Maria do Carmo Piçarra and Teresa Castro, 87–107. Oxford: Peter Lang, 2017.

Tagg, John. *The Burden of Representation: Essays on Photographies and Histories*. Minneapolis: University of Minnesota Press, 1988.

Tagg, John. "Evidence, Truth and Order: Photographic Records and the Growth of the State." In *The Photography Reader: History and Theory*, edited by Liz Wells, 257–260. London: Routledge, 2019.

Tembe, Joel Das Neves. "Uhuru Na Kazi: Recapturing MANU Nationalism through the Archive." *Kronos* 39, no. 1 (2013): 257–279.

Tenreiro, Maria Manuela. "Military Encounters in the Eighteenth Century: Carlos Julião and Racial Representations in the Portuguese Empire." *Portuguese Studies* 23, no. 1 (2007): 7–35.

Thomaz, Omar Ribeiro. "'Escravos sem dono': A experiência social dos campos de trabalho em Moçambique no período socialista." *Revista de Antropologia*, Vol. 51, no. 1 (Janeiro-Junho 2008): 177–214.

Thompson, Drew. "'Não Há Nada' ('There Is Nothing'): Absent Headshots and Identity Documents in Independent Mozambique." *Technology & Culture* 61, no. 2 supplement (April 2020): 104–134.

Thompson, Drew. "Photo Genres and Alternate Histories of Independence in Mozambique." In *Ambivalent: Photography and Visibility in African History*, edited by Patricia Hayes and Gary Minkley, 126–155. Athens: Ohio University Press, 2019.

Thompson, Drew. "Visualising FRELIMO's Liberated Zones in Mozambique, 1962–1974." *Social Dynamics* 39, No. 1 (2013): 24–50.

Thompson, Krista A. *Shine: The Visual Economy of Light in African Diasporic Aesthetic Practice*. Durham: Duke University Press, 2015.

Tonkin, Elizabeth. *Narrating Our Pasts: The Social Construction of Oral History*. Cambridge: Cambridge University Press, 1992.

Trachtenberg, Alan. *Classic Essays on Photography*. New Haven: Leete's Island Books, 1980.

Vansina, Jan M. *Oral Tradition as History*. Madison: University of Wisconsin Press, 1985.

Venter, Al J. *Challenge: Southern Africa within the African Revolutionary Context: An Overview*. Gilbraltar: Ashanti Pub., 1989.

Vicente, Filipa Lowndes, ed. *O Império da Visão. Fotografia No Contexto Colonial Português*. Coimbra: Edições 70/Almedina, 2014.

Viditz-Ward, Vera. "Photography in Sierra Leone, 1850–1918." *Africa* 57, no. 4 (1987): 510–518.

Vokes, Richard. *Photography in Africa: Ethnographic Perspectives*. Suffolk: James Currey, 2012.

Westad, Odd Arne, ed. *The Global Cold War: Third World Interventions and the Making of Our Times*. Cambridge: Cambridge University Press, 2007.

White, Luise. *Speaking with Vampires: Rumor and History in Colonial Africa*. Berkeley: University of California Press, 2000.

White, Luise, Stephan F. Miescher, and David William Cohen. *African Words, African Voices: Critical Practices in Oral History*. Bloomington: Indiana University Press, 2001.

Young, Tom, and Margaret Hall. *Confronting Leviathan: Mozambique since Independence*. Athens: Ohio University Press, 1997.

Z'Graggen, Bruno, and Grant Lee Neuenberg, eds. *Iluminando Vidas: Ricardo Rangel e a Fotografia Moçambicana*. Zurich: Christoph Merian Verlag, 2002.

Page numbers in *italics* refer to illustrations.